Pier Paolo Pasolini

MY CINEMA

Edited by Graziella Chiarcossi and Roberto Chiesi
in collaboration with Maria D'Agostini

Production coordinators: Paola Cristalli and Sara Rognoni

Translated by Stephen Sartarelli: pp. 5-14, 17-21, 23-27, 34-37, 41-42, 44-50, 55-60, 63-67, 71-72, 74-75, 78-79, 86, 95, 99-100, 105-106, 107, 110-113, 115, 117-119, 120, 122, 127-131, 134-141, 143-144, 147-155, 157-161, 163, 165-180, 183-191, 205-212

Translated by Oonagh Stransky: pg. 29-34, 37-38, 87-90, 93, 95-99, 147, 194, 196-204

Translated by Michael F. Moore, Ann Goldstein, Angela Carabelli: pp. 21-22, 23-27, 34-36, 51-52, 95, 99-100, 110-113, 115, 120, 122, 127-131, 133-134, 140-141, 143-144, 152-155, 159-161, 163, 165, 178-180, , 183-187

Translated by Herbert Garrett, Jack Gillin, Peter Glendening, Adrian James, Alison Swaisland, Anita Weston: pp. 63-67, 72-74, 85-87, 91-92, 105, 144-145, 163, 165-178

Translated by John Mathews: pp. 109-110

Translations revised and corrected by Stephen Sartarelli

Images research: Rosaria Gioia

Photographs: Alfonso Avincola, Archivio Carlo di Carlo, Archivio Cameraphoto Epoche srl, Archivio Graziella Chiarcossi, Archivio Scala, Gianni Barcelloni, Deborah Beer (Fondo Gideon Bachmann/Cinemazero), Bruno Bruni (Reporters Associati), Elisabetta Catalano, Domenico Cattarinich, Divo Cavicchioli, Giancarlo De Bellis (Fotogramma), Mario Dondero, Dufoto, Regina Esser, Federico Garolla, General Press Photo, Romano Gentile (Contrasto), Italy's News Photos, Cecilia Mangini, Adriano Mordenti, Movietime, Angelo Novi (Cineteca di Bologna), Marilù Parolini, Duilio Pallottelli (L'Europeo RCS), Angelo Pennoni, Pierluigi Praturlon (Reporters Associati), Publifoto, RaroVideo, Carlo Riccardi (ArchivioRiccardi.it), Paul Ronald (AFE/Collezione privata), Mario Tursi (AFE), Roberto Villa (Cineteca di Bologna)

Posters: Fondo Maurizio Baroni (Cineteca di Bologna)

Graphic design and layout: Mattia Di Leva for D-sign

Post-production imaging: Aldo De Giovanni for D-sign

Thanks to Cecilia Cenciarelli, Rossana Mordini (Cineteca di Bologna), Francesca Fanci, Lapo Gresleri and Manuela Vittorelli

Published by: Edizioni Cineteca di Bologna and Luce Cinecittà, November 2012

Cineteca di Bologna
President: Carlo Mazzacurati
Director: Gian Luca Farinelli
CDA: Carlo Mazzacurati, Alina Marazzi, Valerio De Paolis

With the contribution of

The publisher is willing to provide all entitled parties with any unidentified iconographical sources.

Cover: Pier Paolo Pasolini directing Franco Citti, on the set of *Accattone*, 1961 © Angelo Pennoni

Texts of Pier Paolo Pasolini © Graziella Chiarcossi

CONTENTS

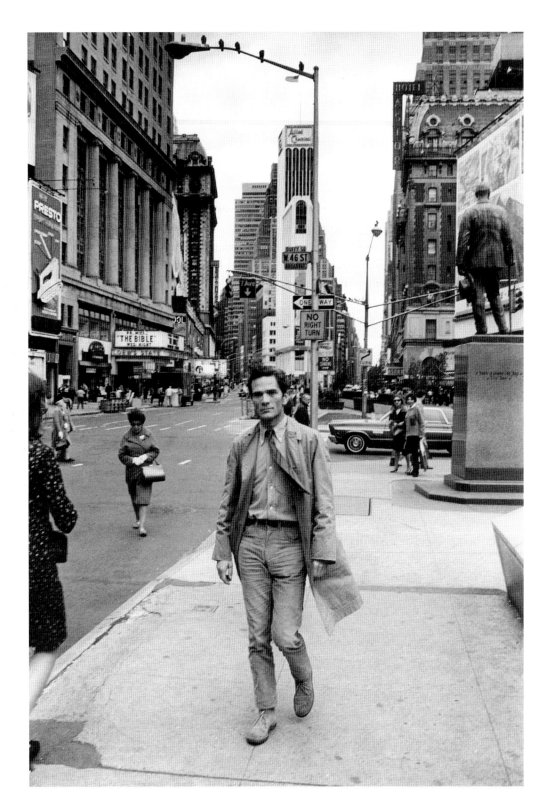

Pier Paolo Pasolini in New York City, 1966

FOREWORD

I met Pier Paolo Pasolini early on in my career, in 1964, when I was only 21 years old and working as assistant set designer for Luigi Scaccianoce. The first film of Pasolini's that I worked on was *Il Vangelo secondo Matteo*, followed by (still as Scaccianoce's assistant) *Uccellacci e uccellini* in 1965 and *Edipo Re* in 1967. *Medea* (1969) was the first film where I was fully in charge of set design.

Pasolini was a unique figure in Italian cinema of the era, independently of the fact that he was an important intellectual and poet. He was not a director in the traditional sense, he didn't come from the world of cinema but from the literary world, and so he didn't have the training and experience that a *cinéaste* in the industry usually has. He adored cinema, but he never lost his perspicacity; he was very careful not to be affected by the pettiness that exists in this profession as in any other. He was the kind of man who was used to defending himself without ever being aggressive, armed only with a firm belief in his own ideas.

One of the first things that amazed me about him was his silent and determined authority, a rarity. He would walk onto the set with the confidence of someone who had already asked himself all the important questions – about set modifications, aesthetic decisions, which actors to use, even for the smallest roles – and found all the answers. Sure, there were still a lot of technical or practical problems that needed to be solved because he really didn't have much experience, but that didn't faze him in the slightest. He didn't mind if his films had "mistakes," if they weren't smooth or perfect. That wasn't his idea of cinema.

His determination was palpable, it could be felt, and he commanded respect from the whole troupe. He was very sure of what he wanted but at the same time he left ample room for the kinds of changes that the spontaneity of non-actors or the nature of his locations could bring to the film, such as the changing light or any number of chance events that can arise when you're filming on location, all of which can bring something surprising and beneficial to the film.

Pasolini could think on his feet and was a fast decision-maker. He never wasted time. Actually, he made the very most of his time. He was physically very strong and could work endlessly, without ever stopping. He was definitely not the kind of director who shouted orders through a megaphone from his chair. He never shouted, he was always on the move, and he was so animated by passion for his work and the desire to be part of everything that he soon became his own director. He guided the troupe without being authoritarian and took the time to explain to his collaborators exactly what he wanted from them. To do that, he used the language that was best adapted to the person with whom he was speaking; he was direct, and this pleased his interlocutors because they felt involved in the decision-making process and not just subjected to a random command. He never was pedantic; there was always an exchange, a real dialogue. At the same time, he always managed to keep a certain distance and address people with the formal *Lei*, myself included.

I remember how much he enjoyed scouting out locations. He either did it himself or with a small number of colleagues by his side. He loved finding a place and comparing the physical reality of it, and its people, with the image he had in his mind. When I went with him I'd watch him closely: he walked and walked with that endless strength of his, he would look at the lines, the

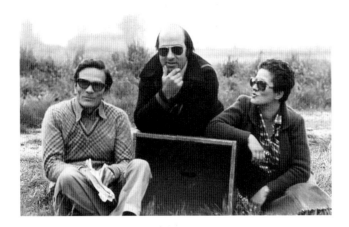

Pasolini, Dante Ferretti (art director) and Beatrice Banfi
(continuity) in 1975, on the set of *Salò*

shapes of the landscape or interiors with incredible tension – the tension of a hunter – never saying a word, his eyes hidden behind dark sunglasses. It was exciting to work with him on the set and with props. He always looked for a kind of fusion, a harmony between invention and the re-elaboration of pictorial forms, getting inspiration from the work of the great painters he loved. His imagination was stimulated by figurative art; it fed on it.

Scaccianoce was a great set designer, with great training, and I learned a lot about my profession from him. But he was not very malleable. He followed his own method, which very skillfully reflected classical and traditional schemes. Pasolini was looking for something else. He mixed environments and styles with great freedom; his research took him in the exact opposite direction from the classical.

I had my first chance to build my own sets when we filmed *Edipo Re*. We arrived in Ouarzazate, which at that time was a sort of Far-West ghost-town, with only two hotels and a hospital. It was desolate. We ate with Scaccianoce, who then took off for Marrakesh. Pasolini got a little angry that Scaccianoce had left and so he put me in charge. He told me to go to Rome and look at the interiors that Scaccianoce had designed because he said he had changed style since the work had been done and he wanted the scenes in the studio to reflect these changes. The set in the studio had been arranged for the

wedding chamber in the royal palace, where Oedipus makes love with his mother. Pasolini wanted the room to be bare and spartan, with essential but important shapes. I saw to this almost entirely myself.

It was then that the harmony between us emerged, a harmony that would last until his death, and for ten very important years of my life. Thinking about it, the harmony established between us was strange because we had completely different tastes in painting: I preferred Art Deco, the imagination of the Thirties and Forties, De Chirico's Metaphysical art and even abstract art, while Pasolini abhorred abstract art and adored the work of artists from the 13th, 14th and 15th centuries.

I think that our mutual understanding owed a great deal to a shared concept of set design as an invention or reinvention of real, historical elements through the blending and contamination of styles and elements that were apparently dissonant but which actually enjoyed a surprising formal harmony.

There's one more reason for our connection, and I think it is a fundamental one: we both had a strong relationship with materials. I only work with real, concrete materials, ones that I love: wood, brick, glass. Even the most imaginative and unreal shapes acquire a stronger and more unique density if they are made with real materials. You can see real materials on the screen, you notice them, and the impact is stronger.

Pasolini never would have liked virtual reality. He loved the physical relationship with objects and the natural expressiveness of things, things that reflected man's imprint, handiwork, craftsmanship, whether it was the work of one man or a group of men. He detested the antiseptic aspect of the modern world and everything that made people and their products, even the simplest and humblest ones, anonymous and indistinguishable.

The importance that he gave to a direct relationship with reality was naturally visible in his choice of filming locations. With Pasolini we were always on the move: for *Medea* we went to Turkey, for *I racconti di Canterbury* to England, for the *Il fiore delle Mille e una notte* to Yemen, Persia, and Nepal. It's no surprise that when he wanted to depict a universe he hated, he shut himself in the studio or used interior shots, as with *Salò*.

All the films that I made with him were set in the past – in a remote past for the first two films of the Trilogy – and a fantasy world for the *Il fiore delle Mille e una notte*, as well as for *Salò*. His goal was never to recreate a past reality; he wanted to reinvent it. The work on sets became a process that led to a contamination of styles. He didn't want to connect to reality but create an autonomous reality that corresponded to his vision and to his visionary imagination. Journeys with Pasolini were life adventures; it was never just a job, because he chose places, spaces, environments that were rich in history, sometimes dramatically so, and sometimes very uncomfortable, but always astonishing from a visual point of view. Think of the conical rocks and valleys of Cappadocia, an unreal landscape, dreamlike, nightmarish even.

He created surprising analogues that – on paper – were puzzling but which always worked on screen, creating unexpected and disturbing effects: in *Medea*, Cappadocia became Colchis; the lagoon at Grado was transformed into the mythical childhood landscape of Jason and the Centaur; Piazza dei Miracoli in Pisa became Corinth. The foreground of a scene wasn't always shot in the same place as the background. For example, the entrance to Medea's house, the large doorway that she looks out of, was built and filmed in the theater, but the background was filmed in Anzio where we set up the sorceress's house on a hillside that descended into the sea. The aesthetic result was one of surprising unity, even though it was filmed in a fragmentary manner and in multiple places.

As I mentioned above, *Medea* was my first independent experience as a set designer. I had just finished working with Danilo Donati on Fellini's *Satyricon* and suddenly received a phone call from *Medea*'s producer, Franco Rossellini, who asked me to come to the set in Cappadocia. Pasolini didn't want to use the set designer that the production team had chosen and he asked them to call me. I dropped what I was doing and left. We started filming at seven in the evening. The first thing I built was the cart that Medea uses to escape from Colchis in order to meet up with Jason. I read the screenplay at night and built the sets by day, adapting them to the places that had already been chosen. It was a real schooling because it was a bold film, from both a visual and narrative point of view.

The next year we made *Decameron* and started the *Trilogy of Life*. Pasolini wanted to film the disappearing folk culture of Italy, and he found it in old Caserta, near Naples, which he knew very well and where there were certain alleys, areas, and roads where we could build on top of preexisting, time-worn structures that were nevertheless still standing, real and concrete.

I remember how pained he was when, on one of our scouting missions, we found a neglected, ancient building, slated for demolition. Already in the 1970s the effects of speculative building development were visible, and he literally suffered physically from it; he understood the gravity of it all. For *Decameron* he showed me some Giotto images, some art from the 14th and 15th century, work by Bosch, but also later artists, including Bruegel, even though it was a Mediterranean film with its roots deep in the universe of Naples. We filmed both in old structures that we adapted and pre-existing ruins that we rebuilt. He was always particularly attentive to the plasticity of things and the graphic quality of the image, to balance and imbalance, and in particular to the compositional symmetries in volume, line and color.

With regard to materials, in *Decameron* wood is a dominant and fundamental element, and not just in the interior shots. Before filming started, I had heard that an old home in Rome was being demolished, and so my colleagues and I rushed over to get all the wood we could. We built all the furnishings and furniture with that wood and thus it became an important component of the film, like the smoky stones in old peasant buildings.

For *Canterbury*, Pasolini wanted to recreate the Gothic world of Northern Europe, a darker world than the Neapolitan one, so he showed me more Bosch and northern European paintings from the Middle Ages. A good part of the village of Canterbury was rebuilt; I built the big beds. If you pay attention, you will see the importance of red, bright red, in the costumes, the furnishings and the decorations, and even in the scene of the fire (where a man is burnt alive).

Pasolini wanted a lava-red color for many scenes of the film. On Etna we rebuilt a Hell inspired by Bosch, with the damned and demons immersed in volcanic earth.

For the *Il fiore delle Mille e una notte*, he showed me Arab, Indian, and Persian miniatures, and stressed the symmetries present in each. You see this in the importance of mirrors in some scenes, including the marriage chamber where Zummurrud pretends to be a man and where she meets back up with Nur-ed-Din at the end of the film. In Isfahan we built a platform two meters high in a sacred building because Pasolini was fascinated by the ceiling, and he managed to get a permit to film that way. The set was curtained off out of respect for the locals, who might have been offended by the profane things that went on there. That room of mirrors is one of the most magical settings in the film.

He also loved Sana'a, and thought it was an incredible city, simultaneously barbaric and refined. I first went to Sana'a in the Seventies when we were filming an episode of *Decameron,* Alibech, which was then cut from the final edit. Even back then, Pasolini was thinking about filming a portion of the *Il fiore delle Mille e una notte* there; his impression of the city clicked with his vision of that future film.

Salò took longer to film. It was mainly filmed indoors, so we had to build sets from scratch. We made the furnishings, wallpaper, paintings, and decor. There used to be an amazing store in Rome where they sold objects from the Forties, such as wallpaper with designs from that period. I remember how we created a bedroom with a black bed, where one of the four "monsters" slept. Pasolini wanted to evoke a closed, detestable world, a world that was intolerant, deadly, and entirely the opposite of the interiors shown in the Trilogy.

I recall how he much attention he paid to the objects on the set, objects that belonged to the bourgeoisie and not to popular culture, as in his other films. Perhaps they reminded him of something. After all, those were the objects from his youth and he was familiar with that world, even if he detested it. We reconstructed the interiors of the villa in a farmhouse near Mantua. The higher echelons of society used to surround themselves with art that was, at the time, considered degenerate; in fact, in the film there are none of the typical Fascist fetishes, no Mussolini busts. On the contrary, there is avant-garde art. Another aspect of the film is the close attention paid to geometric shapes: space is divided into sharp lines, and cold design dominates every space.

Then, suddenly, a few months before the film came out, we got news of his murder. It was a very difficult moment, terrible. A few months earlier he had given me the script of *Porno-Teo-Kolossal* and said he needed some visionary set designs. It would have been an immense job, extraordinary, and I regret not being able to work on it with him. I recall the last thing I did for him: I met with Sergio Citti and drew the first sketches for the sets.

In 2011, when the Cineteca di Bologna asked me to think about an installation dedicated to Pasolini for the Festa di Roma, I envisioned a gigantic typewriter spewing a cloud of paper printed with his words, with his writing on them. The motivation for this image was the memory of the impression I had when I read his pieces in the *Corriere della sera*, when he was still alive. The image I have of him is closely associated with the force and intellectual acumen of those texts, which were an implacable diagnosis of the present that we inhabit.

Dante Ferretti

(Edited by Roberto Chiesi)

PASOLINI, WITNESS TO THE PRESENT

Poets often bear witness to lost or endangered worlds. They tell of the end of an era, a mood, a generation, a history that may be derisory in scope, limited to a small country or even the cramped space of a room, but which the magic of poetry, the fabric of metaphors and analogies make mysteriously accessible to others.

Generally poets return to a reality already gone to erect a work of humble or solemn memory. Pier Paolo Pasolini instead described a process of extinction starting from the first warning signs, as it progressed and grew like an incurable illness. He tried to fight it and prevent it, at first with the optimism of the will, then with a dismay that never turned into unconditional surrender and a sorrow that never became acceptance. And at the same time he followed and combatted its gradual, unstoppable spread with the weapons of poetry.

Pasolini was witness to a process that was consummated in Italy between the 1950s and '70s: the extinction of the folk culture and the different worlds that made it up, from the peasant life of the countrysides to the lumpen proletariat of the cities and their peripheries. This immemorial sphere of life was being wiped out by an indiscriminate industrialization that violated the body of the peninsula's landscape like the bodies of its inhabitants, which were transformed in a few years down to their very language, their gestures, and their identities by a process that Pasolini called "homogenization," which transformed the people *en masse*.

Italy was probably the most emblematic setting of this process, which was assailing ancient cultures everywhere, especially for the speed with which it took place on the peninsula.

The humble story of the "last" people of the countrysides and the *borgate* – the poor and desolate suburbs around Rome – was one of the central themes of Pasolini's inspiration. He told the story of that way of being human from a perspective where visceral, lyrical advocacy merged with social and anthropological analysis. The "poetic" possession of that world was effected through mimesis and the re-invention of language; and to exalt that humanity, Pasolini adopted the key to the language in which it expressed itself and then shaped it in the laboratory of his poetry.

Starting in the early '60s, Pasolini realized with increasing alarm that this humble humanity was changing, abandoning itself in pursuit of other social models being imposed from above – petit-bourgeois models.

It is also as a witness to this loss of traditional identity that Pasolini is being studied by posterity all across the world – through his poetry, his novels, his critical writings on Modernity, his films so foreign to the conventions of present-day cinema. Through him people can measure themselves against the characteristics of a lost and now unknown culture and find, in his writings of forty and more years ago, the keys to deciphering the features of an elusive present lost amidst the undifferentiated mass.

While in Italy new readers and viewers of Pasolini seek in his work perhaps above all an analysis of the causes of the uncentered, formless void of their lives, abroad he is viewed as the only man of his time who was able to capture the essence of the primitive world extending from Italy to the Third World – a lost, defeated world that Pasolini evoked in his poetry, novels and films without minimizing its violence and cruelty.

But Pasolini is the key poet-as-witness also because he employed all the tools of Modernity – books, the daily, weekly and monthly presses, film, theater, radio,

Pasolini in 1958, during the making of *Ignoti alla città* by Cecilia Mangini

the search for the sacred in abjection; the redemption of "low" situations with "high" language and style.

But Pasolini was also a great poet of the self, of the dark nature of the human impulses whose roots strike deep in the secret history of an individual, to the very core of his identity, in an often dramatic dialectic between corporeality and conscience. By applying this aspect without prejudice to the different mediums of poetry (*Poesia in forma di rosa*), fiction (*Petrolio*), theater (*Orgia, Affabulazione, Bestia da stile*), Pasolini exposed what normally remains hidden in an individual's flesh, in the mystery of sexuality, in the enigma of the acts of existence.

While he was being formed intellectually at the University of Bologna in the 1940s, notably under the tutelage of the great art historian Roberto Longhi, Pasolini the poet chose as his lyric universe the peasant world of the Friuli, specifically the village of Casarsa della Delizia, where his mother was originally from. It was not only a humble and marginal world, but one that had never been deemed worthy of its own literature. During the '40s Pasolini evoked this world in poetry both in Italian (*L'usignolo della Chiesa Cattolica)*, not published until 1958) and in the literarily virgin tongue of Casarsese (different from the Friulian dialect spoken beyond the opposite banks of the Tagliamento), which Pasolini fashioned himself for the lyrics brought together in his first book of poetry, *Poesie a Casarsa* (1942), and in the broader collection *La meglio gioventù* (The Best of Youth, 1954). In these poems we already encounter an alternation of lyrical and reflective impulses, as well as short lyric fragments and long epico-lyric poems.

During this same period Pasolini also began his first experiments in theatrical writing. In *I turcs tal Friul* (The Turks in Friuli, 1944), he alternates between a collective dimension – the historical framework of the Turkish invasion of the Friuli alludes to the Nazi invasion of those very years – and an individual, existential one.

At the same time he also embarked on a number of fictional ventures. He wrote short stories which came together in the choral novel *Il sogno di una cosa* ("A Dream of Something", not published until 1962),

television – to attack the growth without progress of the new technocratic society. His experimentalism tested itself in almost every medium of expression – poetry, fiction, essays, theater, film, painting – seeing them as so many casts in which to pour a single font of inspiration that found in oxymoron, stylistic hybridism, and the most apparently strident contradictions some of the motifs of his extraordinary artistic vitality.

One of the reasons for the sort of "old-fashioned" vitality of Pasolini's oeuvre lies precisely in the energy of these different dynamics fusing together in his works, these contradictions that remain unreconciled: a love of the classics and the constant subversion of classical codes; an exaltation of both "barbaric" irrationalism and secular reason; an emphasis on physical reality but also on dream reality; linguistic mimesis of speech and reinvention in the lab; obsession with the sacred and

while diaristic novels revolving around the torments of homosexual eros, *Atti impuri* (Impure Acts) and *Amado mio*, would remain unfinished. The years in Friuli also coincided with his discovery of Marxism and his political engagement in the ranks of the Italian Communist Party, which inspired a number of writings of an ideological nature. His "little homeland" of Friuli was thus an entity of total inspiration that would dominate every mode of Pasolini's expression in those years, including his intense activities as a painter and draughtsman.

His departure from Friuli was brought on by the first scandal of his life, concerning his homosexuality, forcing him to move to Rome. Here, in 1950, he found a new universe that would become the center of his lyrical, fictional and, later, cinematic works. The quasi pagan world of the Roman *borgate* and its population of castoffs indeed served as the inspiration for two successful novels, *Ragazzi di vita* ("The Ragazzi", 1955) and *Una vita violenta* ("A Violent Life", 1959), the language of which was derived from a bold pastiche of mimesis and reinvention.

In the former, the narrative is fragmented, time cadenced by long gaps; in the latter, the story is more linear, the subject more structured, as it describes the evolution of a young thief who goes from support for neo-Fascism to membership in the Italian Communist Party.

The success of the two novels also marked the beginning of a long series of charges of obscenity, indecency, and defamation of religion which would lead to no less than thirty-three trials and accompany Pasolini's work even beyond the grave. From this same decade also date many short stories, some of them already characterized by a "cinematic" style; they would all be brought together, with other fictional efforts, in the collection *Alì dagli occhi azzurri* (Blue-eyed Ali, 1950-1965). Other prose works include diaristic writings compiled during a journey to India with Alberto Moravia and published in *L'odore dell'India* ("The Scent of India", 1962).

The poems of the first Roman period were brought together in *Le ceneri di Gramsci* ("The Ashes of Gramsci", 1957), in which he resorts to Dantean tercets as well as narrative poems and hendecasyllabic lines, but

where compositional freedom already dominates the metrical structure. Also during the 1950s, Pasolini was engaged in passionate studies of dialect literature that culminated in two "panoramic" books, *Poesia dialettale del Novecento* (Twentieth-century Dialect Poetry, 1952) and *Poesia popolare italiana* (Italian Folk Poetry, 1955). From 1955 to 1959 he also took part in the creation of the literary review *Officina*, whose stated intention was to renew twentieth-century tradition in polemical opposition to Hermeticism and Neorealism. His major critical work of this time was the essay collection titled *Passione e ideologia* (Passion and Ideology, 1960), where analyses of style are accompanied by a tendency to foreground poets situated at the margins of tradition, though he also cites the major poet Giovanni Pascoli as a model for what the prominent literary scholar, Gianfranco Contini, dubbed *plurilinguismo*, or "linguistic pluralism" in the Italian tradition.

A return to the lyrical register, compared with the more epic-narrative approach of *Le ceneri di Gramsci*, marks the next poetry collection, *La religione del mio tempo* (The Religion of My Time, 1961), where we already find his characteristic dichotomies between a mythic past and a degrading present, and a religious claim to passion and piety against the sterility of reason and conformism.

A clean severance from the '50s, an accentuation of the diaristic and narrative veins, and a consciousness of profound crisis characterize the 1964 collection, *Poesia in forma di rosa*, where Pasolini adopts again the Dantean tercet while often eschewing rhyme and meter and experimenting with different typographies. And for the first time, Pasolini evokes the Third World as a new myth in his work.

After nearly a decade of collaborating on screenplays for such figures as Mario Soldati, Mauro Bolognini, Federico Fellini and others, in the '60s Pasolini establishes himself as a filmmaker in his own right. His debut, with the 1961 film *Accattone*, takes place at a moment of extreme vitality in the "new cinema" and represents a step beyond Neorealist models in favor of an original Neoexpressionism. It is a cinema of a profoundly painterly nature characterized by an emphatic

frontality of imagery and a "transgressive" use of saturated, high-contrast black-and-white.

In his next two films *Mamma Roma* (1962) and *La ricotta* (1963) – the latter an episode of the anthological *RoGoPaG* – the main characters still belong to the same world of the Roman *borgate*, but the protagonist of the former film, an ex-prostitute, aspires to make a place for herself and her son, Ettore, in the petit-bourgeois world, with tragic consequences. *La ricotta* instead tells the story of a Christlike "passion" experienced by a poor extra on a film set while the director is creating a Mannerist production of Calvary.

The Italian establishment reacted harshly. *La ricotta* was charged with religious defamation and subjected to a grotesque trial where the prosecution (the magistrate Giuseppe di Gennaro) vivisectioned the film on a moviola in the courtroom. In the meantime Pasolini finished *La Rabbia* (1963), an original experiment at making a poem in film, constructed entirely out of archival footage (drawn from movie newsreels, reproductions of paintings and photos, and film sequences), to evoke the social and historical climate of the years between the postwar reconstruction and the economic boom. The voice-over is both in prose (in the painter Renato Guttuso's voice) and in poetry (in the voice of the writer Giorgio Bassani). But the producers forced Pasolini to shorten the film to medium-length so that it could be coupled with a heavy-handed satirical polemic by Giovannino Guareschi. His original project would languish unknown until 2008, when Giuseppe Bertolucci, drawing inspiration from an idea of Tatti Sanguineti, created a hypothetical reconstruction based on the original voice-over text.

In 1963 Pasolini also experimented with another original film form that was variously called location scouting or "notes for a film to be made." The first such example, *Sopraluoghi in Palestina per "Il Vangelo secondo Matteo"* (1964), was, for the author, an opportunity to ascertain that a film about the Passion could not be made in the actual historical setting. *Appunti per un film sull'India* (1968) and *Appunti per un'Orestiade africana* (1970), which were supposed be preludes to a cinematic epic about the Third World, are two open works, de-

liberately left unfinished. In 1964, after making *Comizi d'amore* (Love Meetings), a brilliant example of *cinéma vérité* on Italian conceptions of sexuality, Pasolini made his first film based strictly on a written text with *Il Vangelo secondo Matteo* (1964), which echoes fourteenth and fifteenth century iconography in evoking the Passion of a "revolutionary" Christ nowhere to be found in any of the Hollywood hagiographies.

His meeting the Neapolitan comical genius Totò was one of the inspirations for the creation of the picaresque journey of *Uccellacci e uccellini* (1966), a fable about the crisis of the leftist intellectual in the face of the triumph of consumer capitalism, and for two wonderful films where he tries his hand at color and the "middle style" of the humorous fable: *La terra vista dalla luna* (1966) and *Che cosa sono le nuvole?* (1966). The two films were supposed to be part of a single, episodic film, but the project ran aground with the death of Totò.

In 1966 Pasolini wrote six tragedies in verse, formulating a theory of a new "theater of the word" that would give a central role back to the poetic word, in contrast with most modern dramaturgy. A few of these texts – *Orgia*, *Affabulazione* – unflinchingly lay bare the darkest, most lacerating dynamics of the self. A rough theatrical sketch was also the source of a new novel, *Teorema* (1968), the basis for the film of the same name, while a "rewriting" of the first cantos of Dante's *Divine Comedy* led to an autobiographical poem in prose, *La Divina Mimesis* ("Divine Mimesis", 1963-65), which wouldn't be published until 1975.

During this period he also made the visionary, "barbaric" film *Edipo Re* (1967), in which Sophocles' tragedy becomes myth while the prologue and epilogue contain echoes of Pasolini's own biography. In 1966 during a conference at the Mostra del Nuovo Cinema in Pesaro, Pasolini presented a theory of cinematic semiology in which he unveiled his idea of a "cinema of poetry," in which the subjective, point-of-view shot would dominate and free the "possibilities of expression from traditional narrative convention." Once again his theories showed the makings of genius, and after being hotly contested at first, they would later be re-appreciated by French philosopher Gilles Deleuze.

In 1972 Pasolini collected his writings on the cinema and on language and literature, in the volume *Empirismo Eretico* ("Empirical Hereticism"). Also in '72, Pasolini resumed his once-constant activity as a literary critic for the weekly *Tempo*, in pages of admirable interpretative acumen (the essays would later be collected posthumously in the volume titled *Descrizioni di descrizioni* (Descriptions of Descriptions). In 1971 he had published another volume of poetry, *Trasumanar e organizzar* (Transhumanize and Organize), which actually consisted of three books: an intense private diary, a refined "songbook" and an "entirely political" book, which all shared an unapologetic freedom of composition and structure, a formal iconoclasm, and, as always, a taste for oxymoron.

Meanwhile, as had already been evident in his journalistic writings of the late 1960s for the weekly *Tempo* (under the rubric "Il Caos"), Pasolini by this point was fully aware of the irreversible triumph of consumerist neocapitalism. Against the "unreality" of petit-bourgeois culture he pitted three allegorical films: *Teorema* (1968), in which he imagines the consequences of the sudden appearance of a god (Eros) in the bosom of a bourgeois family; *Porcile* (1969), in which two stories in different epochs alternate to point out that in our present society we not only devour our disobedient children but also our slothful ones; and *Medea* (1969), where he rereads Euripedes' tragedy as the impossibility of harmony between two irreconcilable cultures.

In 1973 he started writing for the most prominent daily in Italy, the *Corriere della sera*, deciphering the features of our "dreadful" epoch and coining images and metaphors that would become emblematic (e.g., the Palace). His articles where collected in *Scritti corsari* (Pirate writings, 1975) and *Lettere luterane* ("Luteran letters", 1976). In 1973-74, he rewrote his early Friulian poetry, "disfiguring" their elegiac meaning out of a need to "start over" from "necessary goods," and published them in *La nuova gioventù* ("The New Youth", 1975). Between 1970 and 1974 he made three films, which he called collectively *The Trilogy of Life*, in which he evoked the past of the common people by reinterpreting the stories of Boccaccio, Chaucer, and the medieval Islamic

Pasolini and Federico Fellini on the set of *Le notti di Cabiria* (1956)

world, attaining, in the third of these films, *Il fiore delle Mille e una notte* (1974), an enchanted, dreamlike form of cinematic narrative. Also inspired by a concept of limitless narrative was his great unfinished novel, *Petrolio*, begun in 1972 and not published until 1992, which takes stylistic contamination to its extremes in a *mélange* of narrative and diaristic passages, critical essays, journalistic pieces, and even photographic material. In 1975, just before he was brutally murdered, he finished the film *Salò o le 120 giornate di Sodoma*, a hallucinatory allegory of the present day as a sort of concentration camp, drawn freely from the unfinished novel of the Marquis de Sade.

Roberto Chiesi

In this book the reader will find a selection of texts in which Pasolini speaks of his cinematic works, film by film, in chronological order, from *Accattone* (1961) to *Salò* (1975). We intentionally chose texts of a heterogeneous nature, not only interviews destined for publication – starting with his long discussions with Oswald Stack (alias Jon Halliday) in 1968 – and statements written by Pasolini as introductions to his films, but also self-interviews, excerpts of film treatments, preparatory notes, fragments of screenplays, unpublished typescripts and personal writings which concretely display the diversity of the forms and media the author adopted to recount his experiences in filmmaking.

The book's final section includes a number of writings on his most important projects that remained unrealized, some due to external causes. The trial for defamation of religion in 1963 prevented him from realizing the compelling story of *The Savage Father*; production problems thwarted the completion of the complex, innovative project of the *Notes for a Poem on the Third World*; and others were cut short by the artist's sudden, violent death, including *Saint Paul* (1968-1974) and *Porno-Teo-Kolossal* (1973-75).

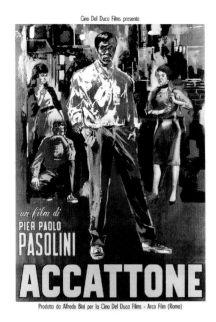

I was supposed to make the film *Accattone* with the producers Cervi and Iacovoni. I was supposed to leave in early September. But around that time, the two producers quite suddenly, and unexpectedly, seemed uncertain, distracted, absent to me. Or was it I who was feeling a little sheepish? Not without reason, of course, given my state of disgrace, so to speak, in the eyes of officialdom and the clergy. And so I went to Fellini. Who that same summer had founded Federiz, his production company, together with Rizzoli. And he had asked me several times, with Fracassi, if he could produce my film himself. Actually, he had negotiated with two young men from the Ajace firm, but without ever reaching an agreement (which would have led to a co-production). My contract with Cervi and Iacovoni involved a different project, however, *La commare secca* ("The Grim Reaper"), which I'd since abandoned. Since I hadn't received any advance, I was free. The summer was going by, and my inspiration was, well, slipping away. And so I went to see Fellini, who greeted me with a big hug. During those same days in early September he was furnishing the company's new offices in Via della Croce, and he was doing it with a youthful pleasure and pride, and preening a little, of course. We embraced and got down to work.

This was how I spent what I think were the happiest days of my life. I had almost all the characters there, and I began having them photographed, dozens and dozens of photographs. By a trusty photographer, who was entirely caught up in my virginal enthusiasm. And by Attilio Bertolucci's son, Bernardo, who was equally caught up. The faces, the bodies, the streets, the squares, the shanties piled on top of one another, the fragments of tenements, the black walls of crumbling highrises, the mud, the hedgerows, the meadows of the urban outskirts strewn with bricks and garbage: everything presented itself in a fresh, new, thrilling light, as if absolute, heavenly.

Accattone, Skinny Giorgio, Scucchia, Alfredino, Crazy Peppe, the Sheriff, Bassetto, Gnaccia; and then the Pigneto quarter, Via Formia, the Borgata Gordiani, the streets of Testaccio; and the women – Maddalena, Ascensa, Stella; and Balilla and Cartagine – all of them captured in sumptuous shots, carefully selected and placed in order: frontal stuff, but anything but stereotyped, lined up as if waiting to start moving, living.

Then, at Fellini's suggestion, I made some rushes – in other words, I effectively shot the film twice, almost in its entirety.

Those were glorious days in which the summer still blazed in all its purity, only slightly drained of its fury from within. Via Fanfulla da Lodi, in the middle of the Pigneto quarter, with its small, low houses and crumbling little walls, had, in its minuteness, a grandiose graininess about it: a poor, humble, unknown little street, lost in the sunlight, in a Rome that wasn't Rome.

We filled it up: a dozen actors, the cameraman, the grip hands, the sound crews. But since there were no groups of onlookers – I didn't want even to hear any mention of them – the whole operation took place in a calm atmo-

sphere. They all seemed like workers mingling with other workers who had jobs in the small workshops of the Pigneto.

I would never have imagined that directing a film could be so extraordinary. I would choose the quickest, simplest way of representing what I had written in the script. Small visual blocks juxtaposed in orderly fashion, but almost crudely. I had Dreyer's suggestion inside me: in reality I was following a guideline of utter simplicity of expression. It would take too long to go into detail: struggling with the light, its continuous, obsessive mutations, struggling with an old movie camera, struggling with my actors from Tor Pignattara, all of them, like me, on a film set for the first time. But these were struggles that always found resolution in small, comforting victories.

I got no sleep during the three nights of the shoot. I was always thinking about the film as if inside a sort of radiant nightmare. Every few minutes I was awakened with a start by these sorts of brief, pleasurable internal hemorrhages, at the start of which would appear the shots or the sequence of shots I was supposed to film the following day or of scenes that would come gradually into my head while sleeping. I spent a whole night blinded by the sun at Ciriola sul Tevere, beneath the Castel Sant'Angelo, with the faces of Alfredino and Luciano laughing, squinting their eyes and making wrinkles round the eyes, with that sly laughter of theirs that demolishes all of life's rules with an ancient, historic joy. The faces of peons, of ship's boys on the *Potemkin*, of monks.

The ordeals with the press, with the moviola, the montage, the sound track, would require a whole volume of memoirs – especially for the uninitiated, of which I was one. At last two scenes were ready, and then began the wait, about which there was no reason to feel doubtful but which nevertheless made me keenly aware of resting on nothing, on a fate that didn't move, that had no future.

I get bored, you know, restlessly bored, in front of meaningless pages. And then suddenly, as expected, the telephone rings, as if to confirm all this. It's Franco, who's supposed to play Accattone, the protagonist. By now he's been calling me every day at this hour over the past week – pointlessly, which he knew. And with him his brother Sergio, my old, irreplaceable assistant, my living dictionary of the Roman dialect, and everyone else. And my anxiety is aggravated by theirs. I don't know how to calm them down, how to treat their potential disappointment. Fellini, yesterday, grabbed the film can and went and looked at the material by himself. We were supposed to do it together, with the actors included, just so they'd be a little encouraged… Only later did Fellini phone me to let me know. In reality it was understandable, and right, for him to act that way. But then the silence returned. I waited all morning for a phone call. Nothing.

The Federiz offices are open and empty, with their beautiful white curtains with green trim, of fine fabric, their furniture reminiscent of a rich, airy refectory. I enter, and there, suddenly, without mystery, is Riccardo

Pasolini with Tonino Delli Colli, Franca Pasut, and Franco Citti

18

Fellini, and there is Fracassi, in his office. As I come in, so does Fellini himself, by chance, through an internal door. The Great Mystifier is unable to hide, behind his eye-shadow, that I've come unexpectedly, and a bit early, but he still welcomes me with an embrace. He's clean and sleek, hearty as a wild animal in a cage. He brings me into the other room, his office. And as he's sitting down, he tells me at once that he wants to be frank with me (ouch!), and that the material he's seen hasn't convinced him, not at all…

I knew it already. It had been clear for at least ten days that he wouldn't like it, perhaps since the first evening when I went to him to suggest that he produce the film – whether or not he was aware of it himself. And so I'm not surprised. And I discuss it with him out of a pure and simple love of clarity and the truth.

What is it, in essence, that Fellini doesn't like? The poverty, the sloppiness, the coarseness, the awkward, almost anonymous pedantry with which I've shot the scene. Fine, I agree. It was my first experiment. For the first time in my life I found myself behind a movie camera, and this movie camera was all beat up, old, and could hold only a little film at a time. I was supposed to film an entire scene in a day. And the actors too were in front of a movie camera for the first time. What was I supposed to do, work a miracle? Yes, of course, Fellini had been expecting a miracle. Which didn't occur, because, having no

Pasolini with Mario Cipriani, Franco Citti and Roberto Scaringella on the set

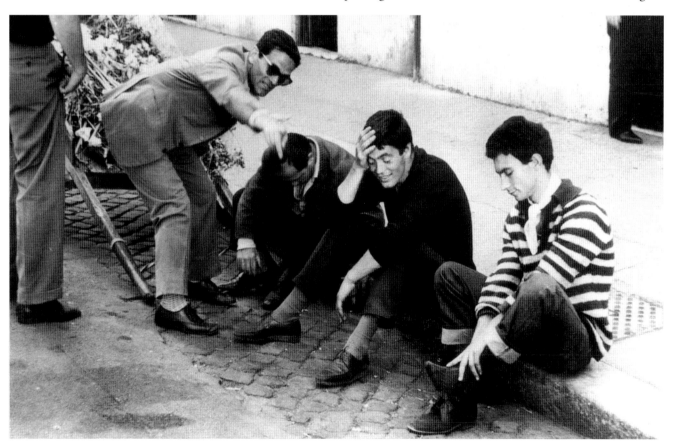

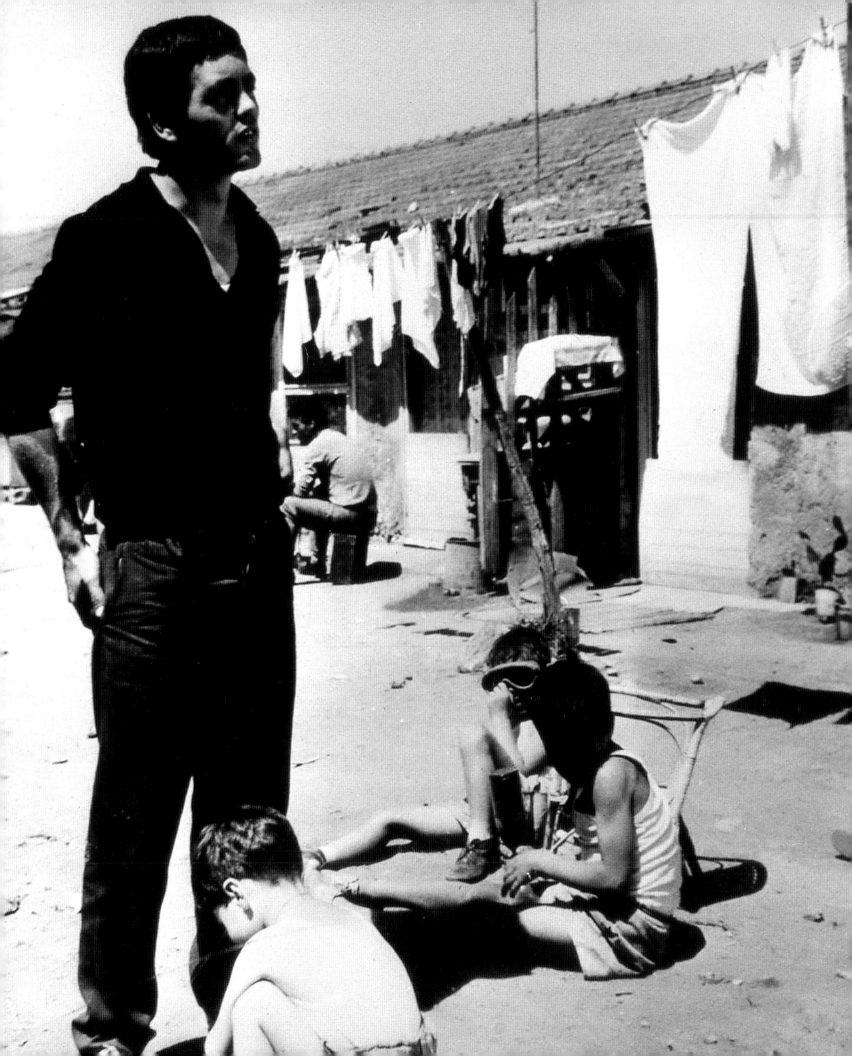

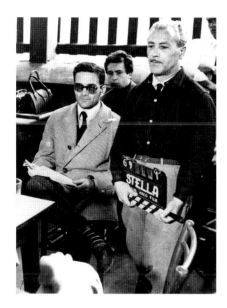

There was everything already in the screenplay, and I didn't invent or improvise anything during the shooting, except for a few small, irrelevant details. That is, I quite faithfully respected the script, even though I had dashed it off in rather approximative fashion, a bit like notes, more as something to be done than as something already finished. Nonetheless, as I wrote the script I already had in mind what I needed to do and what I would do later, while shooting. Naturally, afterwards, between the film and the screenplay there's a qualitative leap, and here it's very hard to express myself off-the-cuff because I still lack the terminology to be able to talk about film. The qualitative leap is precisely in the transition from the screenplay to the finished work. I had the film in my head, and I wrote the screenplay with the image that I would later photograph already in my mind; but the film in the end turned out to be something new, something I made really right there on the spot, as when one is writing. I can take notes for a poem, but then when I've written the poem I realize that the notes and the poem are two different things, with the same leap between them that there is between a script and a movie. I can't really say: There was already everything in the screenplay, as indeed there was. Still, the choice of this sidewalk over another sidewalk, the choice of this light over a different light, of these characters instead of other characters, made it so that in the end, *Accattone* was totally different from what I had seen in the screenplay. That is, in the screenplay I had seen the outline of the scenes making up the film, and I filled in this outline faithfully, I tried to fill it with a truly living substance, with poetic elements or, if you like, with poetry.

From "Una visione del mondo epico-religiosa," tape recording of a debate with students of the Centro Sperimentale di Cinematografia (Rome, March 9, 1964), *Bianco e Nero*, no. 6, June 1964, later in *Per il cinema*, eds. Walter Siti and Franco Zabagli, Meridiani, Mondadori, Milan 2001

Between 1961 and 1975 something essential changed: a genocide occurred. A population has been culturally destroyed. And I am speaking specifically of a physical genocide like those of Hitler. If I had been away on a long journey and come back a few years later, I would have the impression, while going around the "grand plebeian metropolis," that all its inhabitants had been deported or exterminated, and been replaced on the streets and in the yards by slavish, ferocious, unhappy ghosts. Hitler's S.S., to be precise. Drained of their values and models, and their blood, the young have become ghostly casts of another way and conception of being: the petit-bourgeois one.

If I wanted to remake *Accattone* today, I would no longer be able to. I wouldn't find a single youth who, in his "body," was even remotely similar to the youths who played themselves in *Accattone*. I wouldn't find a single youth who could say the same lines, in the same tone of voice. Not only would he lack the wit or the mentality to say them: he wouldn't even under-

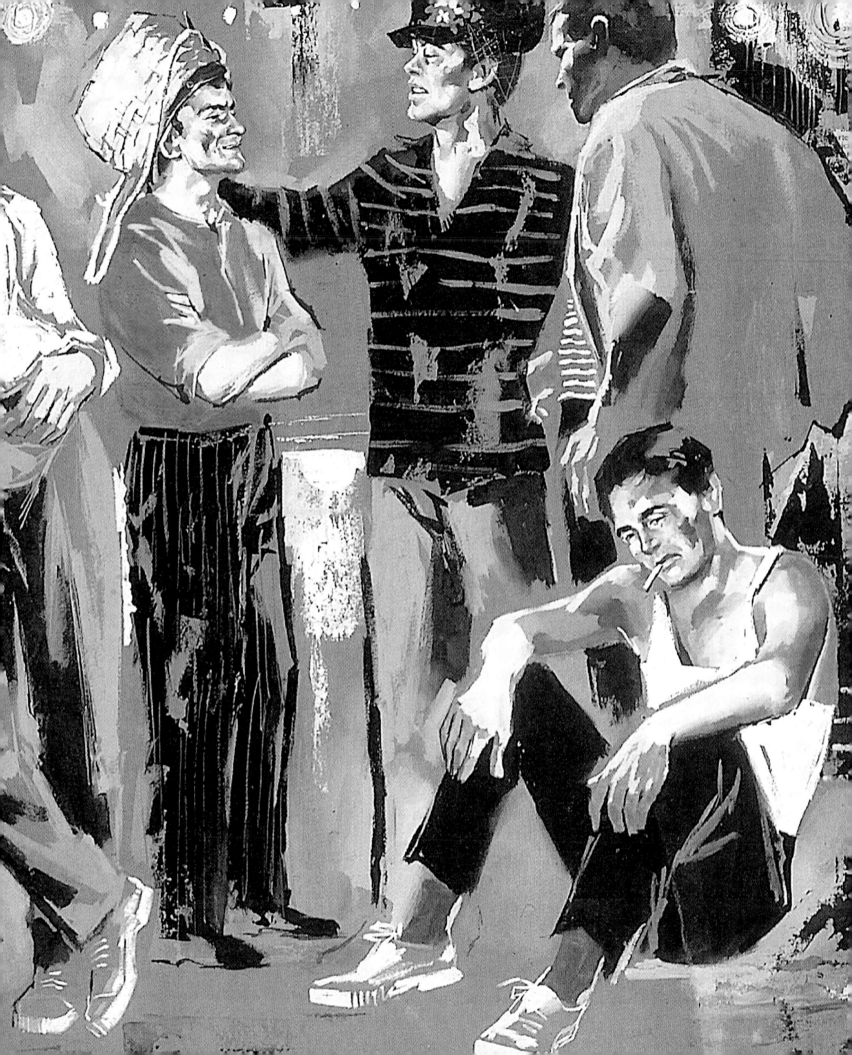

stand them. He would have to do what a Milanese lady reading *The Ragazzi* or *A Violent Life* in the late Fifties would do: that is, consult the little glossary at the back. Finally, even the pronunciation has changed. (The Italians have never been students of phonetics, and we may therefore assume that this development will remain forever shrouded in mystery).

The characters in *Accattone* were all thieves or pimps or muggers or people who lived from hand to mouth: it was a film, in short, about lowlifes and their world. Naturally there was also the life of the slum-dwellers around them, implicated, through *omertà*, the conspiracy of silence, with this underworld, though basically working people (for wretched salaries – like Sabino, Accattone's brother). But as the author, and as an Italian citizen, in no way was I passing a negative judgment on these lowlifes. Their flaws seemed to me human flaws, forgivable, and totally justifiable in a social sense – the flaws of men who obey a set of values quite "other" than that of the bourgeoisie, and who are therefore utterly "themselves."

Pasolini on the set

Pasolini, Franco Citti and the troupe while working on the audition set for *Accattone* (1960)

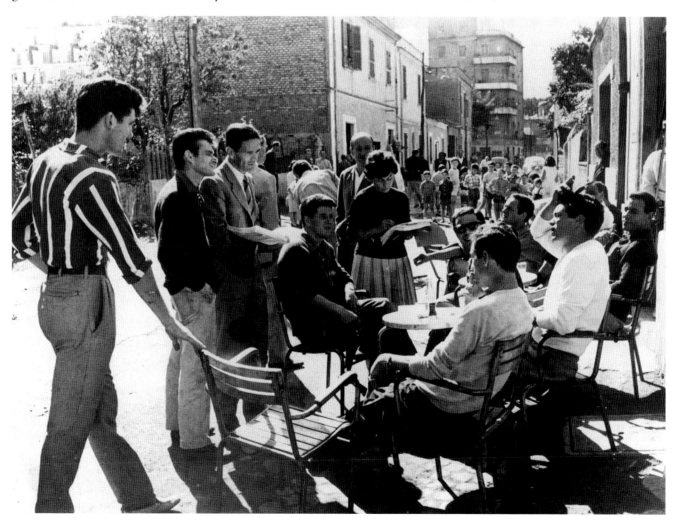

In essence they are tremendously likeable characters: it's hard to imagine likeable people (outside of bourgeois sentimentalism) like those from the world of *Accattone* – that is, from the subproletarian and proletarian Roman culture that existed until ten years ago. The genocide has wiped these characters forever from the face of the earth.

From "Il mio *Accattone* in TV dopo il genocidio," *Corriere della sera*, October 8, 1975, later in *Lettere luterane*, Einaudi, Turin 1976 (Garzanti, Milan, 2009)

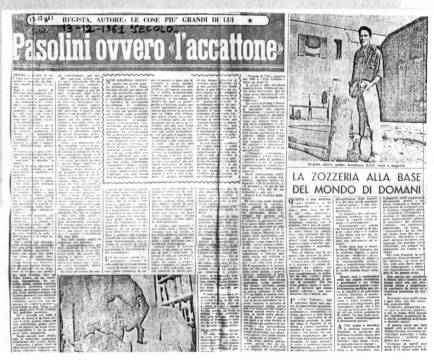

SENSAZIONALE INCHIESTA DEI CARABINIERI SU UN EPISODIO SCONCERTANTE

Denunciato per tentata rapina Pier Paolo Pasolini ai danni dell'addetto a un distributore di benzina

Lo scrittore accusato del reato da un operaio ha negato l'addebito pur ammettendo altre circostanze - Le indagini si sono però concluse con il suo deferimento all'Autorità Giudiziaria

In the early '60s, when Pasolini was still new to filmmaking, his persecution by the right-wing press grew harsher, unleashing a violent campaign of denigration that often identified him with his fictional characters, as in this December 13, 1961 edition of *Il Secolo d'Italia*. When Pasolini was baselessly charged with attempted armed robbery of a gas station in November of 1961, the daily *Il Tempo*, to "prove" his guilt, used a photo from a film *Il Gobbo* (The Hunchback), by Carlo Lizzani, in which Pasolini played the role of Leandro il Monco (Leandro the Maimed).

1962

MAMMA ROMA

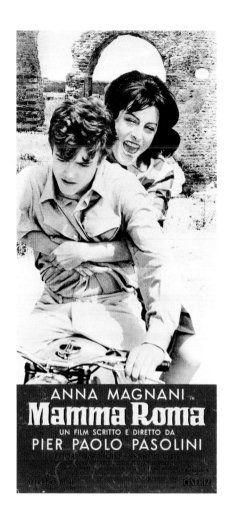

Left, Anna Magnani
Artwork by Gigi De Santis
Anna Magnani

May 4, 1962

Huddled in a doorway along the streets of Cecafumo are the cameraman, the continuity girl, the grip and his crew, all of them, I see, with resigned looks on their faces. Under a large umbrella is di Carlo, my assistant director, and some of the boys who are being filmed today; other cast members stand by the cluttered tables and dismantled equipment. It's sort of a disaster.

Someone tells me that Magnani wants to talk to me, so I go upstairs to see her in the little room a Cecafumo family is letting her stay in.

There's tension in the air. We're both upset by a problem we had with a scene we filmed yesterday, but for different reasons. The only thing we agree on is that we need to retake it.

Magnani explains her view and although it is similar to mine in essence, we have different underlying motivations.

ME: Let's talk about the scene, Anna. The one where you laugh and ask your son, "Isn't the motorcycle I bought you nice? Is it the kind you wanted?" That laugh, talk to me about the laugh.

ANNA: That laugh… you know even better than I do that in order to express the feeling that you've created, that laugh can be executed in so many different ways. It could come first, it could come after, it could be early or it could be delayed. I am a very fragile person. A split-second after I began the scene, just when action was called, you shouted, "Laugh! Laugh, Anna!" and I laughed like an idiot. My laugh in that shot felt fake and because it wasn't spontaneous (I think you'll agree with me), it threw off the rest of the line. I'm not acting well, it's true, not well at all, me of all people, the one they call a consummate actress, an old fox…

ME: I agree with you that the scene is not well done. But what I want you to realize – and not just with this scene but with many other scenes like it – is this: my way of telling you to laugh just as you are about to deliver a line, my way of prompting you to inject expression into the scene, is a habit that I picked up from working with non-professional actors who need a final push when they least expect it, to shock them, almost. You have to understand and forgive me for these interruptions and take them for what they are, just a habit.

ANNA: Of course I do, and that's why we can talk about it so openly, as friends. I know perfectly well that you work with actors you take from the streets and shape like clay in your hands. Even with their instinctual intelligence, they become your robots. I am not a robot. I have had your script in my hands for three months now. I have read it at least four times. I have analyzed even the smallest detail of feeling, the most important ones, the subtlest ones.

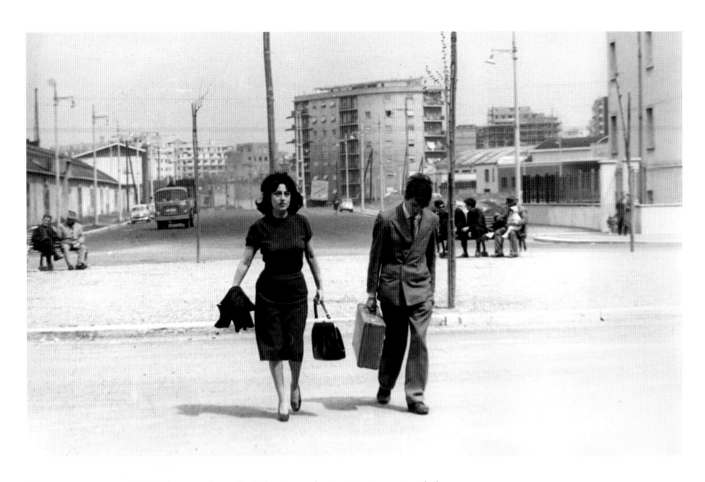

Now, as an actress (No! I hate to be called that!), as the instinctive animal that I am, I have become this character. And so, automatically, and thanks to your script, I should do the same for you. But when it comes to Mamma Roma, I am a novice. And so you shout "Laugh, Anna!" or "More serious, Anna!" at me. As a result, I feel a struggle inside of me to please you. On the one hand I feel that I should be able to perform the way you want by relying purely on my own acting skills. On the other hand I see that sometimes we don't always understand the character in the same way: I feel out of balance. And so I'm neither a good actress (God willing, and thankfully!) nor an obedient robot. I have to be frightfully alive in order to protect myself from dangerous comparisons, Pier Paolo. The boys you direct, whom you mold and maneuver, are far more authentic than I am. And this is a paradox that I can't let the public see.

ME: I have already thought long and hard about this, Anna. Integrating you with the others is the fundamental problem of my new work as director: I knew it would be difficult. But wouldn't it be better to remain tacit about this?

ANNA: No, I think we need to have small conflicts to clarify things. Two intelligent people can always come to some kind of understanding. What's more,

Anna Magnani and Ettore Garofolo

Anna Magnani and Ettore Garofolo

I feel as though I am acting without even being aware of what I am doing and I absolutely need to have awareness.

ME: And I expect it from you; I know I don't need to ask for it. I don't want there to be even the slightest unawareness about what you are doing in any of our work together. So, going back to the specific problem we had with the "Laugh! Laugh, Anna!" scene, we agree on two things: that I am wrong to cut in when you're performing, a mistake which is in part justifiable…; and that you accepted to work with my way of filming, in small visual monads.

ANNA: Ah, yes. When we shoot a scene and start at the end, sometimes I am confused because I don't know what's going on, how the beginning was or will be. Of course, you know… but as a fully conscious actress, I would like to know, too!

ME: Fine, in the future we will study the scenes together from the beginning; we will look at them line by line, so that if you have to start with filming the last line, the difficulty will be purely technical. One thing is for certain: our interpretations of Mamma Roma may differ. But even the most sublime and perfect sonnet by Petrarch leaves room for contrasting interpretations, a screenplay all the more!

ANNA: Yes, but I have blind faith in your stage notes and I have clear ideas about this particular scene… it's just that starting at the end I don't know if I am dosing everything out correctly: the laughter, the emotion, the excitement… I respect your method because I have seen the results. If this is how you created Accattone, I can rest easy. And it's up to me to get over my complex.

ME: Yes, if we had discussed the "Laugh, Anna" scene beforehand, I would have told you that this is the only moment in the film where there is total happiness, where there are neither shadows nor foreboding. The tragedy explodes immediately afterwards. I don't want the scene to have any hint of sadness or pain; it should be complete happiness.

ANNA: I might have laughed a little late because my tone at the beginning was… not quite sadness, but…

ME: Anxiety.

ANNA: No, not anxiety – inner joy.

ME: Well, I don't want that either. It needs to be a scene of simple happiness: common, external happiness, if you will. We should have talked about it, and of

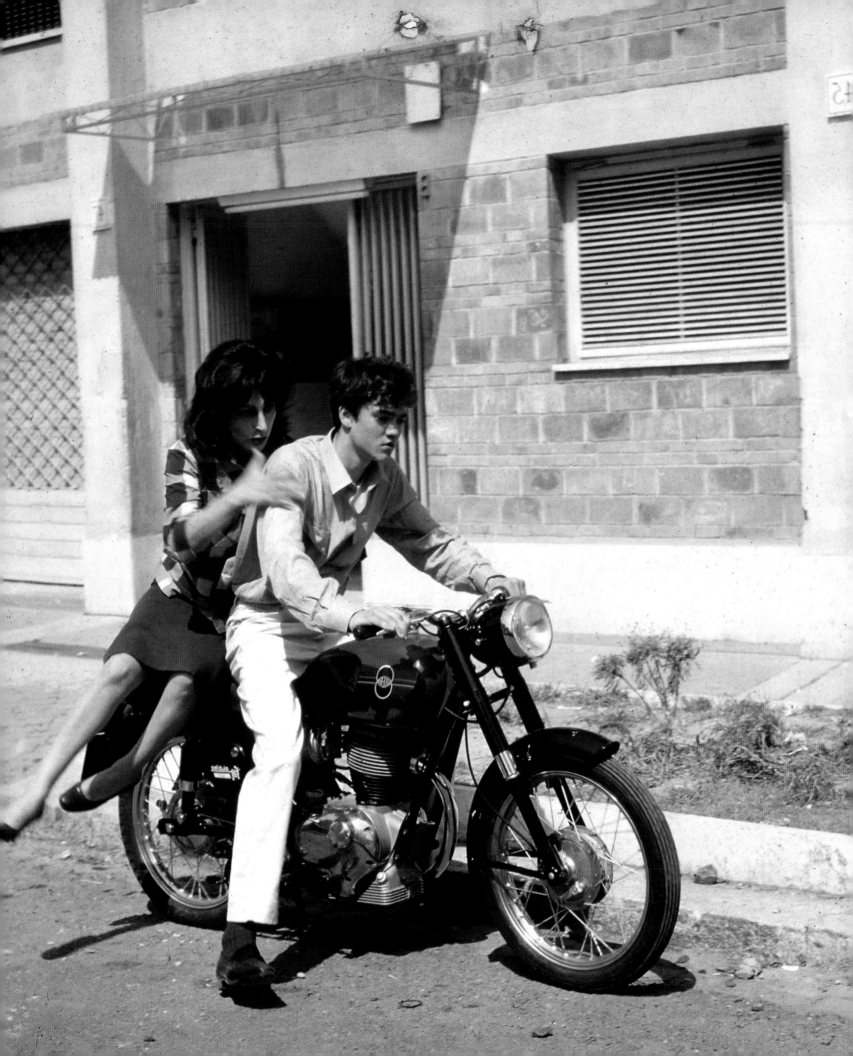

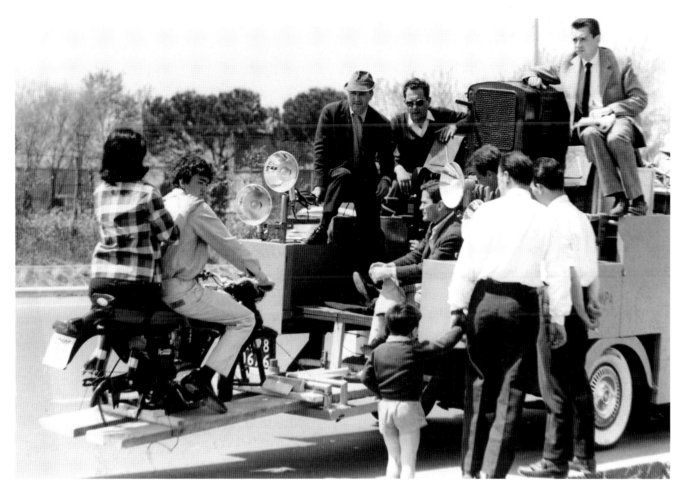

Left, Anna Magnani and Ettore Garofolo

Anna Magnani, Ettore Garofolo, Tonino Delli Colli (director of photography), Pasolini and Carlo di Carlo (assistant director)

course there are many things you can do with it because this kind of happiness, this external happiness, can be expressed in an infinite number of ways. All we have to do is look critically at the scenes together.

The rain comes down with insidious abundance on the lung-colored edges of the houses of Cecafumo – each building just like the next, all lined up asymmetrically against the sky of Acquedotti. (In my conversation with Anna there was too much desire to get along). From the windows of the working-class apartment, the street below shines sinister, its market tables falling apart, looking like thousands of wet, upended sawhorses. (Anna's poetry is, at worst, poetic and naturalistic; mine, at worst, is exquisitely mannerist. I look for plasticity, and in particular the plasticity of an image, never wandering too far from Masaccio and his proud *chiaroscuro*, his black and white – nor from the Archaics and their strange marriage of subtlety and coarseness. I cannot be impressionistic. I love background, not landscape. You can't create an altarpiece with moving figures. I hate the fact that figures move. That's why none of my shots begin with a wide field of vision or an empty landscape. There will always be, even minuscule, a human figure. But he'll be tiny only for an instant, because right

away I call out to my faithful Delli Colli to put on the 75 and zoom in: a close up of his face. And behind him, the background. Background, not landscape. Bustling crowds, the gardens of Gethsemane, the desert, vast cloudy skies. Anna is romantic: she sees the figure as part of the landscape, a figure in movement, connected to things as in an impressionistic sketch, with the power of a Renoir. Lights and shadows in movement on both human figure and landscape, a silhouette dancing against a glimpse of the background – which is never seen frontally – riverbanks, choppy seas, *déjeneur sur l'herbe*, style woods, or Pascarelli alleys). The heavens have opened and it's pouring rain. At the end of the day, making movies is all about sunlight.

From "Diario al registratore," in *Mamma Roma*, Rizzoli, Milan 1962, later in *Accattone. Mamma Roma. Ostia*, Garzanti, Milan, 1993

In a way Mamma Roma is much more like Tommaso Puzzilli, the protagonist of *A Violent Life,* than she is like Accattone. In fact Mamma Roma has an explicit, problematic morality of her own – however crude and primitive – that develops by degrees. In the beginning, there is the "mortal anguish" that she shares with Accattone, a happiness without history (another similarity to Accattone)… but there is already something in her of the other world, which is our bourgeois world, in other words, a petit-bourgeois ideal. In fact, when she goes to pick up her son and bring him to her place in Rome, she already knows very well what she wants, she already has an ideology, a misguided and confused one, of course: a petit-bourgeois ideology, which she has absorbed from the bourgeois world, through familiar sources – television, magazines, comics, movies. So there is already something in her that Accattone did not have: the presence of the petit-bourgeois world and its "ideals"… When she speaks to her son about their new home, when she advises him as to what sort of friends he should have, when she tries to teach him how he should behave, she tries to raise herself, albeit in a disorganized, crude way, to the level of what she believes is real life – that is, the life of the supposedly respectable world, the ideal, in other words: a petit-bourgeois morality and the petit-bourgeois notion of prosperity.

Armed with this ideology, she risks everything in her new life with her son, and chaos ensues, because the contact between petit-bourgeois ideology and her experience as a prostitute can only result in chaos, and this gives rise to confusion, the collapse of her hopes, the failure of her new life with her son.

The first instance of her failure comes with the visit to the priest: with this initiative, she adds to her generic petit-bourgeois ideal a first instance of moral problematics, that is, a sense of her own responsibility, something that until now hadn't even occurred to her. Neither as a prostitute nor as a petit-bourgeois reactionary could she have ever considered herself in any way responsible; she was in-

Franco Citti

Ettore Garofolo

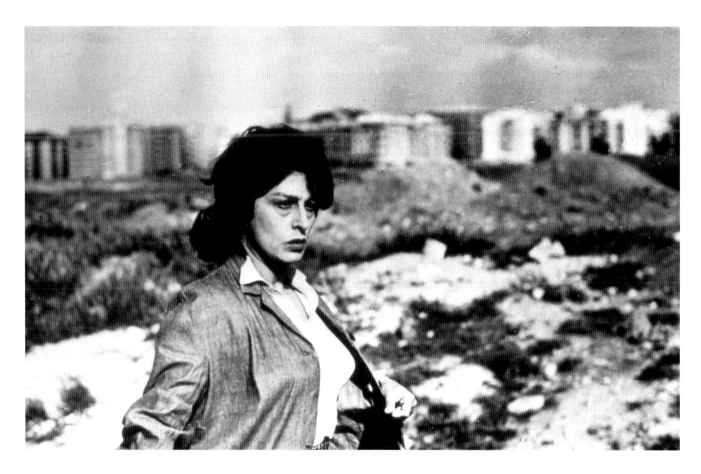

Anna Magnani

capable of such self-reflection. It's the priest – a rather intelligent, rather human priest – who speaks to her for the first time about responsibility, giving her an initial sense of a moral problematics typical of the "Catholic-bourgeois" world.

This first instance of moral conflict is not enough, however. It remains a pure and simple *flatus vocis* – to the point that she decides to resort to blackmail to grant her son a sort of petit-bourgeois status, indeed using her contacts and experience as a prostitute to do so.

When this also fails, however – and she has a foreboding of this when she weeps at the sight of her son working at the job she's arranged for him in such a sordid, base manner – the seed the priest planted in her brain begins to grow, and the first rumblings of conscience begin to do their work. Until – in the second long tracking shot along the avenue of the prostitutes – she finally says to herself, in so many words: "Of course I'm responsible, that priest was right, but if I'd been born in a different world, if my father had been different, my mother too, and my surroundings, I myself would probably have been different."

In other words, she begins to expand the sense of responsibility for her own person, which the priest had grasped, to include her own surroundings.

The film continues, and by the end – explicitly in the screenplay, implicitly in the film – this sense of responsibility, which has expanded from herself to her

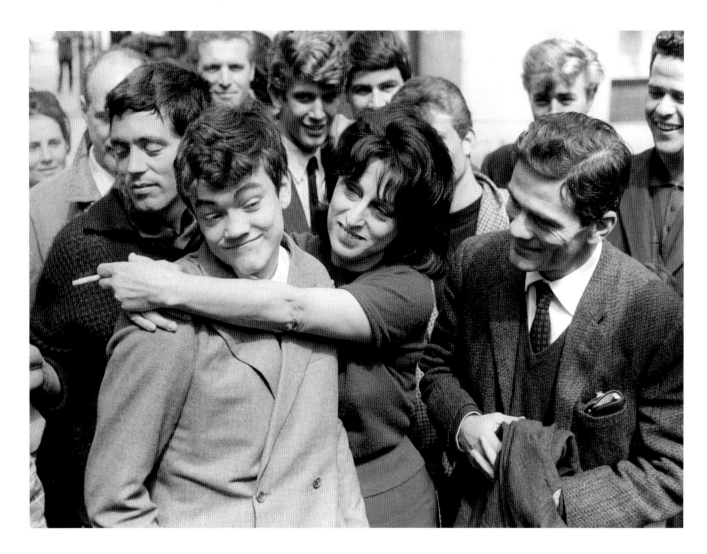

surroundings, is extended to the entire society. The screenplay ends with a cry: "The people responsible, the people responsible!" The film instead ends simply with Mamma Roma facing the white, encroaching city. There is a kind of silent gaze between these two remote, unconnected worlds, which are like two different universes.

For all intents and purposes, what distinguishes this film from *Accattone* is a moral problematics that doesn't exist in *Accattone* because Accattone the man is utterly alone in a world that is utterly alone. This theme of responsibility has three essential aspects: individual responsibility, situational responsibility, and social responsibility. This was all more explicit in the screenplay; naturally, when you're working things out and bringing your ideas and images to the level of concrete expression, certain things are eliminated while others remain. The film is therefore always something slightly different from the screenplay. The theme of responsibility became more internalized in the characters in the film. This is enough, however, to set *Mamma Roma* substantially apart from *Accattone*.

Franco Citti, Ettore Garofolo, Anna Magnani and Pasolini

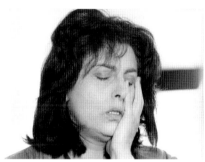

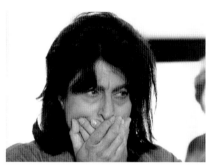

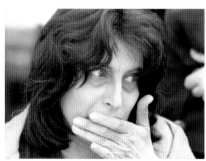

Anna Magnani

Whereas the story of *Accattone* takes place in the *borgata* (the slums on the periphery of Rome), Mamma Roma lives her life in the Rome of the petite bourgeoisie, in working-class housing projects, in a world that is necessarily less epic and therefore less visually striking.

In fact Anna Magnani's character immediately moves into an apartment in the modern outskirts of the city, in one of those big highrises that are less photogenic, I would say, than the hovels of the Borgata Gordiani. The characters, moreover, are more detached from their environment, since *Mamma Roma* is, in effect, a film that penetrates a bit further into people's souls, even if these souls are confused and don't really allow for complex psychological investigations.

From "*Mamma Roma*: ovvero dalla responsabilità individuale alla responsabilità collettiva," interview by Nino Ferrero and Dora Mignano, *Filmcritica*, no. 125, September 1962, later in *Per il cinema*, Mondadori, 2001

Outburst Over *Mamma Roma*

What seems unfair to me is how my film was received by the critics - first in Venice and now, so far, in Rome.

I will also say (since apparently my comments about myself are objective!) that the whole thing is really quite exceptional. Adjudicating *Mamma Roma* as a "society" event instead of a cultural one, as if a work of art were defined by its role in a history of festivals and social successes instead of in a history of style.

I think I am lucid enough to say that scenes such as the opening banquet, the two long tracking shots of Anna Magnani, the love scenes between Ettore and Bruna among the ruins and near the canal, and the final scene are cinematic episodes that cannot be dismissed with general discourse, even one legitimated by ideology and aesthetics or conditioned by the public or social success of the film.

In other words, a work should count for what it is worth, and not for what it isn't worth. Instead, *Mamma Roma* has been judged exclusively for those aspects that can be called into question, almost as if the critic had to frantically search for something to say that he could connect to his ideological interests (or worse): "Sure, there are lots of nice things about the film, but that's to be expected. It's so natural you don't even realize it. However, my exceptional acumen sees what doesn't work, in both *Mamma Roma* itself and *Accattone*."

Thus was born the bee currently in the critics' bonnet, and the unfair situation in which I now find myself.

Of course it can be explained.

First of all, there's the problem of the majority of Italian film critics and their general lack of culture. Everyone feels entitled to write about cinema, and who really knows how newspaper editors even choose their critics… In my case, this tenuous competence, specific as well as general, becomes rather clear, for

the simple fact that judgments of me as a director involve judgments, more or less direct, of me as a writer, or at least a need to refer to a stylistic history that includes my literary work. I have been flabbergasted – if that's the word – on numerous occasions by how strange a cast a literary judgment assumes when it appears in a film review, since such judgment always passes through a lens of journalistic vulgarization. (And it is thoroughly vulgar).

For example, the Mantegna question. In a few interviews I'd talked about – and subsequently wrote about at great length in a piece that appeared in *Il Giorno* and then in the *Mamma Roma* collection – how my figurative vision of reality was rather more painterly in origin than cinematographic. I then went on to explain certain aspects of my process of filming. The painterly references that I was talking about were deeply internal stylistic choices, and not – for crying out loud! – meant in the literal sense of reconstructing a scene of a painting!

But a few movie critics, who had evidently read my writings in the kind of rush that has nothing to do with culture, came to certain conclusions that are almost touching in their utterly helpless naïveté. Because of the final shot where Ettore's body is foreshortened, a choir of voices rang out: Mantegna!

Whereas Mantegna had nothing to do with it. Nothing at all! Longhi, help me out here, explain how it takes far more than a shot of a body with the soles of the feet in the foreground to talk about the influence of Mantegna! Don't these people have eyes? Don't they see that the sharp contrasts of black and white, the *chiaroscuro* of Ettore's grey cell (with his white undershirt and dark face) and the way he is lying on his deathbed suggest the work of painters who lived many decades before Mantegna? Why not try and talk about a strange and wonderful interweaving of Masaccio and Caravaggio? Forget it: how can any "interweaving" be noticed by people who rush to write a certain number of words, whose only concern is not to make too many mistakes… And so they say what everyone else is saying.

Such incompetence could never survive if not supported by conformism and cynicism; this is the mechanism central to Italian film criticism today.

It's fine in the case of a commercial film; the mechanism is manipulated by the various interests that make up the producer-consumer relationship. This is one of the disastrous aspects of our world, a form of neo-capitalistic aridity.

And yet, at the center of this deadly cycle of production and consumption, right at the heart of this cultural aridity, an entirely Italian *cinema d'autore* is coming into being. It represents a kind of cinematic experience that is driven, like poetry, by an intense cultural need.

This is why cinema critics for so many newspapers are ill equipped to do their job. And I'd warrant that this is probably one of the main problems of our culture today.

"Sfogo per *Mamma Roma*," *Vie nuove*, no. 4, October 4, 1962, later in *I dialoghi*, ed. Giovanni Falaschi, Editori Riuniti, Rome 1992

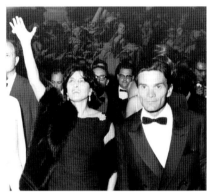

Anna Magnani

Anna Magnani and Pasolini at the Venice Film Festival for the première of the film (August 1962)

Anna Magnani and Pasolini at Gran Gala del Cinema in Rome (June 1962)

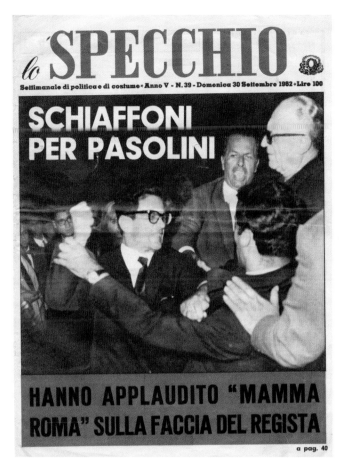

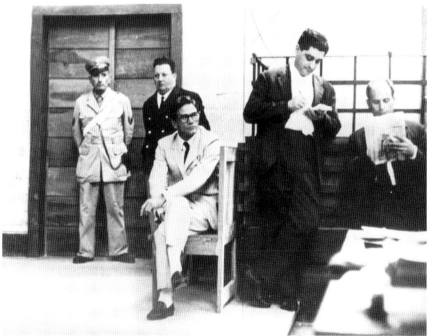

In the photos, Pasolini in the courtroom of Latina in July, 1962, where he was tried for the absurd charge of attempted armed robbery, for which he was acquitted for lack of evidence. On September 20, 1962, the newspaper *Lo Specchio*, hailed the Neofascist attacks on Pasolini at the Roman cinema Quattro Fontane after the showing of *Mamma Roma*.

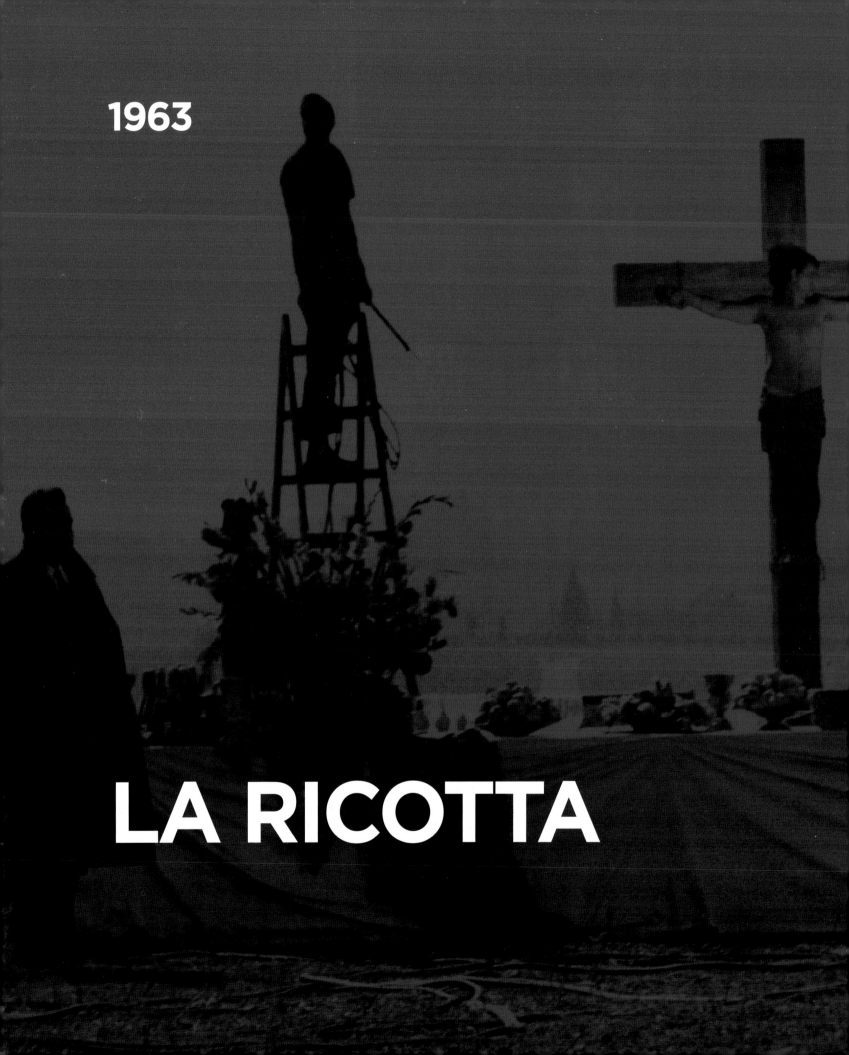

1963

LA RICOTTA

Thwack! one more time – a clean break – Pontormo's *Deposition* in color, in colors that dazzle straight-on. Colors? Call them colors, if you like.

I don't know… If you take some poppies and leave them in the sunlight of a melancholy afternoon, when all is silent ("for never did a woman sing at three in the afternoon" [A self-quote from the *Poesia in forma di rosa*, ed.]), in a cemetery-like heat – if you take them and grind them up, lo, what you get is a juice that dries up at once. Well, water this down a little, on a clean white cloth, then have a child run a wet finger over that liquid: at the center of that finger-mark you'll see an ever so pale red, almost pink, though resplendent due to the freshly-laundered whiteness of the cloth beneath it. And along the edges of the finger-mark you'll get a line of violent, precious red just slightly faded; this will dry immediately, turn opaque, as over a skim-coat of plaster… but in that same paperlike fading it will preserve, dead, its bright redness. So much, then, for the red.

As for the green…

The green is the blue of leaves in pools…

In the evening, when the bells peal and the women sing in doorways, and the night falls like a storm's shadow over the noble peace of the garden, the leaves lie motionless under the water's surface, turning bluer and bluer until they turn green. But is it green or blue? Such was what certain cruel soldiers wore over the centuries. Lansquenets or S.S., they went out and filled the world's ossuaries with the memory of the color of their clothing, lost in the twilight of a storm.

But alongside the blue that turns green in the veins and velvet of the watery leaves, true green remains: the coarse green of Spanish clover, tinged only with the brown of the slightly muddy earth.

There's that green, too.

And the brown: that chestnut hue of mud, dullish. And the one which, from inner frenzy and frost, turns violet in the arch of the vault in the background.

And a second red: a faint color of must or dead strawberries, squeezed as before – grapes or strawberries – on white parchment or laundered linen, then crushed with a finger, so that the liquid spreads entirely to the edges in intensity, and in the middle remains a pallor, a void, a nothingness bright with something that used to be red and still is, but like a fragrant ghost.

The void that remains in the painting, in the bodies of those making up the Holy Family and their acquaintances, presents a dazzling white (opaque and extremely crisp) around the edges, in the folds of the robes, but it, too, is painted. And in this case it consists of a yellow of spikes of grain or a pink of certain flowers whose name I forget, wild roses, I think, which grow crudely amidst the scrubby little shrubs of spring, in common meadows and pastures and along the edges of ditches, with leaves so delicate they come off the moment you touch them. A pink more exquisite, more feminine than

this, is inconceivable. And you can find it in those flowers, which cost nothing. That yellow and this pink – which fill the great void of bodies whose edges froth with poppies, must, strawberries, and lakeshore leaves – are not hues but breaths, delicate breaths, irregular and powerful – like the indelible residue of fire or sun on the flanks of a vapor in the form of a hill or tower.

At the top – coarse green, wilted poppy, opaque yellow – a female saint or an angel, looking down in pity. On the lower right, the Blessed Virgin, all wrapped in a great mantle green with that green of the leaves of pools, gathered round the oval of her face without eyebrows.

On the lower left, two women with faded-strawberry bonnets and water-green robes look at her, one of them helping her, as best she can, to bear up the body of Christ.

Who is held up by the armpits in the lowest part of the painting by an angel, while another, crouching, bears the weight of his legs on one shoulder while looking at the camera. The same way Ivan Ilych put his legs on his peasant's shoulders… These two curly-locked angels with hair tinged red have a peasant look about them too – but they were raised in the city. Their expression deep down is bewildered, or perhaps just doltish. At any rate one of them, the younger, the one holding Christ up by the armpits, a lad of about sixteen, is entirely clad in that grey-green worn over the centuries by soldiers now lost in the world's ossuaries – as I said – who've left the green of that cloth to the twilight of storms… The other angel, the one crouching and thinning a little at the temples – hollow-eyed under his curly half-ginger mane, eyebrows drooping, jawbones a bit too round and big – must be from the Marche region… At any rate, his shoulders, back and belly are nude, while a mantle wraps round him and gathers at the thighs, wheat-yellow over briefs of that same faded, cruel, and dried-up green.

Also at the same level as Christ, but seen from behind, facing the Madonna, is another woman, dressed all in strawberry pink and poppy red, with one arm bare, holding a piece of cloth. An arm as beautiful as an elephant mandible polished by a peach-colored sea.

(1962)

From "La ricotta," in *Ali dagli occhi azzurri*, Garzanti, Milan 1965

The tableaux vivants from Pontormo

Right, Rosso Fiorentino

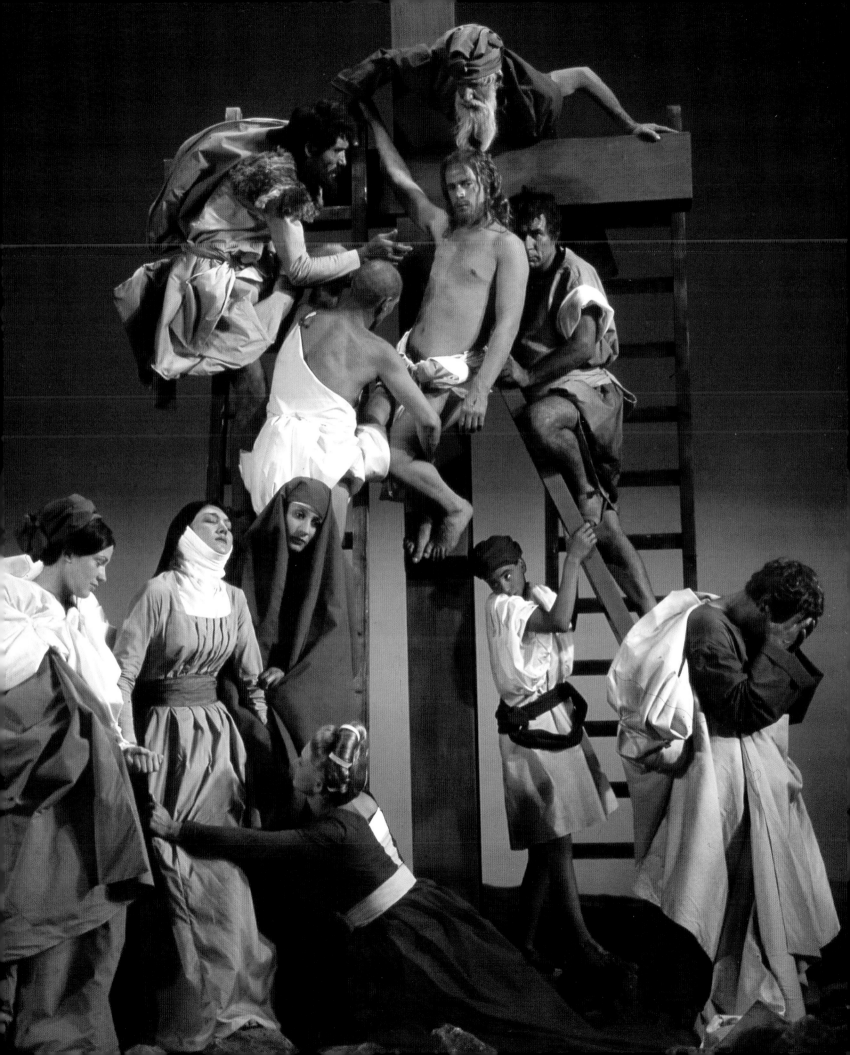

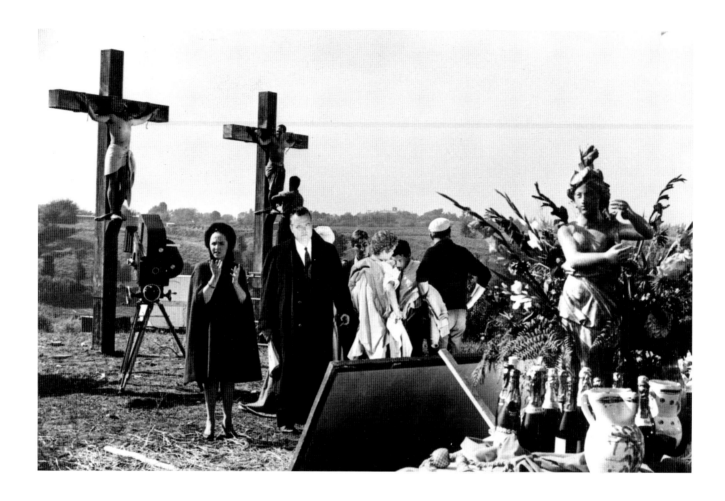

Wednesday, March 6 (1963)

The Saints? These are not, are not the Saints!
Can't you see? One of them is from Trullo, and off-camera,
in front of the guys from the slum, he complains
of being an extra, says he's bored; another one lives
in a prisonlike apartment in Borgo,
married to a mother who's all womb,
he's a feckless husband, the oldest
of his dog-browed sons is a degenerate
with notions – poor fool – of bourgeois grandeur!
Another one comes from thirty years of service
as a waiter in Paris, desperate auntie,
laughing, laughing to ward off scorn,
the last one comes from who-knows-where, Prati or Appio,
a walk-on by profession. These, the saints?
The ones with hairpins, with hairnets

Laura Betti and Orson Welles

From left to right, Laura Betti, Ettore
Garofolo and Orson Welles

Mario Cipriani

over their wigs, who now think they've "made it"
because they're protected by the ecstatic verve
Donati's given their hairdos? Brood of vipers!
"With the excuse of doing a film shoot…"
Oh, I want to shout out to you from Santa Maria
with the offended serenity of one
who is not an enraged victim of form:
"The Saint is Stracci. With the ancient snub-nosed
face that Giotto saw against the tufa and ruins of Castro,
the round hips that Masaccio shaded
like a baker his sacred loaf of bread…
If you fail to see the goodness with which he gives up
the basket of food to his family, who then chew
to the sound of the *Dies Irae*; if you fail to see the innocence
with which he cries over the meal the dog has stolen from him;
if you fail to see the tenderness with which he later strokes
the guilty animal; if you fail to see the humble courage
with which he responds to those who insult him, singing
a song of his forebears from the Ciociaria; if you fail to see
how intrepidly he confronts his fate as an underling
by singing its philosophy in his beloved jargon of thieves;
if you fail to see how anxiously he makes the sign of the cross
before one of your shrines for the poor, before
heading off for the food; if you fail to see the gratitude
with which, after a funny little dance of joy like Charlie Chaplin,
he again makes the sign of the cross before the same shrine
with which you consecrate his inferiority;
if you fail to see the simple manner in which he dies
……………………………………………………………"

From "Pietro II," in *Poesia in forma di rosa*, Garzanti, Milan 1964

To defend himself at his trial for public defamation of religion in the film La ricotta, *Pier Paolo Pasolini wrote out responses, point by point, for each of the charges leveled against him.*

1) The cry of "*la corona, la corona*" ("the crown, the crown") is the first sign of the unbelieving, skeptical, plebeian superficiality of the world around Stracci, which will be witness to his martyrdom. The nonchalant, or irreverent, tone does not, however, refer so much to the "crown" itself as to the goings-on typical of a film set. And if it is mocking anyone, it is mocking the arrogance of the director, who is monosyllabic, self-centered, and bored

in his unpopular guise as a decadent *übermensch* who treats his subordinates condescendingly from the heights of his self-awareness as artist (the "good taste" with which he selects the exquisite color-scheme of the Pontormo composition and the musical passages of Biscogli), and about whom the troupe knows nothing and doesn't want to know anything. The troupe, in fact, considers the "crown" a whim of the director, and in a tone typical of lower-class Roman irony, they partly second him and partly mock him.

I, as the author, intervene directly when – after the irreverent cries have stopped – the crown is raised by two laborer's hands against the whitening panorama of the city, dominating it.

2) It's not Christ who bursts out laughing – and I should repeat this a thousand times – but a humble actor playing Christ, and it's not really even Christ he's playing, but the Christ profanely represented by Pontormo.

The idea of having the actor burst out laughing was suggested by something that actually happened. A young man in the troupe, hearing someone read Jacopone da Todi's lament of the Virgin, apparently struck by the archaic and, for him, incomprehensible language, which sounded like a sort of wail in rhyme, started laughing quite openly.

3) The echoing of the *Dies irae* over the hungry little family eating outside is simply supposed to be a stylistic foreshadowing of death – a death poetically linked to privation, hunger, eating.

4) Let there be no mistake about the fact that "crowd part" (*comparsata*) means working as an extra (*comparsa*) for crowd scenes. It's an arbitrary inference to think that it means anything else. You can ask a thousand different witnesses who know the jargon about this. If somebody wishes to see a certain ambiguity in the extras playing saints, he is free to do so. But he should know that these are not only extras playing saints, but extra saints, so to speak, walk-on saints, who hang around the set during pauses, such as Stracci, for example, or the little angel who appears against a bush, before the blue eyes of Stracci's young daughter. I'd wanted to strike an atmospheric note, rendered vaguely metaphysical, or at least fable-like, by the immemorial light of the afternoon, the absurd peace of the field, the picaresque roguishness of the idling troupe.

5) The bivouac around the cross: more picaresque roguishness on the part of the idling troupe. Or else a depiction, an objective one, of how religion is felt in the modern world, as represented, on its various different levels, in my film, by the troupe itself.

Film extras

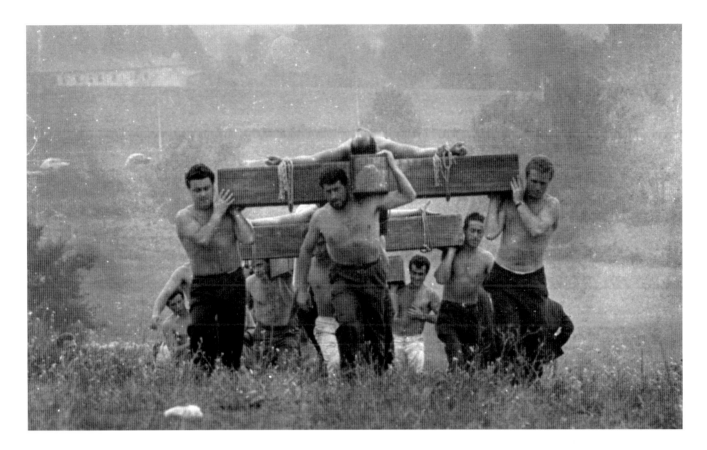

6) The *Dies irae* over the scene of the dog eating Stracci's meal. See note 3): it's the same stylistic motif returning through the fanciful identification with appetite and death (and the film will in fact end with death from privation and indigestion).

7) Pedoti was called Pedoti in the treatment and is still called Pedoti.

8) The ironic face that Welles makes at the end of his statement about his own Catholicism, directed at the journalist (against whom his irony erupts immediately afterwards), almost as if he were saying: "It's pointless for me to make these delicate confessions to you, since at any rate you don't understand a thing."

9) The expression "average man" (*uomo medio*) is used by the director Orson Welles in the same sense as that given it by sociologists: that is, as "conditioned man," "mass man." (Welles' entire speech, however playful and ironic, is in fact sociological in nature). Thus not "average" in the human, pedagogical sense of the word. In this sense we are all "average men." It's the "supermen" who are imbeciles, and this is what my entire literary polemic has been aimed at over the past ten years: that is, to dismantle the myth of the Poet with a capital P, as mystifying, irrational, inspired, and

untouchable, and to give back to the poet his dignity as a citizen. For the average man – in the sense of average citizen, my contemporary, my colleague, whether intellectual or laborer – I have the greatest respect. This is why I'm against censorship, for example, which, is itself presumptuous and paternalistic, as it presumes the audience to be inferior to the artist and the cultivated and ruling classes.

10) The encounter with the two police officers is simply a gag. One of the film's stylistic elements is its quotations of Chaplin, of which this is one. I was quite dismayed in the courtroom when, during the questioning by the prosecutor, I saw the faces of some of the congenial policemen present darken. I had no intention whatsoever of offending those two young men of the people. My intention was only to amuse, with the cheerful innocence typical of slapstick.

(N.B. The voice of the journalist is the same as that of the dubber, Marussig, a reporter for *L'Espresso*).

11) Stracci does not burp on the cross, he hiccups. It is the hiccup of someone who, starvingly hungry as the good Stracci is, finally stuffs himself to excess.

12) I do not understand how there could be any objection to the voice calling the "good thief" back to work over the loudspeaker. I truly don't.

13) There is no ulterior motive to the cruel jokes played on Stracci by his fellow workers. Such cruelty is an aspect of life, the simple everyday life of the impoverished suburbs of the big cities. Living there is often a difficult challenge, and being able to make jokes and to take jokes is part of one's personal sense of honor. As for the story itself, the traumas suffered by Stracci, worthy of those of Tantalus, serve the purpose of preparing and justifying, naturalistically as well as poetically, his final attack, which – because he gorges himself after long privation – leads to his death.

14) The movements made by Stracci at the end of the striptease – which the prosecutor defines as "preagonal" movements – are the manifestation (a recurring motif in the film, from the first frame to the last) of Stracci's physical trauma.

15) "Take away the crucifixes": the inference that this statement has some esoteric meaning beyond a purely instrumental one – referring to the crucifixes there on the set – seems to me so fantastical and arbitrary as to border on the unreal. Had I had any inkling that anyone could imagine anything of the sort, I would certainly have changed the line. Such an interpretation – or anything so diabolical – was the furthest thing from my mind.

Orson Welles

The reason for the line "Take away the crucifixes," as well as for all the other similar lines ("La corona," "Hoist the crosses," "Leave them nailed," "Silence," and so on) is a sort of gag/refrain that musically highlights the transitions or turning points in the action. The effect was intended to be quite simply and innocently comical. Likewise the continual introduction of new, funny, unexpected faces (culminating with the dog) followed the same Chaplineqsue stylistic necessity.

16) I really don't see what is wrong with Stracci saying, while lying on the cross, that he's hungry.

17) As for the beard of Christ, which is there one minute and gone the next, there is a logical explanation for this. When the actual scenes are being shot (that is, the color scenes), Christ has a beard; during the preparations for the shoots, and during the breaks, or in the purely put-on, simulated shots (like the last one when the producer arrives), he doesn't. This could

also be explained by the fact that in the film Christ is played by a veritable actor (with beard) as well as by a stand-in (a nice young man with an innocent, Abbruzzese, beardless face).

18) As for introducing the color scenes, I could make the same argument as for Christ's beard: it's poetic licence, a gesture of stylistic freedom determined by aesthetic – or aestheticizing – demands, that is, serving the purpose of spectacle. I wanted to separate my world from the world of the film being made by my director, almost as if there were no possible point of contact between the two, as if they were two juxtaposed but extraneous realities – but with, indeed, a spectacularly astonishing friction between them.

19) The cry of "Cornuti!" is uttered by the assistant director (dubbed by the same young man who played the part, Paolo Meloni) at the characters of a double make-believe: I. Not at Christ or at the People of the Passion, but at the Christ and the People of of Pontormo's Passion. II. Not at Christ or at the People of the Passion, but at the Christ and the people of Pontormo's Passion which has become a film scene. That is, the cry of "Cornuti!" is shouted at characters of a fiction within a fiction. There is not an average man, not even in the sense intended by Orson Welles, who is not capable of understanding this in the most immediate, complete fashion.

20) For the *Dies Irae* as Stracci is eating, see points 3 and 6.

21) I do not understand what harm can be seen in the fact that Stracci goes and hides in a cave so he can eat in peace. I really don't.

Lastly, I am accused of having wanted to replace the symbol of Christ with that of the lumpen proletariat. I really don't see why. Such would be sheer idiocy on my part, which neither my Marxism nor my religious aspirations could ever justify. It is an inference that leaves me aghast, so arbitrary and senseless is it, surpassed only by that concerning Stracci's children and the extraordinary revelation attributed to them.

I repeat that I was only interested in focusing on the problem of the lumpen proletariat without resorting to false mysticism. This same lumpen proletariat that, as the prosecutor demonstrated he understands, is dying – historically speaking – without anyone knowing what to do about it, unless, as I have written elsewhere in prose and verse, it is Pope John XXIII and the Catholics who are with him.

Text in defense of *La ricotta* (1963), in *Le regole di un'illusione. Il cinema, i film*, eds. Laura Betti and Michele Gulinucci, Fondo Pier Paolo Pasolini, Rome 1996

Screen-test photos

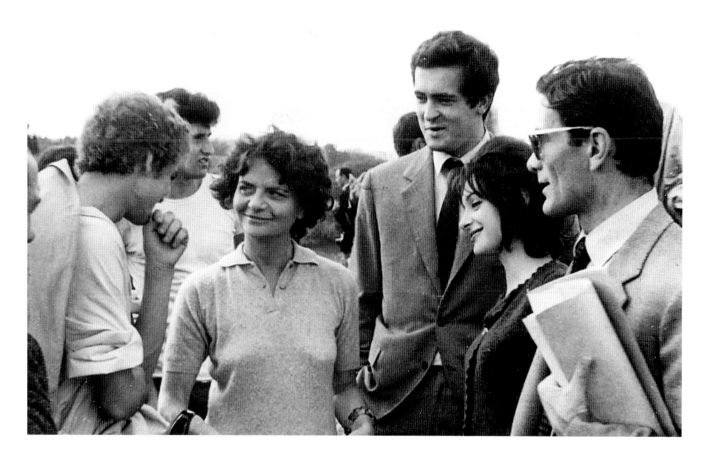

Ettore Garofolo, Elsa Morante, Bernardo Bertolucci, Adriana Asti and Pasolini on the set

With *La ricotta*, it is probably best to speak of collage. The film's "painterly" passages are quotations with a very specific purpose: they quote two painters, two Mannerists: Rosso Fiorentino and Pontormo. I have reproduced their paintings to perfection, though not because they represent my way of seeing things or because I love them. The point was not to reconstruct them as seen through my own eyes, but to reproduce the state of mind in which the director, the protagonist of *La ricotta*, conceives of a film on the Passion – a conception entirely contrary to my own when making *Il Vangelo secondo Matteo*. These conceptions instead almost fit the mold of exorcism: they involve a very precise, very refined, very formalistic reconstruction, the very sort of thing I would never have wanted to do with *Il Vangelo*. Here I attributed this approach, polemically, to the character of the director. I'm not inveighing against directors of other *Bible* films; it's a polemic not against bad taste but against too much good taste…

Stracci is a more mechanical character than Accattone because I'm the one – obviously – pulling Stracci's strings. This can be seen specifically in the constant self-mockery. That's why Stracci is a less poetic character than Accattone. But he is more meaningful, more generalized. The crisis portrayed in the film isn't my crisis; it's not an inner crisis but a crisis in the way of seeing certain problems of the Italian reality. Before *Accattone*, I could only look at Italian social problems

by immersing myself in the details and specificity of Italian life. With *La ricotta*, this had become impossible: Italian society had changed and was still changing: the only way to see the Roman subproletariat at the time was to consider it one of many phenomena of the Third World. Stracci is not a hero of the Roman subproletariat, a specifically Italian problem; rather he is the hero/symbol of the Third World. He's certainly more abstract and less poetic, but more important to me.

From "Le Cinéma selon Pasolini," interview by Bernardo Bertolucci and Jean-Louis Comolli, *Cahiers du cinéma*, no. 169, August 1965, later in *Per il cinema*, Mondadori, 2001

I'd had the idea for doing *La ricotta* before, with another producer who died. But they had mucked it about because they were afraid; they thought it was too violent. Anyway, I hadn't managed to get the film off the ground and so I found myself with a script ready when Bini asked me if I'd do the film for him. But he'd already decided to make an episode film. So that was that. I didn't have any contact with Rossellini or the others at all, I just knew they were doing episodes as well.

I choose actors for what they really are; I chose Welles for what he is: a director, an intellectual, a man with something of the character that comes out in *La ricotta*, though, of course, he is a much more complex person than that. It was Giorgio Bassani who dubbed his voice.

I was given a four-month suspended sentence under a Fascist law, which is still in force because the magistrates here have never been purged. There are plenty of magistrates who were condemned by anti-Fascist courts who are still on the bench. In the Fascist code there are a number of crimes of public defamation – including against the nation, the flag, and the religion. The trial was a kind of farce, and the sentence was quashed on appeal. I still can't say exactly why they tried me at all, but it was a terrible period for me. I was slandered week after week, and for two or three years I lived under a kind of a unimaginable persecution. However, I can't really say why all this happened, unless as an expression of public opinion, which oddly enough, I think is profoundly racist.

It was banned for a while after the trial and the film was confiscated, then I was able to bring it out with a few small cuts like somebody shouting "away with the crosses" (when the director in the film wanted to shoot another scene): this was considered anti-Catholic. But it wasn't a success because, as you know, if a film doesn't come out at the right time it has had it.

From Oswald Stack, *Pasolini on Pasolini*, Thames and Hudson, London-New York 1969

Treatment

It's a film drawn from newsreel material (ninety thousand meters of film – the material of about six years in the life a weekly cinema newsreel that no longer exists). And therefore more a work of journalism than a creative endeavor. More an essay than a story.

To give you a better idea of it, I include here the treatment of the work – the usual five short pages the producer requests for distribution. Bear in mind therefore the intended purpose of this text – a purpose that implies on the one hand a certain hypocritical ideological prudence (the film would turn out to be much more firmly Marxist in its thrust than would appear in this summary); and, on the other hand, a certain aesthetic awkwardness (the film would turn out to be much more refined, in its editing and choice of images, than can be inferred from these hastily written lines).

What has happened in the world since the war and the postwar reconstruction? Normality.

That's right, normality. When we are in a state of normality, we don't look around ourselves. Everything around us appears "normal," without the excitement and emotion of the years of emergency. Man tends to fall asleep in his own normality; he forgets to reflect, loses the habit of judging himself, no longer asks himself who he is.

That is when the state of emergency must be created, artificially. And it's the poets who see to creating it. The poets, those perennially indignant champions of intellectual rage and philosophical fury.

There were a number of events that marked the end of the postwar phase: for example, for Italy, it was the death of De Gasperi.

The rage begins then, with that huge gray, funeral ceremony.

The anti-Fascist statesman and rebuilder "passes away." Italy rises to the mourning of this passing, and prepares itself, in fact, to rediscover the normality of times of peace, of real, oblivious peace.

Somebody, however – the poet – refuses this accommodation.

He observes with detachment – the detachment of discontent, of anger – the last acts of the postwar phase: the return of the final prisoners, in squalid trains (remember?), the return of the ashes of the dead… And… Minister Pella, who triumphantly seals Italy's wish to be part of the European Union.

And so, in peacetime, the machinery of international relations starts up again. One cabinet follows another, the airports see a continuous coming and going of ministers, ambassadors and plenipotentiaries descending airplane gangways, smiling and saying empty, stupid, vain, mendacious things.

In peace our world overflows with a sullen hatred: anti-communism. And against the grey, depressing backdrop of the Cold War and a divided Germany emerge the figures of the new protagonists of a new history.

Left, fire (still frame)

Nuclear tests (still frames)

Kruschev, Kennedy, Nehru, Tito, Nasser, De Gaulle, Castro, Ben Bella.

Until we get to Geneva, at the summit of the four Great Powers, and peace, still troubled, begins to move toward a definitive arrangement. And the poet's rage, at this normalization that is nothing more than a consecration of power and conformism, cannot help but grow.

What is that makes the poet so unhappy?

An infinity of existing problems that nobody is able to resolve. And without their resolution, peace, real peace, the peace of the poet, cannot be achieved.

Colonialism, for example. That anachronistic violence of one nation towards another, with its trail of martyrs and corpses.

Or the hunger of millions and millions of subproletarians.

Or racism. Racism as the moral cancer of modern man, which, like the cancer it is, takes countless forms. It is a hatred born of conformism, of the cult of the institution, of the arrogance of the majority. It is a hatred of all that is different, all that does not fit the norm and therefore disturbs the bourgeois order. Woe to anyone who is different! This is the cry, the formula, the slogan of the modern world. This is the cry against the black people, the yellow people, anyone of color; the hatred of Jews, rebellious sons, poets.

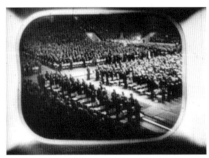

Lynchings in Little Rock, lynchings in London, lynchings in North Africa. Fascist insults against Jews.

This is how crisis breaks out anew, the eternal, latent crisis.

The events in Hungary and the Suez.

And Algeria, as it slowly begins to fill with the dead.

The world, for a few weeks, seems like the world of a few years before. Cannons firing, rubble, corpses on the streets, lines of ragged refugees, landscapes encrusted with snow.

Mangled corpses in the hot desert sun.

The crisis is resolved, yet again, in the world. The new dead are mourned and honoured, and the illusion of peace, increasingly whole and profound, begins again.

Yet together with the old Europe settling back into its old foundations, a new Europe is born:

Neo-capitalism;

the European Common Market, the United States of Europe, the enlightened, "fraternal" industrialists, the problems of human relations, of leisure time, of alienation.

Culture covers new ground: a new surge of creative energy in literature, film, painting. A huge favor to the great possessors of capital.

The servile poet cancels himself out, treating problems as unsolvable and reducing everything to form.

The powerful world of capital adopts, as its bold banner, an abstract painting.

Thus on the one hand, as high culture becomes more and more refined and

First television broadcasts in Italy, 1952
(still frames)

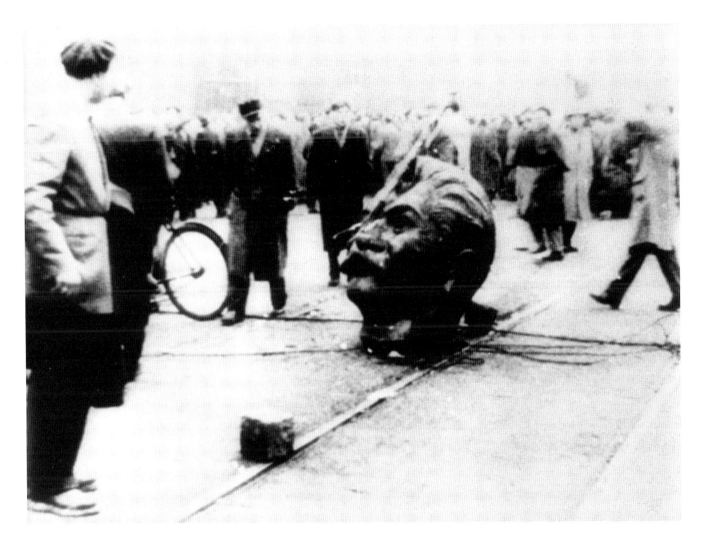

Stalin's statue torn down during the
Hungarian Revolution in 1956 (still frame)

for the few, these "few" become fictitiously "many": they become a "mass." It's the triumph of the "digest," the illustrated magazine, and television above all. Distorted through these media of diffusion, culture, and propaganda, the world is becoming more and more unreal. Mass production, of ideas, too, renders it monstrous.

The world of the illustrated magazine, the worldwide promotion of products, including human products, is a world that kills.

Poor, sweet Marilyn, obedient little sister, laden with your beauty like a fate that gladdens and kills.

Perhaps you took the right path, and taught us this. Your whiteness, your gold, your smile, indecent out of kindness, passive out of shyness, out of respect for the powerful who wanted you that way, you, forever the child, invite us to placate rage with tears, to turn our backs on this doomed reality, on the inevitability of evil.

For as long as man still exploits man, as long as humanity is divided between masters and servants, there shall be no normality, no peace. Herein lies the reason for all the troubles of our times.

And even today, in the Sixties, things haven't changed. The situation of people and their societies is the same as that which produced yesterday's tragedies.

Do you see them? Stern men in double-breasted coats, well-dressed, boarding and deboarding airplanes, riding in powerful automobiles, sitting at grandiose desks like thrones, holding meetings in solemn hemicycles, in splendid, staid settings. These men with faces like dogs or saints, like hyenas or eagles, they are the masters.

And do you see these ones? Humble men, dressed in rags or mass-produced clothes, wretches coming and going along teeming, squalid streets, spending hours and hours at a job without hope, meeting humbly in stadiums or taverns, in miserable little houses or tragic highrises. These men with faces like the dead, without features or light other than the light of life, these are the servants.

It is from this division that tragedy and death arise.

The atomic bomb with its funereal mushroom-cap expanding in apocalyptic skies is the fruit of this division.

There seems to be no solution to this impasse, in which the world of peace and prosperity frets. Only an unexpected, unimaginable turn of events... a solution no prophet can foresee... one of those surprises that life keeps in store when it wants to carry on... perhaps...

Perhaps the smile of the astronauts: that, perhaps, is the smile of real hope, of real peace. With the roads of earth cut off, closed, or bloodstained, now beckons, timidly, the road of the cosmos.

"Gli anni della rabbia," *Vie nuove*, no. 38, September 20, 1962 (response to a reader), later in *Per il cinema*, Mondadori, 2001

Tempera on "enduit" (1934, tempera, private collection, Paris) and *Le Vallon* (pastel, 1928, private collection, Paris), both by Jean Fautrier

Marilyn

Of the ancient world and the future world
all that remained was the beauty, and you,
poor little sister,
the one always running after your older brothers,
laughing and crying when they did, who liked
to wear their scarves and touch
their pen-knives and books when nobody was looking,

you, poor little sister,
daughter of simple people,
you wore that beauty humbly,
and in your simple soul
you never knew you had it,
or else it would not have been beauty.
Like fine gold dust it vanished.

The world taught it to you.
And thus your beauty became its own.

Of the stupid ancient world
and the ferocious future world
there remained a beauty that was not ashamed
to call attention to its small, kid-sisterly breasts,
its little belly so easily laid bare.
And that was why it was beauty, the same
you see in gentle black vagabonds
and gypsies, in the shopkeepers' daughters
who win beauty contests in Miami and Rome.
Like a small golden dove it vanished.

The world taught it to you,
and thus your beauty was no longer beauty.

But still you remained a little girl,
silly as Antiquity, cruel as the future,
while all the stupidity and cruelty of the present
came between you and your beauty.
Passively immodest, obediently indecent,
you carried it always with you, like a smile behind the tears.
Obedience demands that one swallow many tears,
that one give oneself to others,

Marilyn Monroe in a photo-frame
of the film

looking all too happy, asking for their pity.
Like a golden white shadow it vanished.

Thus surviving from the ancient world,
demanded by the future world, possessed
by the present world, your beauty became an affliction.

Now your older brothers finally turn around,
stop their dreadful games for a moment,
snap out of their inexorable distraction
and ask themselves: "Is it possible that Marilyn,
little Marilyn, has shown us the way?"
Now you're the first, little sister, you
who never mattered, poor thing, you with your smile,
you're the first outside the gates of a world
abandoned to a destiny of death.

"Marilyn," from *La Rabbia*, ed. Roberto Chiesi, Cineteca di Bologna, Bologna 2009

La Rabbia is a strange film because it is entirely made up of documentary material. I didn't shoot a single frame. Mainly it's pieces from newsreels, so the material is extremely banal and downright reactionary. I chose some sequences from newsreels of the late Fifties and put them together my own way – they're mostly about the Algerian War, the reign of Pope John, and there are a few minor episodes like the return of the Italian prisoners of war from Russia. My criterion was, let's say, that of a Marxist denunciation of the society of the time, and what was happening in it. One odd thing about the film is that the commentary is in verse: I wrote some poetry specially for it, and it is read by Giorgio Bassani, who dubbed Orson Welles in *La ricotta*, and by the painter Renato Guttuso. The best thing in my half of the film, and the only bit that is worth keeping, is the sequence devoted to the death of Marilyn Monroe.

I did my part, thinking that was all there was to it, but when I'd finished, the producer decided he wanted to have a commercial hit and so he had the brilliant idea of getting another episode with a commentary from the other side of the political spectrum. However, the person he chose, Guareschi, was unacceptable. So there was some trouble with the producer, and anyway the film was a flop because people weren't interested in such highly political material.

From Oswald Stack, *Pasolini on Pasolini*, Thames and Hudson, London-New York 1969

Frames of the film: a *Memento mori*, abandoned mannequins and the Soviet Cosmonaut Gherman Titov

1964

COMIZI D'AMORE

Love Meetings

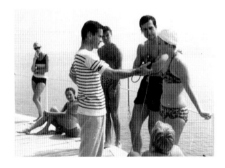

Left and above, Pasolini conducting interviews

A Hundred Pairs of Oxen

First of all, before the opening credits, we might see a pair of newlyweds or an engaged couple about to get married (young, clean, sensual and naive, with the prospect of procreation ahead of them, children...). This should appear every once in a while, between one series of questions and another, and finally explode at the end, right before and during the last phase of the film, just like in a serial romances…

There could then appear on the screen the faces of crazy people, criminals, maniacs, neurotics and other abnormal types. For example, there was that French doctor who, during the war, killed about thirty Jews in his home, in a kind of private cremation oven, and then walled up the corpses in the apartment. Or the American who killed six or seven women on his farm and used their skin to cover chairs, and so on.

Or perhaps a brief documentary specially filmed inside a nursing home or maybe even a psychiatric hospital, with particular attention given to the "rituals" of extreme neurotics. This could appear every once in a while and tie back up with the penultimate, dramatic phase of the inquiry concerning romantic love. Crazy people, victims of the dark side of sex, of untamed bestial instincts, of society's cruel conventions, of lynching by society, and so on. The poor "borderline cases" caught up in the struggle with the instincts that is life, and those who have lost this struggle, in all the many ways possible: through human failure, alcohol, drugs and, indeed, insanity…

The actual start of the film could feature several quick statements by the "editorialists" of the inquiry – on its aesthetic and moral significance (Alberto Moravia), its scientific significance (Cesare Musatti) and, finally, its purpose and target (Pasolini).

In plain language: a battle against the "monsters" – ignorance and the aberrations of reason in a field where moral and biological science have already shed a great deal of light… Therapy – or a pointer in this direction – for those who suffer, directly or indirectly, from the burden of ignorance, hypocritical inhibition or, in a broader sense, from the prejudices governing sexual relations. In short, a dialogue between those who know and those who do not know; a simple dialogue, unadorned and fraternal, in which what the average man of culture takes for granted becomes as well the heritage of the average man *tout court*, who, in these matters, is still in the clutches of the most archaic, absurd and dangerous ideas.

(Note: Naturally, the images of the people explaining shouldn't appear didactic, such as sitting at a table, but should each be placed in a setting in accordance with a specific, inventive characterization. Moravia and the Roman *barocchetto* style, for example. In short, even the film's ideological and pedagogical moments should be, however minimally, "cinema," spectacle).

The people respond. A whirlwind, a chaos, a babel of diverse opinions. The most ridiculous, inconceivable, and contradictory. And naïve, childish, scandalized, seemingly sensible but in fact lacking any logical sense. The people respond. Obviously the framework of the inquiry will have to be very clear, al-

most mathematical; but the mise-en-scène will necessarily have to be as surprising and unpredictable as possible, as chaotic as possible – in accordance with the range of people's opinions on the questions asked.

The investigation can be divided into two parts: a first part in which the public is asked its opinion – the average public, the very people who fill the movie theatre and will have their eyes on the screen and recognize themselves in the "types" of people questioned – and a second part more specifically devoted to the opinions of those "in the know," prominent cultural figures.

Both the first and second parts should be divided into many brief, asymmetrical sections, each with its own title (titles which could be presented over images of frightening animals, spiders, microbes, amoebas, monsters, snakes, all devouring one another...)

The first section could be devoted to the place that sex has in life, its importance to the feelings, thoughts, and instincts that govern our everyday existence. The filmmaker goes out into the street, sees a chubby housewife returning home with the groceries, and asks her: "Excuse me, how important is sex in your life?" Then he sees a fifteen-year-old boy coming out of a school and running towards the tram, and he stops him and asks: "How important is sex in your life, or how important will it become?" Then he enters the office of an important professional, studying his papers under a fake Segantini, and asks again: "How important is sex in your life?"

They will probably all deny that sex has any importance at all in their lives.

But out of the 100 or 200 questions asked, there will surely be a dozen or so that can be chosen so that they complement one another; a half dozen in which the people questioned, based on their hypocrisy, will shield themselves, precluding the very idea that sex could have any importance to them; and a half dozen where, on the contrary, the people questioned will have the courage to admit, sportingly or anxiously, the real importance that sex indeed has in their lives.

It is at such a point as this that one of the editorialists could weigh in (Moravia, for example, with some Roman *barocchetto* behind him) on the question: "Sex: inhibition, hypocrisy, and social conventions." And his arguments would be illustrated, after the first few comments, by available material (for example, we could bring back the images of the "inhibited" people seen earlier, before the credits, the martyrs of repression, the abnormal, the neurotics, the insane, etc.)

And from this – which could be the central theme of the film: the demystification of sexual taboos, the courage to talk about them, to make them objects of scientific study, etc. – we could then reel off all the other sections of the investigation, in a saraband of questions in which the people questioned would practically come to be their own spectators of the film.

A few random questions:

"At what point does abnormality begin and normality end in sexual relations?"

"What are sadists?"

"What are masochists?"

"What are exhibitionists?"

Film still

Pasolini with Cesare Musatti and Alberto Moravia

Pasolini with Giuseppe Ungaretti

"What are fetishists?"

"What are libertines?"

"What is the relationship between alcohol and sex, between drugs and sex?"

Two particularly important sections could be devoted to two very "popular" problems in this area: homosexuality and prostitution. And then we might ask:

"What is the relationship between actual sex life and marriage?"

"What is sexual honor?"

"What is the historical relationship between sexual honor and virginity, between conjugal fidelity and underdeveloped societies?"

"How do you view the question of divorce?"

"What about abortion?"

"And what about birth control?"

This whole series of questions – as well as the variously aberrant replies and the concise explanations of the commentators – must be fast and unexpected. It might be possible to adopt the technique used by directors of sensational news-reels. I mean the technique, certainly not the vulgar and disrespectful motives behind them. The questions must be stinging, mischievous, impertinent, and fired point-blank (they can be toned down in the dubbing, if necessary), so as to wring from those interviewed, if not the truth in the logical sense, at least their psychological truth. An expression in the eyes, a scandalized or angry reaction, or a laugh, can say more than an entire speech.

I repeat that, between one group of questions and another, the editorialists should come in and give explanations specific to the issue covered (while saving general explanations for the second part of the film); and I repeat that such explanations should be illustrated with lively images from our stock. (For example, to illustrate visually the process of "repression," with dramatic immediacy, I remember some excellent material: an Alpinist from Bergamo who had become seriously neurotic, even mad, because of a terrible shock he'd received during his imprisonment in Germany. He'd lived for many days inside a hole alone with an injured friend, whom he fed with grass he'd go out and look for, and who in the end died in his arms. He'd in fact repressed this terrible memory, hence the imbalance. A shot of medication liberates him, and he recalls the scene, standing in front of his little bed, acting it out with cries and groans. One of the most striking scenes ever seen on the screen).

All this available material should be later used liberally in the second part, to let it have a more spectacularly impressive effect.

The second part should be the flip side of the first. Instead of asking the opinions of unprepared people under the sway of their own fantasies and personal taboos, explanations will be asked of cultural figures specializing in a variety of fields.

These "interviews" should also be shot in the manner of a film and certainly not with the flat, embarrassing coldness of television interviews, or ordinary documentaries.

(I could see, for example, Carlo Levi being interviewed in front of one of his extremely long, huge paintings, with the camera panning back and forth, following him as he paces serenely, with a cigar in his mouth, etc.).

It is clear, however, that even framed in this manner, if the interviews are too long or consciously scientific, they will end up being a bore. This is why the documentary material must be very spectacular and scandalous.

Moreover, the questions asked of the specialists, the cultural figures, should be conceived as though being asked by the audience. That is, the spectators should once again be able to identify with those who, on the screen, are presenting the questions and displaying their curiosity.

Thus the query the man of culture responds to should always be framed or suggested by the man on the street, captured precisely at a typical, realistic moment of his life, as in the first part of the film. We ask a housewife: "What sexual problem would you like to see clarified?"; and the same with a high-school student, or a dignified professional, and so on.

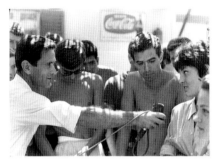

Here are some possible themes for these chance interviews:
"Sex and moral living."
"Sex and social and political life" (what did "free love" ever come to in Russia anyway?)
"Sex and hygiene."
"Sex and the penal code" (interview with Carnelutti, the legal specialist; he explains, for example, in what cases a person's sexual life runs afoul of the penal code; exactly what constitutes the crimes of obscene acts, corruption of minors, and so on).
"Sex and religion," and so on.

Some of these interviews could, for variety's sake, be presented in the form of a "round table" (discussions among various cultural figures specializing, or not, in one of these subjects).

Or, further, they could be presented in the form of a "press conference," where a prominent cultural figure could be bombarded with questions by a "typical" segment of the public.

In this way, the body of the film as a whole will take on the following dramatic form: Starting with the question: "What sorts of things can man's innermost, unconscious life, his instinctive bestiality, lead him to do?" – we will move on to a series of replies that will have arisen variously from the presentation of this central question in the context of a series of other specific questions.

This element should embody a certain emotional and poetic "pathos." (And for this purpose I would like to cite a few passages of *La Rabbia*, for their tone of expressive immediacy, as opposed to a purely rational report). This "emotional and poetic" element should begin to take shape from the first statements made in the film.

The penultimate emotional-dramatic phase of the inquiry will feature the insane, the victims of the dark side of sex, of the untamed bestial instincts, of the cruel conventions of society, of lynching by society, and so on, and the miserable "borderline cases" who have lost the struggle against the instincts that is life itself. Who have lost in one of the many ways possible, from human failure to alcohol, and drugs and end up in the mad-house…

Pasolini conducting interviews
Graziella Chiarcossi dressed as a bride

Pasolini conducting interviews

But life… Yes life, despite such ferocity, is still sweet. Despite all its darkness, it is still innocent. Despite all its complications, it is still simple, and pure. It goes on, almost oblivious to the tragedy and squalor that continually drags down what is sweet, innocent, simple and pure.

A Sunday in summer arrives and with it the wind, the sea, the street full of life, boys in new trousers, girls in low-cut blouses, the dancing, the mothers and fathers with their little children so tender and happy, the life of the city breathing around them so harmoniously in spite of it all… It is a kind of cruel revenge of the good life against the bad, of the bright life against the dark.

And all this could have a final solution – still on an "emotional and poetic" level but conforming to the scientific spirit of the film – by presenting marriage and procreation as the final question. How many weddings are taking place today, in Rome, in Milan? On this beautiful summer day, who is beginning a new life and thinking of the new children who will populate our world?

To this end we could go around to churches and city halls and pick a young, healthy, humble couple and follow them through their ancient, never-changing celebration… I can imagine a marriage among the common people, where we get the feeling that "healthy life, no matter how fictitious and poetical, will prevail over the tragic life" has the force of conviction. A handsome young man and a beautiful girl on their way to be married, she dressed humbly in white and he humbly in black, at the poor local church… with a group of relatives…

And who knows what they might say to someone asking them a few questions about questions of marriage, virginity, children, at such a moment of excitement and artless happiness for them… And if asked, in the end, they might – though a little confused, a little amused and self-mocking, and a little desperate – they might even exchange a kiss.

And that is how the film could end: with a quick, chaste kiss, the final kiss of the good movies of old.

(1963)

"Cento paia di buoi," original title for *Comizi d'amore*, in *Il cinema in forma di poesia*, ed. Luciano De Giusti, Cinemazero, Pordenone 1979, later in *Per il cinema*, Mondadori, 2001

Comizi d'amore had absolutely no success at all in Italy. It only came out in a few "art" cinemas and I don't think it ever went abroad because it did so badly in Italy. Anyway, there would have been a big translation problem: you'd lose the accents and dialects, and the jokes: it would be impossible to dub it and subtitles would to make it too cold. Someone who didn't know Italian properly could not take the film in; he could only see it as a purely sociological event, not as something cinematic; he would only be able to get the *sense* of the answers, not their feeling. At the very least it would need a highly specialized public, as was the case in Italy, where only cinephiles and sociologists who went to see it.

From Oswald Stack, *Pasolini on Pasolini*, Thames and Hudson, London-New York 1969

1964

SOPRALUOGHI IN PALESTINA

Location Hunting in Palestine for
"The Gospel According to St. Matthew"

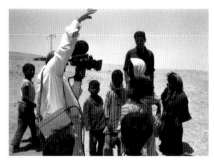

Pasolini with don Andrea Carraro
in Palestine

It came about very randomly, and in fact I never took any part in the camera set-ups or the shooting or anything else. When we went to the Middle East there was a cameraman with us who was sent along by the production company. I never suggested a thing to him, because I wasn't thinking of using the material to make a film, I just wanted some documentation that would help me set *Il Vangelo*. When I got back to Rome the producer asked me to put together some of the footage and put a commentary on it so it could be shown to a few distributors and Christian Democrat bosses to help the producers. I didn't even control the montage. I had someone put it together and then just looked over it, but I left everything, including some very ugly cuts which this person had made – who anyway wasn't even a qualified editor. I had it put on in a dubbing-room and improvised a commentary, so altogether the whole film is rather improvised.

When I landed at Tel Aviv, naturally, I couldn't make out anything. It was nighttime. All I could see was an airport and a city. I rented a car and went in towards the interior. Right at the beginning I got a few images of an ancient world, which was mainly Arab. I thought at first I might be able to use them, but then immediately afterwards the *kibbutzim* began to appear, and reforestation projects, modern agriculture, light industry, etc. and I realized it was all no use – and only after a few hours driving.

The whole film [*Il Vangelo secondo Matteo*] was shot in southern Italy. I had decided to do it that way even before going to Palestine – I went just to satisfy my conscience. I knew that I wanted to recreate the *Gospel* by analogy. Southern Italy gave me a way of making the transposition from the ancient world to the modern without having to reconstruct it archaeologically or philologically.

From Oswald Stack, *Pasolini on Pasolini*, Thames and Hudson, London-New York 1969

1964

IL VANGELO SECONDO MATTEO

The Gospel According to St. Matthew

Left, Rosario Migale (Thomas), second to the right, and walk-ons on the set

Artwork by Maro (Mauro Innocenti)

Drawing by Enrico De Seta

Letter from Pier Paolo Pasolini to Dr. Lucio S. Caruso of Pro Civitate Christiana

February 1963

Dear Caruso,

I would like to give a better in explanation in writing for what I confided to you in person.

The first time I went to see you in Assisi, I found the *Gospel* on the bedside table – a devilishly delightful calculation on your part!

In fact, everything went the way it was supposed to: I reread it – after some twenty years (I think it was 1940 or '41 when, still a youth, I read it for the first time, and out of that came *The Nightingale of the Catholic Church*; after that I'd read it in bits – a passage here, a passage there, as it happens…)

At your place that day I read it straight through, like a novel. And, in the excitement of reading – as you know, it's the most exciting thing one can possibly read! – I got the idea, among others, to make a film of it. An idea which, from the start, seemed to me utopian and sterile – "enraptured," you might say. When in fact it wasn't. As the days and then the weeks went by, the idea became more and more irresistible and exclusive, chasing all my other working ideas at the time back into the shadows, weakening them and robbing them of their vitality. Leaving only it, bright and exuberant in my mind.

After only two or three months, by which time I'd already worked it out – and it had become entirely familiar to me – I presented it to my producer. And he agreed to do the film, a difficult and risky proposition for both of us.

Now I need your help – yours, Don Giovanni's and that of your colleagues. Technical and philological support, but also ideas. I would like to ask you, in short (and Pro Civitate Christiana through you, with whom I'm on more familiar terms) to help me prepare the film, first, and then to assist me during the production.

My idea is the following: to follow, point by point, the *Gospel* according to Matthew, without making it into a script or boiling it down. To translate it faithfully into imagery, to follow the narrative, leaving nothing out and adding nothing. Even the dialogues should be those in Matthew's text, without any statements of explanation or connection, since no image or inserted word could ever be on the same lofty poetic level as the original.

It is this lofty poetry that so restlessly inspires me. What I want to make is a work of poetry. Not a religious work in the current sense of the term, nor a work in any way ideological.

In simple, stark words: I don't believe Christ is the son of God, because I'm not religious – at least not consciously. But I do believe that Christ is divine: I believe, that is, that his humanity is so elevated, so rigorous and ideal, as to surpass the common definitions of humanity. That's why I call it "poetry": an irrational instrument for expressing my irrational feelings about Christ. I would like for

my film to be able to be shown during Easter week in all the parish cinemas of Italy and the world. And this is why I need your help and support. I would never want for my expressive needs, my poetic inspiration, to contradict the religious sensibilities of all of you. Otherwise I would never achieve my purpose of presenting anew, to all, a life that is a model – however unattainable – for all.

I so hope you have confidence in me.

I shake your hand, affectionately

<div align="right">

Yours,
Pier Paolo Pasolini

</div>

From *Il Vangelo secondo Matteo. Un film di P.P. Pasolini*, Garzanti, Milan 1964, later in *Il Vangelo secondo Matteo. Edipo Re. Medea*, Garzanti, Milan 1991

A Charge of Vitality

It really annoys me to have to talk about a book from two thousand years ago: it makes me feel like a hermetic poet or poetess, or a professor hosting a television program. To give a talk as the latest reading of a two thousand-year-old book is always something that makes one respectable, "great," or at least a participant in greatness. But as far I am concerned, it was sheer chance. I have re-read, for the fifth or sixth time in these last few weeks, *The Gospel According to St. Matthew*, for work purposes. In fact I have to begin to transpose the text – without the mediation of the screenplay, but just as it is, as if it were a ready-made screenplay – into a text literally unaltered but technified. For example:

1 – FS of Mary, soon to be a mother.

2 – CU or TCU of Mary who looks off, distressed, humble, ashamed.

3 – CU or TCU of Joseph who exchanges the distressed look, but in a rigid and severe way.

4 – FS of Joseph; the camera pans as he leaves the room.

5 – FS of Joseph; the camera pans as he walks through the orchard (or a vineyard) and lies down under a tree.

6 – CU of Joseph who, tired, aching, closes his eyes and sleeps.

7 – FS of the angel who appears to him, saying, "Joseph, son of David, do not be afraid to take Mary as your wife…".

This is the best reading that one can do of a text. An analysis that a stylistic critic could never have foreseen, as a study of the functionally of the fragments, of the visualizing power of passages which are also interlinking, of the "accelerating" as well as the "delaying" elements studied by Spitzer (St. Matthew is full of these stylistic accelerations; ellipsis and disproportion are his romantic-barbaric characteristic)…

Danilo Donati on the set

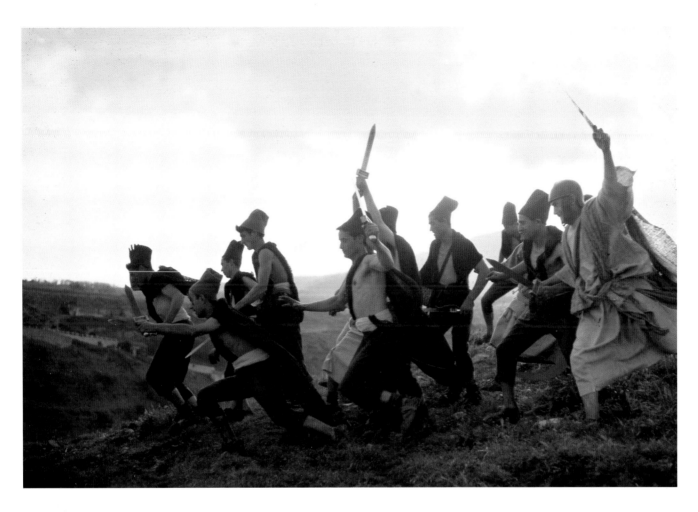

The Herodian soldiers

Why I ever began such a work, and it would be a much longer story to explain, is easy to imagine. I will simply say one thing: as soon as I finished the first reading of *The Gospel* (one October day in Assisi, in the midst of the deadening, extraneous and, in the end, hostile celebration of the Pope's arrival), I immediately felt the need to "do something," a terrible, almost physical, energy.

It was the "increase of vitality" which Berenson used to speak of. This increase of vitality takes on tangible form generally in an effort of critical comprehension of a work of art, in an exegesis of that work – in another work, in short, that elucidates it, and that transforms the first pregrammatical impetus of enthusiasm or emotion into a logical, historical contribution. What could I do for St. Matthew? And yet I had to do something. It was impossible to remain inert, inefficient, after such an emotion, so aesthetically profound, which I had previously experienced only a few times in my life. I said "aesthetic emotion." And sincerely, because this was how that increase of vitality came over me – as overpowering and visionary. The blend of mythic violence and factual culture in the sacred text (the same within which the literate Matthew operated) projected a double image of figurative worlds, frequently connected in my imagination. One physiological, brutally

alive, of the biblical age as it had appeared to me in my travels in India or along the Arab coasts of Africa. And the other reconstructed from the visual culture of the Italian Renaissance, from Masaccio to the dark mannerists. Think of the first frame, of the "FS of Mary soon to be a mother." Can one escape the suggestion of Piero della Francesca's Madonna at San Sepolcro? That child, with blond, almost reddish hair, practically without eyelashes, with swollen eyelids, and a pointed abdomen, whose silhouette has the same chaste outline of an Apennine hill? And right after that, the image of the orchard, in which Joseph settles down to rest: isn't it like one of those dusty pink clearings, with red goats, that I had seen in the Egyptian villages around Aswan, or at the foot of the purple volcanoes of Aden?

But, I repeat, this was the external, stupendously visual aspect of the increase of vitality. Deep down there was something still more violent stirring me. It was the figure of Christ as Matthew sees him. Nothing seems to me more opposed to the modern world than that figure. That Christ, gentle at heart, but "never" so in mind, who never gives up for a moment his own terrible freedom as the will to continually test his own religion – a continual contempt for contradiction and scandal. Following the "stylistic accelerations" of Matthew to the letter, the barbaric-practical functionality of his story, the abolition of chronological time-frames, the elliptical jumps in the story containing the "disproportions" of the didactic standstills (the stupendous, interminable Sermon on the Mount), the figure of Christ should have, at the end, the same violence as a *resistance*. Something that radically contradicts life as it is taking shape for modern man – his bleak orgy of cynicism, irony, practical brutality, compromise, conformity, glorification of his own identity within the general features of the mass, hatred for all difference, theological rancor without religion.

"Il *Vangelo* di Matteo. Una carica di vitalità," *Il Giorno*, March 6, 1963, later in *Il Vangelo secondo Matteo. Edipo Re. Medea*

Letter from Pier Paolo Pasolini to producer Alfredo Bini

May 12, 1963

Dear Alfredo

You ask me to summarize in writing, for your convenience, the criteria that will govern my production of *Il Vangelo secondo Matteo*.

From a religious point of view, for me – having always tried to recover certain religious characteristics from my secularism – two innocently ontological facts are of importance here: Christ's humanity is driven by such great inner strength, by such an irreducible thirst for knowledge and for verifying knowledge, with no fear of scandal or contradiction, that the metaphor of "divinity" stretches the bounds metaphor in this case, to the point of being ideally a reality. Moreover,

Walk-ons on the set
Pasolini on the set

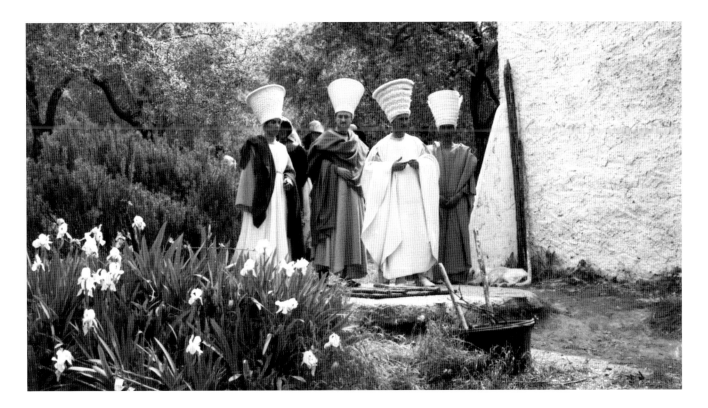

for me, beauty is always "moral beauty" – but this beauty always comes to us in mediated form: mediated through poetry, philosophy, or practice. The only case of unmediated beauty – that is, immediate, in a pure state – that I have ever experienced was in the *Gospel*.

As for my "artistic" relationship with the *Gospel*, it's rather curious. You know, perhaps, that as a writer intellectually born of the Resistance, as a Marxist and so on, for the duration of the Fifties my ideological efforts were all towards rationalism, and polemically at odds with the irrationalism of decadent literature (in which I was educated and loved so much). The idea of making a film on the *Gospel*, and my technical perception of it, is instead, I must confess, the fruit of a wild surge of irrationalism. I want to create a work of pure poetry, even braving the dangers of aestheticism (with Bach and partly Mozart, as musical commentaries; Piero della Francesca and partly Duccio for visual inspiration; and the essentially prehistoric, exotic reality of the Arab world as background and setting). All this puts my whole career as a writer dangerously at stake, I know. But it would be interesting if, in loving Matthew's Christ so passionately, I were afraid to put anything at stake.

Yours,
Pier Paolo Pasolini

From *Il Vangelo secondo Matteo. Un film di P.P. Pasolini*, Garzanti, Milan 1964

It is undoubtedly a historical film, for all its external facets, but in reality it really isn't, because a historical film presupposes above all a faithfulness to history and therefore a historical reconstruction. Now, clearly there is no faithfulness to history as history here, since history as such is entirely mythified. I have taken the historical view exactly as Matthew saw it, and he did not have a historicist, or even historical view of things, but only a mythical view. And that's what I've tried to recreate. My main interest, my goal was not history, but myth. Secondly, there hasn't been any historical reconstruction even in the sphere of myth, because I haven't reconstructed anything. You may have noticed that the little girls are wearing First-Communion earrings. So I've created no historical reconstruction, although the film is entirely built around a series of reconstructions by analogy. That is, I substituted an analogous landscape for the real historical landscape, and the palaces of the powerful were represented by analogous places, the faces of the period by analogous faces. In short, my whole modus operandi was governed by this theme of analogy in the place of reconstruction.

Enrique Irazoqui

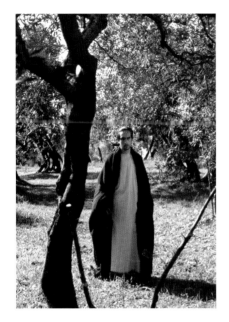

In making the *Vangelo* I wanted to remain totally faithful to Matthew, for aesthetic reasons, but it also seemed like the right thing to do, even historically speaking, because I didn't want to make a Life of Christ, I had no desire to do that, since I had no teleologically or socially specific ideas on what I would do. I didn't want to put the Gospels together and reconstruct a Life of Christ with added dialogues and so on. I really wanted to do it just with Matthew, and I remained true to this idea. Then, as I was making it, I tended to force the material in the direction of present-day realities, and as I was doing so I believed this was very important… For example, when I had Herod's soldiers dressed like Fascists, or Roman soldiers dressed like la Celere [Italian anti-riot police, ed.], or when I made Joseph and Mary like the Spanish refugees fleeing through the Pyrenees, and so on, I thought these things would stand out much more than they actually do – that is, I thought I could bring the *Gospel* up to date without affecting the profound faithfulness I had established from the start, which was my meter. Once a writer chooses a meter he cannot help but remain faithful to it. In other words, I believed that in fact the film was much more expressive, much more violently expressive, more magmatic and expressionistic, than what it turned out to be in the end. That is, all the references to our time, the quotations of Dreyer and Mizoguchi, this ensemble of expressive and expressionistic realities that I thought would stand out so clearly, actually got smoothed over in the whole of the film – although they did add a sort of firmness and detachment, which I hadn't reckoned on, and which came out almost unbeknownst to me. And so I'm still asking myself why.

From "Intervista con Pier Paolo Pasolini," interview by Luigi Faccini and Maurizio Ponzi, *Filmcritica*, no. 156-157, April-May 1965, later in *Per il cinema*, Mondadori, 2001

As I thought of representing Christ as an intellectual in a world of poor people open to revolution, and as I was looking for an analogy between what Christ really was and the person who might play him, I felt the only real possibility would be to use a poet; so I went through all the poets, and two who held my attention for a moment were Yevtushenko and Kerouac, but then I discovered that the photograph of Kerouac was ten or fifteen years out of date – but these were only two of many I considered for a moment.

I chose the apostles according to whatever information we had about them. Some of them were of the people, like Peter, who was a fisherman, so he was played by a young Jewish subproletarian from Rome. About half of them were of humble origin; others, like Matthew, did have a more intellectual background, so I chose an intellectual for him.

The whole film was shot in Southern Italy. I had decided to do this even before I went to Palestine, which I only did to set my conscience at ease. I knew I would

remake the *Gospel* by analogy. Southern Italy enabled me to make the transposition from the ancient to the modern world without having to reconstruct it either archaeologically or philologically. I did a long tour of the South alone by car and chose all the locations and then went back with my assistants and did the planning.

Jerusalem was the old part of Matera, which now, alas, is falling into ruin, the part known as *i Sassi*, "the Stones." Bethlehem was a village in Apulia called Barile, where people really were living in caves, as in the film, only a few years ago. The castles were Norman castles dotted round Apulia and Lucania. The desert part where Christ is walking along with the apostles I shot in Calabria. And Capernaum is made up of two towns: the part down by the sea is a village near Crotone, and the part looking away from the sea is Massafra.

The fact that I made the film by analogy means that I was not interested in exactitude. I was interested in everything but that. Obviously, I have left out objectively important political and social factors. By nature I adopted a definite position in my reconstruction: in a choice between an exact reproduction of Palestine two thousand years ago and getting close to present-day reality, I would choose the latter. Besides, along with this method of reconstruction by analogy, there is the idea of the myth and of epicness which I have talked about so much; so when I told the story of Christ I didn't reconstruct Christ as he really was. If I had reconstructed the history of Christ as he really was I would not have produced a religious film because I am not a believer. I don't believe Christ is the son of God. I would have produced a positivist or Marxist reconstruction at the most, and thus at best a life which could have been the life of any one of the five or six thousand holy men who were preaching at that time in Palestine. But I did not want to do this, because I am not interested in deconsecrating: this is a fashion I hate, it is petit-bourgeois. I want to re-consecrate things as much as possible, I want to re-mythify them. I did not want to reconstruct the life of Christ as it really was, I wanted to do the story of Christ plus two thousand years of Christian translation, because it is the two thousand years of Christian history which have mythified this biography as such. My film is the life of Christ plus two thousand years of story-telling about the life of Christ.

Already in *Accattone* my style was religious – I thought it was (although I prefer the word "sacred"), and all the critics thought it was, though they called it "Catholic" rather than "religious," which was wrong. But it was religious in style rather than content. It's possible to cheat in the content, but you can't cheat in the style. When I started *The Gospel* I thought I had the right formula all ready, and I started out shooting it with the same techniques and style as I used for *Accattone*. But after two days I was in total crisis and I even contemplated giving the whole thing up, which had never happened to me in my whole life, except for this time. Using a sacred style for *The Gospel* was gilding the lily: it came out as rhetoric. Sacred technique and style in *Accattone* worked fine, but applied to

Pasolini and Ninetto Davoli on the set

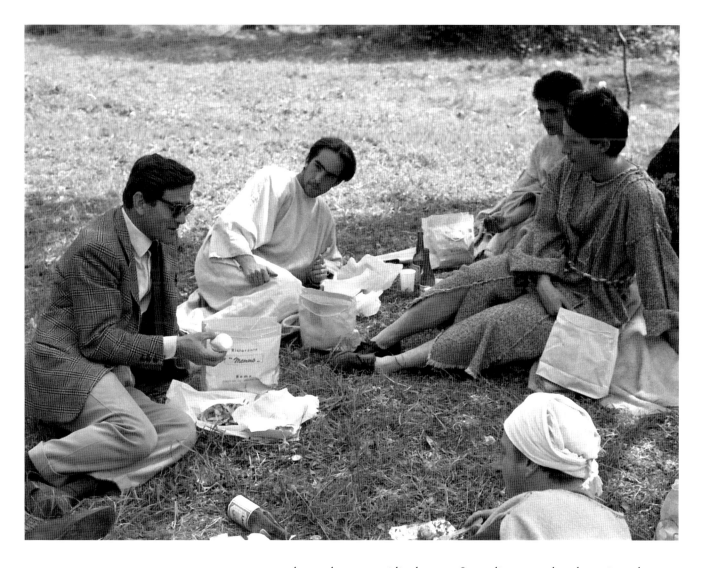

Pasolini, Enrique Irazoqui and Giorgio
Agamben on the set

a sacred text they were ridiculous; so I got discouraged and was just about to give the whole thing up, and then when I was shooting the baptism scene near Viterbo I threw over all my technical preconceptions. I started using the zoom, I used new camera movements, new frames which were not reverential, but almost documentary. A completely new style emerged. In *Accattone* the style is consistent and extremely simple, as in Masaccio or in Romanesque sculpture. Whereas the style in *Il Vangelo* is very varied: it combines the reverential with almost documentary moments, an almost classical severity with moments that are almost godardian – e.g., the two trials of Christ shot like *cinéma vérité*. The same contrast between the styles of *Accattone,* where there is only one figurative element – Masaccio, perhaps deep down Giotto and Romanesque sculpture as well, but anyway only one *type* of reference; whereas in *Il Vangelo* there are numerous different sources – Piero della Francesca (in the Pharisees' clothes), Byzantine painting (Christ's face like Rouault), etc. Recently I saw an exhibi-

tion of Rouault's work with some paintings of Christ where he had exactly the same face as my Christ. Anyway, there are numerous references. And that goes for the music as well: the music in *Il Vangelo* is a mixture of different styles and techniques.

The first images of Mary and Joseph are different: these are two earthly creatures to whom something monstrously divine is happening, which they are not equal to. There is an obvious disproportion between them and the celestial powers which are descending on them. But basically this is only an intensification of the spiritual element there is in all innocence: any innocent young girl is full of mystery, all I tried to do was to multiply a thousandfold the mystery in this young girl. The use of disproportion, people being unprepared for the confrontation with divine events, is deliberate. I shot Christ's first phrase to the peasants like that because I wanted to give a crescendo to his preaching. As you remember, he starts out walking almost alone. Roberto Longhi said something very beautiful about this scene; he said he liked it because Christ was going out into the country with the impetus and the sense of a future full of things to do, the very same way a nineteenth-century impressionist would have gone out to paint in the open air.

The first time I saw the film just after I'd finished it, I thought it did have stylistic unity, and this surprised me; and then I realized this was because I had

Pasolini and the troupe on the set

told the story myself, and therefore I probably do believe after all. The stylistic unity is only my own unconscious religiousness, which came out and gave the film its unity. Then I saw the film again just a month or two ago and I changed my mind about it again: it's not true that it has stylistic unity. What happened was that when I was shooting the film I was changing my mind the whole time and trying out new things like hand-held camera, *cinéma vérité* and so on, and so I expected it to look very varied; then when I saw it just after I'd finished it it was much less of a hodgepodge than I expected. But when I saw it again just now the inner, dramatic nature, which I'd missed the first time, came out. It is a violently contradictory film, profoundly ambiguous and disconcerting, particularly the figure of Christ – at times he is almost embarrassing, as well as being enigmatic. There are some horrible moments I am ashamed of, which are almost Counter-Reformation Baroque, repellent – the miracles. The miracles of the loaves and the fishes and Christ walking on the water are disgusting pietism. The jump from these kind of holy-picture scenes to the passionate violence of his politics and his preaching is so great that the Christ figure in the film is bound to produce a strong sense of unease in an audience.

From Oswald Stack, *Pasolini on Pasolini*, Thames and Hudson, London-New York 1969

Pasolini on the set

1966

UCCELLACCI E UCCELLINI

The Hawks and the Sparrows

The credits are sung against a freeze-frame with a three-quarter daytime moon suspended among moving clouds.

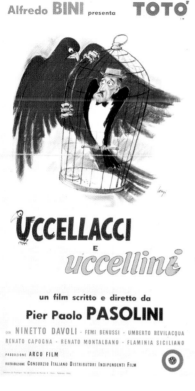

Alfredo Bini
presents
old Totò
sad Totò
merry Totò
in the story
UCCELLACCI E UCCELLINI
told by Pier Paolo Pasolini
with the innocent but clever
Ninetto Davoli.
The rest of the cast
was picked up off the street and they go
from Femi Benussi to Vittorio Vittori.
On the happy and sad merry-go-round,
Luigi Scaccianoce designed the sets,
Danilo Donati made up men and angels,
Nino Baragli edited and re-edited,
Ennio Morricone, along with Pasolini, composed and adapted the music
while "Carmè Carmè" belongs to Totò…
Mario Bernardo with Tonino Delli Colli held the camera,
Fernando Franchi organized it all,
Sergio Citti, the philosopher, helped out.
A small crew wandered through the suburbs
and camped in the countryside and small villages.
Alfredo Bini,
while producing, risked his position,
Pier Paolo Pasolini,
while directing, risked his reputation.

Left, Totò

Artwork by Carlantonio Longi

Drawing by Carlantonio Longi

Uccellacci e uccellini was intended to be a typical film in prose. I had decided to begin the first shot with a 32mm lens, and to continue in this way right to the end. The movements of the camera were to be wholly functional: in short, the camera presence *was not to be felt*, this in keeping with the tradition of the classical comedies (Keaton, Charlie Chaplin, etc.).

But for the second time (the first time it happened to me was in *Il Vangelo secondo Matteo*), such sure, precise technical planning seemed completely wrong. From the very first I found it impossible to apply this technique to my ideocomical tale (I began with the episode of the Crow), and this immediately threw me into crisis, forcing me to adopt the technique, albeit in a moderate way, of the cinema of poetry: I began right away with the asymmetrical shots.

Totò and Ninetto were isolated, with a great deal of space, respectively, on the right and on the left – almost as if they were not walking together, but each one alone, in his own oblique world, not rendered very naturalistically and recognizable by a shot thus conceived. I intended to bring them "together" during the editing, but only in an extreme long shot: two tiny black dots against the horizon and during one lively moment of their dialogue. And that was how I proceeded with the whole film. By "qualifying," rather strongly, with the camera, the substantivizing material (the relevant shots of "Totò looking," "Ninetto laughing," and so on) and foreseeing, for the later editing, an "arhythmic" rhythm, as with a poetic language, but not too poetic.

(January 16, 1966) Ninetto Davoli

The editing of the film is almost finished. I have tightened it and sped it up, taking out an entire episode, the first. It is no longer a film in three episodes, but a single film containing another short film, as told by the talking crow. The visual realization, that is, of the ideology of the Crow, who as a Marxist – though an extravagant one – recognizes the goodness of certain Church policies, etc., and, in any case, the anti-bourgeois significance of all that is sacred.

(January 21, 1966)

I tried to recover the episodes of the tamer and the eagle, reducing them to between eight and ten minutes. I'm not sure at the moment whether these episodes will be re-included in the film or not. In that case it will also be narrated by the Crow, before the friar episode. The length of eight to ten minutes, and thus the reduction of the episode to what it essentially is, that is to "a symmetrical squiggle with lots of black and white," seems to me to restore at least partially some of the poetic value lost in the normal editing. It had lost this poetic value for two reasons: Toto's difficulty in interpreting a *conscious* character *possessing cultural privileges* (I intend "interpreting" here not in a strictly professional sense). He is an *innocent*: and it's because he is innocent that he might become poetic. The other reason is the meager means I had to film the episode with. I had nothing but four white sheets on the walls and this forced me to film the episode, as I was saying, like a black and white squiggle. A sort of illustration of itself done with two or three incredibly poor elements: white, black, some grey (a Léger on the wall), and the characters' faces. The potential expressionistic richness was lost in all this stylization. The culturally-conscious, and therefore prosaic, words of the Tamer sounded suspicious in that naked whiteness, etc. What is more (and still due to these meager means), I didn't film the "funnies," which the tamer was supposed to project into a small screen for the eagle's enjoyment. This "void" has not been filled by anything that could have replaced it.

(January 23, 1966)

From "Confessioni tecniche," in *Uccellacci e uccellini. Un film di Pier Paolo Pasolini*, Garzanti, Milan 1966, later in *Per il cinema*, Mondadori, 2001

The Phases of the Crow

The idea for the Crow went through many different phases. First, the Crow was simply a wise spirit, a sage, and basically a simple moralist (but early on the idea was not for a film but a short story). From moralist the Crow then changed into a philosopher. At this point in time, the idea went from being a story (which I never would have been able to write, not having the linguistic skills necessary) to a film. The philosopher had to be made more precise, since

Ninetto Davoli with Totò

without precision it is impossible to simplify (the act of which is not just a necessary element but a fascinating prosodic norm), for a product whose audience would be moviegoers, etc.

Ever since the beginning, therefore, this philosopher was a "real" sage looking for empirical and absolute – not systematic – reality in things, through a scandalous and anarchic freedom. A sage on drugs, almost, a lovable beatnik, a poet with nothing to lose, a character from Elsa Morante, a Bobby Bazlen, a sublime and ridiculous Socrates who stops at nothing and who has the duty to never tell a lie, almost as if he was inspired by Indian philosophers or Simone Weil.

But with this conception of the Crow, things didn't add up. The two characters on their journey, father and son, are, in their perfect innocence and candid cynicism, following, in their own manner, an inner truth – or rather, according to the genuine automatism of simple men, in the most absolute sense of the term – they are in fact what the Crow should have been, in this latest conception. He would have taught them to be what they always have been, and to be forever what they are by definition. They thus would never have been able to eat the Crow at the end, as was the goal, which is to say to assimilate it, and then set off again down their road, taking from him the small amount they were able to take – in the expectation that a new Crow would come and give them further consciousness of things.

The Crow needed to be well defined in terms of era and history: from the entirety of the anarchic and "Indian" Crow's complex culture, I had to pick out the Marxist element, which could not be anything other than one component of its culture. I wrote the screenplay with a Marxist Crow in mind, though one not entirely freed of the anarchic, independent, sweet and truthful Crow.

At this point, the Crow became autobiographical – a kind of irregular metaphor for the author. And so its psychological background was born: a Marxism grafted – as a norm of innocence, a palingenesis not mad but well thought out – onto a rift in the norm, onto a trauma (nostalgia for life and the detachment stemming from it, loneliness, poetry as compensation, the natural duty of passion and so on).

But the autobiography was most evident in the Crow's kind of Marxism. Its Marxism was open to all possible syncretisms, contaminations, and regressions while holding steady to its firmest points of diagnosis and perspective (the Italian contrast between the pre-industrial and industrial worlds, the future of the worker and so on).

All of this led me, however, to a contradiction. The Crow "had to get eaten" at the end: this was the inspiration and unwavering goal of my fable. He had to get eaten because, from his perspective, he had completed his mandate, his job was over, he had become, as we say, obsolete; and then on the part of his killers, there had to be an "assimilation" of what good – and what little bit of usefulness – he might have given to humanity during his mandate (Totò and Ninetto).

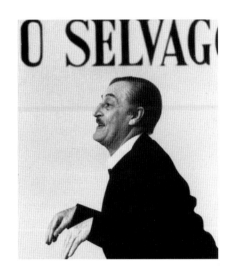

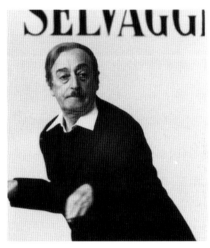

Totò in *Le Grand Cirque*, an episode cut out of *Uccellacci e uccellini*, with Ninetto Davoli and with Pasolini on the set

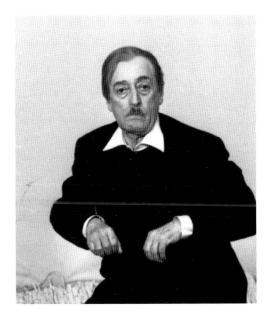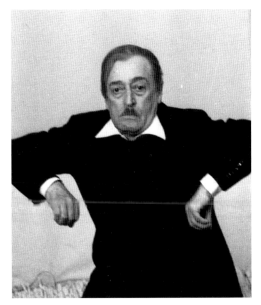

It needs to be kept in mind that the epigraph to put at the top of this story of the Crow was a sentence by Mao from an interview with an American journalist – a sentence that goes something along the lines of: "Where are men going? Will they be Communists or not in the future? Who knows! They probably will be neither Communists nor non-Communists… They will go forward into their immense future taking from Communist ideology that little bit which will be useful to them for the immense complexity and confusion of their forward movement…"

The Crow was, at this phase, Marxist ideology, at a particular "historical moment" in time – which is to say the Marxist ideology of the Fifties – just when it was about to become obsolete. I had to make this point clear in the contradiction: if the Crow's Marxism coincided with my Marxism, since I am in a state of evolution, and since I am above all conscious of the crisis of Fifties Marxism, his story couldn't end, he clearly couldn't become obsolete – as a simple story would demand – and end up being eaten. If the Crow's Marxism didn't coincide with mine, the Crow became an altogether objective character that said things that I don't share any more: a boring and unpleasant character, almost Stalinesque, whose voice would sound "old" amid the very new setting of the story. However, the story requires that he be pleasant, that his comments be right even if they are a bit boring etc., so that being eaten at the end inspires two equivalent feelings: the pleasurable sense of freedom from his ideological obsession of wanting always to explain everything, and compassion for his horrible ending.

So I had to separate the Crow's Marxism from my own and give it a more objective reality. Or rather, like me, he had to be conscious of the crisis of Marxism – in other words the Crow had to be a 1970s Marxist – but with ideas that weren't entirely mine.

In other words: I had to delve into my own ideas, test them, and study them. I had to move forward, change, and understand, so as to be able to lend the Crow my new Marxist perspective. I had to find common ground between my new Marxism and the Crow's, but without applying my inert and purely negative experiences of the past few years.

That is what I attempted to do – which may be nothing for an ideologue, but is quite a lot for a storyteller like me. In this, I was helped by a precious volume which fell into my hands at just the right time: an anthology edited by Franco Fortini which, together with another of his recent books, *Verifica dei poteri* ("A Test of Powers") were the texts that made up the base – getting the screenplay back on track – of the ideological figure of the Crow, extracting from the complicated and horrid skein a summary poetic thread.

"Le fasi del corvo," from *Scritti teorici e tecnici di Pier Paolo Pasolini*, in *Uccellacci e uccellini. Un film di Pier Paolo Pasolini*, Garzanti, Milan 1966, later in *Per il cinema*, Mondadori, 2001

Three moments on the set of *Le Grand Cirque*, with Totò and Ninetto Davoli and Sergio Citti, Pasolini, Mario Castellani and Totò on the set

Totò

The Story According to the Author

On a journey that began who-knows-when and will end who-knows-where, a man is walking with his son somewhere in an apparently endless urban periphery crowded with unlikely road signs and peopled with retired angels, itinerant actors, noisy troublemakers, and more…

Along the road, amidst a confusion of bizarre, absurd, and comical little adventures, our pair also meet a talking crow, who joins them for part of the way. The unusual trio continues under a scorching sun while the crow tries to get the father and the son to tell him where they are going, what they are doing, how they live and what they think of life. But they just don't know!

So the crow tries to enlighten them first by explaining the nature of the events in which they are involved. It's a useless effort, but the crow persists: he is a tenacious talker and tries to take in our two innocents with his forceful dialectical arguments. Totò and his son listen to the learned crow patiently and without surprise. They feel a certain reverence for him, but also a great deal of indifference, and they're anxious to agree with some of the crow's arguments. But deep down they consider him a crashing bore: he keeps on talking, observing, discerning, distinguishing, and they are utterly incapable of following and appreciating his doctrines.

At a certain point the crow tries to buttress his arguments by telling them a true story that, as he duly underscores, concerns some *uccellacci* and *uccellini*. And so Totò, the father, dressed as an old friar, and Ninetto, the son, as a young novice, find themselves living an adventure in the year 1200. Saint Francis asks them to decipher the language of birds so he can preach of love to them as well.

It's an arduous task, but the old friar Totò devotes himself to it with great passion. He spends a number of years on his knees in front of a castle in ruin but enlivened by many small hawks, oblivious to the changes of season, the freezing snow, the lashing wind, the scorching sun, confident that he will one day succeed in understanding the language of the hawks. And in the end he does.

The old friar then tackles, with equal passion, the very difficult task of learning the language of the sparrows, and when he comes to possess the secret of both languages, he can finally talk to both hawks and sparrows in their respective languages and convert them to love.

Yet in their joy over this wondrous discovery, the hawks, conquered by love, hurl themselves at the little sparrows and gobble them up. Friar Totò despairs, but then, with the help of Friar Ninetto and the comforting words of Saint Francis, he begins preaching again. It is true, even in our everyday lives, that the different social classes, however converted to the faith, are not yet sufficiently enlightened to respect one another. Saint Francis's exhortations to the aging friar contain the same considerations on peace and non-violence that Pope Paul VI pronounced to the United Nations.

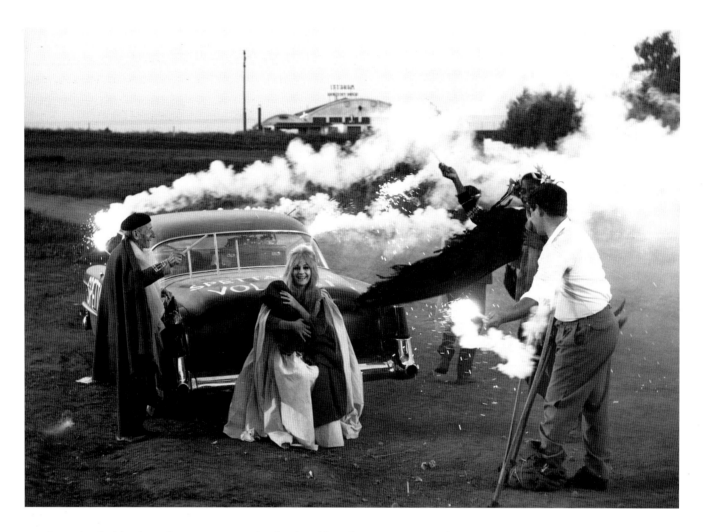

Once the flashback to the year 1200 ends, the three friends, Crow, Totò and Ninetto, continue on their way, witnessing small meaningful events and living adventures that are at once comic and tragic and give the crow pretexts to continue his ideological preaching.

But now Totò and Ninetto can barely hide their boredom. They can't stand it any longer. Through gestures, not words – since they are intimidated by the crow – they form a plan, and suddenly, Zap! They wring the crow's neck, roast him, and eat him.

The crow, the author tell us, is the ideological rationalism that was superseded by Pope John XXIII's message. The crow's demise represents the cruel assimilation of certain ideas. Mankind swallows whatever it has to devour and moves on toward what other goals? In the film humanity is within the vastness of its time.

"La trama secondo l'autore," flyer distributed at the première of the film (1966), later in
Le regole di un'illusione

Lena Lin Solaro and Umberto Bevilacqua
on the right

I consider *Uccellacci e uccellini* to be a film in prose, a prose that belongs, however, to fables, a particular kind of prose that has the nervousness and fantasy that belongs to poetry, without linguistic leaps, without the linguistic violence of poetic cinema. It's a film that is told in prose with poetic moments, something typical of fables. Fables are always metaphorical for the very nature of their technique, and it is obvious that my film is permeated by metaphors. Nor is it necessarily a given that a metaphor has to be understood: in Dante there are sublime metaphors that stand for themselves and not for the meanings explained in the notes. In the same way some fables are beautiful just as they are, even if at the end you don't think about or even understand the moral. I wanted to make a film that was metaphorical, that alluded continuously to something, that was an apologue of something else, and that at the same time had a value in and of itself. I thought it was good that some allusions, some metaphors, were understood, but in case they weren't, that they be of value in themselves as representations. American viewers for example, liked the film more than Italian viewers; they enjoyed it more, and they laughed in New York and Montreal, despite the fact that they understood the metaphors and allusions to a lesser degree than the Italian public.

Flaminia Siciliano, Totò and Ninetto Davoli in *Le Grand Cirque*

From "Razionalità e metafora in Pier Paolo Pasolini," interview by Paolo Castaldini, *Filmcritica*, no. 174, January-February 1967, later in *Per il cinema*, Mondadori, 2001

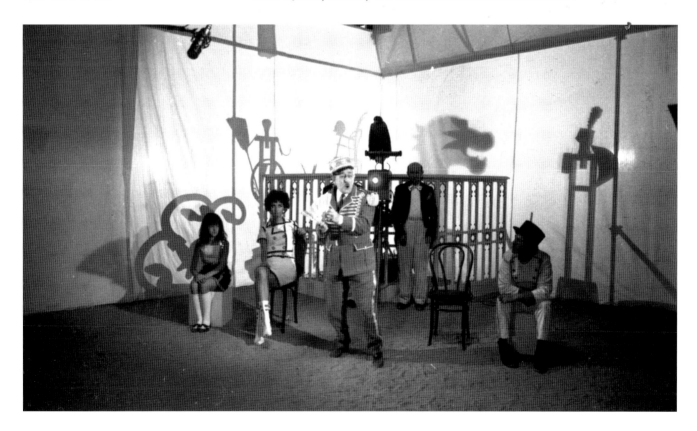

1966

LA TERRA VISTA DALLA LUNA

The Earth as Seen from the Moon

Then there's the project for a very strange book. I have in mind about a dozen comic episodes, which I would shoot with Totò and Ninetto, but I'm afraid I won't have the time to do it. I drafted the film-script of *La terra vista dalla luna* in the style of a comic book (drawing on my rusty skills as a former painter). With this as a starting point, I would like to gradually put together a large comic book – very colorful and expressionistic – forming a collection of all of the stories I'd like to tell, whether we shoot them or not.

From a letter to publisher Livio Garzanti, January 1967, in *Lettere 1955-1975*, ed. Nico Naldini, Einaudi, Turin 1988

Comica

(N.B.: these lines should be read with a Charlie Chaplin or Larry Semon comedy or Donald Duck cartoon in mind).

I. A father and his son, Signor Giocondo and his son, Pampurio, say their final farewells and shed their final tears at the cemetery over the grave where their respective wife and mother has been buried (whose passing we learn about from the amusing and grammatically incorrect epigraph).

The two leave the cemetery, and immediately Signor Giocondo discusses with his son the prospect of remarriage. The son is understanding: indeed there is a need. The important thing is to find a woman they both agree on. They promise to work together, in love and harmony, and choose the right woman, and they shake hands vigorously on it.

II. In search of a wife. Lots of great "gags." One girl with dark hair is pretty, but then she stands up and she has the legs of a toad. They meet another woman and she's fine, but they're not fine for her, and she beats them with her umbrella. They like a third one well enough but her breath smells so bad that the two men faint to the ground.

III. Orange blossoms. One day, as the two men are walking down the streets of this earth in search of the ideal woman, they see one who is as beautiful as a Madonna: she's tall, big, powerful, amazing, and almost imposing to look at. She is praying at a shrine with white walls, green columns and a red altar. Giocondo, helped by his son, tries the unthinkable: and the woman, who's as big and beautiful as the statue of a saint, agrees immediately, smiling sweetly like a child. Why? Because she's deaf and dumb, that's why!

So Giocondo, Pampurio and the woman have to communicate in gestures. Miming a wedding, Giocondo asks her if she is married and she replies in gestures, laughing, saying no, no she isn't. So, he continues – still

Left, Ninetto Davoli, Silvana Mangano and Totò

Pasolini and Totò on the set

gesticulating – given that because of her misfortune (and here the gestures become delicate and light), she probably won't find any better, Giocondo asks her for her hand in marriage. And thus the two are engaged.

The engagement culminates with the wedding. Of all the things that happen on that solemn occasion, the most comical is also the most serious: the splendid but austere beauty of the strange girl, who like a queen rises above the jokes that are traditionally part of a comic hero's wedding.

IV. Happy days. This beautiful, mute woman, though a little crazy due to her condition, is an amazing, sweet, and generous housewife. She is a true angel of the home, or rather, the shack. She washes, irons, cleans and cooks; and whenever the three are at home together they can't restrain their happiness and express it by dancing. Spontaneous, improvised dances, the kind you see in musicals or like the ones blacks do, dances that both thank God and praise life.

V. The devil's hoofprint. Buro's family is very poor and lives in a shack amidst the rundown houses of the slums, which are no better than their shack but which look to them like palaces. One fine day, on the door of one these buildings is a sign that says "Home for Sale." The three of them stand in front of the sign, eyes open wide and daydreaming.

How can they come up with the money to buy that little palace?

Signor Giocondo has an idea and so he starts, with gestures, to communicate it to his lady. It's a splendid idea, but being understood is easier said than done! He tries, and keeps trying, his gestures becoming a kind of insane dance, until he manages to express himself, while Bura looks at him in amazement, pained at being so deaf. It appears that Giocondo is suggesting to his wife that she go up on a rooftop… high, high up… start crying and pretend to want to jump off… and get people to feel sorry for her… and get someone to take up a collection on her behalf… maybe someone would even underwrite a loan.

VI. Accomplices. Giocondo and Pampurio look around for accomplices: a dozen or so people from the neighborhood with faces that I won't even begin to describe, and as soon as the two whisper to them what it's all about, their faces light up, seduced by the age-old idea of tricking thy neighbor.

VII. Bura, as beautiful as the Statue of Liberty, stands far above, at the top of the Colosseum. She waves her arms the way a champion diver would before diving.

Below, the accomplices begin to form a crowd, looking up at her in anguish, calling out to her to be careful, making sad comments. They're soon joined by other people, the poor crowd of passersby. Giocondo and Pam-

Pasolini showing the actress the cemetery scene

Totò, Silvana Mangano, Ninetto Davoli

purio, acting out the roles of desperate husband and son, translate for the crowd what the deaf and dumb woman up there is saying in her language: that she is worried about money, and that her worries are going to make her do something drastic.

And then, carefree as can be, along comes an Anglo tourist, with his camera around his neck, his spyglass and his map. Looking at the map he adroitly clambers up the Colosseum and soon is standing far above the poor woman whom he altogether ignores. After taking his photos and looking through his spyglass, he takes a banana out of his pack, and carefree as can be, begins to eat it. He throws the peel down, carelessly, smugly: the peel falls just below, where Bura continues to wave her arms with the desperate gestures of someone about to jump. And then she takes a fatal step on the peel and – whoops! – she really does dive off the Colosseum.

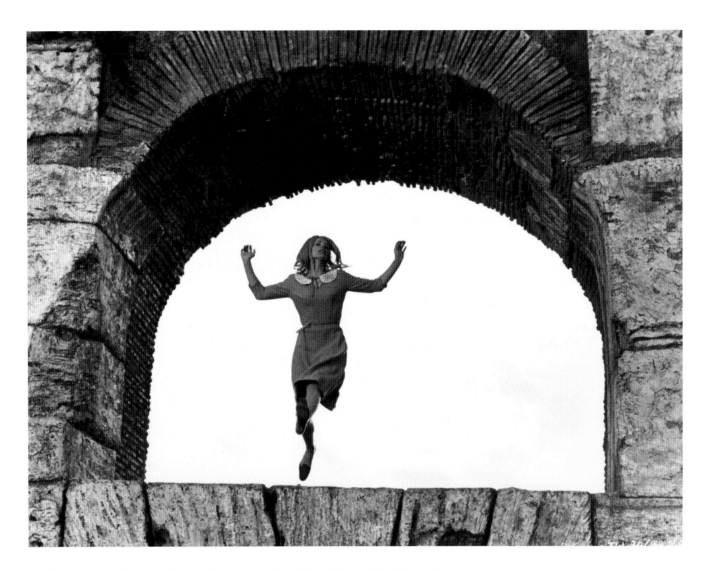

The cluster of accomplices below, seeing her fall and actually doing what was supposed to be a joke, can't hold back and they start laughing, they laugh hard, and fall over in laughter. An epic laughing fit that never ends.

VIII. First-class funeral carriage, black horses stepping lively; horseman in livery; an elaborate coffin. All the money from the donations ended up paying for this. There is only one, teeny tiny wreath of flowers, with a banner that says THE LAST THOUSAND LIRE, AFFECTIONATELY YOURS FOREVER HUSBAND GIOCONDO. Following that carriage worthy of a minister are only Giocondo and Pampurio. The lively horses move swiftly, and the two men, though crying out of real sadness, start to struggle comically to keep up, stopping now and then along the way to drink water from fountains, and then running to catch up to the carriage, mumbling either compliments for the expensive horses or imprecations against them, it's hard

Silvana Mangano

to say which; until they are moving at marathon speed, shaking their behinds like cross-country speed walkers.

Now they stand in front of the grave, with its funny, poetic epigraph that is full of mistakes and tells the story of the deceased. And here they spill tears of heartbreaking sorrow.

IX. They go back to their shack, dead tired from all the sweating they had to do to keep up with the coffin, their morale in pieces.

It's almost dark. They open the creaky door and walk in. And who do they see? It's her, the wife, the mother, in a nightgown, standing there in the middle of the house.

Imagine their fright! They scream and run back out into the street, rubbing their eyes in disbelief, trembling like two reeds…. They think it must be their imagination so they get up the courage and go back, opening the door just a crack. Yes, yes! Mamma mia! It's her, she's there, it's true: she's so beautiful, sweet, familiar…

The two of them get up their courage and, standing outside the door, they try and communicate with her, in gestures. This time, too, it's nearly impossible to communicate with her. It's hard enough to talk to a deaf and dumb person, let alone a deaf and dumb ghost! Gradually she sweetly explains to them that she is a ghost. They don't believe her? No? Let me give you the numbers for lotto: go and play one, two and three. And then you'll see...

X. Giocondo and Pampurio, playing their last hundred lira and betting on the numbers one, two and three, win a tidy sum and go home happy, skipping and dancing.

As they've already broken the ice with the ghost of their bride and mother, she is waiting for them at home; she has washed, ironed, cleaned and prepared a nice dinner.

And so the trio resume their happy life where they left off. They show their contentment by improvising, as in a musical, a delightful dance of joy and gratitude, as previously described in paragraph IV.

Moral: BEING ALIVE OR BEING DEAD MAKES NO DIFFERENCE.

"Comica," first treatment of *La terra vista dalla luna* (1966)

There is no connection with *Uccellacci e uccellini*. This is a completely different film. *Uccellacci e uccellini*, as I liked calling it, is a sort of ideological-comic fable, whereas *La terra vista dalla luna* is a completely different project. That is to say, the film's actual theme is not based on an ideology

or an ideological dilemma, at least not as strictly in *Uccellacci e uccellini*. Of course, there is always an ideology, but here it is infinitely more hidden, mysterious, and unpredictable. There is no continuity; in fact, the idea for this film is very old; it came to me even before I became a filmmaker. It was an idea I had for a story titled *Il buro e la bura* [The Country Bumpkins]. I talk about it in *Alì dagli occhi azzurri* [Blue-Eyed Ali], the book that is a collection of all of my narrative material, scripts, story notes, sketches, half-finished stories, etc. I added a beginning and an end, and I adapted it for a female character (like Silvana Mangano). Totò's character, like Ninetto's, reprises his role in *Uccellacci e uccellini* mainly because he has the same look and a bit of the same personality, but what he says is very different. I used this duo again because I want to present father and son in comedy, and I was very pleased because the idea worked; they complemented each other so well that I rebuilt the story around them, but, I repeat, it's a story that has a completely different message. The reappearance of Totò and Ninetto in this film is therefore the fruit of a specific choice motivated by an equally specific idea as to the relationship between character and actor. I have always maintained that I like to make films with unprofessional actors, with faces, characters, and personalities that exist in reality, whom I take and use in my films. I never choose an actor for his excellence as an actor; that is, I never choose him because he's good at pretending to be anything other than what he is. I select him for what he is. And therefore I chose Totò for what he is. In both *Uccellacci e uccellini* and in *La terra vista dalla luna* I wanted an extremely human character – that is, he should have the sort of good-natured, Neapolitan – and immediately understandable – heart that Totò has. And at the same time I also wanted this human being – so average, such a "good person" – to have something absurd and surreal about him, something clownish, and I think Totò combines all these elements rather felicitously.

From "Razionalità e metafora in Pier Paolo Pasolini," interview by Paolo Castaldini, *Filmcritica*, no. 174, January-February 1967, later in *Per il cinema*, Mondadori, 2001

What I wanted to do originally was make a series of episodes which would make up a full-length feature, all with Totò. When Totò died the idea collapsed. I have vaguely contemplated getting somebody else – I thought of asking Jacques Tati – but now I have rather lost enthusiasm.

Working on the montage of my own films I've realized that even one image has huge importance: sometimes if you just take out one frame, which might seem nothing, it can completely transform a whole scene. All the other episodes in *Le streghe* are rather alike, they are basically anachronistic products of Neorealism. All the other episodes are set in a bourgeois milieu

Right, sketches by Pier Paolo Pasolini for *La terra vista dalla luna* (ballpoint and colored chalk on paper, 1966)

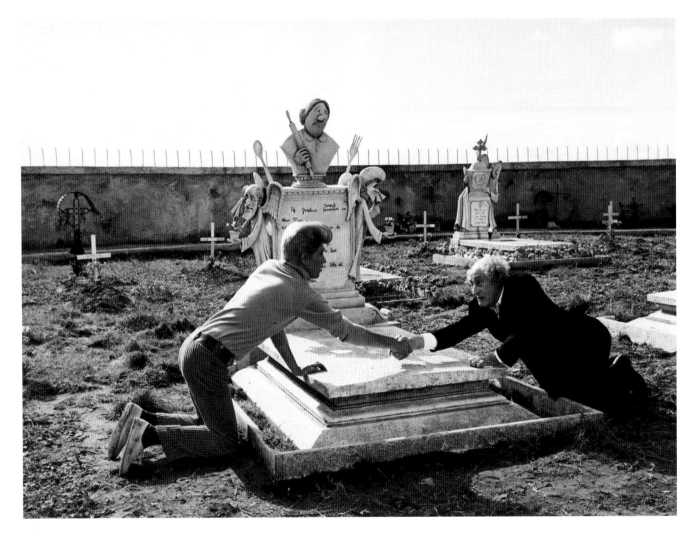

and have a brilliant or comic style, so my episode is unassimilable: when it has appeared, audiences have just been disconcerted. The same goes for the critics – I don't think any of them have yet said anything sensible about it; they have treated it as thought it were simply a kind of bizarre parenthesis in my work, whereas I consider it one of the most successful things I have ever made.

When I'd finished *Uccellacci e uccellini* I realized that ideology played a much greater part in it than I had expected: the ideology was not all absorbed by the story, it hadn't become transformed into poetry, lightness and grace. When I first saw the finished film I felt the ideology was a bit heavy, and so I began to regret that I had not made a much lighter and more fable-like film, even a picaresque film, which might have been less meaningful ideologically but would have been more ambiguous and mysterious, more poetic. I really felt quite sorry about it because Totò and Ninetto were such

Ninetto Davoli and Totò

a lovely couple, and so poetic in and of themselves; I felt they were full of possibilities. So I thought of making a film which would be all fables, and one of these was *La terra vista dalla luna*.

It is rather in the tradition of Kafka's surrealism, or very slightly related to some surrealist painting. It has nothing to do with the surrealism of Buñuel in *Un Chien andalou*; rather, if anything, it relates to the light, mysterious surrealism of *Belle de jour*. So the surrealism in my film has rather little relationship to historical Surrealism, it is basically the surrealism of fables: its origins are almost folk, and it is no accident that the moral of the film "to be dead or alive is the same thing" is taken from Indian philosophy – it is a kind of slogan of Indian philosophy. The sense of mystery that transforms the landscape and characters into an atmosphere that is not realistic (which we call "surrealist") is projected by a basically philosophical message, which admittedly comes to me secondhand.

I found two or three locations which had utterly fabulous colors and I just used them. Everything is real and the only location that does not come off well is the Colosseum. The others are poor people's seaside resorts, down at Fiumicino and Ostia, where people have built these huts and painted them fantastic colours. The interior of the house where Totò lives and that incredible pink villa with the tower he climbs to show Silvana Mangano how to pretend to throw herself off the Colosseum are both real.

Totò is such a human person, so naïve, so ordinary, so recognizable and so clownish, all I did was just to bring out the clown in him; and the same with Ninetto – there is something magical in Ninetto, and so I just emphasized this feature. That's all I did, I just emphasized characteristics which were already there, I didn't invent anything.

The model could only be Chaplin's early comic movies, which were silent. At one point when Silvana Mangano is cleaning out a pile of incredible junk in Toto's house she finds a photograph of Chaplin – that's the key quotation, obviously.

From Oswald Stack, *Pasolini on Pasolini*, Thames and Hudson, London-New York 1969

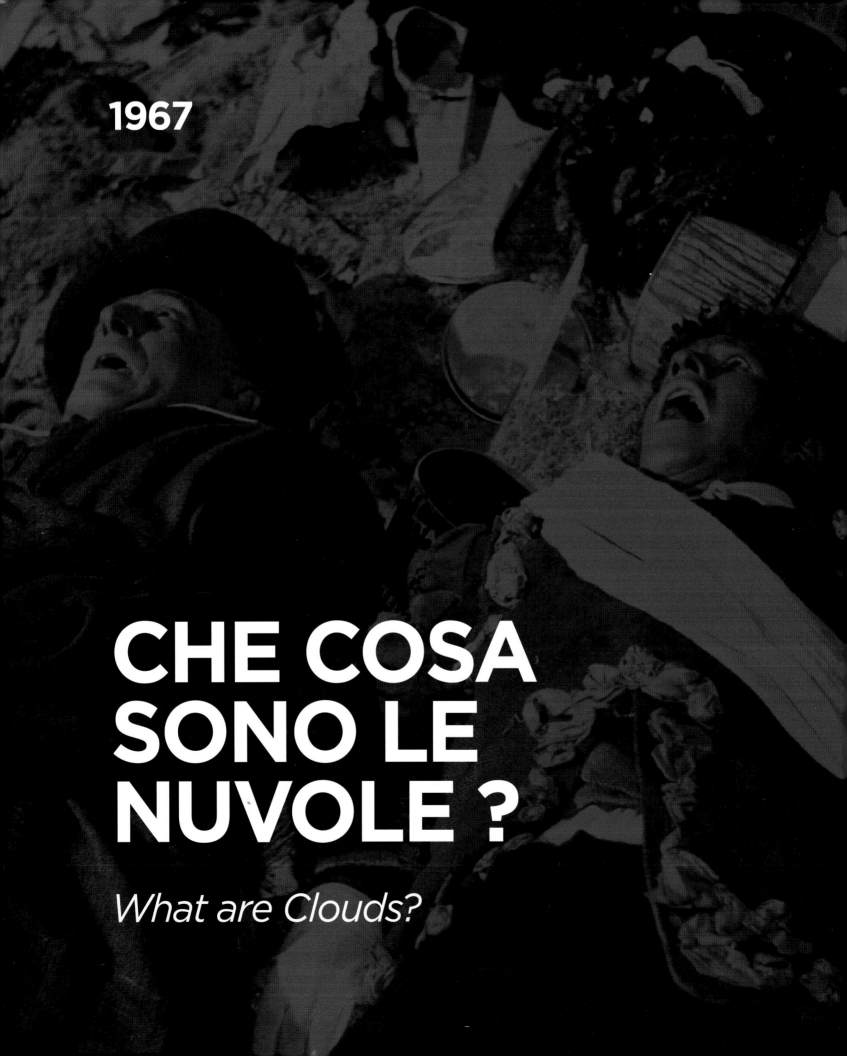

1967

CHE COSA SONO LE NUVOLE ?

What are Clouds?

I had long thought of making a colossal film made up of episodes; some long, some short, but all comical. The title was supposed to be *What is cinema*, or more modestly, *Smandolinate* [Flattery]. De Laurentiis gave me the opportunity to shoot two of these comic episodes: first with *La terra vista dalla luna*, and now with *Che cosa sono le nuvole?* What would be the ideology of these two farces? It's not very comical, to be honest (Italians, in fact, hardly laugh at my comedies). The basic structure is picaresque, which, like all things representing pure vitality, masks something deeper, namely, the ideology of death. In effect, *Che cosa sono le nuvole?* ends with the death of the two protagonists, who are two puppets, or marionettes, Iago and Othello: the enraged public kills them before they can commit their crime. These two marionettes are tossed by a garbage man (the popular crooner Domenico Modugno, who sings all the while) into a horrible dump; but there, in this garbage heap, they discover the world, which is supposed to be their heaven.

From a RAI TV interview (1967), in *Le regole di un'illusione*, Fondo Pasolini, 1996

What are Clouds?

May I be damned
if I don't love you.
Were this not so,
I'd know no more.
All my foolish love
blown through the sky
blown through the sky...
just like that

But ah, the grass so soft and sweet
the scent makes my heart race!
Ah, you should never have been born!
All my foolish love
blown through the sky
blown through the sky...
just like that

The stolen heart that smiles
steals something from the thief
but the stolen heart that weeps
steals something from itself.
And so I say to you

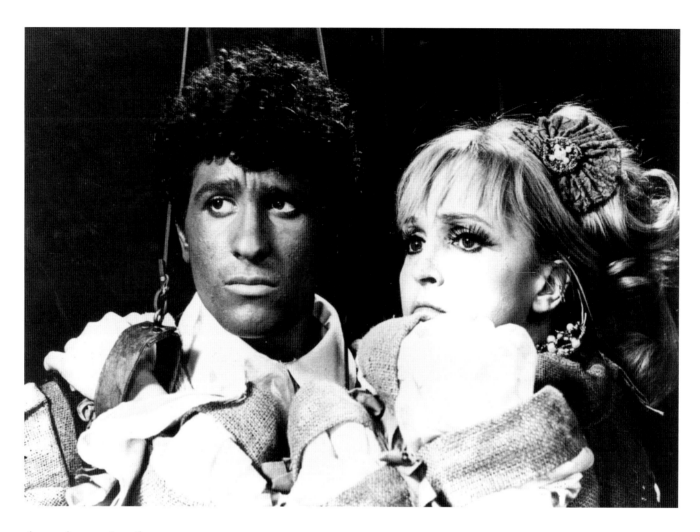

that so long as I smile
I'll never lose you.

But these are only words
and I have never heard
a heart, a weary heart
was healed by words.
And all my foolish love
blown through the sky
blown through the sky...
just like that

(1967)

"Che cosa sono le nuvole?," lyrics by Pier Paolo Pasolini (music by Domenico Modugno),
in *Per il cinema*, Mondadori, 2001

Ninetto Davoli and Laura Betti

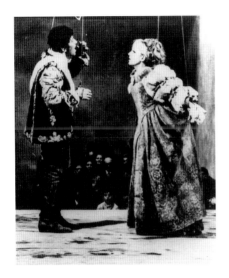

From the script

SCENE XXII [FINAL SCENE]. EMBANKMENT. COUNTRYSIDE. CITY OUTSKIRTS. OUTSIDE. DAY.

The garbage truck looms black against the sky, driving along an embankment.

All around is sky, nothing but sky! And the whole city! The other world, the world in sunlight!

Everything is filthy, neglected, miserable. The high-rises in the distance, a few shacks, some gnarled fig trees, vegetable gardens going to seed.

The truck stops at a point along the embankment where the slope is a bright array of colors – the dump.

The garbage man calmly climbs down from his cab and opens the rear doors of the truck: and all the dead things filling his truck come tumbling out, rolling down the slope like a colorful little avalanche. Including the bodies of Iago and Othello.

A long POV shot of the two bodies rolling down the slope accompanied by their terrified screams, shows the sky, ground, and garbage whirling around them.

Until the camera, finally still, points upwards, fixing a vast blue sky swept by fast-moving white clouds.

The eyes in Othello's battered, swollen face light up with keen curiosity and irrepressible joy. Iago's eyes likewise gaze in amazement and ecstasy at the spectacle of the sky and the world, seen for the first time.

Othello: Heeeey, what are those?

Iago: They're… they're… clouds…

Othello: And what are clouds?

Iago: Who knows?

Othello: They're so beautiful! They're so beautiful!

Iago (in the throes of comic ecstasy): O heartbreaking wondrous beauty of creation!

And the clouds drift by, moving swiftly across the great blue sky.

From "Che cosa sono le nuvole?" (1967), *Cinema & Film*, no. 7-8, Winter-Spring 1969, later in *Per il cinema*, Mondadori, 2001

Ninetto Davoli and Laura Betti

1967

EDIPO RE

Oedipus Rex

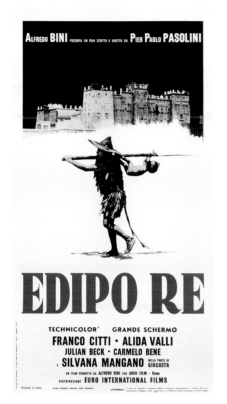

Aestheticism and humor have presided over my choice of the key moments in Oedipus' life, the ones that acquire meaning after the protagonist's death. They follow one another, almost of their own accord, in the same temporal order as in his life, but over a disproportionately shorter time – or rather, through the artist's reflections and the editing procedures available – in a synthesized whole.

For example, I composed the frames in a much more cinematic way than usual (I don't know whether they turned out beautiful or not, but what I was trying to do was make them beautiful, to come up with "beautiful shots"); and I used as well the technique of detachment from the events portrayed (such as Angelo's eyes as he watches the Sphinx), desecrating it in almost comical fashion, but in such a way as to make us incredulous and effectively deny us any feeling of involvement in the elements of the myth). We were born of Cervantes and Ariosto (as well as Manzoni). And what about tragedy? Didn't I want to bring the tragedy of Oedipus to life? A truly crushing tragedy? There is of course tragedy in my version, in spite of everything, since the innermost motivation of both aestheticism and humour is the fear of death. Which is why the bourgeoisie can always illegitimately call themselves Christians even when they forget Christ and think of nothing but tomorrow.

How I managed to keep the state of mind necessary for aestheticism (the contemplative and slightly lazy appreciation of beauty) and for humor (the desire to go on smiling, no matter what, though our eyes be full anguish) in Morocco, when shooting in the way we had to shoot, I really don't know…

The other reason the film was shot with "aestheticism and humor" is that I am no longer terribly interested in the objects of Freud's and Marx's research. I'm no longer quite so seriously immersed in the magma that makes Oedipus into the object of Freudian and Marxist analysis. It's true that at the end of the film Freud would seem to have won out over Marx, while Oedipus goes off to lose himself in the green fields of poppies and the waters where he was suckled as a child. But more than Freud it is *Oedipus at Colonus* that suggests this sort of idea: or at least, in the arbitrary mish-mash of Freudian and Sophoclean suggestion, the latter emerges as the stronger. Let's be clear on this point: I consider *Oedipus at Colonus* the least graceful of Sophocles' tragedies; in fact I think it's decidedly ungraceful. And yet it contains two or three fragments which can only be described as sublime. It is these I was referring to. As for Freud, he's used in the film the way a dilettante might use him. Oedipus knows Tiresias from before, when guided by the *anghelos* (messenger) who will later appear as Angelo (his role, incidentally, is precisely that of intermediary between Tiresias and Oedipus-the-novice). This is the point at which the Marxist and Freudian moments meet, sticky and puerile as I believe them to be. Then again Freud triumphs in the sequence with the Sphinx, the only one I radically changed (apart from re-

placing Antigone with Angelo); in fact the Sphinx does not set a riddle, but asks Oedipus directly to clarify on his own the enigma he contains within himself. Oedipus refuses, and pushes the Sphinx back into the abyss it originally came out of – a little comically, to tell the truth – knowing that by pushing it back into the abyss he would be able to marry his mother. We thus have here an audio-visual case of repression.

I want to stress the fact that now, at forty-five years of age, I have broken free of this Freudian-Marxist tangle. *But free to go where?* I have certainly never dreamt of making love to my mother. Perhaps I should refer the two or three readers who have stayed with me this far to a couple of lines from *L'usignolo della Chiesa Cattolica* (The Nightingale of the Catholic Church):

> *the dream in which my mother*
> *slips into my trousers.*

If anything, I have dreamt instead of making love to my father (against the chest of drawers in the wretched little bedroom my brother and I shared) and perhaps to my brother as well. And I have dreamt many times of making love to women of stone. Of course I'm not counting the dreams that have recurred several times throughout my life, where I climb endless, dreary flights of stairs in dreary homes, searching for my mother who has disappeared.

But after all it's been a while since I've had such dreams. Silvana Mangano might have the same scent of primroses about her that my mother had in her youth, but Franco Citti certainly has nothing in common with me – save his rather high cheekbones.

It is because he is so different from me – even with his monstrous inferiority and guilt complexes – that I chose him as protagonist. What happens to him is not an intimate drama but a tragedy. The events are thus entirely externalized – on the stage of a mysterious but real world. He lives out this tragedy *en plein air* without awareness, as an innocent but aggressive victim.

From "Perché quella di Edipo è una storia," in *Edipo re. Un film di Pier Paolo Pasolini*, Garzanti, Milan 1967, later in *Il Vangelo secondo Matteo. Edipo Re. Medea*, Garzanti, Milan 1991

This is a film structured on four levels. The first involves childhood memories, at once concise and profound. Then there's the second, phantasmagorical part, which I call hallucinatory, and I feel it's the best part. It is pure invention, because I started off with nothing already known to me. I was guided by the pure pleasure of imagination. My only reference was what anyone could find in an encyclopedia. You open it and read: "Oedipus, King of Thebes," and so on, getting very little information. As in *Il Vangelo*

The Sphinx
Julian Beck
Silvana Mangano

secondo Matteo, I didn't want to re-create anything from an archeological or philological point of view, and so I read no Greek or historical or philological texts on these so-called Greek "Middle Ages" in which I wanted to situate my story. I invented everything. For me, this is the most "inspired" part of the film. The third part is nothing more (or less) than Sophocles' *Oedipus*. Here – and I don't know if I succeeded in doing so – I wanted to do what Godard in *La Chinoise* called "the third movement" of the film. Then comes the last part – without a doubt the most arbitrary, and a bit didactic, which I feel came out pretty well in terms of plasticity: it is the moment of sublimation. What is sublimation? It is an ideological choice, an uncertain ideological choice, to be sure. First, Oedipus is a decadent poet, then a Marxist poet, then nothing at all, only a man who is about to die (here I took elements from *Oedipus at Colonus*)…

While Oedipus was for me a simple man destined to act but not understand, whose evolution toward his hidden truth makes up the entire drama,

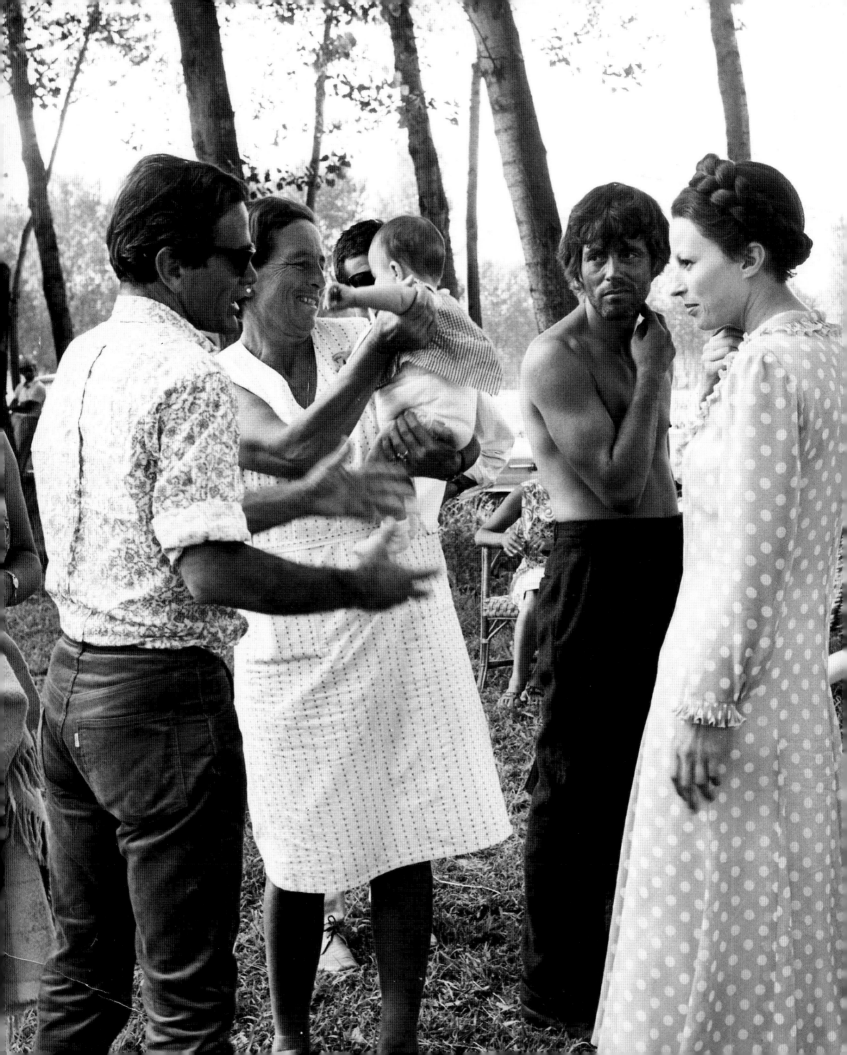

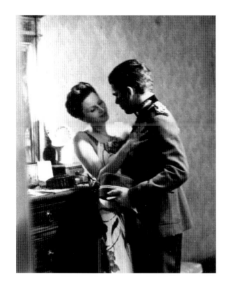

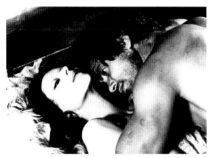

Left, Pasolini, Franco Citti and Silvana Mangano on the set

Silvana Mangano and Luciano Bartoli

Silvana Mangano and Franco Citti

Silvana Mangano and Pasolini

Jocasta's character is completely different: it is pure mystery. I must say, however, that Jocasta is, all in all, the more successful character of the two. In her, I gave a mythological representation of my mother, a mother who does not change: like a Medusa, she perhaps transforms herself, but never evolves. This is where she gets her ghostlike semblance…

I would have liked to insert a pause between the death of his father and his encounter with the Sphinx. The film called for a pause at this point: it's too dense, too stuffed with things happening. We needed a happy, almost comic interlude. I wanted to shoot Ninetto dancing with a multicolored, red, green and blue bird. Oedipus would look at this dance, and this moment of pure aesthetic beauty would have been useful. A breath of air, a matter of pacing. Before shooting, I saw all sorts of children with this bird. When it was time to shoot, we couldn't capture a single one. I'm not satisfied with the part shot in the studio, either. What I don't like is not so much the love between son and mother (which I really do like, because a bed, on set or not, is still a bed – concrete and real, and the scene is shot in long takes), but the whole part involving the public. I needed to be freer. Keeping Godard always in mind, I wanted that third movement of the film to be extremely faithful to the Sophocles text, and shot very simply. Because of the studio, I had to continue to be arbitrary and "inventive," as in the beginning. Fortunately, almost miraculously, I was able to shoot a scene in Morocco that was supposed to be shot in the studio: the encounter with the old servant who was to kill baby Oedipus. The Moroccan landscape saved the scene.

From "Pier Paolo Pasolini (*Edipo Re*)," interview by Jean-André Fieschi, *Cahiers du cinéma*, no. 195, November 1967, later in *Per il cinema*, Mondadori, 2001

The film is partly an autobiographical projection. I shot the prologue in Lombardy, to evoke my childhood in Friuli, where my father was an officer, and the epilogue, or the return of Oedipus the poet, in Bologna, where I started writing poetry. Bologna is the city where I fitted most naturally into bourgeois society. At that time, I thought I was a poet of that world, as if that world were absolute, unique, and class differences had never existed. I believed in the absoluteness of the bourgeois world. As with my later disenchantment, Oedipus leaves the world of the bourgeoisie behind and enters the world of the common people, the workers' world. He no longer sings for the bourgeoisie but for the exploited class. Thus the long march toward the factories, where perhaps another disillusionment awaits him…

From *Entretiens avec Pier Paolo Pasolini* (1969), ed. Jean Duflot, Belfond, Paris 1970, later Gutenberg, Paris 2007

1968

APPUNTI PER UN FILM SULL'INDIA

Notes for a Film on India

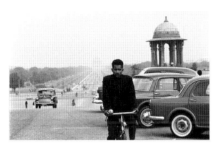

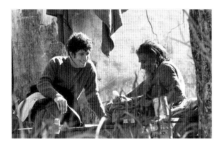

My next film will be titled *Appunti per un poema sul terzo mondo* (Notes for a Poem on the Third World), and will consist of four or five episodes, with one in Africa that I would like to call *Il padre selvaggio* (The Savage Father), but I'm not sure. Instead of *Il padre selvaggio*, I may do another film I have in mind, along the same lines, an *Oresteia* set in Africa. I would re create analogies, however arbitrary and poetic or even irrational in part, between the ancient Greek world – where Athena appears and, through Orestes, donates the first democratic institutions – and modern-day Africa. Orestes would thus be a young black man, possibly Cassius Clay (I thought of him as the lead), who would relive the tragedy of Orestes. Whether I choose *Il padre selvaggio* or the *Oresteia*, it in any case would not be made as an actual film, but as a "film to be made."

I experienced this kind of filmmaking in India a few years ago. I also went to India with a film idea – the story of a maharajah who, according to an Indian myth, offers his own body to feed tigers (this, ideally, before the liberation of India); and, after India's liberation, the maharajah's family disappears as its members die one by one of hunger during a famine. I went to India to see myself whether this was a good idea. I wanted to hear from Indians themselves, including an actual maharajah and a few of his gurus, as well as local writers and the general public, whether such a film could be made. The film that came out, however, has the same plot, but the story still seems to be a "film yet to be made." I would like to expand the experience that I gained accidentally in India, and shoot similar episodes other typical third-world settings, one of which would be *Il padre selvaggio* – that is, if don't do the *Oresteia* instead.

From "Incontro con Pier Paolo Pasolini" (April 1968), interview by Lino Peroni, *Inquadrature*, no. 15-16, Autumn 1968, later in *Per il cinema*, Mondadori, 2001

Left, photo taken during the shooting

Pasolini on the set

Photo taken during the shooting

Ninetto Davoli

Pasolini in India

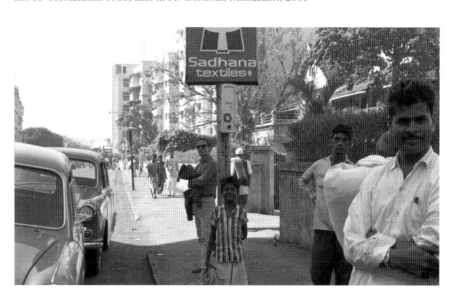

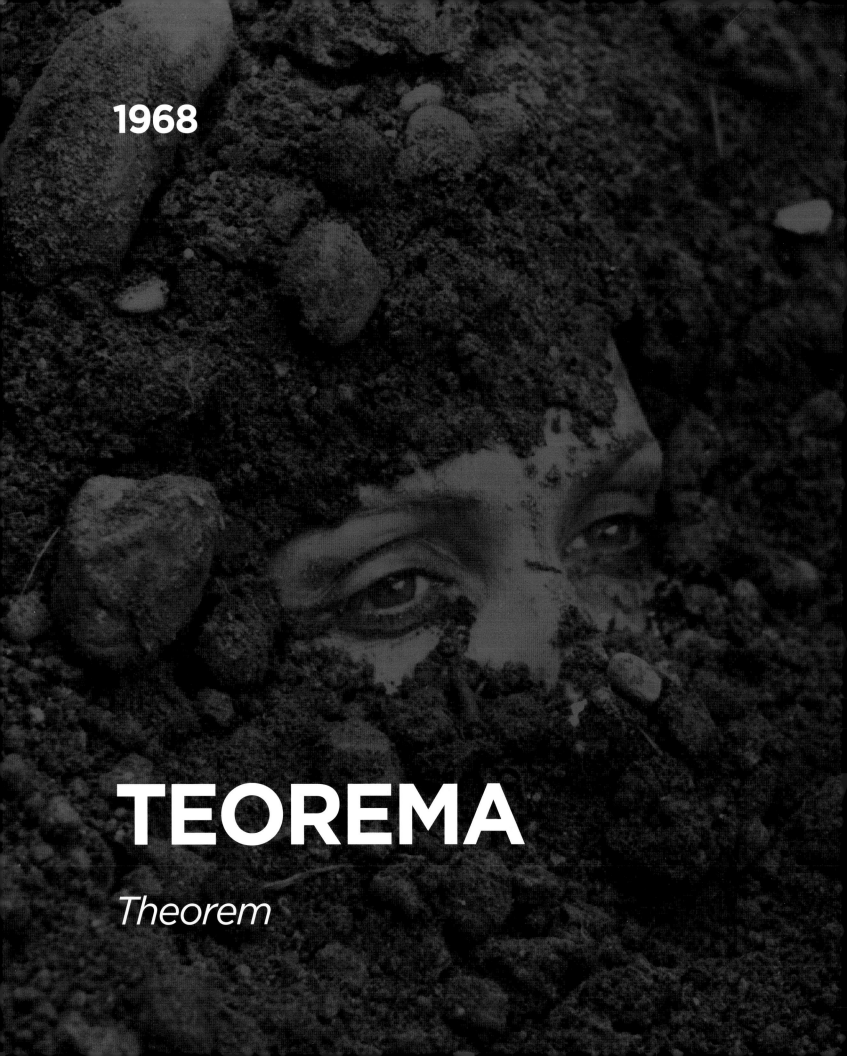

1968

TEOREMA

Theorem

Left, Laura Betti

Artwork by Bob De Seta

Pasolini, Terence Stamp and Laura Betti
on the set

Poet of Ashes

As for my future works...
you shall see a young man come one day
to a beautiful house
where a father, a mother, a son and a daughter
live the life of the rich in an unselfcritical state,
as though it were everything, life pure and simple;
there's even a maid (from subproletarian lands);
the young man arrives,
beautiful as an American,
and first the maid immediately falls in love with him
and hikes up her skirts. He gives her his sweet
member swollen with rage. Then the son
falls in love with him; the two of them sleep together
in the boy's room, along with the relics of childhood; and to the son,
too, he gives his silken, more adult and potent member;
obliging and generous, for he is the one who gives,
he shall give the same gift to the mother,
who worships his clothing, his trousers, his shirt,
his underpants, which he'd left behind in a chalet
on a hot summer day, on the Tyrrhenian sea;
and again he shall give the same gift to the father, becoming
father to the father – since with ambiguous maternal sweetness he is,
by name, father –
the father awakened at dawn
doubled over in pain
in his belly discovers, as he gets up to go to the bathroom,
the silent beauty of four o'clock in the morning
and an already radiant sun... He shall discover his own love
with the same sense of wonder
with which he discovered that sun;
a love like that of Ivan Ilych for his servant,
a peasant boy, except that it is conscious and dramatic,
because he, the old industrialist with the face
of Orson Welles, is a petit-bourgeois and dramatizes everything.

During the hours of the father's illness, he gives
the same gift of his member – before the father –
to the fourteen-year-old daughter, who is in love
with her father and discovers him, the young man who is all love,
through her father's loving eyes. Then
the youth goes away:

the road at the end of which he disappears
remains forever deserted.
And each, in waiting, in remembering,
like the apostle of a Christ not crucified but lost,
finds his or her destiny.
It is a theorem,
and each destiny is a consequence.
The destinies are what you would expect,
those of a world where you, with your obnoxious
Anti-communist smile, and I with my childish anti-bourgeois
hatred, are brothers:
we know all about that sort of thing!
The way an anxious neurosis sets in,
the way a little female victim, fourteen years old,
ends up in a hospital bed,
fists clenched so tight that not even a chisel
could pry them open,
the way a boy talks to himself like a madman
while painting and invents new techniques
until he becomes
a Giacometti or a Bacon,
his spectacular, ghostly figurations
symbols of the tragedy of the world in a sick soul
stinking from the wretched rot of evil; the way
a middle-aged woman, still beautiful and well-preserved,
cannot forget the Christ of the Church
and at the same time, once lost,
cannot resist the desire to lose herself again,
and thus lives between fast boys and Christian anxieties;
and the way, finally, a father
who had confused life with possession,
once possessed,
loses life, throws it away: that is, he donates his prized possession
– a factory on the outskirts of the big city –
to his workers; and he gets lost in the desert,
like the Jews.
Cases of conscience, all of them.
The maid, however, becomes a holy madwoman;
she goes to the courtyard of her former subproletarian home,
remains silent, prays, and performs miracles,
curing the sick,
eating only nettles till her hair turns green,
then finally, when dying,

has herself buried by an excavator as she weeps,
and her tears, gushing up from the mud,
become a miraculous spring.
Before the Father and the Mother
there was, in the earthly paradise, a First Father,
and we lived deep in his midst.
Then, the important thing became the love of the mother
with whom we identified
because we cannot live
without identifying with someone. We cannot, therefore,
conceive of love without maternal sweetness.
That First Father has thus a Mother's sweetness.
But in a bourgeois family
he is no longer able to unleash moral dramas.
Religion – the religion of the direct rapport with God –
still exists in the world preceding the bourgeois world.
The workers watch and wait.

From *Poeta delle Ceneri* (1966-1967), Archinto, Milan 2010

Left, Silvana Mangano; Terence Stamp
and Silvana Mangano; Andrés José Cruz
Soublette; Terence Stamp and Massimo
Girotti

Silvana Mangano

Teorema was conceived as though I was painting with my right hand on a gold ground, while frescoing a large wall with my left. And I couldn't honestly tell you which version prevailed: the book or the film. *Teorema* was conceived about three years ago as a verse drama; it was then transformed into a film, and, at the same time, into the story on which the film was based and which was, in its turn, corrected by the film version.

From "Come leggere nel modo giusto questo libro," *Teorema*, Garzanti, Milan 1968

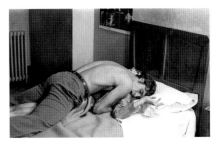

Teorema examines a religious experience. It's about the arrival of a divine visitor to a bourgeois family. This visit demolishes everything that the bourgeoisie knows about itself, which the guest has comes to destroy. Authenticity, to use an old term, destroys inauthenticity. After the guest leaves, each member of the family is left with an awareness of his or her own inauthenticity and inability to be authentic because of class and historical limitations. Thus each family member has a crisis, and the film ends with the following general moral: whatever the bourgeoisie does is wrong. Besides their traditional mistakes, such as the idea of Nation, the idea of God, the idea of denominational church, and so on, even when the bourgeoisie is sincere, intimate, and noble, it is nevertheless always wrong. While at first this condemnation of the bourgeoisie was specific and blatant (and, until 1967, autobiographical), here it remains "suspended," because the bourgeoisie is actually changing. There is no longer any reason for indignation and rage against the bourgeoisie in the conventional sense, since in revolutionizing itself, it is identifying all of mankind with the petite-bourgeoisie.

Nowadays, the whole of humanity is becoming petit-bourgeois. This raises new questions to which the bourgeois himself, and no longer the working man or the opposition, must respond. These questions cannot be answered either by those of us bourgeois in the opposition, or by the "natural" bourgeois. This is why the film remains "suspended" and ends with a yell, which in its pure irrationality signifies this suspension…

From "Incontro con Pier Paolo Pasolini" (April 1968), interview by Lino Peroni, *Inquadrature*, n. 15-16, Autumn 1968, later in *Per il cinema*, Mondadori, 2001

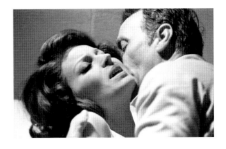

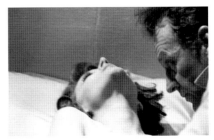

As the title indicates, *Teorema* is based on a theory that is mathematically demonstrated *per absurdum*. Here is the question: if a bourgeois family were visited by a young god, be it Dionysus or Jehovah, what would happen? So my starting point is a hypothesis. Industrial society has taken shape in complete contradiction with the previous agrarian society (represented in the film by the maid), which had a sense of the sacred. This sense of the

Carlo De Mejo and Silvana Mangano
Mangano with Massimo Girotti
Right, Emilia (Laura Betti) levitating

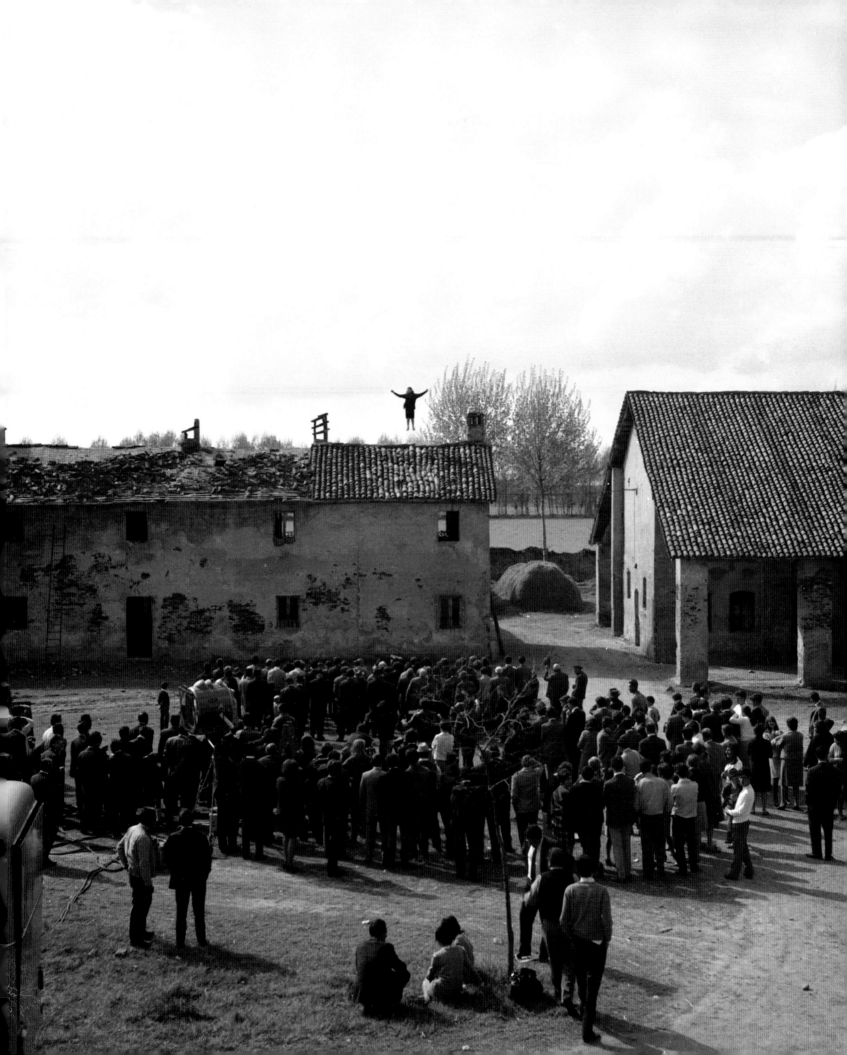

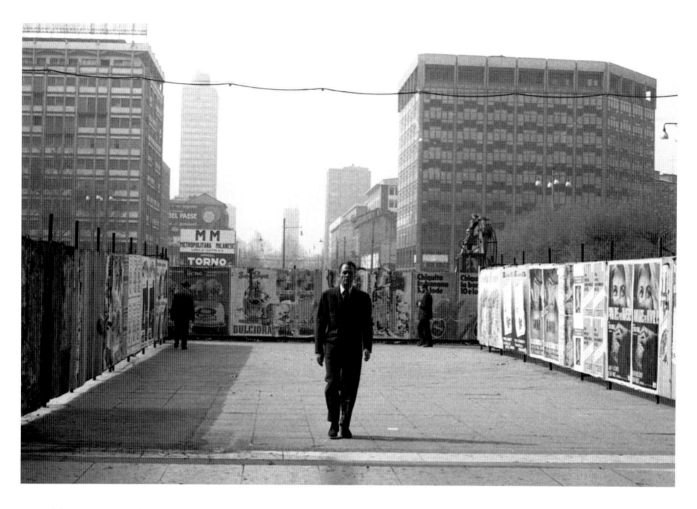

sacred later came to be associated with religious institutions. Sometimes it even degenerated into violence, especially when it was alienated from power. All in all, however, the sense of the sacred was rooted in the heart of human life. Bourgeois society has lost this sense and replaced it with an ideology of wealth and power.

From "Entretiens avec Pier Paolo Pasolini" (1969), ed. Jean Duflot, Belfond, Paris 1970, later Gutenberg, Paris 2007

Massimo Girotti

Right, Laura Betti and Pasolini on the set

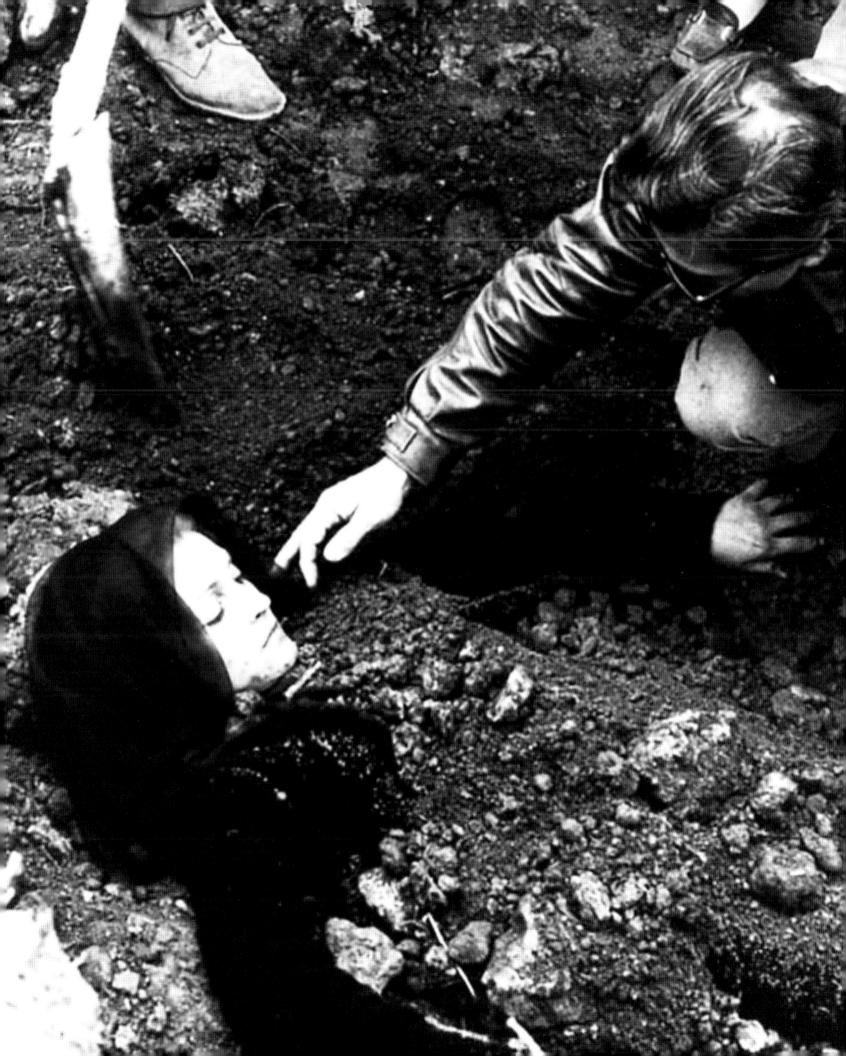

1968

LA SEQUENZA DEL FIORE DI CARTA

The Paper Flower Sequence

My episode in *Vangelo '70* is called *Il fico innocente* (The Innocent Fig Tree), I think. It's very short, only twelve minutes. Initially it was just one long tracking shot all the way up the Via Nazionale in Rome. It's still twelve minutes long, but I've spliced in two or three different frames. *Vangelo '70* is supposed to be inspired by parables or bits in the Gospels, so for my episode I chose the innocent fig tree – you remember when Christ wants to pick some figs but because it's March the tree hasn't produced any figs yet, so he curses it. This an episode which has always been very mysterious to me and there are several contradictory interpretations of it. The way I've interpreted it goes like this: that there are moments in history when one cannot be innocent, one must be aware; not to be aware is to be guilty. So I got Ninetto to walk up Via Nazionale and while he's walking along without a thought in his head and completely innocent, a number of images of some of the important and dangerous things happening in the world pass superimposed across the Via Nazionale – things he is not aware of, like the Vietnam War, relations between the West and the East and so on. They're just shadows that pass above him which he knows nothing about. Then at a certain moment you hear the voice of God in the middle of the traffic urging him to know, to be aware, but like the fig tree he does not understand because he is immature and innocent, and so in the end God condemns him and makes him die.

From Oswald Stack, *Pasolini on Pasolini,* Thames and Hudson, London-New York 1969

The film would later be called *Amore e rabbia* and Pasolini's contribution *La sequenza del fiore di carta*.

Left, Ninetto Davoli

Ninetto Davoli

1969

PORCILE

Pigsty

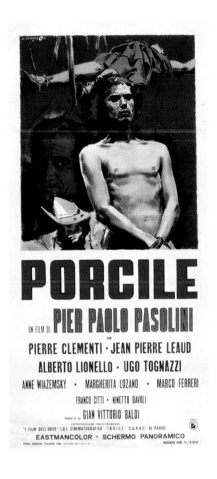

To Jacques Tati – Paris
(Turin, November 1968)

Dear Jacques Tati,

But I don't want to tear you away from Hulot! What I want in my film is none other than Hulot himself! I know you *only through Hulot*. Through Hulot's face, Hulot's long legs, Hulot's high bottom. It's this same Hulot who, in my mind, should appear in my film. Naturally I would ask you for a variant of him: my Hulot, instead of being a petit-bourgeois, should be a *grand bourgeois*, an industrialist from Bonn and, perhaps, adding a little moustache, he should bear a slight resemblance to Hitler. Hulot as a "gentle" Hitler. You would take long walks down endless corridors in a neoclassical villa, going back and forth through sublimely elegant doorways. What I mean by this is that your approach to Hulot would remain intact: his ceremonious way of walking, shy and insecure, displaying hypersensitivity, good breeding, and a well-read background, his way of allowing others to go first when going through a doorway, and so on. This would all remain intact – a bit more like the Hulot of neocapitalism in *Playtime* than the one of paleocapitalism in *Les Vacances de M. Hulot*. The only serious addition would be the "dialogue." But I would film the scenes with something of the technique of *Playtime*: full, complete figures, so that your physical presence and characteristic gestures could absorb speech. At any rate, your character would have only one long "speech," very long, actually, which I include attached hereto, because it is the character's self-portrait. A character whom, after conceiving him separately for the theatre (the text of *Porcile* is a tragedy in verse), I decided to adapt to Hulot for the screen. I ask you please, therefore, with all my heart, to accept my request. Many of my hopes rest upon it. You are a film director, and so you know what this means. You know how much of the director's own person is invested in a choice, and how much of himself is hopelessly lost if this choice fails or cannot be realized.

Please forgive me and accept my fondest regards.

Yours,
Pier Paolo Pasolini

From *Lettere 1955-1975*, ed. Nico Naldini, Einaudi, Turin 1988

Left, Ugo Tognazzi in an early take of the *finale*, later cut out

Artwork by Angelo Cesselon

Pasolini on Mount Etna

First of all, the form, which is much stranger than the others because it consists of two alternating stories. The way it's edited you see the sequences of one, then the sequences of the other, then a scene from one, then a scene from the other. I still don't know how many to use, or whether there will be long passages alternating with short ones. I don't know because it depends

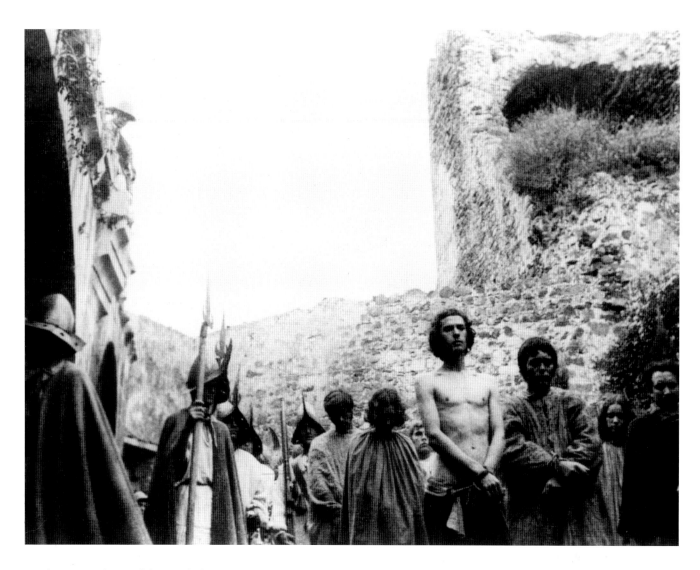

on decisions that will be made later on. Nevertheless there are two alternating stories that are different, far apart from each other, that have one point in common, at which they coincide, and where they are superimposed and unified. But for now the similarities are quite vague.

These are the stories. One is about a young man (Pierre Clementi) who wanders in the desert without knowing who he is or where he is, who is starving to death, so he eats insects and reptiles and is terrified of the soldiers whom he sees passing by on the horizon. One day one of the passing soldiers lingers behind. The youth attacks him. He was armed because in the meantime he had found the remains of some soldiers in a battlefield, had taken their weapons, and so, having assaulted this soldier, he killed him. He doesn't intend to eat him, or maybe he does, I don't know. The fact is that, slowly but surely, he detaches the head from the torso and throws it into a volcano, inside the mouth of the volcano, and then goes back and

Pierre Clementi and Franco Citti

starts to devour him. He carries the naked corpse toward the desert and
stops eating. At that point cannibalism becomes not just a vital need but a
kind of madness, of ideology for art, ecstasy, drugs. He is joined by others,
including Franco Citti, who lives this same experience innocently, while the
youth lives it consciously. This tribe of cannibals, addicted to human flesh,
is captured, judged by respectable people (who are presented in a hateful
form although they are beautiful), and condemned to be devoured by other
animals, by dogs and jackals, tied to stakes, and abandoned there. Ninetto
Davoli, who witnesses the torture, is among the respectable people. So ends
the first story.

The second story instead is set in Bonn, Germany, where there is a mys-
terious, ambiguous boy (a little like the protagonist of the first episode)
who is played by Jean-Pierre Léaud. A girl is in love with him but he doesn't
love her, though for no specific reason… There's something mysterious in
their relationship that will never emerge. He is the son of a big German in-
dustrialist, a kind of Krupp, who lives in Godesberg, a village, a residential
area where Adenauer used to live, near Cologne. The industrialist has a rival
who is even more lively and energetic than he is. He is the son of one of the
Krupps, here called Klotz the Great, to whom the industry belongs, so he
is from old money. His competitor instead is a neocapitalist. By engaging a
private investigator, he tries to find some way to blackmail the neocapital-
ist, and discovers that his rival is a war criminal who has in his possession
some mummified bodies of Jews. This is something that really happened
with a man named Hirt, who used to have luncheons with the skeletons
of Jewish Bolshevik Commissars at the Anatomy Institute of Strasbourg,
which is where I got the idea for other atrocious things that happen in the
film. Once he learns that his competitor was a Nazi war criminal, he feels
triumphant and considers how to destroy him. At that moment, as happens
in comedies – and the whole film is resolved in a Brechtian, grotesque key –
his competitor comes to his house to visit him, and slowly it comes out that
he, too, had done the same thing – namely, hired a private eye to blackmail
his neocapitalist competitor, having learned that the man's son makes love
to a pig. Instead of blackmailing each other, the two men join forces, so we
end up with a Klotz & Kulen corporation. During the merger party, the
son goes to the pig as usual and runs into the ghost of Spinoza, with whom
he has an exchange of opinion. Spinoza is the first rationalist philosopher
and therefore is guilty, in a certain sense, of the bourgeois rationalism that
he repudiates at that moment, saying that reason always serves a god, and
once you have discovered God you have to stop there, go no further, not
carry the rational as far as the myth of reason, which was a bourgeois myth.
While he is speaking with Spinoza we return to the merger party. Some
peasants arrive, including Ninetto, who tells the story of how the son, this
boy, was devoured by pigs. At that point the former Nazi inquires whether

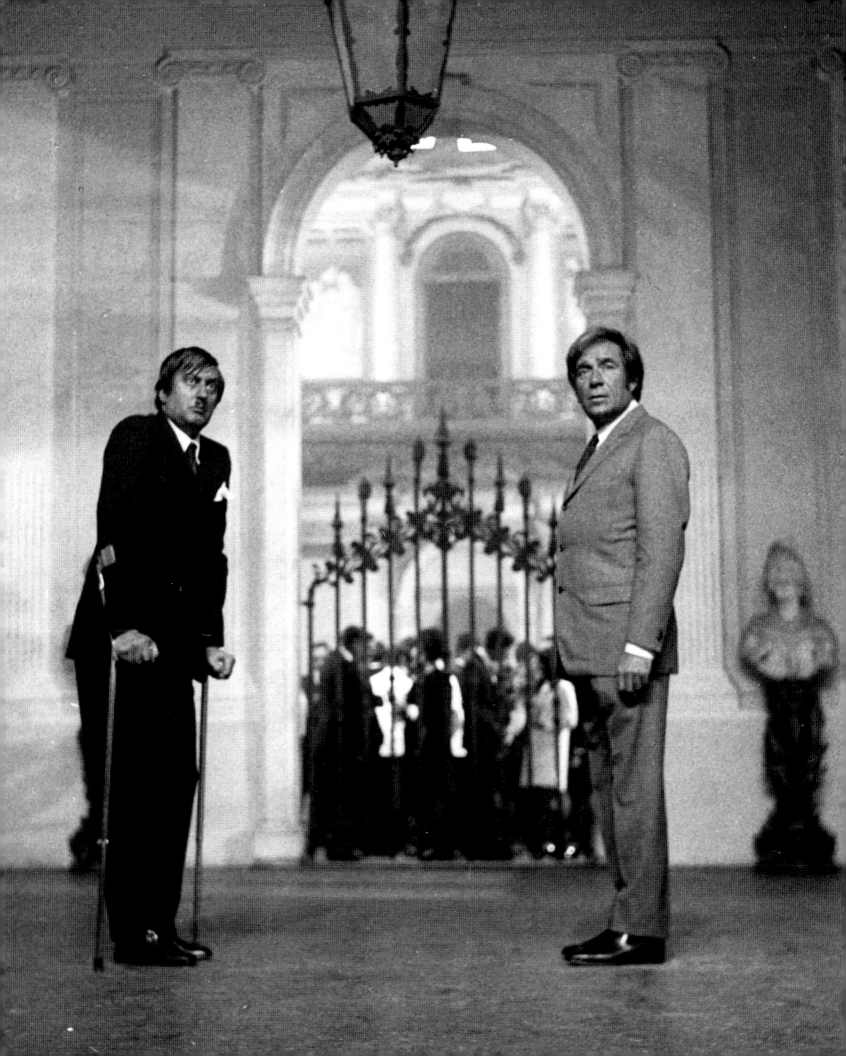

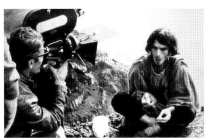

he was devoured completely – whether nothing, absolutely nothing, was left of him. Ninetto reassures him this was so. The whole thing concludes with the words, "Shhh… don't say anything to anybody".

From "Entretien avec Pier Paolo Pasolini," interview by Gian Piero Brunetta, *Cahiers du cinéma*, no. 212, May 1969, later in *Per il cinema*, Mondadori, 2001

I know how much of myself I put into making *Porcile*, a film done with poor means, filmed in one month, on a ridiculous budget. It was marvelous, of course. Because expressing oneself, even through the most anguishing difficulties, is always marvelous. And then there are the human adventures of the work whose value can never be taken from you, like love affairs that last a day, immediately distant and yet indelible; the relationship with the actors – the desperate Pierre Clementi, the anguished Jean-Pierre Léaud, on whom working had the same effect as a mother's caress has for a lost child; the bewildered Lionello who with heartbreaking effort managed to overcome the impossibilities of his role, to be joyfully victorious; the adorable Anne Wiazemsky, always perfect and invulnerable, like a precious pedigree animal (or like Marco Ferreri); Ninetto – Ninetto Davoli – who for the first time in his slightly comical experience as "actor, like it or not," was aware of what he was doing and acted the last scene with tears in his eyes, and finally Tognazzi, one of the best and most intelligent men I have ever met. And then the adventures with nature. I don't think anyone has ever suffered the cold as we did, first on Mt. Etna, with the wind, the fog, the snow, and the rain, and then in January in a Venetian neoclassical villa near Padua which must be freezing cold even in the summer… There the strength of things was an inner strength: we were the dominators of a difficult and unpredictable reality which was wretchedly intransigent but only on a pragmatic level! How sweet it was to possess it, to be merged with it!

From "Umiliare," *Tempo illustrato*, no. 37, September 13, 1969, later in *I dialoghi*, ed. Giovanni Falaschi, Editori Riuniti, Rome 1992

Left, Alberto Lionello and Ugo Tognazzi
Pierre Clementi and Pasolini on the set

1969

MEDEA

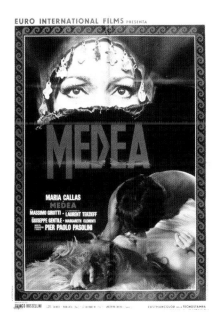

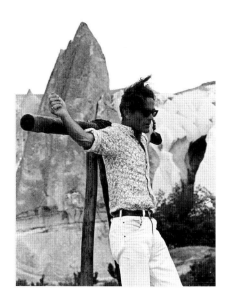

Left, Maria Callas

Artwork by Enrico De Seta

Pasolini on the set

A Procession Approaches: it's Maria Callas

On the floor of one of these little valleys – on the gravel bank beside the river – with wheat all round – and rows of poplars and prickly olive trees, silvery against the pink of hundreds of peaks – an absurd little crowd, impressing itself violently upon my retina, comes walking towards me.

The light – indeed – is that of dreams: the last rays of the sun just skimming the horizon. In another two or three minutes' time the sun will have disappeared and there will remain that grey, divine dusk suffused with pink. But at this moment the flaxen fairness of the light passes over the grass, the pebbles, the wheat… and becomes reflected, blindingly, against the backdrop of this desert. And thus, whatever happens in this light is already, in itself, barely credible.

The advancing crowd is made up of Italians and Turks: there are some who work and some who are merely curious and stay furtively on the edges, ever ready to escape. The crowd's apparel is multicoloured and discordant. In this international crowd there is extreme freedom of dress. Altogether there are probably not even a hundred people, with only about thirty moving along the river bank, while the others are dispersed over the valley – on the high slopes, on the little terraces, amid the thick of the vegetation.

Against the sky of the setting sun and the white streamers of the clouds, without even a touch of red, on a distant edge of the river bank, silhouetted as black little figures, are the technicians around their camera: it is not our troupe, but some television company – and they are busying themselves as befits a great occasion.

Down here, on the river bank, a leading group of Turkish workmen, etched on my retina, are pushing a black and grey cart shaped like a "V". They are surrounded by others whose tasks are connected with the cart and everyone is animated by a great deal of good will. Behind them, there, a scattered and composed group in the scintillating and yet near disorder of a Flemish painting. At the center of it all there is a female figure. Down to her bosom she is covered by a white veil that only barely permits one to glimpse her face and her long loosely-flowing hair. Emerging from beneath this veil, dangles a bunch of golden necklace chains, large and heavy, and they sound darkly like the bells of grazing cows: the chains hang down over a sky-blue "scapular," with rich silvery borders, which seems very ancient indeed, of the kind preserved in the showcases of museums and so old that one expects them to crumble into dust as soon as one touches them. Under the scapular fall the drapes of a long and flowing black robe. *Thus she moves ahead like an unrevealed queen.* Behind her there is another little group of followers. Among them, her faithful maid dressed in green and red who keeps two magic little dogs on a leash – innocent as two in-

sects, two butterflies on their first flight, fluttering here and there, and at the same time they are decrepit, of a wisdom befitting peasant kings. And yet further behind, carrying the instruments of their crafts, all the others, who don't know as much as the light of the dying sun…

"Avanza un corteo: è la Callas," *Tempo*, no. 26-28, June 1969, later in *I dialoghi*

How did you originally get the idea to adapt Euripides' tragedy for the screen?
It was first suggested by the producer Franco Rossellini. […] But then a lot of time went by between the moment I accepted the producer's idea and when I started working on the film. What I mean is that I abandoned the Greek myth and started reading essays on the history of religions, ethnology, anthropology, with the result that little by little, my imagination began to move in that direction, basically leaving Euripides behind, though I did keep a few of his ideas.
Why did you choose Maria Callas to play Medea?
I can easily explain that. Two or three years ago, I got the idea to adapt Euripides' *The Trojan Women*. I'd started to work out a sketch of the subject and

The Argonauts

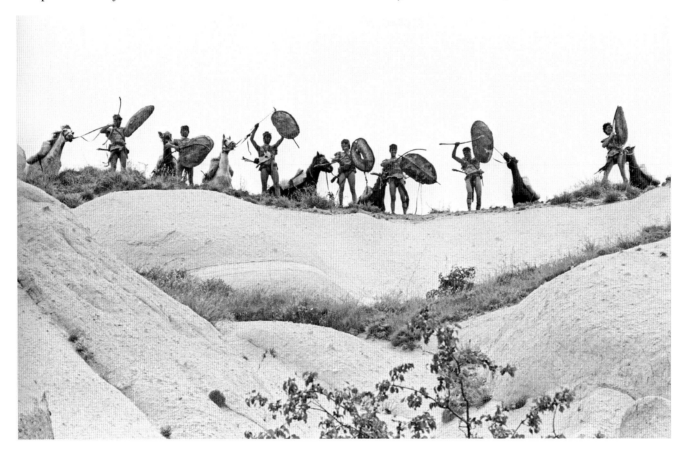

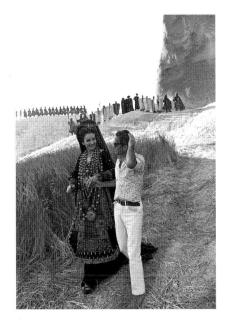
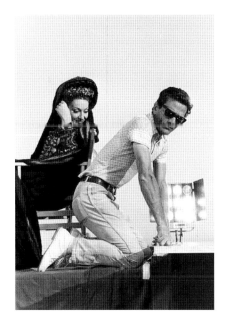

Maria Callas and Pasolini on the set

Maria Callas and Pasolini on the set
of *The Decameron*

think about the situations, costumes, and so on. Afterwards, however, since I tend to get so many ideas all at once, I never carried out this project and moved on to other things. Later I thought of Callas for the role of Jocasta in *Edipo Re*, but it wasn't possible. When the producer Rossellini suggested we do *Medea* with Maria Callas, I immediately accepted. These were two old wishes of mine that suddenly coincided.

When we compare Edipo Re *and* Medea, *what stands out is the different approach. Your treatment of myth seems not to follow a psychological/psychoanalytical line so much as a politico-sociological one.*

Yes, you're right to say that, even though you can only compare the two films from the outside. In reality, I'm not so interested in myth and mythology. *Edipo Re* is not based on Sophocles or Greek mythology, but on Freudian psychoanalysis. What I mean is that in my film I projected Freudian analysis onto myth. And when I say "myth" I'm not referring to a specific myth of Sophocles or Euripides, I mean "myth" in the general sense of the word. My *Edipo* is nothing more than a projection of Freudian theory onto a time of myth. *Medea*, on the other hand, is based on the history of religions, on Frazer, Lévi-Strauss, Levi-Brüle. Reading their books gave me the idea to conceive the world of Medea as a symbolic fragment, an oneiric-visionary image of the Third World.

So would it then be, as I said, a politico-social vision?

Yes, it had to come to that of necessity. The key to the film would be the clash or dramatic relationship between an ancient, religious world immersed in a sacred vision of reality and a modern world, rich, secular, and skeptical, represented by Jason. From this clash derives what Eliade calls the spiritual catastrophe, which is what typically happens to anyone who comes into

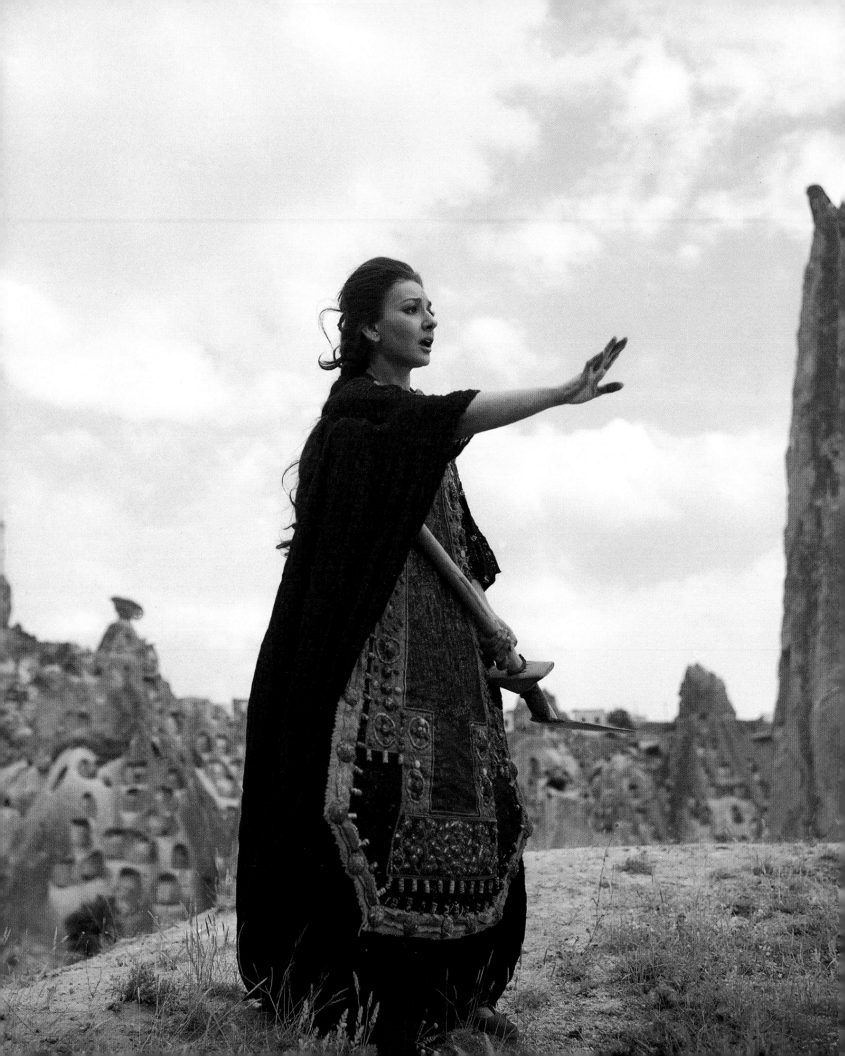

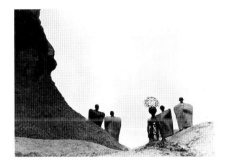

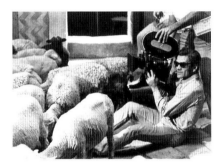

Left, Maria Callas in a dream sequence
edited out

A nightmare of Medea's (sequence cut
out)

Laurent Terzieff and Pasolini on the set

Pasolini on the set of a sequence later
cut out

contact with neocapitalism. On the other hand, as I just said, it was inevitable that things should come to this, because the clash between the Third World and the contemporary world is a theme typical of all my work, both literary and cinematic, perhaps because it constitutes a crucial point of my personal history and ideology.

Didn't the religious theme undergo a change in Medea?

No, I don't think it underwent any change, because I'm not religious. I'm not Catholic. I don't feel, so to speak, any specifically religious problematics in me that might involve changes of mind or reflections on one's own religion, or conversions. My religious vision is therefore always the same, because it's nothing more than an attitude, a position with regard to religion. In brief, I have a religious sort of relationship with human beings, with the landscape, with history. This relationship is always the same because it's part of my nature, my personality, my psychology, which is immutable. It's very rare for someone's psychology to change, especially deep down. If you noticed a change in *Medea*, it would be a relative one, so to speak, concerning the external thematics. Because while this religiosity may be fully internalized in *Accattone*, or while it may succeed in becoming the true story of the Son of God in *Il Vangelo secondo Matteo*, as told by a simple man, in *Medea* it's the depiction of a generically religious world that sees reality as a kind of hierophany.

Your previous films, particularly Edipo *and* Porcile, *are to a certain degree autobiographical. Is the absence of self-representation in Medea intentional?*

That's a point worth discussing, because if, in the films you cite, there's a more direct, more explicit autobiographical participation, you can't really say it's less strong in *Medea*. I would say instead that every work is autobiographical because it falls into the domain of personal experience. If I hadn't lived in the impoverished suburbs of Rome, if I hadn't traveled in India and Africa, I could never have portrayed a world such as the one in *Medea*, for example. *Medea* might be perhaps the most intellectualized part of my autobiography, though perhaps also the least psychologized.

Haven't you ever thought of making a theoretical film based on the experiences you've discussed with me? In other words, to keep on evoking the memories of your childhood which make up the first part of Edipo Re?

No, because in general I express that sort of thing in my poetry. Everything I need to express about myself, I pour into my poetry. I've never had the desire to make a rigorously autobiographical film. Does my life seem so interesting to you that its story should be told? On the whole it's a boring life, repetitive and unchanging.

Do you think Medea *will have success in the Third World? Success in the sense that people will know how to read it?*

While I confront the problems of the Third World, my audience is not the Third World. A typical inhabitant of the Third World is not in a position

to understand a work of literature or the cinema. You are Venezuelan, but you are not part of the Third World, just as I am Italian but not part of the Third World either – as might be, for example, the poor suburbs of Rome or Sicily. My films have had success among people who belong to the Third World in a general sense, people who, being part of the elite of Third-World countries are part of the same international bourgeois culture as me. To give you an example, in Italy my films have been successful in the large industrial centers, but not in Lucania or Puglia in the South. Perhaps future generations will be able to understand them.

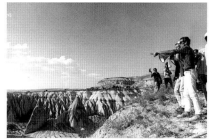

How did you choose the music, and how did you adapt it to the sequences?

I took the music from the Unesco collection of folk music of the world. For the religious world of Medea, I chose sacred Tibetan chants. But the chants you hear in the city of Corinth (the rich, refined, mannerist city) are from Iran. Refined songs of love. Strangely enough, these love songs bear a slight resemblance to certain kinds of Spanish music, though that was brought there by the Arabs. For the world of Jason, I chose some traditional Japanese folk music, as if to suggest that the Argonauts were samurai invading a foreign land.

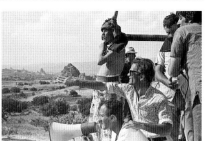

Why did you use the architectural structures of Pisa to represent Corinth? Don't you think the viewer will recognize them immediately?

A cultured viewer, perhaps. In fact, though, I don't think very many people realized that it was Pisa. Anyway, the shots were extremely discrete, meaning that I filmed only the walls – that is, what was essential to the scenes. Because, while for the world of Medea I found (in Turkey and Iran) a visionary landscape that was fantastical in and of itself, and to which I didn't need to add anything, for the world of Corinth, which is a human world, I found nothing in nature. And therefore I had to reconstruct it intellectually. That's why I chose Pisa, in order to represent it with the extraordinary geometrical beauty of its marble.

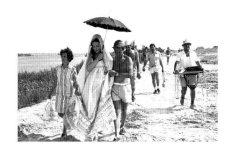

Do you select the costumes yourself?

I don't personally see to the costumes, but I don't let anyone interfere, either. The choice of costumes, like the choice of the music, is one of the stylistic moments of filmmaking in which I am personally involved. Naturally, for this I need the cooperation of a good co-worker, who should be inventive more than ingenious, even though the initial ideas are mine.

And on what historical basis is this selection made?

You know that folk cultures are always prehistoric, compared to bourgeois culture, the culture of the dominant class of a nation. For this reason you can easily use costumes from a variety of folk cultures without them clashing. For the selection of costumes, I employed a syncretic process, and so I chose folk costumes from Turkey, Iraq, Africa, Spain. Since I wanted to depict a prehistoric world, I chose costumes that are prehistoric with respect to the history of our civilization. For example, those stiff capes made of

Pasolini on the set

Maria Callas and Fernando Franchi on the set

The White Athena

The deep theme of the *Oresteia*, at least for modern readers, is the transition from a *medieval* period to a *democratic* period: from the transformation of the Maenads (medieval gods of existential terror) into Eumenides (gods of irrationality in a rational world).

If something similar is happening in Africa today, Athens (the model of democratic forms) is undoubtedly the progressive white world; and Athena, the goddess who taught democracy to Orestes, establishing the first human tribunal and the institution of voting, is a white goddess.

The plan for a film based on the *Oresteia* of Aeschylus, set in modern black Africa, could thus be the perfect guideline for a documentary about modern black Africa.

A sequence – maybe taken from archive footage – of a recent civil war (Congo or Biafra) could foreshadow the Trojan war, and the return to the fatherland of an army that is victorious but profoundly tired and disheartened, etc.

The "fatherland" could be a tribe or a village with its ancient tribal structure (here there could be a short documentary sequence on a typical village in the forest).

Through the same technique of "notes for a film to be made" (already used in my documentary on India), I would select the face of a possible Agamemnon from among some tribal chiefs, as well as a possible Clytemnestra, a possible Electra, a possible Orestes.

A short documentary sequence of a funeral rite could suggest the death of Agamemnon. Another short sequence on an African exorcism dance could suggest the appearance of the Maenads.

After killing his mother, Orestes flees.

The character provisionally chosen as a possible Orestes, fleeing the eye of the camera, would guide us through a terrifying medieval landscape, dominated by the Maenads: everything that is still "wild" in Africa: the forest, the savannah, the beasts, the unbearable silences, the looming threat of thousands of undefined perils – in short, the atrocious enmity of nature.

And then we enter "Athenian" world of democracy and progress. Our guiding characters lead us into a city that suggests Athens, a typical city of the new modern Africa. And here, what in Aeschylus is the establishment of the human tribunal, such as the right to vote and other things, is replaced by a short documentary sequence on the modernity of the city, on its democratic, progressive spirit.

Finally, there is the return of Orestes, redeemed from terror, to his tribal world, his village. Dressed in modern clothes, with a "modern mentality," he presents himself to the elders of his "medieval city" (who are in thrall to terror and to the idyllic life) as a reformer, bearing the message of democracy.

Left, film still

Pasolini in Africa

A new festive dance (not some hackneyed folkloric dance, in other words, shot and edited in nondocumentary style) could then suggest the transformation of the Maenads and Eumenides – from savage, terrifying irrationality to irrationality that integrates rationality as a necessary complement – in other words, the fecund survival of the African *ethnos*, along with its myth, within the new type of society.

The documentary would be visually objective: the funeral sequences are sequences of a real funeral, the sequences of a modern city are sequences of a modern city; the speaker's job, as in a documentary on India, is to clearly express the intentions and allusions of the *Black Oresteia* to be made.

"L'Atena bianca" (1968), in *Le regole di un'illusione*, Fondo Pasolini, 1996

Notes for setting the Oresteia in Africa

The following points are clear even after only a very superficial and hasty reading:

a) The whole of the *Oresteia* is a long preparation for the final "catharsis." In this preparation, consisting of a chainlike and fatally determined succession of vendettas and bloody events, these sanguinary characters and murderers are seen to be moving in a environment that is archaic in culture and religion, tyrannical in politics: in short, a "savage" environment.

b) The "catharsis" consists in the foundation of the Aeropagus, due to the Goddess of Reason. Or, in simple words, in the transformation of a "savage" city into a "civil" one, where sinister tyranny dominated by archaic gods is replaced by democratic institutions under the guidance of new Gods.

c) The Erinyes, after dominating the whole of the first part of the tragedy as Goddesses of Tradition – indeed, a savage Tradition, dripping with blood and pervaded by terror – are not destroyed in the end by the Goddess of Reason, but transformed. They still remain irrational, archaic divinities, but rather than presiding over atrocious, obsessive and degrading dreams, they no preside over the works of poetry, imagination and feeling.

Now, it is quite clear that such a basic theme, even though it remains valid and universal, risks being outdated when it refers to Europe today. Instead, there is a world where that theme is central theme of a story in our times, and that world is the African world.

The *Oresteia* synthesizes Africa's history over these last hundred years: the almost brusque and divine passing from a "savage" state to a civil and democratic one. The series of kings, who dominated the African lands (though in their turn dominated by the dark Erinyes) in the atrocious and century-old stagnation of a tribal and prehistoric culture, have suddenly been swept away. And Reason, almost *motu proprio* has established democratic insti-

Alberto Moravia, Pasolini and Dacia Maraini during the shooting of the film

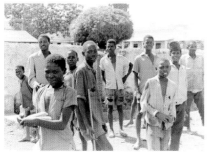

tutions. We must add that now, in the "Sixties," the years of the "Third World," the years of "Negritude," the burning problem and question is the transformation of the Erinyes into Maenads. Aeschylus' genius foreshadowed all of this. All advanced people today agree that archaic civilizations – superficially referred to in terms of folklore – must not be forgotten, despised, or betrayed. But rather they must be absorbed within the new civilization, integrating it, making the latter specific, concrete, historical. The terrifying and fantastic divinities of African prehistory must undergo the same process as the Erinyes, they must become Eumenides.

These are structural reasons for the transposition of the *Oresteia* into the African world. But as always, when these reasons are right, they open unexpected and certain perspectives of spectacular and artistic rewards.

For example, one need only think of the stupendous part that could be played by the chorus in African film. One only has to take the people of some village (I would say without doubt, from the so-called "Sudanese" Africa, whose monarchical institutions, beneath the trappings of "Arabization," preserve elements of the Pharaonic monarchy in Egypt, which descended into the whole of Equatorial Africa from the North, through Nubia), and I would simply say to these people: "Sing and dance," and there we would see the Greek choruses come to life again.

Again, one need only think of the sense of reality that the Erinyes could derive from African dress. From their horrid tattoos emerges a sense of reality that no other make-up and no other costume could ever confer upon them in a film set in Europe.

And again, one can think of a figure like Cassandra, who foresees, even physically sees her own death – which will occur before very long in the house of the King – and describes it. This "solo" by Cassandra, once again, could be completely sung, in that kind of trance that often seems to grip blacks when they sing.

As you can see, the film would, in some way, form part of a genre already familiar to the public – the musical. Only that in this case we would have a tragic musical – the mystic tragedy so typical of negro chant.

The great characters of the Tragedy – Agamemnon, Clytemnestra, Orestes – could be played by great black American actors: or even by famous blacks who are not actors; for example, certain unforgettable boxers, singers or dancers, who have become legendary all over the world.

"Nota per l'ambientazione dell'*Orestiade* in Africa" (1968-1969), *La città futura*, no. 23, June 7, 1978, later in *Appunti per un'Orestiade africana*, Edizioni Cineteca di Bologna, Bologna 2009

During the shooting

1971

IL DECAMERON

The Decameron

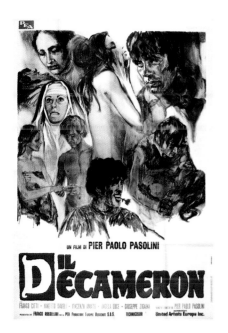

To Franco Rossellini
(Rome, Spring 1970)

Dear Rossellini,

Having finished reading the *Decameron* and having reflected on it, my original idea for the film has now changed. It's no longer a question of choosing three, four or five stories set in Neapolitan surroundings, a kind of compression of the whole opus to a part "selected by me," but of selecting the highest possible number of stories (this first draft includes 15) to give a complete and objective portrayal of the *Decameron*. This means, therefore, a film of at least three hours.

For practical reasons – and out of loyalty to the primary source and inspiration – the largest number of stories remain the Neapolitan ones, so the connecting thread of the film remains the Naples of the lower classes; but other stories will be added to this central grouping, each one representing something of the interregional and international spirit which characterizes the *Decameron*.

Taken together, the film will thus become a kind of fresco of the world in the period between the Middle Ages and the bourgeois era: stylistically it will represent an entire realistic universe.

From the point of view of production, therefore, the work is now more ambitious; in addition to Naples, there will also be "Cicilia," "Barbary," Paris, the sea; and therefore the feudal castles of the Loire, the desert with its Kasbahs, and the *legni*, the ships that sailed the Mediterranean from Egypt to Spain.

The film will last, as mentioned above, at least three hours, and instead of being divided into two parts, it will be divided into three, each of which will constitute a sort of thematic unit tied together by a sequence of events that will take the place of the narrative structure adopted by Boccaccio and represent my function as author with artistic license.

From *Lettere 1955-1975*, ed. Nico Naldini, Einaudi, Turin 1988

What follows is a complete but schematic screenplay. Complete as concerns the unfolding of events, situations, places, and characters; schematic as concerns the "tone," the "atmosphere" of the film. That is, what's missing are the final retouchings of the writing that would give the reader the sense of "seeing things"; here things are only indicated. Actually it's really a working screenplay, which is supposed to be "useful" but not concerned with "entertaining."

The film itself, on the other hand, is supposed to be very entertaining. Among various indications in the screenplay it is taken for granted that

the film should have an amusing inventiveness, something "extra" whereby nothing will be purely informative, while everything will be immersed in a joyful, sensual atmosphere.

I'll give two plain examples, both to do with the first story, the one about Martellino pretending he's been miraculously cured. The screenplay gives only the essential unfolding of events, whereas a series of amusing gags are anticipated for the film itself. For example, as Saint Arrigo (Henri) is dying, the three Neapolitan "clothing salesmen" are relieving themselves somewhere in the Loire valley, bare-buttocked and whistling a Neapolitan tune. Then, nearing a city in which the church bells are pealing for the death of Saint Arrigo, they put on, in front of some children, a spontaneous little performance, free of charge, *alla napoletana*, enacted by the actual Neapolitan mimes who would act in the story.

These are two very small examples that the reader of the screenplay should bear in mind to enrich his reading experience.

But why the gags, the reader might ask, why the comical details? Weren't they carefully and duly described in the screenplay?

For a very simple reason: because the screenplay is already by itself so rich in functional situations that to add secondary details would have meant complicating things beyond belief and making the whole thing illegible.

Then there is another reason: that I will no doubt invent many comical details and gags while filming, adapting to the real situations and characters I will have chosen.

Indeed the film is supposed be absolutely "real" – full of the fanciful and unpredictable reality of the Neapolitan world.

In fact the main thing to bear in mind while reading this screenplay is the following: the real protagonist of this film is this same "Neapolitan world." The characters change, alternate, replace one another, and disappear, but their world, the Neapolitan world, remains always the same. It is therefore a "choral" film that has decidedly refused to be a film "of episodes" – and that is why there are so many different stories. There may be many, but they form a single story, a "carousel" whose continuity is utterly coherent.

It is a film about the people, of the people, and also for the people.

It will be my task to arrange things so that the story will always be absolutely clear and easily understood. Story for story, it should be always easy to follow; it will have no hidden agendas or meanings. It will be utterly decipherable, because this is an essential element of its style. The thirteen stories make it so that this is not a film in episodes (an unpleasant formula often unwanted by the audience), but, contrary to appearances, a unified film, sparkling with life and the joy of living, like a prism with many facets.

Typescript (1970), in *Le regole di un'illusione*, Fondo Pasolini, 1996

Silvana Mangano, Franco Rossellini and
Pasolini on the set

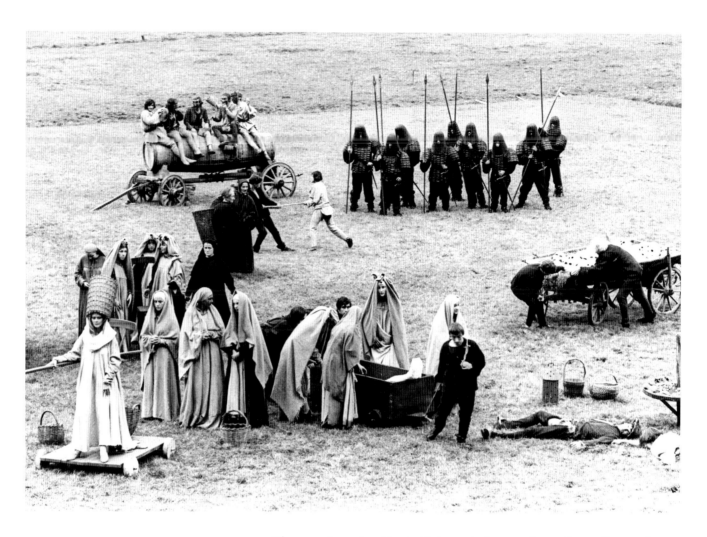

A film still of Ciappelletto's episode in Bolzano

The story I need to film in Bolzano is the one about Ciappelletto, a knave sent by a powerful lord to look after his interests in a northern city, where he falls ill and dies. But before dying, to please his hosts, two usurers, he makes a bogus concession and passes himself off as a saint, after which he is honored as such.

The way you see it, the matter is very simple. In Bolzano I needed a sumptuous dwelling, a convent, a church, a series of exteriors, rustic and urban. I found the sumptuous house at once: Roncolo Castle, both the exterior and the interior (the dining room in which Ciappelletto falls ill – a heart attack?). For his bedroom I found a wonderful reconstructed Tyrolean wood-burning stove in the Bolzano Museum. (Speaking of which, the Bolzano Museum is one of the most beautiful I have ever visited; I was quite moved by the extraordinary grace of those rooms). I found a few country exteriors, and at the eleventh hour of my stay in Bolzano I found a narrow old street, without doors and with short arches that make the light geometrical. I found the cloister (in Bressanone), and lastly I found the church interior I

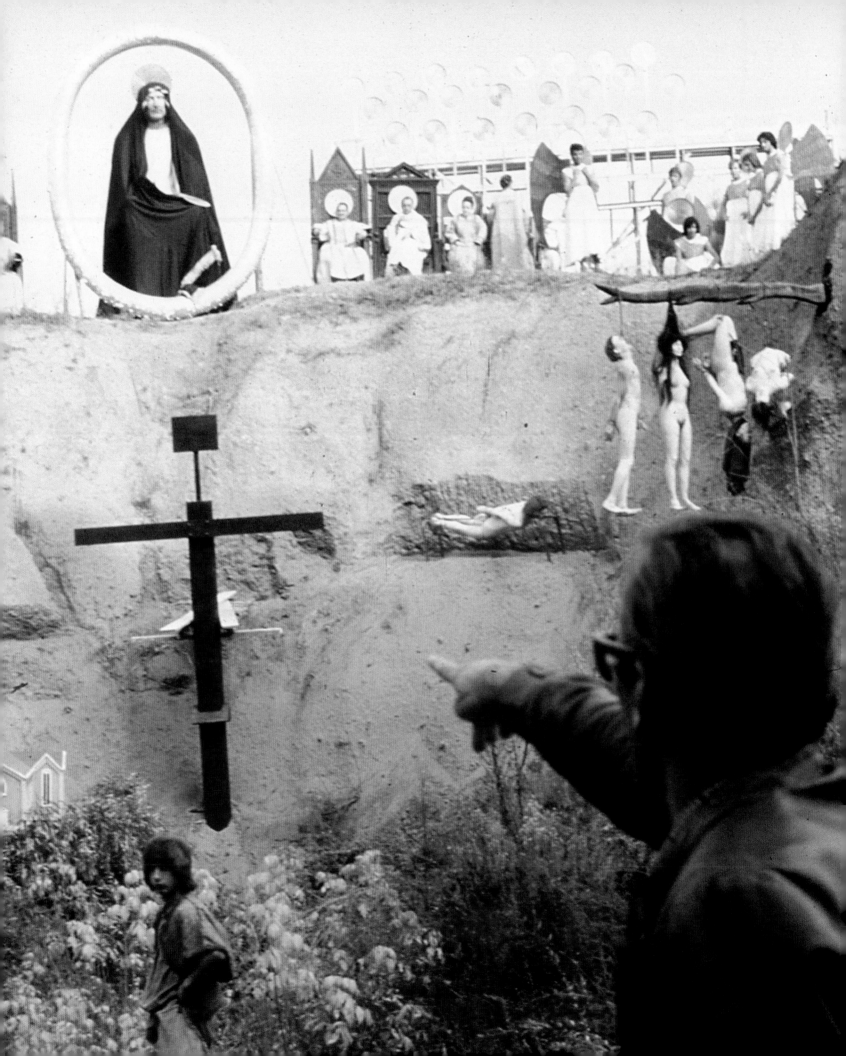

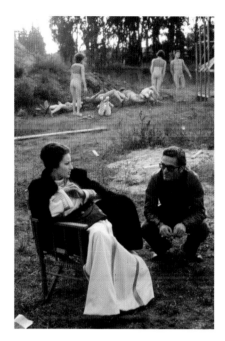

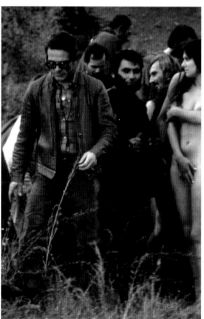

wanted (San Martino in Bolzano). I didn't find the church exterior I needed, because the churches in the South Tyrol are too Tyrolean; they're unmistakable, whereas, as you know, in Bolzano I'm looking for a North between the Middle Ages and the fifteenth century, but essentially ahistorical, poetic, undatable. All right, then, I'll give up my church exterior. Making films is like that: heartbreaking renunciations, painful adaptations, but alongside continual discoveries, inventions, new solutions.

I'll also select my characters and extras in Bolzano, and here too I'll look for the atypical that is nevertheless concrete. I've already seen some stupendous faces, especially among the old men, which recall all the poetry of the Germanic world.

And since, naturally, I didn't find an "aggregate" city either, instead of opening with a panorama of such a city, I will depict it through a series of details.

I will lift such details forcibly from the paintings of Bruegel, of the ancient, magical, cruel and slightly monstrous life of the peasantry. I shall select the characters from this series of evocations in Bolzano and the surrounding area. And I would be very pleased if I could find a Tyrolean who could be the friar for me, all of a piece but naïve at heart and holy (Ciappelletto's holiness will be his in reality).

This moment of the preparation of the film – the search for characters and places – is perhaps the most beautiful one, the real reason I love film so much. Though there are, I repeat, sorrows as well.

This time there has been one very specific, very clear sorrow, and it has been the constant theme of my research across half of Italy. The sorrow lies in seeing that in the last two or three years, neo-capitalist Italy has destroyed, with unprecedented cynicism, Italy itself. I don't want to seem rhetorical or sentimental, and yet I must say that this has become my obsession. When I think about this destruction, I fall prey to a rage that, as you can see, prevents me even from speaking. An impotent rage. There is nothing to be done. Power, while continuing to call itself traditionalistic, conservative, a protector of Western culture, has in reality decided not to conserve anything, to ignore all tradition and to lack any sort of respect whatsoever for, indeed, Western culture.

Aren't the Norman castles in Sicily and the villages in the Madonie part of Western culture? And yet if you want to save so much as a small house or a little wall – let alone a castle – from neo-capitalist devastation, you can do nothing. Perhaps this is why I felt such love when visiting, as I mentioned above, the museum of the city of Bolzano, because there the love of tradition is a blessing (and to think that the citizens of Bolzano, as I've learned, don't even know it exists!). It's hopeless. Nowadays a love of the past is a threat to the powers that want to be rid of it.

Typescript (August 1970), in *Le regole di un'illusione*

Left, Pasolini on the set of the scene of the painter's vision

Pasolini with Silvana Mangano

All works are autobiographical. Even those in which you cannot decipher explicit autobiographical elements. Who knows why this banal truth has become so foregrounded in the eyes of those interested in my work? Is this a sign of racism? I think so.

Even the *Decameron*, which was supposed have been the least autobiographical of my works, ended up becoming autobiographical just the same, almost aggressively so (if the style had not been so resolutely comical). This is how. The short stories I used in my film include the one on Giotto, so I had to choose who would play Giotto. After much fretting I decided on Sandro Penna, our greatest living poet. Penna is a little crazy, and he has a looser relationship with practical life than anyone I know (he is a slave only to his free-wheeling habits). Well, after creating an infinite number of obstacles for himself, for me, and for everyone, Sandro decided to accept. I was happy, because in the meantime I had given a reality to Giotto by adapting myself to Sandro's reality. This is a faulty mystification (but I'll explain shortly how it can be justified). The Giotto story, with the long coda that I invented, which was supposed to have been the connective tissue to the second part of the film had, through Penna, taken on an air of mythic folly, as extravagant as you can imagine, but in a certain sense absolute.

I was in Caserta Vecchia, working away, which always seems impossible, when, after a series of exasperating phone calls (which, for that matter, only increased my love for him, like the jilted lover I was), Penna uttered the great no.

We were three days away from the date set aside in the ruthless "work schedule" for shooting the Giotto episode. What could I do? I thought of asking [Paolo] Volponi, who I had thought of before asking Penna. I called him, he almost said yes, and I consoled myself that, even with Volponi, Giotto would remain the same distance from the author as the other characters. He would enter into the "objective whole" of a work suspended in the sky like a solemn, comical balloon. But on the last day Volponi said no, too! Ah! The vicissitudes of a poor filmmaker!

Starting a few days earlier, Sergio Citti, unencumbered by petit-bourgeois pride, who had gone from being the director of *Ostia* to slipping back down to the rank of assistant, had suggested I play the part myself. And in my heart, I knew there was no other choice, although I continued to fight tenaciously against my fear of the camera and against the new meaning that my work would take on, through my physical presence in it. The lovely balloon up there, suspended in the mythic sky, would have to be dragged down to earth, unmasked, and seen from the inside.

It took me five minutes to make up my mind. "Where are Giotto's clothes?" I asked the costume designer, the seamstress. They were brought to me. I went behind the rubble of a crumbling house in Caserta Vecchia where I was shooting the horse market, and, like an extra, on the grass, I took off my trousers, my shirt, my undershirt, my chain and put on the costume. I reap-

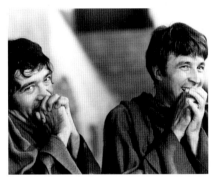

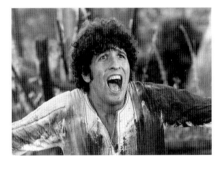

Film stills
Ninetto Davoli

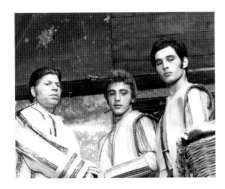

Film stills

peared in front of the camera dressed up in this way, and I felt like I was sinking into the bowels of the earth. The troupe looked at me, hiding its bemused disbelief behind its philosophical Roman apathy. After framing the scene, I threw myself headlong into the world on the other side of the camera.

What does my presence in the *Decameron* mean? It means ideologizing the work though an awareness of it: an awareness that is not purely aesthetic, but –through the vehicle of physicality, that is, through my entire way of existing in time and space – total. With the words that I utter at the end of the film, the work becomes ironic – that is, it becomes a particular experience, unmythified. The "faulty mystification" turns out to be a game.

In reality I was not just having fun with this film. I understood something very simple that it had taken me ten films to understand: namely, that cinema is a game.

Giotto is no longer Giotto, but ironically, as Forese announces (in the guise of a two-bit Neapolitan lawyer), a "northern Italian student of Giotto," who goes to Naples to paint realistic frescoes in the Church of Santa Chiara (the exact same way that I went to Naples to shoot the film. I only realize now that the late August day when I drove to Naples in my car, alone, to begin work, was one of the happiest and most beautiful in my life).

I have said that a poet has "only one era in life" (by poet, I meant his style). I am well aware that the era of my style was the 1950s, and I'm proud of that. But perhaps I made that remark when I was disheartened. Because now there's something new: I've discovered play.

The disobedience of young people is all right. But the disobedience of the elderly? The first is based substantially on obedience (obedience to the Revolution rather than to bourgeois parents); the second is based substantially on play. Society is less afraid of it because society is more afraid of the obedient – they are the majority – than the disobedient, even if they do play, because there are not many of them. Society colludes with working people because their numbers are immense and they are obedient in their own way, but it does not collude with minorities (the ones Hitler eliminated in the concentration camps).

In the *Decameron* I filmed the way I know how: more than ever in my own style. But while in *Porcile* and *Medea* my game was atrocity, now strangely it's happiness. A happy work (made with great seriousness, of course) seems to me to contradict all expectations. It's complete disobedience. (But maybe I'm lying).

At first the problem was humor, which made me angry. Me, humorous? How can you reconcile humor with naïveté, which for me was the only quality possible, even at the risk of being ridiculous? Had life got the better of me? Humorists are generally reactionaries! And so on and so forth. Humor detaches you from the "material." But with the *Decameron* (at least while I was shooting it), it wasn't a question so much of humor and detachment from the material as of playfulness. You can see that the loss of faith (which is always stupid) was initially traumatic for me. But then, with the

total loss of faith (in history, that is), I rediscovered a joyousness, yes, a joy I had never felt before and therefore had never lost. When I was young my disobedience was, according to a rule still followed today, fundamentally a form of obedience. Thus I was unhappy because I was no longer one of those youths born to obey, blessed by life (I say this without irony but rather a lingering envy that no longer pains me: it simply moves me).

"I am a force of the past," as I said in *La ricotta*, having Orson Welles (as dubbed by Giorgio Bassani) read my verses. I am even more so today.

Of course my psychological "transfer" with tradition is both positive and negative, because I've hardly lost my mind. Fascism pays lip service to protecting the past, erecting a spiritual barrier to the destructive folly of neo-capitalist cynicism and revisionism. Nevertheless the villages of the Madonie and Sana'a would have been safe a little longer under a Fascist regime. It's such a shame we can't stand it!

I play, but when I play I draw a distinction between myself and a reality that I no longer like. In the *Decameron* I play with a reality that I still like but that no longer exists historically. I chose Naples because it's a pocket of history. The Neapolitans decided to remain who they were, and thus to allow themselves to die. Like certain African tribes, the Beja, for example, in the Sudan, who do not want any relations with the present-day world, and allow themselves to die out, relegated to their villages, faithful to themselves, practicing self-exclusion. This isn't exactly what the Neapolitans do, but close.

My choice of Naples was not a polemic against Florence, but against all of assholish neocapitalist and television-happy Italy. No linguistic Babel, therefore, but only pure Neapolitan speech. But this is not a dialect film. Neapolitan is the only oral Italian language that exists at the international level. In technical language, which I suppose the reader rightly disdains, the "language of cinema" has the same code as the "language of reality." So, as the cinematic codifier, to express who you are through cinema, I use you as the "sign of yourself": as you appear and as you speak. The cinematic decoder (the audience) will decode you on the screen (your myopic eyes, your big nose, your masochistic pallor, on the one hand; your unhappy voice and way of expressing yourself on the other) the same way that you are decoded in reality. That's all there is to it. Think how irritated you would be if I, in a novel, were to "use" you to create a character, violating your right to mysteriousness, your right to not be understood! But it would be nothing but a bland employment of who you are, through the (indeed magical) system of written-spoken linguistic signs. Imagine then if I were to use you through cinema, which grabs you and sells you off, in all your physicality, which is what most belongs to you, if it is in our bodies that we live our lives and our history.

Well, like every director, for about ten years I have violated people by using them. And I have silenced my conscience with the excuse of art (or art-

Ninetto Davoli

The *Alibech* episode, edited out of the film

house cinema). But beware of invoking art! It's the worst crime of the spirit!

Only, in the *Decameron* I did all this "playfully." I let the actors "play," as the French would say, and set it straight. To Sandro Penna I said: "Come on, let's have fun, put on this funny costume designed by Danilo Donati, lend the ineffable mystery of your physical presence to a mythic Giotto whom you will playfully evoke, let him live through your body, and you'll see how much fun it will be behind the scenes!" Or to the drinks vendor from Mergellina: "*Ueeh, guagliò*, come here, put on these nice clothes of felt and gold, act the part, lend your birdsong to this fellow Riccardo, who's been dead for centuries, and let's play a game together." There's no one who won't see how cinema, done in this way, begins to resemble, in an altogether extraordinary way, the sublime ritual that in past centuries was the theater.

I had no expectations in the *Decameron* of expressing reality with reality, men with men, things with things, or to create a work of art, but only "to play" with a reality that jokes around with itself. Despite the incomparable violence of reality that is served up in heaps on the screen, the *Decameron* represents, for the first time in my career, a film of performance; or at least this is what it seems to be from the material I am putting together.

…Yes. Strange as it is to say, "playing" in film means being professional and… creating realism. Everything that I reconstructed in the *Decameron*, all the costumes and sets, I wanted to recreate in the most realistic way possible (I renounced the sort of "fantasy" I'd used in *Edipo*, for example, or in *Medea*). The unnatural element is in the "playfulness," *le jeu*, as the French say, and not in the reconstruction of the environment we were acting in. The style is "comical," and therefore the world is "the everyday."

As a result of this, a friendly complicity was created for the first time between the actors and me (at other times I have become a friend, even a close friend, of the actors, but it has always been outside of work). The actors (there were about forty "protagonists," all of them from the street, and absolutely free of any kind of ambition: a journalist made me smile when he delicately called them "beginners") and I became friends with them on the set in the way that travelers in a second-class cabin become friends after sharing some wine. With regard to them, my conscience was clean. I wasn't using them for work (artwork!) that was unfamiliar to them, only to later throw them overboard: I played with them, and in playing, we had fun, and having fun, the differences disappeared. And if we were to meet again, on the streets of Naples, it would be like meeting old friends.

From "Io e Boccaccio," interview by Dario Bellezza, *L'Espresso colore*, November 24, 1970, later in *Saggi sulla politica e sulla società*, eds. Walter Siti and Silvia De Laude, Meridiani, Mondadori, Milan 1999

Pasolini in the role of "Giotto's best disciple"

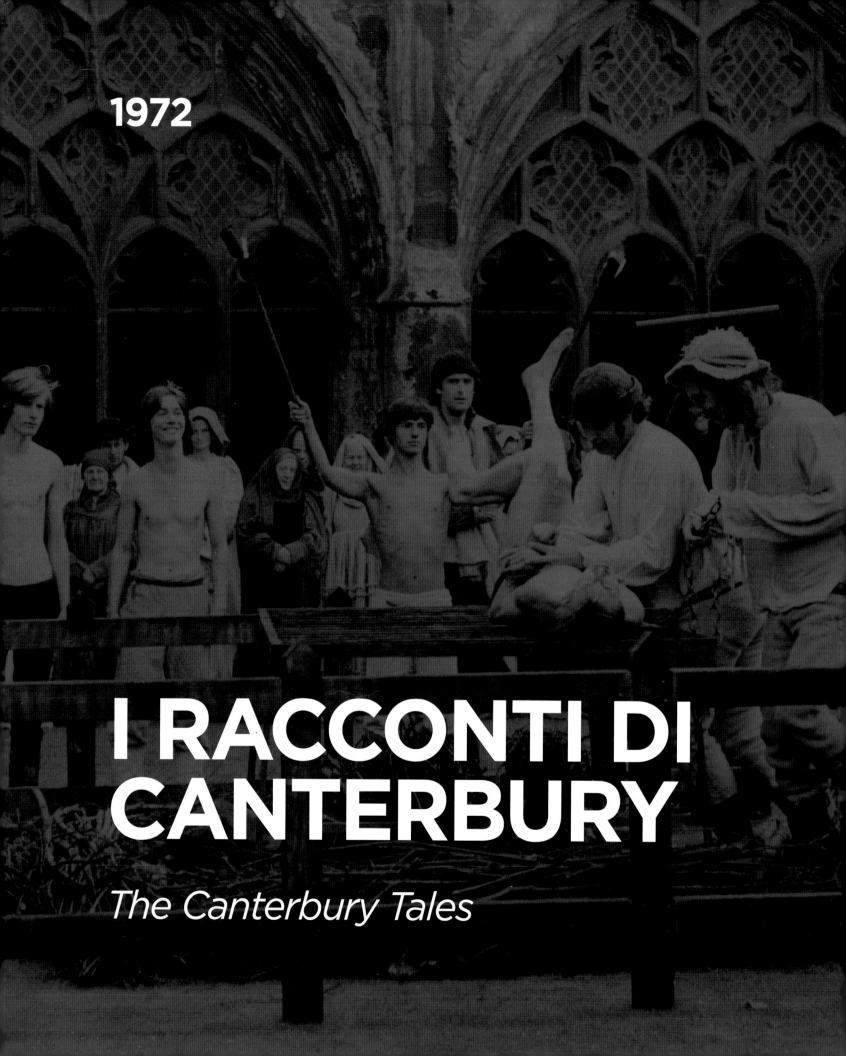

1972

I RACCONTI DI CANTERBURY

The Canterbury Tales

On Boccaccio and Chaucer

Boccaccio and Chaucer both prefigure Shakespeare. This is of no importance, I know. It's just something people say, and it doesn't concern either Boccaccio, Chaucer, or Shakespeare. It concerns, rather, the history of the bourgeoisie and its culture. Boccaccio anticipates the "sublime" Shakespeare of great sentiment unleashed and dominated; and, in this respect, he anticipates above all great Italian opera and Verdi. Boccaccio's foreshadowings of Shakespeare can all be found in the historical novellas, the ones that concern the legendary past (the Middle Ages had already vanished from Boccaccio's head) and the characters of high social extraction (kings, their daughters, etc.). Chaucer's foreshadowings of Shakespeare, on the other hand, can all be found in the realistic passages in the comic style. In both Chaucer and Shakespeare there is a mirroring of life as it is lived. (I remember a passage of Pasternak on Shakespeare in which he describes Shakespeare upon arrival in London, the inns, the squares, the hustle and bustle of business, and so on – a passage that could be inserted in Chaucer without anyone even noticing). Boccaccio seems never directly to mirror the chaos of reality. He returns reality to an order that never betrays it, not even for an instant – it's even inconceivable. Boccaccio's reasoning, as a bourgeois reasoning, possesses a maturity and high-mindedness which, at least in Italy, would never be reached again. In Chaucer, especially in the prologues and "conversations," there is the declared intention of directly mirroring reality, a reality left in all its ineffable disorder and physicality. To the point that some occurrences seem random, wonderfully random, as in certain primitive writers (such as the Milanese Bonvesin de la Riva). These flashes of reality, which light up with the radiant glow of an apparition, and therefore in a sense elude the domain of reason, are always accompanied by a moralistic and somewhat pedantic sermonizing (as is also the case in the primitives, like the abovementioned Bonvesin). This certainly makes Chaucer more "uncivilized" than Boccaccio, whose bright flashes of reality caught in its physical violence always originate in reason, which well knows how to apportion its lighting ("diffuse" light à la Giotto, or Caravaggesque – and operatic – backlightings, when it's not actually patinated in gold or with red sunlight à la Rembrandt!).

Aside from possessing a euphemistic strength that never betrays reality, Boccaccio has a "good upbringing" in the real, one that we will find again only in the highest, most refined cases of the subsequent history of bourgeois society. Chaucer, I repeat, is more uncivilized. His euphemisms are certainly more coarse, and his good upbringing has something peasantlike and barbaric about it. (Boccaccio never talks about farts and things of that sort, whereas Chaucer is constantly doing so).

From "Cose su Boccaccio e Chaucer" (1971), in *Le regole di un'illusione*

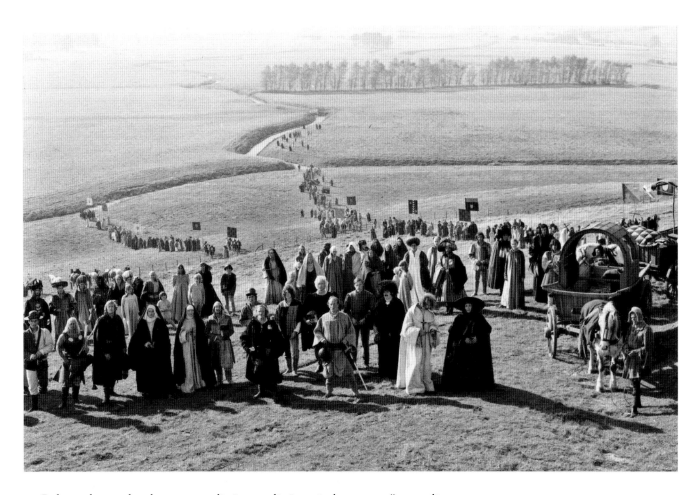

I chose those tales that were realistic – realistic, mind you, not "naturalistic" – more in a poetic sense than as fantasy or myth. Chaucer straddles two different epochs. He has something medieval, Gothic, about him: the metaphysics of death. But one often has the impression of reading an author like Shakespeare or Rabelais or Cervantes. He's a realist, but also a moralist and a pedant, and he displays extraordinary intuition. He's still got one foot in the Middle Ages, but he's not a commoner, even though he collects his tales from folk tradition. In essence, he's already a bourgeois. He's already looking towards the Protestant revolution and even the democratic revolution, in so far as these two phenomena come together in Cromwell. But while Boccaccio was a pure bourgeois with his conscience at ease, in Chaucer we already sense something unpleasant, a troubled, unhappy conscience.

I've used Chaucer's words, but translated them into a modern idiom. For example, for *The Pardoner's Tale*, the one about the three young men on the margins of society, who live by their wits, I found the three youths to play the parts right on the street. Purely by chance, all three were Scottish, so they'll be speaking with a Scots accent. I'll shoot the *Cook's Tale* – the story

The Pilgrims

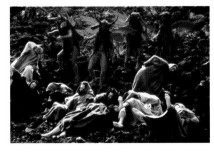

of Peterkin – in the docks of London, and that episode will be in cockney. I'll make it an homage to Chaplin, who was also from London. Later, when I found myself down by Bath and Wells, I liked the way the people spoke there very much, so I'll also use the Somerset accent in a few passages. I like to use the living language, and put together some of the most disparate dialects.

One thing that surprised me in the working-class young people and women I used for the small parts was that, in this country, they don't seem to have the same sense of humor as your privileged bourgeoisie. Chaucer has the bourgeois characteristics of moralism, pragmatism, and a sense of humor. He's already a privileged bourgeois Englishman, in that respect. Perhaps humor is a class privilege in Britain. Before coming here I'd never realized this.

From "Interview by Pasolini on the set of *The Canterbury Tales*," by Richard Lomax and Oswald Stack (Jon Halliday), *Seven Days*, London, November 17, 1972

There are twenty-one *Canterbury Tales* in all, plus a few fragments, but I have selected eight and preceded them with a prologue in which I introduce all the pilgrims. I am Geoffrey Chaucer. I myself take part in the journey, listening with amusement as the husbands complain about their wives, the parents about their children, the priests insult one another, and people poke light-hearted fun at the nuns. As an actor, I had decidedly more fun in this role than as Boccaccio's Giotto, who's always so worried about his work. Here I joke and mock my own human 'inventions.' The innkeeper, who leads the company and invites the pilgrims to tell two stories each, one on the way there and the other on the way back, is played by Al Capone's former chauffeur, whom I cast after seeing him preach, from a soap box in Hyde Park, against war in the world. There are English stage actors, foremost among whom is Hugh Griffith, as well as Italian actors. The latter – aside from Laura Betti, who plays the saucy Wife of Bath – all play the 'magical' roles. Franco Citti, for example, is the Devil; Prosperina and Pluto are respectively played by Elisabetta Genovese and Giuseppe Arrigo, who earlier appeared in *Il Decameron*. Both will perform for me in *Il fiore delle Mille e una notte* as well, the third film of my trilogy, which I hope to conclude in 1972.

I wanted the costume designer, Danilo Donati, to indulge his fantasies. The overall figure earmarked for creating the costumes was one hundred million lire [about $150,000 at the time]. That's a lot, but the set creation of this film is extremely important, because it will serve as a key to interpreting

Tom Baker and Laura Betti

Pasolini on the set

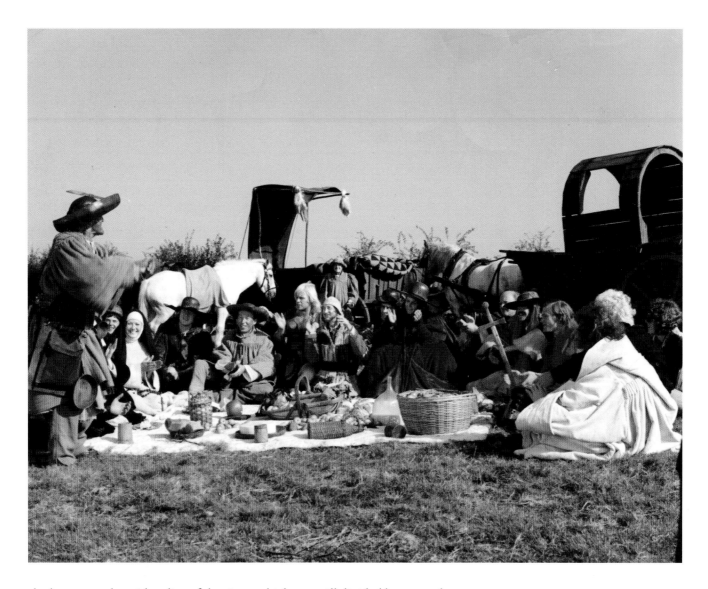

the human and social reality of the time, which was still divided between the three classes of knighthood, clergy, and commoners, all three of which are brought together in the group of pilgrims, who in my view should perfectly embody the English nation in a precise unity of culture and race.

I want to amuse and be amused, I want to bring to life a folkloric world that is being lost forever and rekindle in the audience the pleasure of imagery, through my colorful reconstructions of history. I believe implicitly that these films of mine will end up being political on top of everything else, precisely because they go against the grain of the wrongheaded, hypocritical vogue of 'engaged' but politically non-committal films. Maybe *I racconti di Canterbury* – though an English film – will revive the Italians' appreciation of layovers at inns and the reality of every man in his day-to-day existence.

Laura Betti (seventh from the right) with the group of Pilgrims

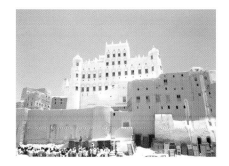

We appeal to UNESCO – Help Yemen save itself from destruction, begun with the destruction of the walls of Sana'a.

We appeal to UNESCO – Help Yemen to become aware of its identity and of what a precious country it is.

We appeal to UNESCO – Help stop this pitiful speculation in a country where no one denounces it.

We appeal to UNESCO – Find the possibility of giving this nation the awareness of being a common good for humanity which must protect itself to remain so.

We appeal to UNESCO – Intervene, while there is still time, to convince an ingenuous ruling class that Yemen's only wealth is its beauty, and that conserving that beauty means possessing an economic resource that costs nothing. Yemen is still in time to avoid the errors of other countries.

We appeal to UNESCO – In the name of the true, unexpressed wish of the Yemeni people, in the name of the simple men whom poverty has kept pure, in the name of the grace of obscure centuries, in the name of the scandalous revolutionary force of the past.

From "Le mura di Sana'a," Appeal to UNESCO, *Epoca*, March 27, 1988, later in *Per il cinema*, Mondadori, 2001

I shot this short documentary on a Sunday morning. It was the last Sunday that we spent in Sana'a, the capital of northern Yemen. I had a little bit of film left over from the shooting. Theoretically I shouldn't have had the energy to start making this documentary, too. Not even the physical strength, which is the minimum requirement. Instead energy and physical strength were enough, or at least I made them be enough. I wanted to do this documentary too badly. Call it a professional bias, but I felt the problems of Sana'a as if they were my own. The disfigurement that is invading them like leprosy wounded me with a pain, a sense of impotence, and at the same time such a feverish desire to do something that I was forced to make a film of it. The documentary was supposed to be an appeal to Unesco (within which there seems to be a bureau that deals with the urban landscapes of "developing" countries). Of course in Sana'a there is still no *intelligentsia*. Nor is there public opinion (there are no newspapers or television; the transistor radios are eternally playing a kind of passionate music broadcast by who knows what station or else solemn news programs)… The origin of this architecture is probably Jewish. The diaspora brought the Jews this far (I don't know in which century). In the cities of Jibb and Jibba, in the heart of the region, the star of David is on the gates. And in effect there is a certain resemblance with mediaeval Jerusalem. But maybe the Jews elaborated on a refined, preexisting architectural canon. The problem is not just Yemen, but many Arab countries. Certainly the case of Yemen is absolutely particular because in reality the whole country needs to be saved. Like a museum? So be it. The space is enormous, the cities small. You could build modern neighborhoods separated from the old cities…

From "Pasolini racconta con rabbia l'assurda rovina di una città," *Corriere della sera*, June 29, 1974

Left, Sana'a in 1970

Sana'a photographed in 1973 on the set of
Arabian Nights

1974

IL FIORE DELLE MILLE E UNA NOTTE

Arabian Nights

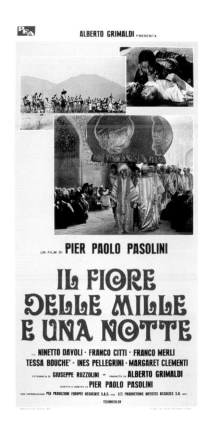

My initial source of inspiration for the film was a critical reading of the *Thousand and One Nights*. A strange critical reading. In fact I am no expert in Arabic literature or in Arab history. Is it possible to do a critical reading of a text without any kind of historical background? Obviously not. But there are compensating factors. For example, my existential knowledge of the Arab world. I can say that I know the Arabs better then the Milanese (which squares with my odd expertise in the Third World). So I was able to place *Il fiore delle Mille e una notte* in a historical context by placing it in the context of the common people of today.

All the characters in *Il fiore delle Mille e una notte* are craftsmen, merchants, and peasants, in addition, of course, to rulers and aristocrats (but, as in all feudal societies, the poor and the rich think in the same way, which is revealed incontrovertibly by the aesthetic sense that they all share). My Marxist condemnation of a world in which "men exploit men" is not even slightly retroactive. I hardly consider the poor of the past to be subhuman simply because they never had class consciousness and rebelled only occasionally through rebellions of a subproletarian and peasant nature. I neither condemn nor despise their resignation or their passivity.

These, too, are forms of life. If, moreover, in most cases they are extraneous to the culture and power, that does not seem to be the case with the Arab world of *Il fiore delle Mille e una notte*. Here the poor have the same culture as the rich (a magical world, homosexuality, common sense, fractioning of power, which would seem to be archaic and very traditional elements, not elements from the culture of the poor, but also of the rich and privileged). Perhaps the appeal of *Il fiore delle Mille e una notte* lies in this unity of the powerful and the subservient: a powerful appeal, for me. For one because there is no person in the world of *Il fiore delle Mille e una notte* who does not have a profound sense of his or her own dignity (not even the poorest beggar is without it), and then because I don't know through what mysterious way, through what cultural unities – from which each person draws his or her right to human dignity – a particularly deep, violent, and happy eros takes shape and is experienced (periods of repression are when commerce in the senses is most intense, fortunate, and exciting). What matters is the tolerance of the people, not of the powerful. And every popular morality based on honor is tolerant.

From "Pasolini: 'Conosco di più gli arabi che i milanesi'," *Stampa sera*, August 24, 1974

My *Thousand and One Nights*

In *Thousand and One Nights* a Queen sees a very beautiful boy and says that he is the most beautiful creature in the world; and a King sees a very

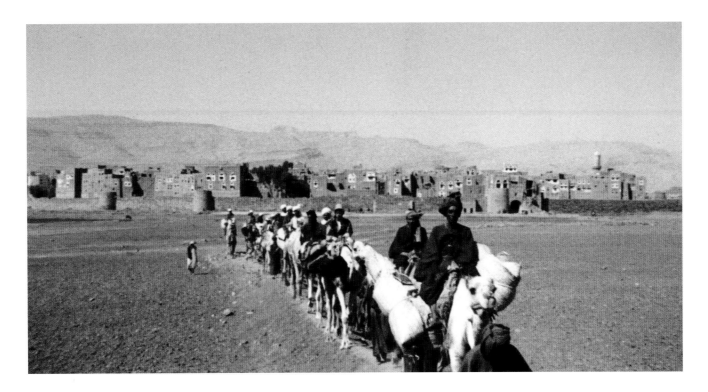

beautiful girl and says that she is the most beautiful creature in the world. In the project for the film, however, it is a Queen (Queen Zobeida, though she is not really the Zobeida of the *Thousand and One Nights* and will inevitably have another name), who sees a very beautiful girl and considers her to be the most beautiful creature in the world. And it is a King, the famous Harun el Rashid – he too will have another name in the film – who sees a very beautiful boy and, in turn, considers him to be the most beautiful creature in the world.

The Queen, who for the moment I am calling Zobeida, vaunts the beauty of the girl she has seen in the streets (during a migration of the tribe), and the King, in turn, vaunts the beauty of the boy (likewise seen during the same migration in the desert). Everybody knows how the thing is going to end. The King and Queen decide to give the boy and the girl a sleeping potion, and then to have them lie side by side for a comparison, though the task of judging who is more beautiful is entrusted to the youngsters themselves. This is one of the great inventions of the *Thousand and One Nights*. Indeed, the one who wakes up and falls in love with the other will be the *less beautiful*. Everybody also knows that, in the end, the boy and girl, waking up one at a time, will both fall in love. First the boy makes love with the sleeping girl, and then the girl makes love with the sleeping boy. Thus the wager is won by neither the King nor the Queen. And the sublime and anomalous invention of "the less beautiful falling in love with the more beautiful" ends up becoming part of the code of divine justice and strictly impartial destiny.

An image from the original prologue, later cut out

This tale was filmed entirely in Eritrea. It was a last-minute decision, an unexpected development in the chaotic adventure that is the preparation of a film. It had already been long decided that I would shoot it in Yemen, specifically in the Wadi Dar area (I'll talk about that a little later). I was in Eritrea just to look for actors, especially girls, who are impossible to find in Arab countries. Eritrean women have a special sort of beauty, an apprehensive beauty. When I saw a mixed-race girl of Eritrean and Italian parents in the PEA offices (who would eventually play the part of Zumurrud, the slave girl), I was almost moved to tears by the sight of those delicate features, which are slightly irregular but as perfect as those of a bronze statue, and those eyes lost in a sort of imploring uncertainty. In Asmara I was looking for other girls like her. The idea to use Eritrean women came to me while thinking of an experience from some ten years ago. I was in Port Sudan, and I'd learned that there was a tribe – the Beja tribe – who entirely rejected modern history. They stayed holed up in their village, a few miles from the city, and had no relations of any kind with the world outside. You couldn't enter the Beja's village, but I'd managed with my stubborn insistence to persuade a young cab driver to take me there. Once we were inside, among the first tents, a group of youths at play came up to us in hostile fashion, as if they didn't even want to hear us speak. In fact, the moment we opened our mouths, they pulled out their daggers and old swords. And so we wisely withdrew. I did succeed, however, in entering the village at a later point, and actually getting inside the tent of the chiefs, who had also invited in a group of young people to sing some traditional tribal songs. On that same occasion, when on my way back to Port Sudan, I saw another small village, defenseless, dirty and abandoned. It was a village of only prostitutes, all Eritrean. They came from Eritrea to earn their dowries, and when they'd made enough money, they went back to their land and got married. The profession of prostitution isn't any cause for scandal in Eritrea, where relations between men and women are free and equal. In Asmara, too, where after going around the city all day, thrilled by the beauty and grace of the inhabitants, I would keep going around in the evening, especially to bars of ill-repute in an area near the main street that divides Asmara in two. And there I found many other female characters for the film – such as Dunja. But I also found some male characters as well, whom it wouldn't have been practical to look for in Yemen (where the people's beauty isn't quite so spectacular, except for the elderly), because afterwards they would have to shoot scenes in Persia or India as well, and it was more economical to have them travel from Asmara.

For similarly practical reasons, it was more convenient for me to shoot a hunting scene in Eritrea (the scene in which Tadji meets Aziz who tells him his story: the divine "Story of Aziz and Aziza," which would have been worthy of being set to music by Stravinsky). In looking for sites for the hunt, I went to a peninsula (Buri) near Massawa and also to the hinterland,

Franco Merli (dressed in white)

to Agordat. It's not easy getting around in Eritrea. There's a civil war going on. A clandestine Eritrean army is fighting for independence; it's a partisan struggle similar to that of the Vietcong, a tragedy the Eritrean people hide behind their strange, humble smiles, and which the Negus hides even better behind his diplomatic skills (he has established relations with all the world's left-wing parties; he's even been to China; and when half a dozen Eritreans hijacked an Ethiopian airliner and were killed in a horrifying episode, not even *L'Unità*, Italy's Communist newspaper, sufficiently highlighted the fact that these were *resistance fighters*).

Once it was decided to film the entire group of Harun fragments in Eritrea, the number of characters that needed to be found there was multiplied. Aside from the throng of minor characters (first of all the poet Abu Nuwas), we had to find the Queen, whom we tentatively called Zobeida, and the King, temporarily called Harun. As well as the two "beautiful youths," Sitt and Hasan (whose names were also taken from other tales of the *Thousand and One Nights*, because I annexed the episode of the two youths whose beauty is compared to the anecdotes of Harun, whereas in reality it is the start of another tale).

At the moment I still don't have a clear sense of who will play the so-called Harun. I'm wavering between a soccer player and a young shop owner. I saw the former in the stadium of Asmara, as he was playing in a first-division match of the Ethiopian championship. The game was at a slightly higher level than in a first-division match in Italy, but the real attraction – for anyone in love *with all Eritreans*, like me – was the audience. They were gentle, orderly, not without humor, with a few outbreaks of literally savage violence, at the entrance, by a group of young boys, who were clubbed with equally savage violence by the police. I must say, however, that even that violence didn't contradict their grace. It was just one of the many things of life. Both those on the giving and receiving ends seemed to be thinking that all this only concerned them due to random chance – life's random chance, just the way it goes. It's still not clear to me whether it's a matter of hypocritical resignation or angelic wisdom. To repeat, in recent years a war even crueler than the Vietnam war is being fought in Eritrea, and so the people in the audience at the stadium were a people in revolt. In the stadium there was one grandstand left empty (for the authorities), and there, all lined up, as in a primitive painting, were a great many breathtaking beauties: they were the red-jerseyed reserves of the local team. Among these reserve players there was one with dark and sweetly sorrowful features, an ancient shyness, and the boldness of impoverished youth, a tall slender physicality entirely expressed in a *young man's* body, not a *boy's* body. Though always polite and apprehensive, the Eritreans don't remain *boys* long, but become *young men*. When I sent for him, he came at once, listened to me, and agreed to work with me.

Franco Merli and Ines Pellegrini

Franco Merli

The other candidate for the role of Harun I found in an eatery in Keren. He was sitting alone at a sumptuously laid table such as you used to see in the trattorias of the Veneto twenty years ago (there was even the same aroma of sage and roast). The face of this man eating beside us looked like a Benin mask. It was so perfect that it looked detached from his torso; he had a light moustache of the sort that all the young men wear in Eritrea, short hair molded to the shape of his head, which was perfect though rounded (whereas generally the moving beauty of male Eritrean heads lies in their oblong shape, with the back slightly protruding, the hard, frizzy hair stuck to the skin as on a metal statue).

I'd already selected Zaudi for the role of Zobeida some time before, during my first scouting mission in Asmara, but I also knew her from before, as she was the wife of the first person who had helped me with my early searches in Eritrea. His name is Giulio Biasiolo – the name tells us he's from the Veneto, from Oderzo, to be precise. And he, who's the same age as me, lived there at the same time I did, during the war and the partisan resistance. We may even have seen each other sometime after the war, at some country dance in the villages between the Veneto and the Friuli. At any rate, I met him some years ago, the first time I went to Eritrea. We traveled together

by car to Massawa, a memorable journey because it was the very day of the Negus' annual visit to Massawa. Every street in every village was decked out in celebration – with flowers and brightly colored fabric of red, yellow, purple, green, the colors of Coptic painting, spread out with a precision I would like to describe in pages of Proustian prose. In the villages, the elderly askaris had their rifles – faithful by definition, they were now faithful to the Negus (though I wouldn't swear on it). Perhaps the celebration was beautiful only because it was formal.

We kept overtaking the imperial cortege and being overtaken by it. With us was Ninetto, who'd never heard mention of the Negus, and every time the emperor passed by he would greet him with his light, untroubled soul, with that sweet smile that levels everything, and the Negus would respond – smiling more each time – bringing his hand to the visor of his military cap. Since Biasiolo was half Eritrean (his mother was born in a village near Asmara), the fact of marrying an Eritrean girl – Zaudi, that is – fitted into his ideology of humility and resentment. Zaudi isn't so painfully thin as the other Eritrean girls, who are like little birds. You can tell she is rich, because wealth means plumpness, all across the Bandung, for as long as it lasts. And

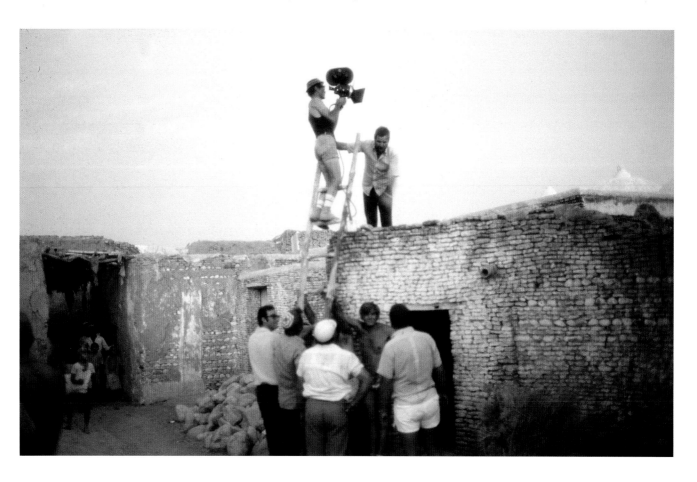

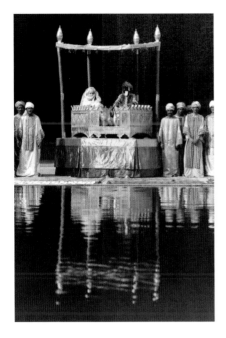

Zaudi is ever so slightly plump. She has a radiant smile. Her humility lies in her discreetness and silence. But her gracious tongue is sonorous and self assured, indeed like a queen's.

But we still had to find Sitt, the girl, and Hasan, the boy. In theory this should have been very easy, but in practice it proved anguishingly difficult. The difficult part was the choice. Beautiful, pathetic young boys, with bodies that were true gifts, abounded in Asmara and Kern; same for the girls. I therefore had to wait for someone absolutely stunning to appear. As far as the boy is concerned, I don't think I can say I actually said: "There he is! That's him!" I must have said "There he is!" a half dozen times along the street or in those little bars for the nocturnal vices. The choice finally fell to Fessazion Gherentiel, the bartender in one of those places, a shining apparition, whose smile burst onto his face like a silent light. The line of the protuberant back of his head, with his dense, firm, fuzzy hair, had the curious variant of forming a little clump, due to the part, which is very rare among the boys, whose hair is normally very compact, as though indistinct from the rest of the head. And the way he bowed when he shook your hand was also amazing. Eritrean boys are accustomed to bowing, like their fathers, who whenever they meet execute a whole series of bows and kiss each other's hand. It's a precious ritual, stereotyped but sincere. When they shake the hand of someone they consider superior, the boys grab it with both their hands and bend slightly at the knees. Their strength, the roughness of their agile legs, makes it so that their bow has nothing servile about it, not even physically (since there's certainly nothing psychologically servile about it). The poor son recreates the poor father: the institutions of the world of poverty do not involve conformism. In a feudal society, obedience to the fathers is not weakness, but supreme dignity.

The search for Sitt was a little more out of the ordinary. I searched among all the prostitutes in Asmara, the sweet, touching young girls who, even when they become women, never lose their purity (sex seems to have no connection with sin). The ones who struck me the most were their young servants. For example, I'd already found a Sitt in a place for prostitutes outside the neighborhood I mentioned. It was the inner courtyard of one of those Asmara houses about which I said there are no words in Italian to describe. It was evening. The lights were on, and outside the doors of the prostitutes' rooms there were vases with incense fumes rising out of them, from a few embers almost orange in color. The poverty was without hope. Beaten earth floors, naked walls, filth. The doors of the prostitutes' rooms were all open wide, and you could see inside: the dirty double bed, though made up with touching care, few chairs, a dresser, a small sofa where two or three girls sat together, combing each other's hair. And between one prostitute's room and another there was the room of a small nameless family, an old man, a woman, some children. It turned out to be a priest's room. In fact

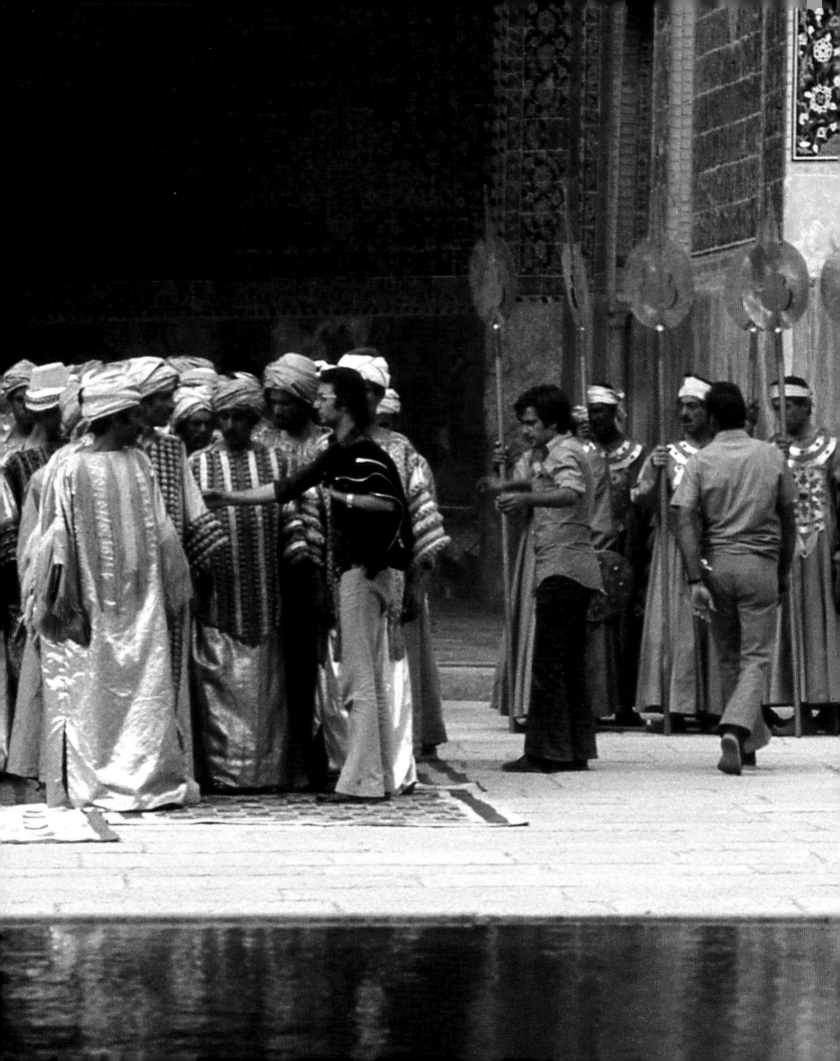

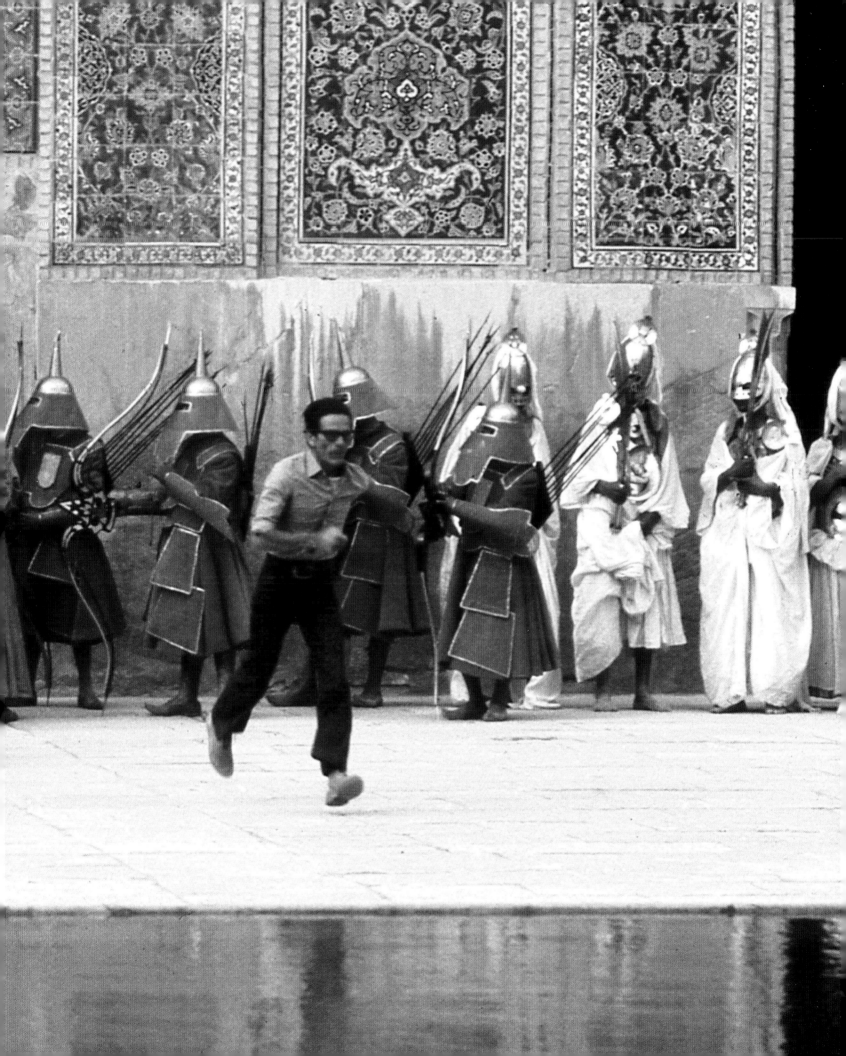

he was dressed all in white: white trousers, a large white *futa*, a white turban on his head. And his features, which smiled but looked sort of offended, or frustrated and even a little resentful, and displayed an indescribable dignity and authority that was nevertheless informal. And he too, with his small family, was sitting thoughtfully in his miserable space, through whose open door a sumptuous light projected. Each of the prostitutes' rooms had a young female servant in them; she tended the fire in the incense burner, or else cleaned or made tea. All these servant girls were wearing old, faded little dresses that looked clean, with a high waist under the just-blossomed little breasts, and reaching down to about the knee. Unlike their mistresses, they wore their hair in traditional, almost wild fashion, with tight, very narrow little braids running from the forehead down to the nape, all parallel, so that the head ends up looking striped, like a zebra. On the nape the hair is left in its natural state, but kinky and hard as it is, it doesn't fall in disorderly fashion, but forms a sort of elegant heraldic crest.

So, to tie together the different scattered threads of the story, Sitt and Hasan are sleeping inside the royal tent, where the chief of the tribe and his wife have had them brought to compare their beauty. They are naked, and their sleep is the sleep of the innocent. I know a little about the body of Fessazion Gherentiel, who will play Hasan. I hadn't ever done that before, out of sense of discretion and shame for what would have seemed like a slave merchant's behavior, but a series of mistakes led me to do so, at least in a few cases – that is, to see the naked body of the actor before using it, before using, that is, his nudity. It sounds brutal to say it, and to do it, after all. The boy undressed in front of me, Peter, and Fredzy in the room of the Imperial Hotel that Peter was staying in. It all happened very quickly and in silence. He took off one by one his skimpy garments, which were all dry, especially his socks and shoes, which were white with dust, and there, in dry, dusty air, his naked body appeared, clad only in a pair of colorful striped underpants. The bulge of the penis was, so to speak, normal, and so I signaled to Fessazion not to finish stripping, just as he was obediently, and submissively, about to do so. As for Giana Idris, I did not ask her to do the same thing; there was no need. Her light little dress, hemmed beneath the just-budded breasts, conveyed a perfect sense of her body's proportions and perfection. She's probably Bilen, from a tribe that lives in the Keren territory together with the Beni-Amer group. The Bilen have the custom of "sewing up" girls' vulvas, for the simple reason that they're supposed to be virgins at the time of marrying. The method is effective, in an objective sense, in that it gives Bilen women, who are famous in Eritrea for this, a carefreeness and freedom that is even more apparent than in the women of other tribes.

The problem is to shoot the scene with these two naked youngsters looking at each other, each discovering the body and sex of the other in turn, each

making love physically, though without the other being aware of it, and having to go through all the gestures of possession, made difficult by the sleep and innocent inertia of the other body. I have no doubt that Fessazion will do everything he has to do, happily and gently, with a smile beaming white as sugar across his face, but what about her? In the narrow space between the outer covering of the tent and its square interior, the pseudo-Harun and the pseudo-Zobeida lift the corner of an exquisitely embroidered, primitive straw curtain and watch the action, which should be seen from their point of view. The point of view should first be identified with my own and then with that of the spectator.

What interests us about this point of view is partly its pure and simple beauty, which makes it contemplative. But in part it is also the sexual excitement, which is fully involved with the action. Except in the case of a voyeur, the gaze of a person observing two naked bodies performing a complete act of love is not sufficient in itself. It is not an end in itself. Rather, it involves an identification with one of the two protagonists of the union, and, at the same time, an impossible feeling of desire for the other. The pleasure one feels watching a sexual act being enacted – of which he has personal experience – consists also in the pain of knowing that at that very moment he is inescapably shut out from it. Watching a love scene being enacted is thus like looking at something lost that has returned, something dead that has come back to life. It is an acknowledgement through reason of something previously only experienced through the body. It is a re-reading, with the objective – but not unmoved – eyes of a scholar, of a text too vast to be interpreted. And lastly, it is a reconfirmation of the inexhaustibility of a desire that is continually reborn from its own ashes. The reconfirmation gives consolation, as is always the case when we intellectually acknowledge the mechanism of something that is painful and inevitable. The moralism profoundly rooted in all of us makes us think that the desire to watch a representation of a love scene is merely a vulgar weakness, if not worse.

People therefore tend to think that a poet who recreates a scene of sexual love does it simply because *he has nothing to say*. They do not realize, of course – as the old mechanism demands – that it is they who are repressing what the poet is trying to say. At best, they establish a hierarchy of interests. Nobody would ever say that someone goes to see *The Battleship Potemkin* because of a "political interest," thus diminishing the film's meaning, whereas they *all agree* that a person who goes to see film in which sex is recreated with full nudity, does so because he is driven by a miserable "sexual interest," which is therefore hierarchically considered *inferior* to other interests. This objectively diminishes the value of the film, which is thereby considered of an inferior grade. In fact we all know that "religious" and "political" interests are really inferior to sexual interest, which at least is innocent, and – in short – anterior to the social conditionings that at times render it miserable

and vulgar. But even if we consider it a sin when a spectator chooses to see a film which freely represents intercourse, that choice, that "interest" is infinitely freer than any other interest. If for no other reason than because it concerns that which a man deep down, obscurely, places before everything else. The very thing a moralistic judge neither wants to know, nor admit, is the ultimate expressive culmination of a formal search conducted precisely for the person *who has a complete and rigorous grasp of this search*. In this case the brown Eritrean cock of Fessazion Gherentiel and the sweet little cunt of Giana Idiris.

I said at the beginning of these notes that in the text of the *Thousand and One Nights* it is Harun who discovers Sitt's beauty, and it is Zobeida who discovers Hasan's beauty, while in the film is the inverse. It's a change I introduced into my film, though decidedly in the style of the *Thousand and One Nights,* the guiding principle of which is stereotypy, but also exquisiteness and ambiguity. Every tale is the story of an anomaly of fate. Banality simply has no place in it. The general pattern of the accumulating tales ensures that – in the real story of Sitt and Hasan – it is right and proper that the King should discover the girl and the Queen the boy. An infinity of other anomalies see to setting this obvious and natural beginning right. In the film – which is infinitely poorer in terms of quantity and complexity – I had to recover and concentrate the errant motifs, the elements given but not mentioned, the unexpressed, which all form the magical-realist aura of the unfolding plot. It this particular case, for example, I recovered a symmetrical homosexuality, on which there is superimposed (thus rendering its reality prehistoric and profound) an equally symmetrical heterosexuality, though it remains, in its turn, consequently suspended and deprived of its blind certainty.

What's more, homosexuality, along with magic, is the antagonistic element of the *Thousand and One Nights*. The protagonistic element, I repeat, is destiny, which – nevertheless – would not become aware of itself if it were not contradicted by the very thing that it cannot recover. Destiny can become anomalous and turn itself into history, but the antagonistic elements "forcing" it into this anomaly remain ontological, immutable. In the *Thousand and One Nights* one can find an infinity of pathetic eulogies of homosexuality and an infinity of examples of the veneration of magic. But no explanation is ever attempted.

We arrive at a desolate airport between the desert and the sea, encircled by distressing, heavenly pink mountains. Beyond those mountains lies the city, which we reach from behind, that is, by the landward route, through a naked, dusty little valley in which the modern part of the city has been built (in the usual indescribable disorder). I felt my heart break, and darkness enveloped me. I realized that history was stubbornly thwarting my anti-historical illusions, with stupid ferocity.

Alessandro Ruzzolini, Angelo Pennoni, Pasolini, Franco Citti and Beatrice Banfi

Franco Merli, Ines Pellegrini and Pasolini

From above, as I half-closed my eyes, appeared the vision of the real Al Mulkalla: a small white city teeming around a circular harbor, with its tall houses of five and six storeys, fashioned like sublime cakes of sugar. But when I fully opened my eyes, there were only a few truly ancient houses, left in their original barbaric, exquisite form, with their porous material consumed by swellings and crumblings, white lime and light-blue shutters and frames, legendarily tiny. In reality it had all been rebuilt with cheap materials, drawing only superficial inspiration from the original style, in that approximation devoid of any sense of form, typical of everything that is modern and imposed by history. The style, however, was just the thing I was looking for (and dreaming of, with impure antihistorical excitement): the Yemeni style, an only partially resolved enigma, the answer to which, if it exists, is known by only a few. Unlike the architecture of the rest of the Arab world, which is horizontal – the divine horizontality of those adobe walls that enclose the secrecy of the houses in a sort of small, essential, rustic, religious universe – the Yemeni style is vertical. Houses five, six, seven stories high (at Shibam, in the Hadramaut, there are even skyscrapers of a sort), huddled together along narrow streets, exactly as in modern Western cities. If the idea of Venice was born somewhere in the east, then this somewhere is Yemen. Sana'a, the most beautiful city in Yemen, is a small, primitive Venice sitting not on the sea but atop the squalid dust of the desert, amidst gardens of palm and barley.

In despair over the loss of Al Mukalla, I'd chosen as lodgings a poetic hotel on the port, tended only by youths, very plain (a bed cost about fifty to sixty-five cents a night). But as our presence was officially accepted – through the gracious permit granted by the central government – we were dinner guests at the House of the People. Not without some fear on our part, but that was quickly dispelled. Indeed we were served an exquisite fish pie. The deputy governor, a boy not much older than twenty, accompanied us into the small garden after the meal, and we talked with him a long time about revolution. He wasn't joking. In his eyes there was a determination that wasn't only focused on action; it also expressed culture.

Early the following morning we left for the Hadramaut. Driving the Land Rover was a young black man, cheerful as only blacks can be. He sang and he laughed, and only once did he lose heart, like a wounded animal, when something went wrong with the car's engine. It was as if he felt the pain of the car in his body. He was a young hope of the revolution, named Islam, and he was proud of it. His father, like all of his forebears, had been a slave, under the emir. Eight hours in a Land Rover, across a hilly desert, are not easy (or are all too easy) to imagine. The hours went by. The desert is a vision nuanced by slight changes that make its immutability all the more obsessive. Time, for those who like obsession, doesn't pass. The hardness of the seat is one element of the exalting repetitiveness.

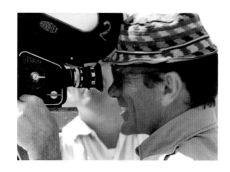

When we reached the Hadramaut valley it was already night. Here was the first village with its little ochre skyscrapers, their cramped little myopic windows without light. In the darkness I glimpsed – full of hope – an endless oasis of large, squat, dense palm trees. And all around, at a higher elevation, the desert terrace, into which the river had carved the long valley, in strata, over the centuries. The town of Seiyun was lost in the night's deep silence, even though it wasn't later than seven or eight o'clock. We looked for the House of the People. There were problems – the caretaker, the governor – and so we walked around in the town, which we saw only in profile: tall, formless buildings between large gardens, long avenues dotted with palm trees and dusty...

The next morning I woke up early, in the vast room of the white House of the People, and I went to the balcony. Under the just-risen sun, in an unreal silence, Seiyun lay before me, perfect in design, against the terraced ridge of the desert, immersed in gardens of palm trees, in a valley completely deserted and empty on one side, and vast and green with dense palms on the other. The houses were tall but bare, without ornament, with small windows, and as though split in two by a sort of rectangular cut, blackened by smoke, under which were the small doors.

Despite the light's blinding whiteness and the oppressive, afternoon-like heat, a perfect silence reigned over the small city. The town seemed to enclose its self-awareness within itself like a secret, perpetuating its own habits – like that morning silence – as in a dream. The small white columns supporting the pediments of the richest houses called to mind a Classical age from before the Classical age, the more mature period of the Pharaonic or Mycenaean age. Time was like a sea of haze and light against whose melancholy backdrop Seiyun had remained intact in a form without regret and without hope.

From "Le mie *Mille e una notte*," *Playboy*, September 1973, later in *Romanzi e racconti*, eds. Walter Siti and Silvia De Laude, Meridiani, Mondadori, Milan 1998

In Il fiore delle Mille e una notte, *Ninetto (Aziz) always has a fly buzzing around his nose. Is this a dramatic physical rendering of human impulses, such as we often find in Chaplin (or in* Il fiore delle Mille e una notte, *in the children that chase Nur-ed-Din and throw stones at him)?*

It is indeed the same Chaplinesque physical rendering you mention, and it is present in all my films. In the last film it is even more joyous, more light-hearted, more transparent than in the others. In *I racconti di Canterbury*, the whole Ninetto piece is an explicit homage to Chaplin. Basically the comic element winding through all three of my last films originates with Chaplin...

In all three films there is a sharp divide between the first and the second part, especially in the last one, which in the first part is jumpy, the images sped up, while

Pasolini on the set

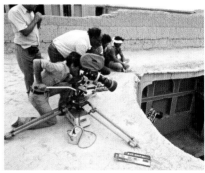

Pasolini with Angelo Pennoni in Shibam, Hadramaut (South Yemen), 1973

Pasolini with Alessandro Ruzzolini (Camera Operator), Gideon Bachmann e Salvatore Sapienza in Murcheh Khvort (Iran)

Pasolini with Alessandro and Giuseppe Ruzzolini (Director of photography) in Murcheh Khvort (Iran)

in the second the picture is more steady, allowing you to use within it techniques that are completely new to you, such as fade-outs and fade-ins and process screens...

It's true, but this symmetrical ordering is accidental. For one, the beginning became jumpy and a little rough also because I cut about a quarter of an hour from it. For example, you arrived at the scene in which the slave girl is sold, which now is sped up, in a more calm, constructed manner. The cuts made the beginning more impressionistic. In the second part, and this is not accidental, a Chinese box design in set up. A series of realistic figures that are slowly embedded into other realistic figures become a series of make-believe figures.

In the Aziz episode there are languages that are either anomalous or subconscious, such as the language of mime. Behind this three-person story (Aziza, Aziz, and the girl), there is a religiously structured language, an initiatory language. The girl who expresses herself in an anomalous way from the balcony, through signs, probably has her literary origin in a sense of hierophany or theophany. The story probably came out of a social stratum that practiced an esoteric religion. The outlines of this religious design remain clear in her mode of communication.

Rather than transmit speech, the speakers, in essence, reveal themselves as moments in a Universal Discourse, which you make significant once again by isolating them in an emerging corporeality.

Yes, and I shot that episode with greater enthusiasm than I have in any other film. In a way, even the arabesque, the squiggle Aziz traces by running back and forth, becomes itself a mysterious language...

Now do you feel as if you've completed one film or three?

Three. Especially because in the middle there was the hiatus of *Canterbury*, which I shot in a completely different state of mind, though not intentionally so... It was a very unusual period, I was very unhappy, and I wasn't in the right frame of mind for a trilogy that was supposed to be carefree, in the "middle style" of dreams and comedy, and fairly abstract. And if I had not been so unhappy, I would never have thought of quoting Chaplin so openly, with bowler hat and cane. I also have to say that the world that I found in England, when I was shooting *Canterbury*, was very different. In Naples and the East I had no barriers. I could unleash around me this language of the earth, of things, of volcanoes, palm trees, nettles, and above all, people. Instead in England this world is cut out by a child's hand, and the people that I chose belonged to a very historicized, bourgeois world, and this constriction weighed on my state of mind. It's hard to talk about a film as a test of your state of mind, but at any rate I've always had a very passionate relationship with the films that I shoot. They are true loves.

In Il fiore delle Mille e una notte *for the first time you use techniques that are unusual for you, fade-ins and fade-outs, rear projections...*

I was forced to use rear projections, since I couldn't allow my actor to be eaten by a lion. However, while we're on the topic, let me say that they

make sense in their way, even if I got there accidentally, for practical reasons. The fades are a style that I rediscovered. Maybe the period of the *Il fiore delle Mille e una notte* is one that implies fade-outs. But I don't think I'll be using them anymore.

The rain, or rather the tears, the sweat from the earth that you see in Nepal: was it artificial?

No, but I accepted it enthusiastically; by the way, I'd like to shoot my next film, about Saint Paul, in the winter, with the snow, the rain, the fog, in the North. It's a reaction. I've always made films in the sun. I can remember that when I was shooting *Mamma Roma*, I said, "Basically, making movies is a question of sun." Now I want to make films filled with rain.

How did you get the idea of making a film on Saint Paul? Have you been thinking about it for a while?

I'd say that I have. I wrote the screenplay seven years ago...

Who have you thought of casting to play Saint Paul?

I don't know, it's still wide open... I haven't wanted to imagine a specific face yet... Saint Paul will have the face of a man of action, generally speaking... but he is most himself in the moments in which he is suffering from this strange illness. It's hard to understand whether it's an ulcer, epilepsy, or anxiety, a form of neurosis. In the moments when he loses his strength and is just some poor wretch who falls prey to evil, he is a saint, and has his highest moments, his rapture, his most dazzling insights...

Going back to Il fiore delle Mille e una notte, *is the moon that you see in Ninetto's episode fake?*

Yes. You wouldn't have been able to do anything with a real moon. Apparently there is wonderful film stock in America that allows you to shoot at night with minimal light... At that point, light can seriously become a refined instrument, which would serve only to mold the faces. The way that I photograph them, the faces are very constructed, with light, even if they seem snatched from life, accidental...

Did you have Il fiore delle Mille e una notte *dubbed for foreign distribution?*

In France I did, and I chose the voices. It came out nicely, because the voice of the professional dubber is an exclusively Italian phenomenon. In Italy the dubbers speak a language that has nothing to do with the way you or I or Ninetto speak. In France, instead, a dubber speaks like a French intellectual. For the Italian dubbing I chose dubbers who were for the most part from Lecce, because I needed a generically southern *koiné* that was not immediately identifiable.

From "Conversazione con Pier Paolo Pasolini," interview by Alessandro Gennari, *Filmcritica*, no. 247, August-September 1974, later in *Per il cinema*, Mondadori, 2001

Franco Merli and Ines Pellegrini

Right, Pasolini directing Alberto Argentino and Franco Citti

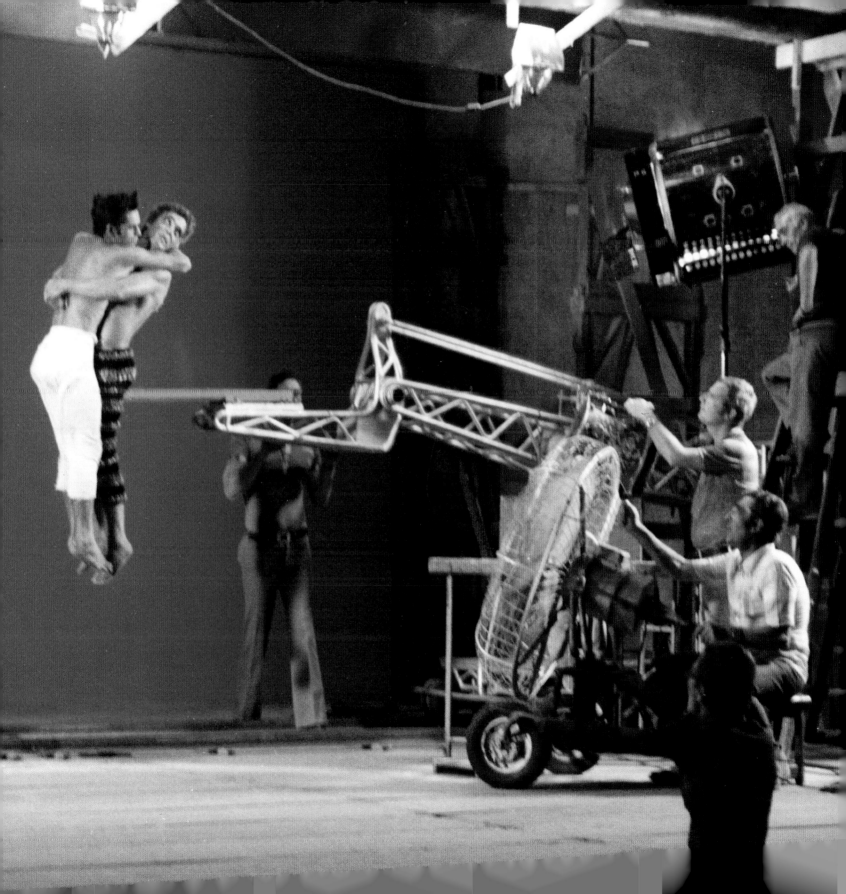

1975

SALÒ O LE 120 GIORNATE DI SODOMA

Salò or the 120 Days of Sodom

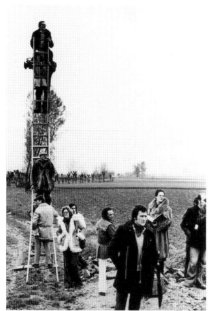

Left, Uberto Paolo Quintavalle (on the right)

Pasolini on the set

Sex as Metaphor of Power

Are there any precedents for this film in your work?

Yes, *Porcile*. Also *Orgia*, a play that I directed myself, in Turin, in 1968. I got the idea in 1965 and wrote it between 1965 and 1968, the same time I wrote *Porcile*, which was also originally a play. It was originally supposed to be a play like *Teorema* (1968). De Sade came into the picture through Artaud's theatre of cruelty, and, as strange as it may seem, through Brecht, an author I hadn't much liked until then, but for whom I'd felt a sudden but not overwhelming love in the years leading up to the big protests. I'm not happy with either *Porcile* or *Orgia*. Estrangement and distancing are not for me. Nor is cruelty.

What about Salò?

It's true, *Salò* will be a cruel film, so cruel that (I suppose) I'll have to keep my distance from it, pretend I don't believe in it, and play with it in a cold way... But to finish what I was saying about precedents... In 1970 I was in the Loire valley doing location scouting for *The Decameron*. I was invited to a debate with some students from the University of Tours, where Franco Cagnetta teaches. He gave me a book to read on Gilles de Rais and the documents of his trial, thinking I might want to make film out of it. I thought about it seriously for a few weeks (a good biography of Gilles de Rais by Ernesto Ferrero came out in Italy recently). Of course I later decided not to. I was too busy with the *Trilogy of Life*...

Why not?

A cruel film would have been overtly political (subversive and anarchistic, at that time), and thus insincere. Maybe I had a prophetic sense that the most sincere thing inside of me, at that moment, was to make a film about the kind of sex whose joyousness compensated, in a real way, for repression, a phenomenon that was about to end forever. Not long thereafter tolerance would make sex sad and obsessive. In the *Trilogy* I evoked the ghosts of characters from my previous realistic films. Without social criticism, obviously, but rather with a love for days gone by that was so violent that it constituted a criticism not of a particular human condition but of the present as a whole, which is so obligatorily permissive. Now we are irreversibly inside that present. We have adapted ourselves to it. Our memory is always bad. So now we are living what is happening today, the repression exercised by the powers of tolerance, which, of all types of repression, is the most atrocious. There is no more joy in sex. Young people are either ugly or desperate, wicked or defeated...

Is this what you're trying to express in Salò?

I don't know. It's what we are living, which we obviously can't ignore. It's a state of mind. It's what is harbored in my thoughts, and I suffer from it personally. So maybe this is what I am trying to express in *Salò*. A sexual relationship is a language (in my work this has only been clear and explicit

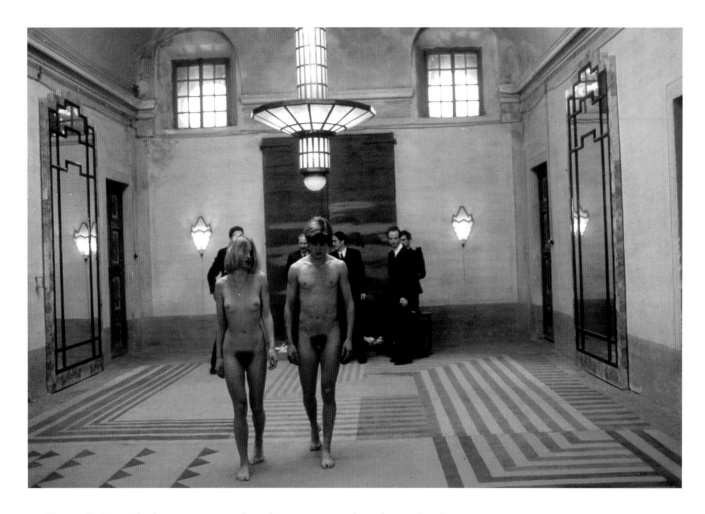

in *Teorema*). Now the languages or rather the sign system has changed radically in a few years. I cannot stand outside the evolution of any linguistic convention of my society, including sexuality. Sex today is the fulfillment of a social obligation, not a pleasure against social obligations. From this stems a social behavior that is radically different from what I was accustomed to. So for me the trauma was, and is, almost intolerable.

In practical terms, in Salò...

The sex in *Salò* is a representation or a metaphor of this situation. The one we are living through nowadays. Sex as obligation and ugliness...

If I understand correctly, you may have other intentions that are less interior, perhaps, and more direct...

Yes, that's what I'm trying to get at. In addition to the metaphor of the sexual relationship (obligatory and ugly) that consumerist power's tolerance is making us live nowadays, all the sex in *Salò* (and there's a huge amount of it) is also a metaphor for the relationship between power and those subjected to it. In other words, it is the representation (possibly oneiric) of what Marx called the commodification of man: the body is reduced to an object

Dorit Henke and Sergio Fascetti

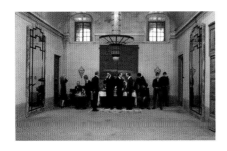

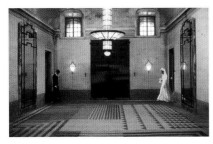

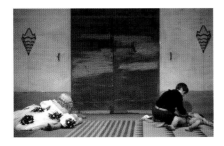

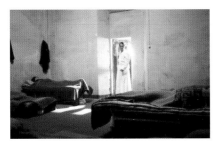

through exploitation. So in my film sex is called upon to play a horrific metaphorical role. The complete opposite of the *Trilogy* (if, in repressive societies, sex can also be an innocent derision of power).

But doesn't your 120 Days of Sodom *take place in Salò in 1944?*

Yes, in Salò and in Marzabotto. I took as a symbol the power that transforms individuals into objects (as in the best films of Miklós Jancsó) – Fascist power and, in this specific case, the power of the Republic of Salò. But it remains a symbol. This archaic power facilitated the representation of my subject. Actually I give the whole film a wide, blank margin for broadening that archaic power to become a symbol of all power, whose possible forms are thereby accessible to the imagination... And then... The fact is, power is anarchical. And, power has never been more concretely anarchical than it was during the Republic of Salò.

What does Sade have to do with it?

Sade was the great poet of the anarchy of power.

Beg your pardon?

There is something brutal about power – any kind of power, legislative or executive. In its laws and in its practices, all it does is sanction and make realizable the most primordial, blunt violence of the strong against the weak. Of the exploiters against the exploited, to repeat. The anarchy of the exploited is desperate, idyllic, and above all a castle in the air, eternally unattainable. Whereas the anarchy of the powerful is concretized very easily into laws and practices. Sade's powerful people do little more than write rules and regularly apply them.

Excuse me for bringing up practice again, but in practice, how is all of this applied in the film?

Easily. More or less the same way as in Sade's book. Four powerful men – a duke, a banker, a chief justice, and a cardinal – ontologically and therefore arbitrarily reduce humble victims to objects. They do so through a kind of mystery play that, probably consistent with Sade's intentions, is organized according to Dantean forms. A vestibule to Hell, and three circles. The main figure (which is metonymical) is accumulation (of crimes) but also hyperbole (I want to reach the limits of what can be endured).

Who are the actors that play the four monsters?

I don't know whether they'll be monsters. At least no less and no more than the victims. In choosing the actors I did the usual mélange of different types: Aldo Valletti, an extra who in more than twenty years has never been given a single line; Giorgio Cataldi, an old friend from the Roman slums (whom I've known since the days of *Accattone*); Umberto Paolo Quintavalle, a writer, and finally Paolo Bonacelli, an actor.

Who will be the four shrews that tell the story?

They'll be three beautiful women (the fourth plays the part of the pianist in the film, since there are only three circles of Hell): Hélène Surgère,

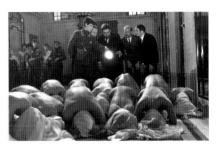

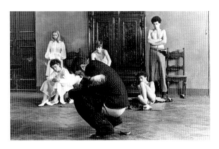

Caterina Boratto, and Elsa de' Giorgi. The pianist will be Sonia Saviange. I chose the two French actresses after seeing Paul Vecchiali's film *Femmes femmes* in Venice, a beautiful film in which the two actresses are truly "sublime," as the French say.

And the victims?

All non-professional boys and girls (at least in part. The girls I chose include models, because of course they have nice bodies and, above all, are not afraid to show them).

Where are you shooting?

In Salò (exteriors) and Mantua (interiors and exteriors where the kidnappings and round-ups take place), and the Bologna area. A little town on the Reno river will fill in for Marzabotto, which was destroyed...

I know that shooting began two weeks ago. Can you tell us how the work is going?

Spare me. There's nothing more sentimental than a director talking about his work on the set.

"Il sesso come metafora del potere" (self-interview), *Corriere della sera*, March 25, 1975, later in *Per il cinema*, Mondadori, 2001

For *Salò* every detail must be executed with great care, and therefore, if someone has to fall down dead, I will make him repeat the act many times until he actually looks like a body falling down dead. I will not, moreover, cut up the scene; it must all be formally of a single piece, so that I can use it to enclose the horrors of Sade and Fascism within a single envelope.

To this end I need a structure that will maintain a very precise, well defined rhythm, which for this reason will be less realistic precisely because it is more perfect. The confirmation will then come from the Dantesque character I've given the film's structure – which in my opinion was already one of Sade's intentions – by dividing it into circles in perfect keeping with the theological verticalism of Dante's *Inferno*.

De Sade was a writer of pages. His pages are generally rather ugly, with the exception of a few sentences that can be singled out and are, in fact, brilliant. "All this is good because it is excessive," is, for example, a beautiful sentence, but one finds them only every so often. No, he can't hold the page; he really didn't have that quality, of a writer who could command the page, nor was it possible he could ever be one; perhaps because had his pages had that forward momentum that a real writer can give them, he would have achieved a certain elegance that appears only very rarely in his work. He's a writer of structure, and this structure is at times rather elegant, solid, well delineated, as for example in the *120 Days*, where the structure is rather pre-

cise in design. Other times his structures are open to infinity, accordion-like, poorly delineated, formless.

Unlike Sade, I was educated and lived in a literary and cultural milieu in which the page matters, and therefore I feel very keenly the concrete fact of art. So it's a different thing. The restlessness, the anxiousness to shoot that I have when making a film are due to a hunger I get to consummate immediately whatever it is that fascinates me at that moment. But my other films were mostly conceived in such a way that I had to bring the material together first and then edit it, and so I had to gather together so much of it that I would go home with my bags completely full and then watch it all again, select, and edit. This time I don't have to gather together the material like some formless magma; I have to have it already organized as I film it, and therefore my haste is more calculated, because since I'm filming mostly indoors this time, the film that comes out has to be perfect, even in the conventional sense of the term.

Power codifies and ritualizes, as do erotic acts, and since the gesture is always the same, and forever repeated the same way, the sodomite gesture

Scene of a round up

Right, Claudio Troccoli and Maurizio Valaguzza

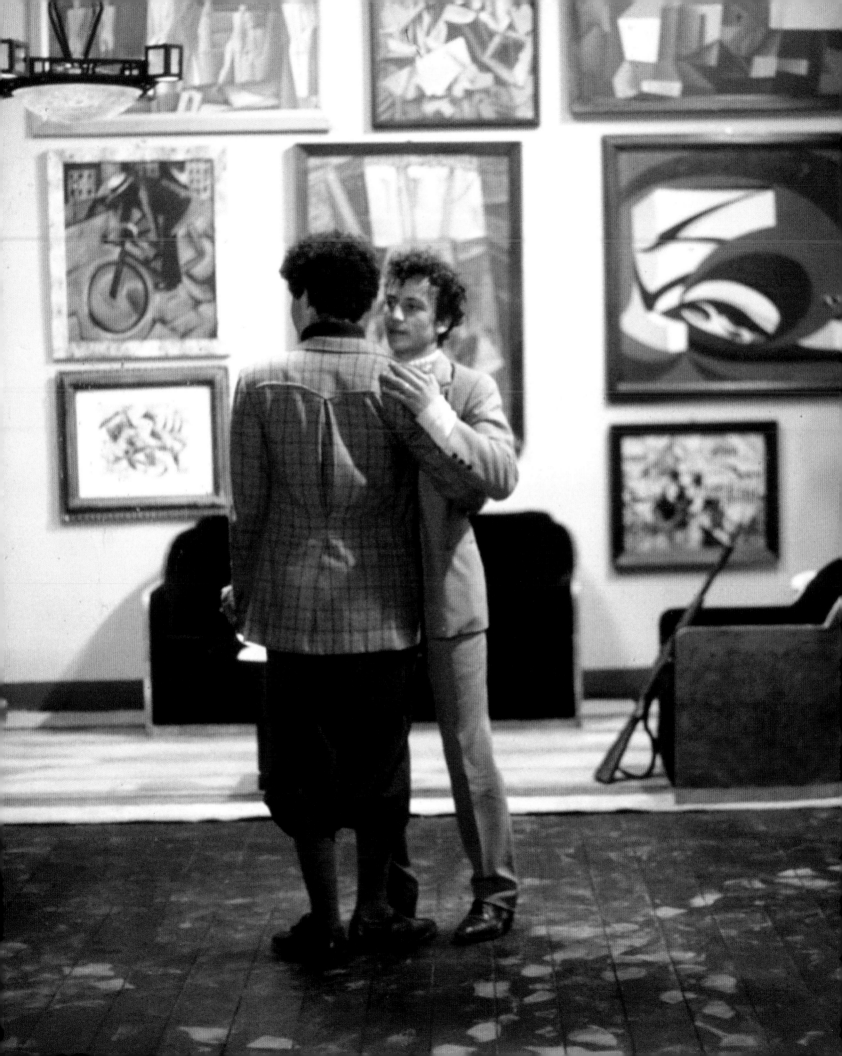

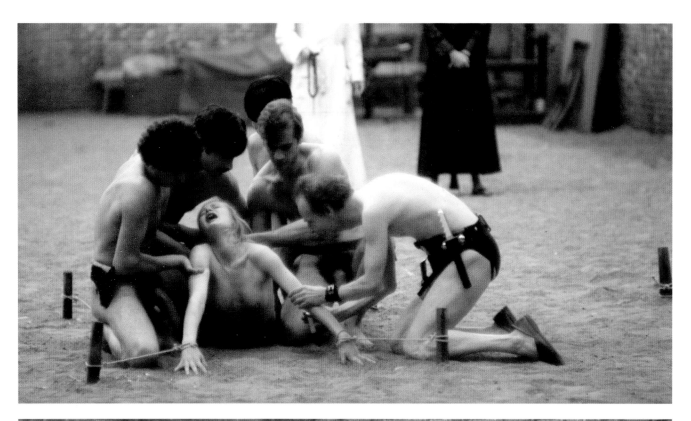

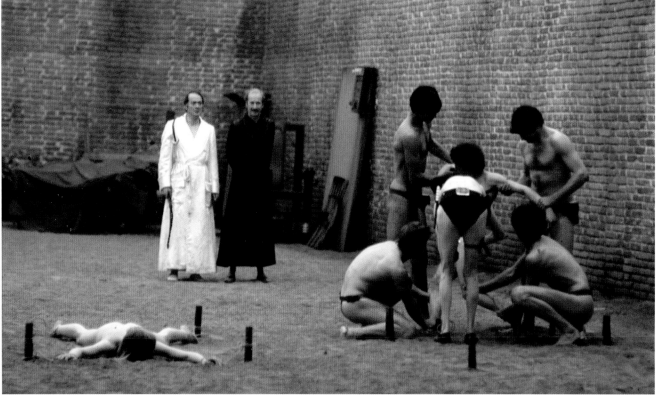

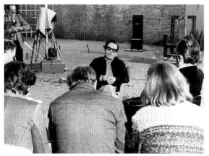

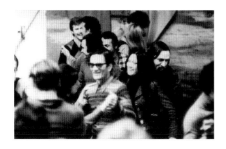

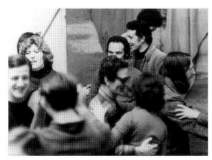

is the most typical of all, because it is the most useless and best sums up the repetitiveness of the act, precisely because it is more mechanical than the others. Into this context is added the gesture of the executioner, which is anomalous, because the executioner can perform his act only once; and indeed so as to have more than one victim, it becomes a question of killing a thousand, just to be able to repeat oneself. Or, another solution – which I added to the film – is to pretend to kill the victim and in reality not to. Put the pistol to his temple, pull the trigger, and shoot, having loaded the pistol with blanks. Coming back to life then becomes a perverse variant, as the ritual of death has already been enacted.

Another important thing, which I took from Klossowski, which I then repeat in Blanchot, is the model of God: that is, all these Nietzschean *über-menschen ante litteram*, by using their victims' bodies as things are, in reality, nothing more than gods on earth – that is, their model is always God; at the moment they passionately deny Him, they make Him real and accept Him as a model.

I don't very often repeat a scene unless it proves particularly hard for me to get what I want. But generally speaking, doing scenes over tires out the actors, who in my case, being usually non-professional, give their best straight away, with an immediate spontaneity. And so if we have to shoot over, they become less effective, because they don't know how to perfect their performance. For this reason I always very clearly explain how I want the lines said, and so the first time they say them, they're already in front of the clappers. I do this also for two other reasons: first, because the entire reality of the film must be filmed; and second, because you can never know in advance which will be the most felicitous, the most real moment. In fact, many times during the editing I've found myself choosing the first of four takes.

From "Conversazione con Pier Paolo Pasolini," interview by Gideon Bachmann and Donata Gallo, *Filmcritica*, no. 256, August 1975, later in *Per il cinema*, Mondadori, 2001

Left, Dorit Henke and Aldo Valletti

Left, Giorgio Cataldi and Uberto Paolo Quintavalle

Pasolini and Tonino Delli Colli on the set in Marzabotto

Pasolini during the press conference in Cinecittà

Pasolini in the dance sequence, early take of the film's finale, later cut out

UNREALIZED FILMS

My Long Journey

It was my most ambitious effort, and the one that required the most formal attention and stylistic commitment. A political-ideological film is easy. It is far more difficult to make a pure film, to seek the pure storytelling of the classics, to stay away from ideology and yet also avoid the temptation of evading it. More than one ideological element is hidden in these three films of mine: the main one is nostalgia for that past I tried to recreate on the screen. Seen from within, seen by me, I have to say that these last films of mine, the films of the *Trilogy of Life*, constitute a fascinating experience for me.

The great majority of the stories from *A Thousand and One Nights* are about a journey. When the story is so short that there is no way a full journey can be described, it's an anecdote about a traveler: therefore, even if the story is all there, at that intersection, in that marketplace, we are always "elsewhere."

The journeys in *A Thousand and One Nights* are always the result of an initial anomaly of destiny. Everything is normal: destiny is normality, and then the unforeseen happens: destiny "manifests" itself in a highly anomalous way. And it happens in a way that is in part irreverent, and usually humorous, hierophanic. Normality is interrupted through God's intervention (or through his mechanism, Destiny), and after the first anomaly comes another. There follows a chain of anomalies. This chain extends through the narrative of the journey, or rather through the schema of consciousness and the conquering of the "elsewhere." The hero is destined to return: and to return precisely to normality. However, he returns visibly transformed. His discovery of "elsewhere" was a kind of initiation.

My film *Il fiore delle Mille e una notte* is also a long journey, and the hero (or heroes), however passively, take the heroic strides of someone undergoing a great test. The structural schema of the "journey" was also the schema of *Uccellacci e uccellini*; it can also be said that it is the schema behind *Gospel* (the journey to Jerusalem). Indeed everything actually begins with the journey of Christ ("When Christ first comes on screen he looks like a painter who, for the first time in the history of painting, sets out to paint *en plein air*," is what Roberto Longhi told me about the scene in *Gospel,* and I hold his words close and safe at the bottom of my heart like a precious treasure).

Now, with *Il fiore delle Mille e una notte* out of the way, I'm wavering between two projects: *Saint Paul*, or a film about Ideology. St. Paul means the "journeys" of Paul, so this is supposed to be a film about journeys. But for Paul the initiation has already happened, like a thunderbolt: he was reborn, or really *born* on the road to Damascus (while traveling!). His other journeys for purposes of organization, elections, or catechistic teaching, and are therefore unpleasant. My film about Paul is anti-Church (founded by Paul and not by good old St. Peter). The travels of St. Paul, the priest, stand in a sort of opposition to the immobility of St. Paul, the saint. So the film is also the representation of a clear dissociation bordering on schizophrenia. On the one hand there's the founder of the Church – strong, energetic, self-assured, fanatical (and therefore odious); on the other, the humble creature "enraptured to the Third Heaven" – sickly, weak and tormented by questions of God.

But the other project about ideology is also a story of a long journey. A comet (Ideology) leads one of the Magi on a long journey. In following it he experiences the whole of reality, from one "elsewhere" to another: Naples, Rome, Milan and Paris – all metaphors of other cities, archetypal cities. As I said I don't know which of the two films I'll make first. Basically, however, the theme will be journeys. Right now, having nearly reached the end of my own journey, I'm not in a frame of mind for telling their story, and I'm not even sure I learned anything from them.

"Il mio lungo viaggio," *Tempo illustrato*, Rome, May 31, 1974, later in *L'Oriente di Pasolini*. Il fiore delle Mille e una notte *nelle fotografie di Roberto Villa*, ed. Roberto Chiesi, Cineteca di Bologna, Bologna 2011

Il padre selvaggio (The Savage Father) only got as far as a scenario. The other project I had at the time was called *Bestemmia* (Blasphemy) which I abandoned because I did *Il Vangelo*. But I've gone on working on it and I've written it out as a poem – it's a script in verse form. Eventually I'll publish it as I've been dragging it around now for five or six years.

Charles de Foucauld was another vague project. I've decided to scrap that idea and all the other saint ideas I've had and do a life of Paul, which I'm going to start in the spring of 1969. It will be completely transposed onto modern times: New York will be Rome, Paris will be Jerusalem, and Rome will be Athens. I've tried to find a series of analogies between the capitals of the world today and the capitals of the ancient world, and I've done the same thing for the actual events – e.g. the opening episode where Paul, who is a Pharisee, a collaborator and a reactionary, is standing by at the murder of St. Stephen, along with the executioners, is going to be done in the film with an analogous episode during the Nazi occupation of Paris, where Paul will be a reactionary Parisian collaborator who kills a Resistance fighter. The whole film's going to be transpositions like that. But I'm going to be extremely faithful to the text of St. Paul and his words will be exactly the words he uses in his letters.

From Oswald Stack, *Pasolini on Pasolini,* Thames and Hudson, London-New York 1969

THE SAVAGE FATHER

Chapter I – Killing the Lion is Beautiful

The beginning of the school year in an African secondary school in the capital of an African state that acquired independence one year earlier. The secondary school: four one-storey shacks in a flat dusty clearing of red earth amid some palm trees.

A democratic schoolmaster teaches in the school, he's a new arrival in the new State. He is about to begin his dramatic experience teaching African students who are mostly children of civil servants and local tribal chiefs; he will fight the conformism taught to the children by previous colonizing teachers.

Among his students, there is a certain Davidson who is the most hostile to the new methods and culture of the new teacher. He is the most hostile precisely because he is the most intelligent and sensitive of them all. It is, in fact, the intelligent and sensitive ones who feel so passionately about things that their attachment to them, and even to the institutions that promote conformity and empty rhetoric, can become disruptive.

At the core of this struggle is the problem of freedom and the democratic relationship between blacks and whites.

From the direct and extremely sincere dialogues with the teacher we get a detailed political picture of the recently freed African state. Its relationship with the UN, its connection to the ex-colonial state and so on…

The new teacher's methods, the way he explains things, precisely because he is sincere and democratic, always appear "scandalous" to the students who are used to supine acceptance and to the mechanical ways of an authoritarian education.

One day, for example, the teacher gives the students the following subject to write about: "Describe your real life in the tribe, at your homes, in the forest." What he gets are rhetorical and mystifying compositions. So the teacher rephrases the topic: he wants his students to courageously discuss the embarrassment, misery, and superstitions in the tribes that they come from. He tries to explain "prehistoric culture," "magic," rituality, taboos, cannibalism, and so on, to them..

After the third or fourth attempt a kind of miracle occurs: Davidson writes a very sincere composition and because it is so well written it has a kind of poetry to it. He writes in a vivid manner and includes imaginative details from a typical tribal situation. When a boy becomes a man, it is his duty to kill a lion.

The teacher, amazed and happy, praises the composition in front of everybody and comments, after having read it, on the useless and cruel habits of the tribes.

The students understand the teacher's criticism of the archaic ways of the tribe, which are now superseded by the history of the African people. Nonetheless, Davidson can't help but say in his sweet, deep voice, "But killing the lion is beautiful!"

Yes, it's not easy to take a critical distance from one's life and world. And this instinctive vitality is the basis for another level of intellectual laziness and conformity.

Especially in their study of poetry, the students show laziness and mental reservations: they don't understand "modern" poetry. They are unthinkingly used to academic classicism…

Here, too, the teacher tries to deal with the "scandal" and reads his students a difficult poem by an African poet, Niger or someone like him: a poem that echoes the refined European models of an Eliot or a Dylan Thomas…

The black students have the same reaction as most of the white students, they don't understand it, they get distracted, they almost laugh at it.

Slowly, the teacher explains it to them and comments on it with concrete and immediate examples that they all comprehend; he makes the once incomprehensible verses clear and brilliant.

But Davidson does not want to understand.

(N.B. This first part may seem dry, but all the dry political and cultural discussions are illustrated with visual episodes: documentaries regarding the political situation of the State, the relationships with the UN and so on. The composition written by Davidson on the hunting of the lion is the focus. And finally, the

comment on the difficult poem by the teacher will be lived visually through episodes with rapid details where the pupils themselves will be the protagonists).

Chapter II – The strong colors of a Cubist painting

The final days of the school year are the same in all schools across the world: full of regrets and hopes, sadness and joy. The results are what they are; miracles never happen even if progress has been made, knowledge acquired, and resistance overcome.

But during these same final days of school, when kids should feel optimistic about the things they have accomplished with effort and passion, there's a vague air of anguished pessimism.

There is unrest in the new black State; it is still a long way from achieving real independence, real freedom. The colonialists are still present, they wear the faces of private capitalistic exploiters and they protect their interests by unscrupulously fomenting bitterness and separation in the country, even civil strife.

Some tribes rebel and fight other non-secessionist tribes ferociously; the UN has to send in new troops to maintain order in the country.

In this atmosphere of vague, imminent tragedy, the first year of the democratic school comes to an end.

But the students nurture the ancient joy of vacation that is the same everywhere in the world; they are kids, after all…

Davidson will head to the interior and spend his vacation in his village. The day before he leaves he wanders the streets of the capital with his best friends for a little fun. The "strong colors of a Cubist painting" are visible in the port, in the colorful locales where the young amuse themselves, and where whites, Indians, Arabs and blacks mingle.

The cafes are full of people: happy people, dressed in colorful clothes, like Americans.

In one of these cafes, Davidson bumps into his teacher; it's the first time they've ever met outside of school. The teacher is with his white friends, his compatriots, young "Blue Berets": blond, happy men who

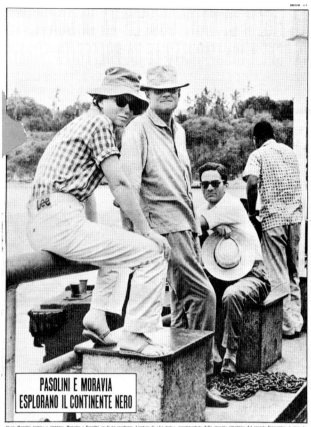

Dacia Maraini, Alberto Moravia and Pasolini during the location hunting in Africa for *The Savage Father* (from a magazine)

are a little drunk and full of youthful bluster. One of the men, a friend of the teacher, comes from the same European city.

The young blacks and whites become friends, the teacher introduces them to each other; in fact, he is rather young himself…

Then the teacher leaves and the young people stay on. They drink, they get a little drunker; they hug each other and go off to find women.

The big dream of the black kids is to make love with a white woman: they know the poet's words about this ancient, desperate desire by heart… They go looking for the white woman in the pleasant neighborhoods by the port… but along the way something stops Davidson. It's a black girl with her friends… (This is a scene that

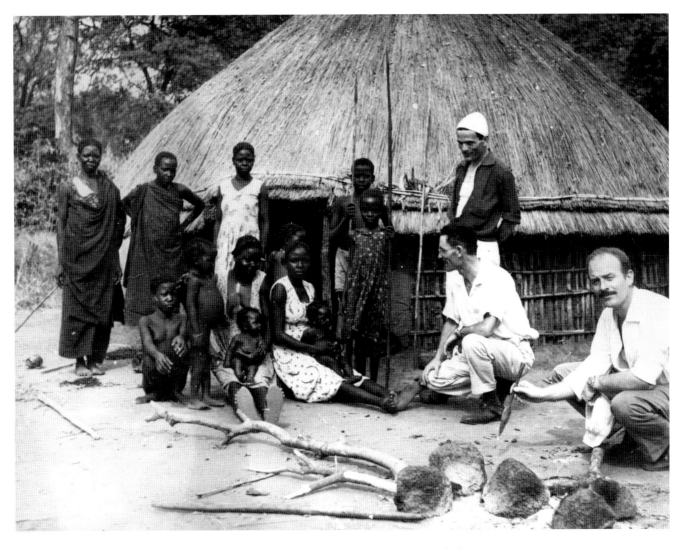

Pasolini and the producer Alfredo Bini during the location hunting in Africa for *The Savage Father*

needs to be developed on location, in keeping with African psychology and habits). Davidson leaves his friends, makes his excuses… talks to the girl… stays with her. He falls in love with her. Then after the vacation…

Chapter III – Black light

Everything that the kids' stories relate, everything said in their compositions or in conversations with the teacher, everything the kids rationally understood of the teacher's learned comments, we now see before us.

This is the prehistoric world of Africa, and it has just been touched by history.

The tribal life, the taboos, the rituals, the hatred.

We are entirely *inside* African life, where characters can speak in their own language without translation, either spoken or written; the world is entirely theirs and they express themselves entirely in their own language. But their actions, in their untranslatable mystery, are entirely simple, and speak atrociously for them.

Davidson has fallen back into his own world, in the heart of Africa.

In moments of tranquility and normality, his "his-

torical culture," his European culture, could become part of his family and friends in the village. But this is not a moment of peace. The tribe is part of a region of the State that has proclaimed its own independence, and a real and proper war has started in the forest.

And war, with its terror and contagious thirst for killing, can't be anything but regressive. In war, everything that is historical and civil disappears, reduces itself to pure machinery – to objects that are used for killing: weapons, jeeps, airplanes.

Gradually, Davidson's village becomes the most ferocious center of the brief war.

White mercenary troops, UN troops, and African troops all face off in wild, useless, frightening and senseless battles; political chaos coincides with the ancient beastly rage of men born in the jungle.

Davidson, slowly, but necessarily, falls to an abject condition: he abjures his conscience without being conscious of it. Little by little, the ways of the tribe become his own; because they are the ways of his father, brothers, relatives. He takes up weapons and fights alongside them. It's an epidemic, a plague.

Fighting against the secessionist tribes are the UN troops, including the "Blue Berets" that Davidson had met in the capital.

In alternating scenes of almost total silence with poetic and documentary overtones, in the most funereal forest, perhaps even in the rain – we follow the story of the "Blue Berets" on the one side, and the black and mercenary troops on the other. There's a war scene, one of the many vain and ferocious ones, near an airport situated deep in the interior.

The Blue Berets, with their homesickness, their world as young Europeans, their typical soldierly camaraderie; the Blacks with their prehistoric rage, rituals, dances; the concentration camps; the collective hunger, the massacres.

A group of whites, including Davidson's "Blue Beret" friends, are captured and taken prisoner. Taken to the village. Killed. Slaughtered.

With the ferocity of past eras, religious rituals of cannibalism rise to the surface: vertiginous folly. Two or three nightmarish images. Davidson is among the tribe members who take part.

Chapter IV – The Dream of Something

Peace returns. The schools reopen. It's the first day of a new school year. The students arrive full of excitement; not like other years, when school was a boring obligation. Now, with the new teacher, things are going to be different.

And so the teacher, sitting down his desk, has the amazing surprise of seeing that his teaching has yielded surprising fruits. And a wave of emotion comes over him and his students.

He steps away from his desk and walks between the desks, among his kids: they are like friends meeting up again. Davidson looks at him robotically and erupts into a kind of terrorized moan.

And so begins Davidson's "illness." Mysterious to all, because it is unfamiliar and unimaginable to all, his trauma has produced a neurosis.

Davidson does everything mechanically: eats, sleeps, goes to school, in a certain manner he even manages to study. But it's as if he were disassociated from himself, as if he were someone else.

He learns the basic ideas, writes the compositions, answers the scholastic questions; but it is as if something separates him from reality, keeps him in a world of shadows and terror.

The teacher goes looking for his Davidson, the student he had put so much hope in; and Davidson understands this. Just as he is aware of his "illness" and understands his teacher's long and detailed explanations of nervous illnesses; and he tries to work with this man who interrogates, observes and scrutinizes him.

Where does Davidson go after school? What does he do?

The teacher follows him: Davidson doesn't go anywhere. He wanders around like an automaton. He avoids the markets but without any inner passion. Often he goes to the port, to a certain deserted place.

One day, in a corner of the port, while Davidson is there, a black girl stops and smiles at him and goes up to him. But Davidson, almost afraid, doesn't answer, then turns and runs away. He goes and cries at the edge of the forest like an animal, in a desolate spot.

He's not so sick that he's a lost cause. His neurosis is a kind of paralyzing crisis that keeps him in a state of absence and refusal to exist.

Perhaps the miracle happens by chance. Sometimes neurosis contains its own cure… A God can appear, or a holy image… But also a phantom of another kind…

One day, in class, the teacher re-reads the poem by the great African poet that he read the year before and that his students, Davidson in particular, didn't understand. Everyone now understands it, and Davidson, when he hears it, finally shows some sign of life… the teacher realizes this and reads the poem out loud with all his soul. The spark of life in Davidson's eyes and face soon goes out, but not entirely, not completely…

While the kids are playing soccer in the clearing in front of school, Davidson goes and sits off to the side. He's thinking… and in his head he hears words. They are verses. He hears them and he repeats them. He gets up. He goes to the classroom, to his desk, to write. They are devastating lines, lines of utter desperation and death; they are not just his, not just Davidson's, but belong to the entire black race.

The following day, Davidson, with the spark of life in his eyes, goes up to his teacher and timidly, in silence, shows him what he wrote.

The lines are beautiful; and the teacher tells him so immediately, with great surprise and happiness. He tells him that they are so beautiful that he will send them to a European magazine so they can be published, and he hugs him, full of hope.

Davidson, who had always cooperated with his teacher in his impotent struggle against the "illness," now realizes, along with the teacher, that something has happened.

The "illness" is no longer part of him like a malignant force, making him absent and mute; it is no longer unfathomable and invincible; it has begun to break down.

Expressing himself means healing. It doesn't matter if the expression is confused or if the hope that lies beneath the expression is only "the dream of something," as Marx says.

With this timid hope in the bottom of his heart, Davidson wanders to his usual place, back at the port. He is glum and upset.

And then again, while he's walking, the voice, the inner voice, tells him other desperate lines: Black man, what is the use of loving? To give birth to other unhappy black men like yourself?

And when he sees his girlfriend with her friends, happily walking along, heedless, unknowing, other lines come to mind. But they are more human, they blossom explicitly with the hope of "the dream of something," a confused but happy future, the thought of which gently brightens the darkness of the black boy's face.

"Il padre selvaggio," *Film selezione*, no. 12, July-August 1962

NOTES FOR A POEM ON THE THIRD WORLD

Introductory Notes

As the title says, the theme of this film is the Third World, and specifically India, Black Africa, the Arab countries, South America and the Black Ghettoes of the United States.

Each one of these countries is the "setting" for an episode: the film consists of five episodes. These episodes will not be – in all probability – clearly divided: there will be no ending separating one and the other. The argument will remain the same. And of course there will be no lack of other settings mixed in with these five fundamental ones – for example Southern Italy, or the mines of the larger Northern countries with their shantytowns filled with Italian, Spanish, Arab and other immigrants.

The fundamental themes of the Third World are the same for all the countries that belong to it. As such, these themes will be present, implicitly or explicitly, in all five episodes.

And yet each episode will deal with, or rather will emphasize, a particular theme.

The episode filmed in India will include the themes of the pre-industrial world in the process of development: Religion and Hunger (see below for the subject of the episode).

The episode filmed in Africa will deal expressly with the relationship between "white" culture (i.e. Western, that is, rationalistic, characterized by a bourgeoisie, and altogether industrialized) and the culture "of color," that is, archaic, folk, pre-industrial and pre-bourgeois cultures (with the resulting conflict and all of its dramatic ambiguities and indissoluble problems).

The episode filmed in the Arab countries will focus on "nationalism" as a necessary phase for the petite bourgeoisie now emerging as a result of early industrialization. Nationalism and how it leads to war: whether it is right (in the case of the Algerian war of independence against the French) or wrong (in the case of the war – represented in our episode between the UAR and Israel).

The episode filmed in South America will cover the specific theme of "guerrilla warfare": the conflict within revolutionary forces in countries where class consciousness is still immature (constituted as they are by immense masses of urban or agrarian sub-proletarians), or, in actual terms, a conflict between orthodox Marxism and Castroism.

The fifth episode, the one set in the ghettoes of North America will focus on the theme of "dropping out," which is to say exclusion and self-exclusion as two equally dramatic elements of racism and the resulting violence.

All of these themes are already part of the consciousness of many minorities (through the testimonials and words of many writers from Sartre and Fanon to Obi Egbuna and Stokely Carmichael et al). So, in historical terms, the film will treat them as objectively as possible. They constitute the logical unity of the film. All the same, together with this logical unity there will also be an affective unity: a "sentiment" will connect these five episodes and will be the *raison d'être* of the film, its subjective aspect, and its style. This "sentiment" will be violently and perhaps even unrealistically revolutionary, so that the film itself is an act of revolution (non-partisan, of course, and entirely independent).

The immense amount of ideological, practical, sociological, and political material that is used to make a film of this kind obviously prevents us from making a formal film. It will have to follow the formula of "A film about a film that needs to be made" (this explains the choice of the title as "Notes for a poem etc.").

Each episode will be composed of a story, with some brief narration during the most important and dramatic scenes, and location scouting scenes for the story

Pasolini shooting *Appunti per un film sull'India*, in 1967

itself (with interviews, enquiries, documentaries etc.). The excerpts of the episodes in which the story is told according to normal procedures will be filmed and edited normally: the excerpts of location scouting "for the story that needs to be told" will retain their casual and immediate qualities.

Stylistically, therefore, the film will be heterogeneous, complex and spurious; but the starkness of the problems discussed and the purpose of direct revolutionary intervention will keep it simple.

Arab Countries

The film begins (and ends) in the Sinai on the day after the end of the Six Day War.

The desert is full of destroyed tanks, fallen airplanes still burning, abandoned camps, and the dead. Piles of dead bodies. The Arab army has become, in fact, an army of the dead etc. The burning napalm, the horrible mutilations caused by bombardments etc. Authentic documentary material will represent this situation in all its horrible truth.

Among the heaps of cadavers of Egyptian (or Jordanian) soldiers lies a man; the camera stops on his body, isolating it from the rest. He's young, a boy, strong etc., burnt and mutilated.

Slowly his burns and mutilations disappear, his skin goes back to being beautiful, healthy, intact, and sweet. The boy looks like he is asleep.

The camera stays on him, as if expecting something. This something happens, and the cadaver comes to life.

And so a long interview with the revived corpse begins, with the desert and the dead in the background, surrounded by the final fires.

The actor who plays the part of this young dead Arab soldier (whom we will call Ahmed) is Assi Dayan, the son of General Dayan.

The interview with the dead, revived Arab soldier actually splits into two distinct interviews: the first interview is with the actor, Assi Dayan, and the second interview is with the character, Ahmed.

The two interviews alternate according to the canonical scheme of "alternate editing."

Now, Assi, the son of Moyshe Dayan, is speaking. He is a well-educated and conscious young man. Ahmed, on the other hand – the character that he interprets – doesn't speak because he is young, illiterate, innocent and unknowing.

The interview with Assi Dayan will therefore be spoken: the other interview with Ahmed, which alternates with this one, will be silent.

Following the discourse of Dayan as pretext, the film will gradually turn into an enquiry or documentary on Israel: an industrialized state, or rather, technocracy, very civilized, etc. We will see its factories, the way of life that is lived there, its kibbutzim, and so on. But above all, we will hear the reasons (of young Dayan, of his father, of Ben Gurion – and those of the dissenters). All of these reasons will tend to justify nationalism (or Zionism) above all and the resulting war.

Ahmed's storyline gives us the pretext for filming a documentary on his "underdeveloped" country (either Egypt or Jordan). To do this, we need only see – with no words – some of the moments from the boy's every-

day life in times of peace. We see his miserable country village; his poor home; his work; his friends; his fiancée (whom he doesn't know); the political atmosphere he lives in (fanatical Nasserian nationalism). He too, therefore, without speaking or commenting, and only by representing himself, will answer the same questions that Dayan answers: why nationalism and why war.

The reasons that Dayan gives by speaking and the reasons that Ahmed gives with his uncomprehending silence are equivalent. There can be no choosing between the two.

At the end, the cadaver – resuscitated only for the time necessary for the interview – will re-form its horrendous wounds, its atrocious burns, and it will lose itself in the unforgettable silence of death.

It is this conclusion, this pure expression of inexpressible grief, that will be the moral judgment of the film. In other words: a condemnation of every kind of nationalism, in whatever historical form, and of war, for whatever reason.

In fact, the young, well-educated Israeli and the young illiterate Arab are the same person. They are the same dead boy, to whom no one will be able to give back a life that was lost for unjustifiable historical reasons disproportionate to eternity.

South America

The episode set in South America (together with the one set in the ghettoes of the United States) is the one closest to an investigation or to a location scouting, using the story it tells us a simple, veritable storyline. This story is the story of Che Guevara in Bolivia. The narrative pretext for this episode is a "letter" he wrote to his mother who stayed in Europe. The pretext serves to simplify and humanize the arduous, polemical, and desperate theme of guerilla warfare and to explore the resulting ideological tensions between orthodox Marxism and Castroism.

The locations allow us to see if the agrarian and worker populations of South America are ready for a revolution or if they are still politically immature and

incapable of the kind of decisions that will make them responsible for their own destiny.

The central interview of the episode will be an interview with Fidel Castro (and in the event such an interview is not possible, there will be a short reading of his funeral Oration for Che Guevara). The life of Che Guevara, as mentioned, and especially the final part of it leading up to his death, will be seen in short glimpses; in the other episodes an actor performs the role of protagonist, but here Che Guevara will represent himself (through the minimal use of archival footage).

Ghettoes of North America

The protagonist of this episode will also be a historical figure who recently died, and precisely in the way he expected: Malcolm X.

In this case, an actor will play him -- but even more than an actor we could call him a demiurge, or transfer figure. In fact, unlike the episode of the Arab Countries, in which the young Dayan played a young Arab, a character totally unlike him in a racial, social and human sense – here the person playing Malcom X could be Cassius Clay or Stokely Carmichael or another Black Power leader. In this way, both character and interpreter would be perfectly analogous, racially, socially and humanly.

Following the actor and guide, the episode will tell the story, in mediated fashion, of Malcolm X (compare with his "Autobiography"), and at the same time it will be a documentary on the life of Blacks in America and what they think of themselves. In particular, how they act within the ideological spheres of "black power," from "violence" to "self-exclusion" etc. The only narrated scene that follows a typical movie outline will be the scene of the assassination of Malcolm X.

Note for *The Savage Father*

The following pages, though presented in the form of a treatment, are actually a proper screenplay. The only thing missing from the text is the dialogue.

In the film that I will make on *The Savage Father*, there will be no dialogues (or they will be reduced to a few lines): indeed, the dialogue part of the film can be entirely abolished and replaced with interviews and enquiries that express the same concepts (in other words, the difficulty of being a white, rationalistic, and Marxist teacher teaching black students in an irrational farming culture who tend to take on a reassuring form of conformity from the educators).

The interview-guide for these problems might be an interview with Sartre.

This interview could return throughout the film as a kind of link between the vital scenes (filmed in the stark manner of silent films) which will represent only actions and situations (the arrival of the teacher and the first day of school; the first escape of the black boy protagonist; the meeting with the white soldiers; vacation in the native village; the battle; the allusion to the ritual of anthropophagy; the return to school; the resolution of the drama).

Notes on the film on India

The idea for *Notes for a Poem on the Third World* came to me while filming a documentary in India that was about scouting for locations for a film in this story.

While filming in India, I realized the enormous vastness of possible subjects for a film on the Third World: India, on the one hand, did not present itself as a typical Third World country (in fact it lacks some of the essential situations: for example there is no truly strong political opposition that tips the balance towards violent forms of contestation); on the other hand, the other problems it has in common with the Third World are of such vast and elusive proportions that "reducing" them to the duration of a normal-length film is a very difficult task.

I would reduce the Indian film to the fundamental themes of Religion and Hunger (in other words, I would go back to the initial schema of the story), glossing over the other, but dramatizing to the utmost the tension between those two fundamental themes. In fact, reducing

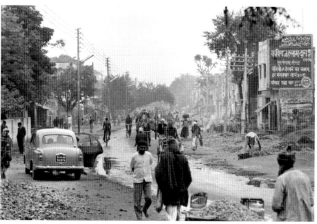

On the set of *Appunti per un film sull'India*, 1967

the film to episodes, I would be forced to concentrate everything on the five dead figures: the father who gives himself over to the tigers, the mother and the three children who die, one by one, of starvation.

"Appunti per un poema sul Terzo mondo," in *Pier Paolo Pasolini Corpi e luoghi*, eds. Michele Mancini and Giuseppe Perrella, Theorema, Rome 1981, later in *Per il cinema*, Mondadori, 2001

SAINT PAUL

The poetic idea – which should become at once the film's guiding thread and its novelty – lies in transposing the whole story of Saint Paul to our times.

This does not mean that I want somehow to tamper with or alter the very letter of his preachings. On the contrary, as I've already done with the *Gospel*, none of the words uttered by Paul in the film's dialogues will be invented or inferred by analogy. And since it will of course be necessary to make a second selection of the saint's apostolic speeches, I shall make this selection in such a way as to encapsulate the entire span of his apostolate (and for this I will seek the help of specialists, who will guarantee the absolute faithfulness to the whole of Paul's thought).

Why do I wish to transpose his earthly story to our times? It's quite simple: to create cinematically, in the most direct and violent manner, the impression and conviction of his relevance to the present day. To create explicitly for the viewer, in short, and without even forcing him to think, that "Saint Paul is *here, today, in out midst*." That he is addressing himself to our society. It is our society that he laments and loves, threatens and forgives, attacks and tenderly embraces.

By applying such temporal violence to the life of Saint Paul, making it unfold again in the mid-Sixties, naturally requires a whole long series of transpositions.

The first, and most central, of these transpositions consists of replacing the conformism of Paul's times (or rather the two types of conformism, the Judaic and the Gentile), with a contemporary conformism – which will be that typical of present-day bourgeois civilization, in both its hypocritically and conventionally religious aspect (analogous to that of the Jews in Paul's day), and in its secular, liberal, and materialist aspect (analogous to that of the ancient Gentiles).

This major transposition, basing itself in analogy, inevitably implies many others. Within this play of transpositions implying one another in turn and requiring therefore a certain consistency, I would, however, like to maintain my own freedom of choice. Since my primary purpose is to represent Saint Paul's ecumenical apostolate faithfully, I would also like to liberate myself from the requirement of a certain external, literal consistency. I'll explain.

The world in which Saint Paul lives and works – in our film – is thus the world of 1966 or '67. It is therefore clear that all the place names will have to be changed. The center of the modern world – the capital of modern colonialism and imperialism – the seat of modern power over the rest of the globe – is no longer Rome. And if it's not Rome, what is it? I think the answer is clear: New York, together with Washington. Secondly, the cultural center, the ideological, civil and, in its way, religious center – the sanctuary of enlightened, intelligent conformism – is no longer Jerusalem, but Paris. The city equivalent to the Athens of that time would be, roughly speaking, today's Rome (seen naturally as a city of great historical but not religious tradition). And standing in for Antioch, by way of analogy, would perhaps be London (as the capital of an empire antedating American supremacy, just as the Macedonian-Alexandrian empire preceded the Roman).

The theater of Saint Paul's journeys is therefore no longer the Mediterranean basin, but the Atlantic.

Moving from geography to socio-historical reality, it is clear that Saint Paul demolished, in revolutionary fashion, by the simple force of his religious message, a kind of society based on class violence, imperialism, and slavery above all. It is therefore clear that the role of the Roman aristocracy and the various ruling classes of its collaborators abroad would be played, by analogy, by the present-day bourgeoisie that controls capital, while the meek and humble would become, by analogy, the remaining lower bourgeoisie, the working class, and the lumpen proletariat of today.

Naturally, none of this would be presented so explicitly or didactically in the film! Things, characters, and places will speak for themselves. And from this will arise the most novel and perhaps poetic aspect of the film: the "questions" the new converts ask Saint Paul will be the questions of modern men; they will be specific, detailed, problematic, political, and formulated in a language typical of our times. Saint Paul's "answers,"

on the other hand, will be what they already are: that is, exclusively religious, and for the most part formulated in the language typical of Saint Paul, universal and eternal, but not current, in the strict sense of the term.

Through this process the film will thus reveal its underlying theme, which is the opposition between "contemporary relevance" and "holiness." Between the world of history, which tends, through its excess of presence and urgency, to flee into mystery, abstraction, and pure questioning, and the world of the divine, which, in its religious abstraction, comes down to mankind and becomes concrete and operative.

As for the film's composition, I can imagine doing an "episodic tragedy" (according to Aristotle's ancient definition) – since it seems apparently absurd to recount Saint Paul's life in full. It would be a series of significant, decisive episodes told in such a way as to include the others as much as possible.

At the start of each of these episodes, which will take place in our time, the real date will appear on the screen (63 or 64 AD, and so on). Similarly, for clarity's sake, before the opening credits appear, a map of Saint Paul's actual peregrinations will be shown, replacing that of the "transposed" itineraries.

What follows is a rough outline of some of the episodes that will most likely constitute the film's skeleton.

1) *The martyrdom of St. Stephen*

We're in Paris, during the Nazi occupation. Among the French, some are collaborators, some protest passively, others put up an armed resistance (the Zealots). Saint Paul, a Pharisee, is a bourgeois well entrenched in his society by long family tradition. He opposes the foreign domination only in the name of a dogmatic, fanatical religion. He lives in a state of unconscious insincerity, which creates an almost insane tension in his soul, which was made for being sincere in the extreme. The events of Stephen's trial and death unfold exactly as they are narrated in the *Acts of the Apostles* – while integrating other historical testimonies. No event or word will be invented or added. Except, of course, for the fact

that instead of an ancient stoning, we will witness an atrocious modern lynching. But the dying Stephen will utter the same words of forgiveness. And Paul – present at the execution, representing the officialdom that believes it will thus free itself of the truth that will in fact destroy it – will heed them.

2) *The conversion*

As in the Acts of the Apostles, Paul asks to go to Damascus to continue the persecution of Christians. Damascus in our case is a city outside the Nazi domain – it could be in Barcelona, Spain, for example – where Peter and other of Christ's faithful have taken refuge. The journey through the desert is also a journey across a symbolic desert: we are along the roads of a great European nation, in the countryside of southern France, then the Pyrenees, then Catalonia, lost against the hopeless background of war – in a silence that could be made real and tangible by completely muting the film's soundtrack, so as to render imaginatively, and even more anguishingly than reality, the notion of the desert. On one of these large modern roads full of traffic and normal acts of everyday life, but plunged into total silence, Paul is struck by the light. He falls, and hears the voice of his vocation.

Blinded, he reaches Barcelona, where he meets Ananias and other Christian refugees. Converted, he joins up with them, then decides to withdraw to the desert to meditate.

3) *The idea of preaching to the Gentiles*

It's what in screenplays is called a "turning point." Paul returns to his new friends, already holy, drawn by an élan of love and inspired willpower, when an idea of his own reverses the situation and creates terrible new difficulties and entirely new prospects. It is a veritable revolution within the revolution. I would like to reconstruct the concrete moment (perhaps inventing it, if there is no direct testimony), in which a new light of inspiration comes down to Saint Paul.

Thus begins his apostolate – of which we shall see the first acts – which was "scandalous to the Jews, and foolish to the Gentiles."

4-5-6) *Adventures in preaching*

A series of three or four "typical" episodes of the first phase of his preaching – "typical" and therefore also representative of entire series of other episodes whose story can't be told. For the series of episodes of the conversion of people belonging to the cultured upper classes, we could select the preaching in Athens (which we said we would replace, by analogy, with modern Rome, skeptical, ironic, liberal); whereas for the series of episodes dealing with the conversion of simple people, we could select two stories, one involving workers or craftsmen, the other the most sordid, abandoned lumpen types – such as the story of the makers of silver "souvenirs" at the temple of Venus (if I remember correctly), who see their gains decrease as the temple, a pilgrimage destination, becomes discredited; and the story of that group of poor devils who, to make ends meet, pretend to be able to drive the devil out of the possessed, like Paul and in Paul's name, but do not succeed and meet a bad end, and so on in this fashion.

7) *The dream of the Macedonian*

The episodes I described in the previous paragraph could all take place in Italy. Now Paul heads northwards. The dream of the Macedonian could therefore be replaced by a "dream of the German."

Paul has one of those painful sleeps of the sick, which has him moaning as though delirious. And then suddenly, in the profound peace of a dream a beautiful figure appears to him: a young German, blond and strong. He speaks to Paul, entreats him to come to Germany. His call, in which he lists Germany's real problems, and why Germany needs help, sounds "unreal" inside that holy dream. He talks about neocapitalism, which satisfies only pure material well-being but withers the

soul, about the Nazi revival, about the blindly technical interests that have replaced the ideals of Classical Germany, and so on. But as he's speaking this way, the strong blond youth slowly – as though something outside of him were physically manifesting his inner state and truth – turns paler and paler, fatigued, devoured by a mysterious illness; little by little he becomes half-naked, horribly emaciated, and falls to the ground and curls up: he becomes one of the atrocious living corpses of the concentration camps…

Almost as in a continuation of this dream, we see St. Paul in Germany, having heeded this call. He is walking with the fast, sure step of the Saint along a vast autobahn leading straight into the heart of Germany…

(I've lingered on this point because this is where the film's theme is established. And it will be further developed mostly in the final part of the martyrdom in Rome (New York) – that is, the contrast between the "present-day" question asked of St. Paul and his holy "reply.")

8) *Religious and political passion from Jerusalem to Caesarea*

Paul is back in Jerusalem (Paris). Here begins the chain of violent, dramatic events, which are too well known for me even to summarize here. They will be the most dramatic sequences in the film and conclude at Caesarea (Vichy) with Paul's request to be judged in Rome.

9) *St. Paul in Rome*

This will be the film's longest and richest episode. In New York we are in the navel of the world. Here "contemporary" problems attain a maximum level of violence and prominence. The corruption of the ancient world, together with the anxiety fed by a confused sense of the end of that world, is replaced by a more desperate corruption, an atomic desperation, so to speak (neurosis, drugs, the radical questioning of the society). The dominant condition of injustice in a slave-society

like that of Imperial Rome can here be symbolized by American racism and the condition of the blacks. It is the world of power, of the vast wealth of the monopolies on the one hand, and on the other, the anguish, the death-wish, and the desperate struggle of the blacks, whom St. Paul is trying to evangelize. And the "holier" his response, the more it upsets, contradicts and alters the current reality. Saint Paul thus ends up in an American prison and is sentenced to death. His death will not be depicted realistically (though, as usual, the electric chair will replace, by analogy, the decapitation); instead it will have the mythical and symbolic aspects of a re-evocation, like his fall in the desert. St. Paul will suffer his martyrdom in the middle of traffic on the outskirts of a paroxysmally modern big city, with its suspension bridges, skyscrapers, the vast, crushing crowd that passes by the spectacle of death without stopping and continues to swirl around, down its enormous streets, indifferent, inimical, without meaning. But in that world of steel and cement the word of "God" has resounded (and keeps on resounding).

From *San Paolo*, Einaudi, Turin 1977

PORNO-TEO-KOLOSSAL

The Cinema

Two characters on a "journey" (the discovery of the world, cf. Don Quixote). The journey is guided by an ideological eschatology: discovering without wanting to, guided by another false purpose. Believing that one has reached a goal, one discovers reality as it really is, without any goal whatsoever.

The two characters are a Wise King (one of the many dozens of Magi who set out to worship the newborn Messiah etc.) and his servant.

The outline of the story is as follows: the Wise King sets out towards the place where the Messiah is born, but the along the way so many things happen to him that when he gets to the Place, not only has the Messiah been born, but he has already lived his life and is dead, founding a religion that is also over.

Arriving at the Place in vain, the King dies.
The gruff, coarse, and feckless servant who has accompanied the King reveals himself as the King is about to die: He is an Angel, and he takes the King by the hand to take him to Heaven, which the King has earned. But Heaven is gone. The two turn around like Lot's daughters and become pillars of salt.
(They turn around towards the world of Reality, whose values they have discovered while seeking others).

The story begins in Naples, where rumor has spread that a Messiah is about to be born. San Gennaroesque scenes of fanaticism, celebrations, processions, pandemonium, etc. (*cinéma vérité* style).

The Wise King sets out from Naples (played by Eduardo De Filippo) with a little Roman servant, il Romanino (played by Ninetto Davoli), mustachioed, disrespectful, absent-minded, argumentative, and rude (he's cheerful only when he feels like it).

They get on the train (in black and white: the "journey" as such is filmed in the style of comic classics, directly quoting them – Keaton, Chaplin) and orient themselves towards the point indicated by the star.

On the train, metaphysical discussions and small talk, inserted into the silent comic context.

The road signs the train passes say "Gomorrah."

The train stops at Gomorrah, the two get out and their first adventures begin: in detective style, Western style, musical style, thriller style.
In Gomorrah "heterosexual" sex creates social chaos: crime, rape, bank robberies, orgies, nightclubs.

Seven or eight stories of this sort interrupt the King's journey and make him stop. He gets involved out of curiosity and the pity he feels, despite the fact that it all lies outside of his eschatological purview.

The peculiarity of these interruptions of the journey stems from the fact that the King isn't interested in the stories he gets involved in because they concern pity, purity, morality etc., but because they involve vices. The Wise King, in short, gives of himself and his treasures (reserved for the Messiah) to help others with their vices, which make them unhappy. To give them, in spite of themselves, a little happiness.
In this way he helps lovers, men and women in their tawdry, wild affairs; he helps some hippies (so to speak), who are utterly stupid and ignorant, to finance their undertakings, and so on.
The setting is a metaphorical one of a typical modern city (in this case, Gomorrah is Milan).

The two resume their journey – once again in the style of silent comedy. And this time they reach Sodom.
The world of Sodom is portrayed in the Neorealist style, Rossellini and Fellini. Here there is only sex. But unlike heterosexuality, the sex doesn't produce social madness and crime etc. At the most, it produces art. Everything is therefore more decidedly comical in

the Italian style, farce, etc. Another seven or eight love stories of queers interrupt the journey of the Wise King and his servant, who become involved in new salacious adventures etc.

Here too the Wise King squanders the treasure he is carrying with him to honor the Messiah, in order to help men with their pitiful vices (a fag who hasn't any money to pay a young boy, etc.).

The guiding thread is that of Lot and his daughters, until their transformation into salt statues.

The young servant takes a little of the salt to make a soup, as he and his master have pitched camp a bit outside of Sodom, which is destroyed and incinerated.

Grandiose scenes in "blockbuster" style of the destruction of Sodom (in this case, Rome).

The third city is Numantia. The pair arrive after typical silent-film vicissitudes (still philosophizing, weaving the metaphysical web of the film, which is truly poetic and real).

Numantia is besieged by an army rather like the American army in Vietnam. It is hard to get through the lines, but the star points to Numantia…

We leave our heroes in their predicaments between tanks and the camps of the besieging army, and we enter Numantia.

The style becomes *auteurish*: Eisenstein, Dreyer, with Godardian touches, quotations, and so on.

The people of Numantia do not want to surrender and fall under the rule of the terribly powerful enemy, etc.

Collectively (after a quick description of the different characters with their specific histories), the people of Numantia decide to commit collective suicide, so as not to give up their freedom.

They are all in agreement, the politicians, the populace, the intellectuals, the most famous scientist, the most famous poet…

We return to our heroes, who through a series of comical strategies manage to slip through the ranks of the attackers and enter Numantia.

The city is entirely deserted.

Until they see the first dead. The entire population has committed suicide. Since Numantia is Paris, we see the Seine swollen with corpses, the lampposts of the Etoile are laden with the hanged, the Champs-Elysées, etc. The insides of apartments are full of families killed by gas or sleeping pills. In short, everyone in Paris-Numantia is dead.

The film risks becoming tragic. And so Romanino the servant takes a small flute from the hands of a dead little boy and begins to play, a cheerful triumphal march, a sort of new *Ça ira*, and Eduardo sings along, improvising merry words extolling the heroic death of these people. Eduardo sings a little, the servant sings a little, in an amoebaean song in the middle of that vast cemetery.

But not everyone is dead. One out of all those people didn't have the courage to kill himself: the poet.

The Wise King and his servant find him alone, sitting at a table at the Café de Flore, amidst a crowd of dead intellectuals.

And now the enemy army invades and captures the city.

The poet, the sole prisoner, is taken before the chief of the enemy army. He didn't kill himself because of his fear of death – a horrendous, visceral terror sustained by the idea that nothing compares to life.

He has betrayed his people, and now serves the enemy. He sits at the table with the head of the enemy army. (In keeping with the canon of comic films, the Wise King and Romanino are also present, having finagled their way into being taken on as cook and waiter).

The head of the enemy army and the poet start chatting, until the poet softly recites a poem of Mandelstam

that ends with uncertainty as to whether to toast with a wine from Castel del Papa or from Orvieto (?). The military chief sends for wine, saying it's from Castel del Papa. The poet tastes it and says no, it's from Orvieto. A wild argument breaks out, with each defending his opinion. The military chief threatens the poet, saying that if he doesn't admit that he is right, he will have him shot. But the poet keeps saying that the sweet little wine they're drinking is Orvieto. In the end the chief has him shot, and the poet goes to his death heroically, shouting, before he dies, "Long live the Revolution!"

It is the last adventure in the real world for the Wise King and his servant (I've gone on a bit here, but it's no longer than their other adventures in Gomorrah and Sodom). And so they make a few more stops, all surreal, in a comic style that is increasingly rarefied and metaphysical (e.g., Keaton being chased by rolling stones), until they come to a place indicated as the Birthplace of the Messiah, and here what I said at the beginning happens.

Il cinema, first treatment of *Porno-Teo-Kolossal*, unpublished (1973)

Rome, September 24, 1975

Dear Eduardo,

Here at last, *in writing*, is the film I've been talking to you about for years. It's basically all here. The dialogues are missing, as they are still up in the air. I am counting a lot on your collaboration for them, perhaps even improvising while on the set. I entrust Epifanio entirely to you – deliberately, as a foregone conclusion, by choice. You *are* Epifanio. The "you" of dreams, apparently idealized, but real in effect.

I said the text was *in writing*, but actually it's not true. In reality I dictated it to the tape recorder (for the first time in my life). So it remains, at least linguistically, oral. You'll immediately notice, in reading, a certain leaden sort of mood, repetitive and pedantic. Pay no attention to it. For practical reasons, I couldn't have done otherwise.

I read it myself today for the first time in its entirety – a short while ago. And I was traumatized: upset by its "ideological" thrust as, indeed, an "epic," and crushed by its organizational bulk.

I hope with all my heart not only that you like the film and agree to do it, but that you'll help and encourage me to tackle such an undertaking.

<div align="center">

A warm embrace,
Yours,
Pier Paolo

</div>

From *Lettere 1955-1975*, ed. Nico Naldini, Einaudi, Turin 1988

BIOGRAPHY

Pier Paolo Pasolini was born in Bologna on March 5, 1922, to Carlo Alberto Pasolini, a lieutenant in the Italian Army from a once-wealthy family of Ravenna, and Susanna Colussi, an elementary school teacher at Casarsa della Delizia in Friuli. Throughout his infancy and adolescence, Pasolini had constantly to adapt to new environments due to his father's frequent transfers to various northern Italian cities: Bologna, Parma, back to Bologna, Belluno, Conegliano, Sacile, Idria, again in Sacile, Cremona, Reggio Emilia and Bologna.

In 1925 his brother Guido was born in Belluno.

At the age of seven, Pasolini wrote his first verses at Sacile. He attended elementary school in Reggio Emilia and completed his primary education in Bologna. In 1938 his literature teacher at the Liceo Galvani, Antonio Rinaldi, reads Rimbaud to the class.

He then enrolls in the Literature Department of the University of Bologna and attends the courses of the noted art historian Roberto Longhi (under whose guidance Pier Paolo wished to graduate).

From November 1942 to May 1943 he writes for the magazine *Il Setaccio*. The magazine features drawings and watercolors and published writers like Mario Ricci, Fabio Mauri, Giovanna Bemporad, Luciano Serra and Sergio Telmon.

Pasolini's first collection of poetry, *Poesie a Casarsa* was published in June 1942 by the Libreria Antiquaria, owned by Mario Landi. This volume, written in the Friulian dialect, was printed at Pasolini's expense when he was twenty. He continued to study in Bologna until 1942, when he was forced to return to Casarsa. Back at Casarsa, Pasolini composed poetry in both dialect and Italian.

In early September Pasolini joined the army in Livorno. On the eighth of September, upon the declaration of the Armistice, he left the service and took refuge in Friuli.

His brother, Guido, joined the partisan Osoppo-Friuli brigade in the mountains of Carnia in June of 1944. Here, presumably on February 10, 1945, Guido and his company were murdered by communists under the command of Tito. The family was not notified of the death until much later. Frequent bombings of Casarsa's railway crossing made the town an increasingly dangerous place to live. Pier Paolo and his mother decided to distance themselves from the train station and relocate in Versuta. Together they organized a small private school where Susanna taught small children and Pier Paolo held classes free of charge for students who could not travel to Pordenone or Udine to attend school. In February of 1945, with the help of Riccardo Castellani, Cesare Borbotto, Ovidio Colussi, Rico De Rocco and his cousin Nico Naldini, Pasolini founded the "Academiuta di lenga furlana"(The Little Academy of the Friulian Tongue). That same year his father was released from prison in Africa, where he had been captured, and returned to Italy in poor health. Presenting his thesis on Giovanni Pascoli: *Antologia della lirica pascoliana (Introduzione e commenti)*, Pasolini graduated with honors from the University of Bologna in November of 1945.

In 1945 Pasolini joined the PCI (Italian Communist Party). Between 1947 and 1949 he taught in Valvasone, a small town located near Casarsa. He spreads *murali*, political information in dialect and Italian for the Communist party of San Giovanni in Casarsa. An accusation of corruption of youth and indecent public behavior triggered heated arguments in Casarsa. Not only was the poet suspended from his teaching post but also expelled by the PCI on grounds of unbecoming moral and political conduct.

In Friuli the atmosphere was becoming too restrictive, and in early January 1950 Pier Paolo and his mother moved to Rome. They first resided at Piazza Costaguti, Portico d'Ottavia. Later Pasolini moved to Ponte Mammolo, a location near the Rebibbia prison.

On that occasion Carlo Alberto Pasolini, the father, joined the family in 1951. Shortly after arriving in Rome, Pasolini began to accumulate writing material for *Ragazzi di vita.* In 1951 he met Sergio Citti and established not only a close friendship but also a professional relationship with him. In late 1952 he published a study of 19th-century dialect poetry. This work wins the unanimous approval of E. Montale, E. Falqui, G. Vicari, F. Fortini and G. Bellonci. His first novel, *Ragazzi di vita* (The Ragazzi) is published in 1955. The work has great success.

Published in 1957, his poetry collection *Le ceneri di Gramsci* ("The Ashes of Gramsci"), shares the prestigious Viareggio Prize with Sandro Penna's *Poesie.*

Together with Sergio Citti, the writer collaborates on the Roman dialogues for Federico Fellini's film *Nights of Cabiria.* In December of 1958, Pier Paolo's father and diligent secretary, Carlo Alberto Pasolini, passes away.

In 1959 Pasolini publishes *Una vita violenta* ("A Violent Life").

Between 1960 and 1961 he premieres as a director and screenwriter with *Accattone.*

His collection, *La religione del mio tempo* (The Religion of My Time), receives the Chianciano award in 1961.

Il sogno di una cosa (A Dream of Something), a novel that Pasolini had started some fourteen years earlier while living in Casarsa, is brought out in 1962 by Garzanti publishers. The book describes the land and people of Friuli.

In 1963, the writer is brought to trial for certain scenes contained in the short film, *La ricotta,* in what was perhaps the most clamorous of the many legal motions brought against him. At first he was found guilty but the charges were later dropped.

The same year Pasolini changes residence and moves to the prestigious Roman quarter of EUR.

In the years between 1961 and 1964, a distinct "Pasolinian" poetics emerges in the poems collected in the volume *Poesia in forma di rosa* (Poem in the Shape of a Rose).

At the Pesaro Festival in 1965 there is a great deal of discussion over the use of language in cinema. Debates are presented by semiologists and scholars, from Italy and abroad (including Roland Barthes). Pasolini gives a broad presentation on "Cinema and poetry." In 1972

he publishes the essay collection, *Empirismo eretico* ("Heretical Empiricism"), which contains many of his studies on language and cinema.

In March 1966 Pasolini is confined to bed due to a bleeding ulcer. During his convalescence he writes six tragedies in verse and the first draft of *Teorema.*

Pasolini makes his first trip to United States in October of 1966 for the New York Film Festival, where *Accattone* and *Uccellacci e Uccellini* are being featured. While working in Italy on a film project about Saint Paul, Pasolini, influenced by his experiences in America, considers moving the film's setting from Rome to New York. The project was never completed.

In March, 1968, after the battle of Valle Giulia between university students and police, Pasolini writes a pamphlet in verse, intended for the magazine *Nuovi Argomenti*, in which he expresses his sympathy with the police, whom he calls "children of the poor." The weekly *L'Espresso* publishes the pamphlet in modified form.

A writing titled *Manifesto per un nuovo teatro* (Manifesto for a New Teather), comes out in the January-March 1968 issue of *Nuovi Argomenti*. Pasolini defines a new theater as "a theater of the word" and at Turin in November the poet makes his début as a director, with his tragedy, *Orgia* (Orgy).

In 1971, in collaboration with the extreme-left group Lotta Continua, he helps create the documentary *12 Dicembre*, directed by Giovanni Bonfanti.

Also in 1971 he publishes a new poetry collection, *Trasumanar e organizzar* (Transhumanize and Organize). He is also at work on a new series of Friulian poetry, which he publishes together with a rewriting of his early dialect poems in 1975 in the collection *La nuova gioventù* ("The New Youth").

In January 1973 he begins his work as a columnist with the *Corriere della Sera*. The articles are collected in the volume called *Scritti corsari* (Pirate Writings, 1975) and *Lettere luterane* (Luteran Letters, 1976). In 1975 Pasolini submitted to Einaudi publishers a work he defines as a "document," entitled *La Divina Mimesis*.

On the night of November 1, 1975, Pier Paolo Pasolini is brutally murdered on the beach at Ostia, near Rome.

Pier Paolo Pasolini

1

2

3

4

5

6

7

VD Maggio 1937 Ginnasio Galvani

8

9

10

11

12

13

1. Pasolini as an *avanguardista* in the 1930s

2. At age 3 with his mother, Susanna, in 1925

3. At age 9, in 1931

4. At age 14, in 1936

5. With his little brother Guido

6. Pasolini's father, Carlo Alberto Pasolini

7. With his father in Florence in the 1930s

8. Class photo from the Liceo Galvani, 1937

9. At the moment of enrolling at the University of Bologna, in 1939

10. With his cousin Nico Naldini in the 1940s

11. With Luciano Serra (on the right) in Bologna

12. At Malga Troi in the 1940s

13. As a teacher with his class at Valvasone, in 1947

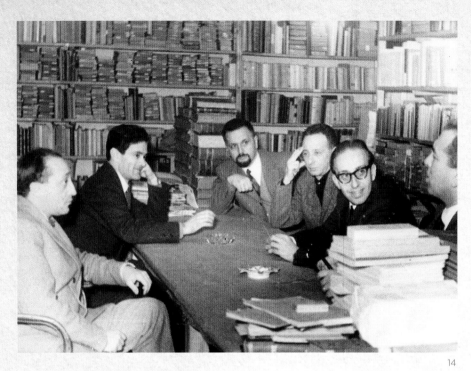

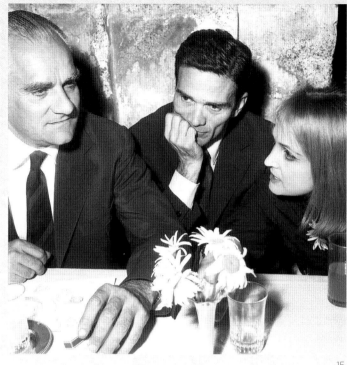

14

15

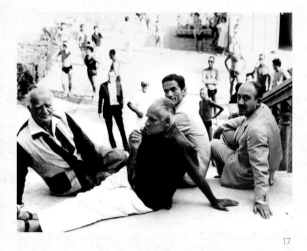

16

17

18

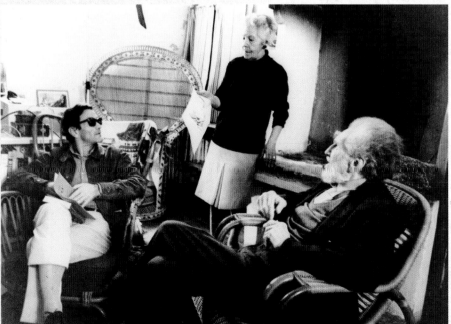

19

14. With the editorial staff of *Officina*: Francesco Leonetti, Roberto Roversi, Achille Romanò, Gianni Scalia and Franco Fortini, in the 1950s

15. With Alberto Moravia and Laura Betti, in 1960

16. With Giuseppe Ungaretti and Carlo Emilio Gadda

17. With Leonida Repaci, Alberto Moravia and Guido Piovene at the Venice Film Festival, in 1961, the year of *Accattone*

18. With Alberto Moravia, in 1961

19. With Ezra Pound and his wife Olga Rudge during the shooting of the television program, *An Hour with Ezra Pound*, in 1967

20. With his mother Susanna in Rome

21. With his mother

22. With his mother and Sergio Citti, in 1961

23. Susanna Pasolini with Elsa Morante (seen from behind in head-scarf) on the set of *The Gospel According to St. Matthew*, 1964

24. Susanna Pasolini on the set of *Teorema*, in 1968

25. Pasolini with Elsa Morante, his mother and Graziella Chiarcossi on the set of *The Gospel According to St. Matthew*, 1964

20

21

22

23

24

25

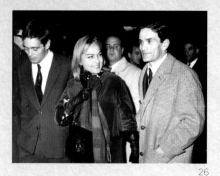

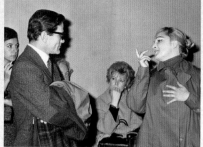

26

27

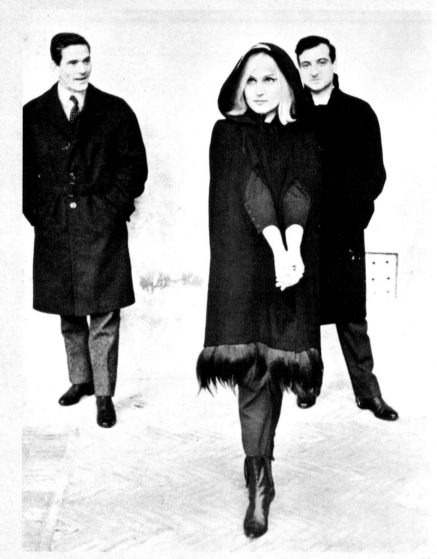

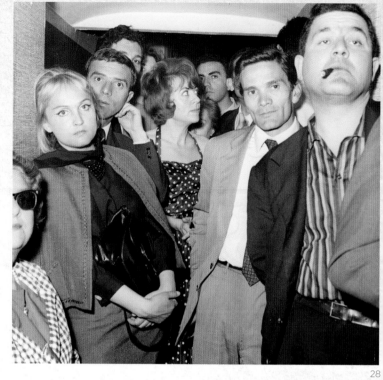

28

29

30

31

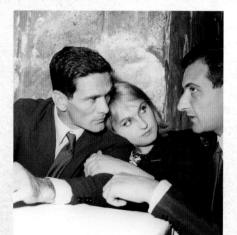

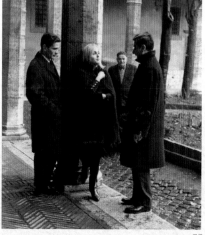

32

33

26. With Franco Citti and Laura Betti at the première of *Accattone*, in 1961

27. With Dacia Maraini and Laura Betti in the 1960s

28. With Laura Betti and Nico Naldini

29, 33. With Laura Betti and Goffredo Parise, in 1961

30. With Laura Betti in the early 1960s

31. With Laura Betti in 1969

32. With Laura Betti and Goffredo Parise at the Nymphaeum in Valle Giulia for the Strega Prize, in 1960

34. A 1967 painting of Laura Betti and Ninetto Davoli, made by Pasolini at the time of shooting *What Are Clouds?*

35. Ninetto Davoli

36. With Ninetto in 1967 during the filming of *Notes for a Film on India*

37, 39. With Ninetto Davoli from the late 1960s

38. With Ninetto on the set of *Decameron*, in 1970

34

35

37

36

38

39

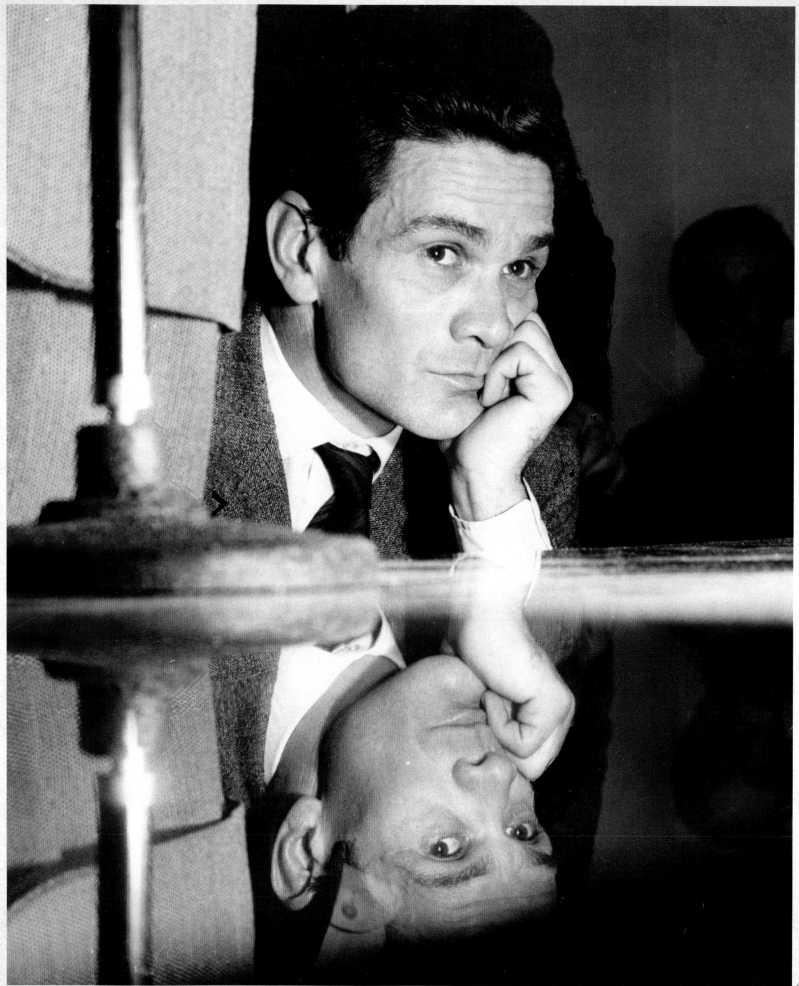

40. Pasolini in the late 1950s

41. *Self-Portrait with Flower in Mouth*, 1947

42, 44. On the set of *The Gospel according to St. Matthew*, in 1964

43. On the set of *Salò or the 120 Days of Sodom*, in 1975

45. Self-portrait, 1965

46

47

48

49

50

51

46. With friends on a soccer field in Bologna, in 1939

47. With friends on a soccer field in Casarsa, in 1941

48, 49, 50. With the team of actors and singers in the early 1970s

51. With the troupes from the films *1900* and *Salò*, in 1975

52, 54. On the field in the late 1960s

53. On the field

55. Suiting up in 1974

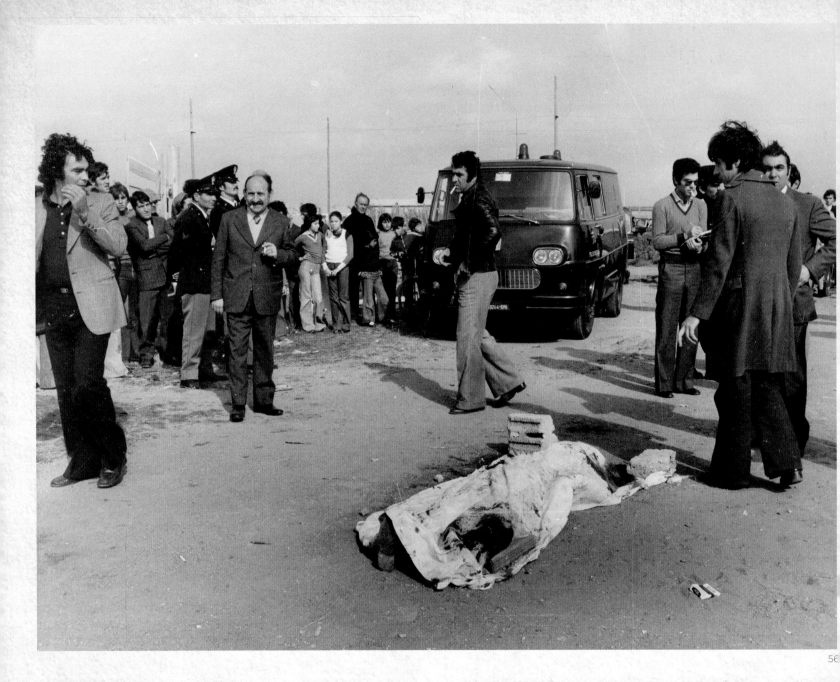

56

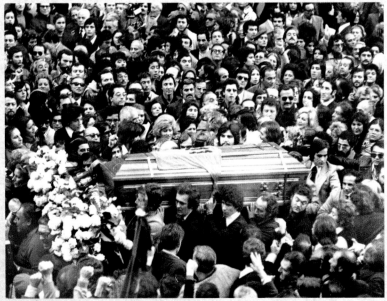

57

58

56. Murder scene at Via dell'Idroscalo, Ostia, November 2, 1975

57, 58. Scenes from the funeral on November 5, 1975

59. The murder scene some days after the crime

60. The same scene, having become a dumping site in the 1990s

FILMOGRAPHY

ACCATTONE
Italy, 1961

Story and screenplay: Pier Paolo Pasolini. *Dialogue collaboration:* Sergio Citti. *Director of photography:* Tonino Delli Colli. *Art director:* Flavio Mogherini. *Set decorator:* Gino Lazzari. *Music co-ordination:* Carlo Rustichelli. *Music:* Johann Sebastian Bach. *Sound:* Luigi Puri. *Editor:* Nino Baragli. *Assistant director:* Bernardo Bertolucci. *Second assistant director:* Leopoldo Savona. *Stills photographer:* Angelo Pennoni. *Continuity:* Lina D'Amico. *Cast:* Franco Citti (*Vittorio Cataldi, "Accattone", dubbed by Paolo Ferrari*), Franca Pasut (*Stella*), Silvana Corsini (*Maddalena*), Paola Guidi (*Ascenza, dubbed by Monica Vitti*), Adriana Asti (*Amore*), Romolo Orazi (*Accattone's father-in-law*), Massimo Cacciafeste (*Accattone's brother-in-law*), Adriano Mazzelli (*Amore's client*), Francesco Orazi (*the peasant*), Mario Guerani (*the Police officer*), Stefano D'Arrigo (*the Magistrate*), Galeazzo Riccardi (*er Cipolla*), Giovanni Orgitano (*er Scucchia*), Giuseppe Ristagno (*Crazy Peppe*), Leonardo Muraglia (*Mammoletto*), Luciano Conti (*the Mohican*), Luciano Gonini (*Gold Foot*), Mario Cipriani (*Balilla*), Piero Morgia (*Pio*), Renato Capogna (*Er Capogna*), Roberto Giovannoni (*the German*), Roberto Scaringella (*Carthage*), Silvio Citti (*Sabino*), Edgardo Siroli (*first dimwit*), Renato Terra (*second dimwit*), Adele Cambria (*Nannina*), Amerigo Bevilacqua (*Amerigo*), Dino Frondi (*Dino*), Franco Bevilacqua (*Franco*), Mario Castiglione (*Mario*), Sergio Fioravanti (*Gennarino*), Tommaso Nuovo (*Tommaso*), Umberto Bevilacqua (*Salvatore*), Enrico Fioravanti (*first policeman*), Nino Russo, Emanuele Di Bari (*Mr. Pietro*), Franco Marucci, Carlo Sardoni, Adriana Moneta (*Margheritona*), Polidor (*the undertaker*), Sergio Citti (*the waiter*), Elsa Morante (*a prisoner*), Alfredo Leggi. *Production Company:* Arco Film (Rome) / Cino Del Duca (Rome). *Producer:* Alfredo Bini. *Production manager:* Marcello Bollero. *Unit manager:* Eliseo Boschi. *Stock:* Ferrania P 30, 35mm. *Negatives and positives:* Istituto Nazionale Luce. *Dubbing and synch sound:* Stabilimenti Titanus. *Shooting period:* April - July 1961. *Studios:* Incir De Paolis (Rome). *Locations:* Roma, Subiaco. *Running time:* 116'. *Premiere:* XXII Mostra di Venezia, sezione "Informativa", August 31, 1961. *Awards:* First Award, Karlovy Vary Festival, 1962.

MAMMA ROMA
Italy, 1962

Story and screenplay: Pier Paolo Pasolini. *Dialogue collaboration:* Sergio Citti. *Director of photography:* Tonino Delli Colli. *Camera operator:* Franco Delli Colli. *Camera assistant:* Gioacchino Sofia. *Art director:* Flavio Mogherini. *Set decorator:* Massimo Tavazzi. *Music co-ordination:* Carlo Rustichelli. *Music:* "Violino Tzigano" by Cherubini - Bixio, sung by Joselito, "Concert in C Mayor" by Antonio Vivaldi. *Sound:* Leopoldo Rosi. *Editor:* Nino Baragli. *Assistant editor:* Andreina Casini. *Assistant director:* Carlo di Carlo. *Second assistant director:* Gianfrancesco Salina. *Stills photographer:* Angelo Novi. *Continuity:* Lina D'Amico, Mirella Comacchio. *Cast:* Anna Magnani (*Mamma Roma*), Ettore Garofolo (*Ettore*), Franco Citti (*Carmine*), Silvana Corsini (*Bruna*), Luisa Orioli (*Biancofiore*), Paolo Volponi (*the priest*), Luciano Gonini (*Zaccarino*), Vittorio La Paglia (*Mr. Pellissier*), Piero Morgia (*Piero*), Leandro Santarelli (*Begalo, the Roscio*), Emanuele di Bari (*Gennarino the troubador*), Antonio Spoletini (*the fireman*), Nino Bionci (*the painter*), Roberto Venzi (*the airman*), Nino Venzi (*a client*), Maria Bernardini (*the bride*), Santino Citti (*bride's father*), Lamberto Maggiorani (*a patient*), Franco Ceccarelli (*Carletto*), Marcello Sorrentino (*Tonino*), Sandro Meschino (*Pasquale*), Franco Tovo (*Augusto*), Pasquale Ferrarese (*Lino from La Spezia*),

Renato Montalbano, Enzo Fioravanti (*male nurses*), Elena Cameron, Maria Benati (*prostitutes*), Loreto Ranalli, Mario Ferraguti (*male prostitutes*), Renato Capogna, Fulvio Orgitano, Renato Troiani (*pimps*), Mario Cipriani, Paolo Provenzale (*thugs*), Umberto Conti, Sergio Profili, Gigione Urbinati (*patients*). *Production Company:* Arco Film (Rome). *Producer:* Alfredo Bini. *Production manager:* Eliseo Boschi. *Unit manager:* Fernando Franchi. *Shooting period:* April - June 1962. *Studios:* Incir De Paolis (Rome). *Locations:* Roma, Frascati, Guidonia, Subiaco. *Running time:* 115'. *Premiere:* XXIII Mostra di Venezia, August 31, 1962. *Awards:* FICC Award (Federazione Italiana dei Circoli del Cinema), Mostra di Venezia, 1962.

LA RICOTTA
Italy-France, 1963

Story and screenplay: Pier Paolo Pasolini. *Director of photography:* Tonino Delli Colli. *Camera operator:* Giuseppe Ruzzolini. *Art director:* Flavio Mogherini. *Costume designer:* Danilo Donati. *Music co-ordination:* Carlo Rustichelli. *Editor:* Nino Baragli. *Assistant director:* Sergio Citti, Carlo di Carlo. *Stills photographers:* Paul Ronald, Angelo Novi. *Continuity*: Lina D'Amico. *Cast:* Orson Welles (*the director, dubbed by Giorgio Bassani*), Mario Cipriani (*Stracci*), Laura Betti (*the "star"*), Edmonda Aldini (*another "star"*), Vittorio La Paglia (*the journalist*), Maria Berardini (*the stripper*), Rossana Di Rocco (*Stracci's daughter*), Tomas Milian, Ettore Garofolo, Lamberto Maggiorani, Alan Midgette, Giovanni Orgitano, Franca Pasut (*the extras*), Giuseppe Berlingeri, Andrea Barbato, Giuliana Calandra, Adele Cambria, Romano Costa, Elsa de' Giorgi, Carlotta Del Pezzo, Gaio Fratini, John Francis Lane, Robertino Ortensi, Letizia Paolozzi, Enzo Siciliano (*the guests*). *Production Company:* Arco Film (Rome) / Cineriz (Rome) / Lyre Film (Paris). *Producer:* Alfredo Bini. *Production manager:* Eliseo Boschi. *Unit manager:* Fernando Franchi. *Stock:* Ferrania P 30, Kodak Eastman Color, 35mm, b/n e colour. *Processing laboratory:* Istituto Nazionale Luce. *Dubbing:* CID-CDC. *Synch sound:* Titanus. *Shooting period:* October -

November 1962. *Studios:* Cinecittà (Rome). *Locations:* Roma suburbs (Pratone dell'Acqua Santa, Acquedotto romano). *Running time:* 35'. *Released:* February 21, 1963, Milan. *Awards:* Grolla d'oro, Saint Vincent, July 4 1964.

Fourth episode of the film *RoGoPaG*. The other episodes are: *Illibatezza* by Roberto Rossellini, *Il nuovo mondo* by Jean-Luc Godard, *Il pollo ruspante* by Ugo Gregoretti.

LA RABBIA
(l.t. The Rage)
Italy, 1963

Commentary in verses: Pier Paolo Pasolini. *Assistant director:* Carlo di Carlo. *Narrators:* Giorgio Bassani (*poetry voice*) and Renato Guttuso (*prose voice*). *Music:* "Songs of the Cuban revolution", The Barbudos, Songs of the Algerian revolution, "Non c'è altro che Dio", "I sogni muoiono all'alba" by Simoni e A.F. Lavagnino, "Lo Shimmy" by A.F. Lavagnino, "Concerto disperato" by Simoni, "Tiger Twist" by A. Sciascia. *Paintings by:* Ben Shahn, Jean Fautrier, Georg Grosz, Renato Guttuso. *Editors:* Pier Paolo Pasolini, Nino Baragli, Mario Serandrei. *Assistant editor:* Sergio Montanari. *Stills photographer:* Mario Dondero. *Production Company:* Opus Film (Rome). *Producer:* Gastone Ferranti. *Negatives and positives:* SPES, 35mm, b/n and colour. *Editing period:* January - February 1963. *Running time:* 53'. *Released:* April 14, 1963. Two-part film. The second part is by Giovannino Guareschi.

In 2008 Giuseppe Bertolucci made an "hypothesis of reconstruction" of Pasolini's first project, *La rabbia di Pasolini*, produced by Cineteca di Bologna, with the voices of Bertolucci himself and Valerio Magrelli.

COMIZI D'AMORE
(Love Meetings)
Italy, 1964

Story: Pier Paolo Pasolini. *Directors of photography:* Mario Bernardo, Tonino Delli Colli. *Camera operators:* Vittorio Bernini, Franco Delli Colli, Cesare Fontana.

Camera assistants: Francesco Cappelli, Sandro Ruzzolini. *Interviewer and commentator:* Pier Paolo Pasolini. *Music co-ordination:* Pier Paolo Pasolini. *Editor:* Nino Baragli. *Assistant editor:* Andreina Casini. *Speaker:* Lello Bersani. *Sound:* Oscar De Arcangelis, Carlo Ramundo. *Stills photographer:* Angelo Novi. *Participants:* Alberto Moravia, Cesare Musatti, Camilla Cederna, Oriana Fallaci, Adele Cambria, Peppino di Capri, Giuseppe Ungaretti, Antonella Lualdi, Graziella Granata, Ignazio Buttitta, Graziella Chiarcossi (*the married girl*). *Production Company:* Arco Film (Rome). *Producer:* Alfredo Bini. *Production manager:* Eliseo Boschi. *Stock:* Ferrania P 30, Kodak Plus X, 16 and 35mm, b/n. *Negatives and positives:* Istituto Luce. *Sound recording:* Fonolux. *Shooting period:* March - November 1963. *Locations:* Napoli, Palermo, Cefalù, Roma, Fiumicino, Milano, Firenze, Viareggio, Bologna, beaches along the Roman coast, Calabria beaches, Bagheria, Venezia Lido, Catanzaro, Crotone, the garden of Pasolini's home. *Running time:* 92'. *Premiere:* XVII Locarno Festival, July 27, 1965.

SOPRALUOGHI IN PALESTINA PER "IL VANGELO SECONDO MATTEO"
(l.t. Locations Hunting in Palestine for the film "The Gospel According to St. Matthew")
Italy, 1964
Commentary: written and narrated by Pier Paolo Pasolini. *Participants:* Pier Paolo Pasolini and don Andrea Carraro. *Directors of photography:* Aldo Pennelli, Otello Martelli, Domenico Cantatore. *Music co-ordination:* Pier Paolo Pasolini. *Stills photographer:* Angelo Novi. *Production Company:* Arco Film (Rome). *Producer:* Alfredo Bini. *Shooting period:* June - July 1963. *Locations:* Lake Tiberiades, Mount Tabor, Nazareth, Cafarnao (Galilee), Baram, Jerusalem, Be'er Sheva, Bethlehem (Giordan), Damascus (Syria). *Running time:* 52'. *Premiere:* Spoleto, Festival dei Due Mondi, July 11, 1965.

IL VANGELO SECONDO MATTEO
(The Gospel According to St. Matthew)
Italy-France, 1964
Screenplay: Pier Paolo Pasolini, based on the *Gospel According to Matthew*. *Director of photography:* Tonino Delli Colli. *Camera operator:* Giuseppe Ruzzolini. *First camera assistant:* Gianni Canfarelli Modica. *Second camera assistant*: Victor Hugo Contino. *Art director:* Luigi Scaccianoce. *Assistant art director:* Dante Ferretti. *Set decorator:* Andrea Fantacci. *Costume designer:* Danilo Donati. *Assistant costume designer:* Piero Cicoletti. *Costumes*: Piero Farani. *Music:* Luis Bacalov, Joahnn Sebastian Bach, Wolfgang Amadeus Mozart, Sergej Prokofiev, Anton Webern, Congolese "Missa Luba", Spirituals and Russian revolutionary songs. *Sound:* Mario Del Pezzo. *Editor:* Nino Baragli. *Assistant editor:* Andreina Casini. *Assistant director:* Maurizio Lucidi. *Second assistant director:* Paul Schneider. *Stills photographer:* Angelo Novi. *Continuity*: Lina D'Amico. *Cast:* Enrique Irazoqui (*Jesus Christ, dubbed by Enrico Maria Salerno*), Margherita Caruso (*young Mary*), Susanna Pasolini (*old Mary*), Marcello Morante (*Joseph*), Mario Socrate (*John the Baptist*), Settimio Di Porto (*Peter*), Otello Sestili (*Judas*), Enzo Siciliano (*Simon*), Giorgio Agamben (*Philip*), Ferruccio Nuzzo (*Matthew*), Giacomo Morante (*John*), Alfonso Gatto (*Andrew*), Guido Cerretani (*Bartholomew*), Rosario Migale (*Thomas*), Luigi Barbini (*James of Zebedea*), Marcello Galdini (*James of Alfeo*), Elio Spaziani (*Thaddeus*), Rodolfo Wilcock (*Caiaphas*), Alessandro Clerici (*Pontius Pilate*), Paola Tedesco (*Salomè*), Rossana Di Rocco (*Angel*), Renato Terra (*a pharisee*), Eliseo Boschi (*Joseph of Aramathea*), Natalia Ginzburg (*Mary of Bethany*), Ninetto Davoli (*young shepherd*), Amerigo Bevilacqua (*Herod I*), Francesco Leonetti (*Herod II*), Franca Cupane (*Herodiades*). *Production Company:* Arco Film (Rome) / Lux Compagnie Cinématographique de France (Paris). *Producer:* Alfredo Bini. *Production manager:* Eliseo Boschi. *Unit manager:* Enzo Ocone. *Stock:* Ferrania P 30, 35mm b/n. *Processing laboratory and opticals:* SPES. *Sound recording:* Nevada. *Dubbing:* CDC. *Sound mixer:* Fausto Ancillai. *Shooting period:* April - July 1964.

Studios: Incir De Paolis (Rome). *Locations:* Orte, Montecavo, Tivoli, Potenza, Matera, Barile, Bari, Gioia del Colle, Massafra, Catanzaro, Crotone, Valle dell'Etna. *Running time:* 137'. *Premiere:* XXV Mostra di Venezia, September 4, 1964. *Awards:* Jury Award, XXV Mostra di Venezia; OCIC (Office Catholique International du Cinéma) Award; Cineforum Award; Union International de la Critique de Cinema Award (UNICRIT), Lega Cattolica Award for Cinema and Television of RFT; Grifone d'oro Award, Città di Imola; Gran premio OCIC, Assisi, September 27, 1964; Prix d'excellence, IV Concorso Tecnico del Film, Milano; Caravella d'argento, International Festival of Lisbona, February 25, 1965; Nastro d'Argento 1965 for best director, cinematography and costume designer.

UCCELLACCI E UCCELLINI
(The Hawks and the Sparrows)
Italy, 1966

Story and screenplay: Pier Paolo Pasolini. *Directors of photography:* Tonino Delli Colli, Mario Bernardo. *Camera operators:* Franco Di Giacomo, Gaetano Valle. *First camera assistant:* Antonio Orlandini. *Second camera assistant:* Sergio Rubini. *Art director:* Luigi Scaccianoce. *Assistant art director:* Dante Ferretti. *Costume designer:* Danilo Donati. *Assistant costume designer:* Piero Cicoletti. *Costumes:* Piero Farani. *Music:* Ennio Morricone. The lyrics on the title credits, sung by Domenico Modugno, are by Pier Paolo Pasolini; the song "Carmé Carmé" was written and sung by Totò. *Orchestra conducted by:* Bruno Nicolai. *Sound:* Pietro Ortolani. *Editor:* Nino Baragli. *Assistant editor:* Rossana Maiuri. *Assistant director:* Sergio Citti. *Second assistant directors:* Carlo Morandi, Vincenzo Cerami. *Stills photographers:* Divo Cavicchioli, Angelo Novi. *Continuity:* Lina D'Amico. *Cast:* Totò (*Innocenti Totò / brother Ciccillo*), Ninetto Davoli (*Innocenti Ninetto / brother Ninetto*), Femi Benussi (*Luna, the prostitute*), Francesco Leonetti (*Crow's voice*), Gabriele Baldini (*Dante's dentist*), Riccardo Redi (*the engineer*), Lena Lin Solaro (*Urganda*), Rossana di Rocco (*a friend of*

Ninetto), Cesare Gelli, Vittorio La Paglia, Alfredo Leggi, Renato Montalbano, Mario Pennisi, Fides Stagni, Giovanni Tarallo, Umberto Bevilacqua, Renato Capogna, Pietro Davoli (*medieval louts*), Vittorio Vittori. *Production Company:* Arco Film (Rome). *Producer:* Alfredo Bini. *Production manager:* Fernando Franchi. *Unit manager:* Gilberto Scarpellini. *Stock:* Ferrania P 30, 35mm, b/n. *Processing laboratory and opticals:* SPES. *Sound recording:* International Recording (Westrex Sound System). *Dubbing:* CDC. *Sound mixer:* Emilio Rosa. *Shooting period:* October - December 1965. *Studios:* Incir De Paolis (Rome). *Locations:* Roma, Fiumicino, Tuscania, Viterbo, Assisi. *Running time:* 86'. *Premiere:* Cannes Film Festival, May 13, 1966. *Awards:* Nastro d'Argento to Pier Paolo Pasolini for best original story and Totò for best actor.

LA TERRA VISTA DALLA LUNA
(The Earth as Seen from the Moon)
Italy-France, 1966

Story and screenplay: Pier Paolo Pasolini. *Director of photography:* Giuseppe Rotunno. *Camera operator:* Giuseppe Maccari. *Art directors:* Mario Garbuglia, Piero Poletto. *Costume designer:* Piero Tosi. *Sculptures:* Pino Zac. *Music:* Ennio Morricone. *Sound:* Vittorio Trentino. *Editor:* Nino Baragli. *Assistant director:* Sergio Citti. *Second assistant director:* Vincenzo Cerami. *Stills photographer:* Angelo Novi. *Cast:* Totò (*Ciancicato Miao*), Ninetto Davoli (*Basciù Miao*), Silvana Mangano (*Assurdina Caì*), Mario Cipriani (*a priest*), Laura Betti (*the tourist*), Luigi Leoni (*the tourist's wife*). *Production Company:* Dino De Laurentiis Cinematografica (Rome) / Les Productions Artistes Associés (Paris). *Producer:* Dino De Laurentiis. *Stock:* Kodak, 35mm. *Shooting period:* November 1966. *Locations:* Roma, Ostia, Fiumicino. *Running time:* 31'. *Premiere:* XVII Berlin Festival, February 23, 1967. Third episode of the film *Le streghe* (*The Witches*). The other episodes are: *La siciliana* by Franco Rossi, *Senso civico* by Mauro Bolognini, *La strega bruciata viva* by Luchino Visconti, *Una serata come le altre* by Vittorio De Sica.

CHE COSA SONO LE NUVOLE?
(l.t. What Are Clouds?)
Italy, 1967

Story and screenplay: Pier Paolo Pasolini. *Director of photography:* Tonino Delli Colli. *Art director and costume designer:* Jurgen Henze. *Music:* the song "Che cosa sono le nuvole?" by Domenico Modugno and Pier Paolo Pasolini, is sung by Domenico Modugno. *Editor:* Nino Baragli. *Assistant director:* Sergio Citti. *Stills photographer:* Angelo Novi. *Cast:* Totò (*Iago*), Ninetto Davoli (*Othello*), Laura Betti (*Desdemona*), Franco Franchi (*Cassius*), Ciccio Ingrassia (*Roderigo*), Adriana Asti (*Bianca*), Francesco Leonetti (*the puppeteer*), Domenico Modugno (*the garbage collector*), Carlo Pisacane (*Brabanzio*), Luigi Barbini, Mario Cipriani, Piero Morgia, Remo Foglino. *Production Company:* Dino De Laurentiis Cinematografica (Rome). *Producer:* Dino De Laurentiis. *Stock:* Kodak, 35mm, colour. *Negatives and positives:* Technicolor. *Shooting period:* February - March 1967. *Studios:* Cinecittà (Rome). *Locations:* Environs of Roma. *Running time:* 22'. *Released:* June 14, 1968, Rome. Third episode of the film *Capriccio all'italiana*. The other episodes are *Il mostro della domenica* by Steno, *Perché* by Mauro Bolognini, *Viaggio di lavoro* by Pino Zac, *La bambinaia* by Mario Monicelli, *La gelosa* by Mauro Bolognini.

EDIPO RE
(Oedipus Rex)
Italy, 1967

Screenplay: Pier Paolo Pasolini, based on Sophocles' *Oedipus Rex* and *Oedipus at Colonus*. *Director of photography:* Giuseppe Ruzzolini. *Camera operator:* Otello Spila. *Camera assistant:* Sergio Rubini. *Art director:* Luigi Scaccianoce. *Set decorator:* Andrea Fantacci. *Assistant set decorator:* Dante Ferretti. *Costume designer:* Danilo Donati. *Assistant costume designer:* Piero Cicoletti. *Costumes:* Piero Farani. *Music co-ordination:* Pier Paolo Pasolini. *Music:* Wolfgang Amadeus Mozart's "Quartet in C Major K 465", Popular Rumanian folk songs, ancient Japanese music.

Sound: Carlo Tarchi. *Editor:* Nino Baragli. *Assistant director:* Jean-Claude Biette. *Stills photographer:* Bruno Bruni. *Continuity:* Lina D'Amico. *Cast:* Silvana Mangano (*Jocasta*), Franco Citti (*Oedipus*), Alida Valli (*Merope*), Carmelo Bene (*Creon*), Julian Beck (*Tiresias*), Luciano Bartoli (*Laius*), Ahmed Belhachmi (*Polybus*), Pier Paolo Pasolini (*the high priest*), Giandomenico Davoli (*Polybus' shepherd*), Ninetto Davoli (*Anghelos*), Francesco Leonetti (*Laius' slave*), Jean-Claude Biette, Ivan Scratuglia (*priest*). *Production Company:* Arco Film (Rome) with the participation of Somafis (Casablanca, Morocco). *Producer:* Alfredo Bini. *Production manager:* Eliseo Boschi. *Production supervisor:* Mario Coccioletti. *Production secretary:* Walter Fabrizio. *Stock:* Kodak Eastmancolor, 35mm, colour. *Processing laboratory and opticals:* Technicolor. *Sound recording:* NIS Film. *Sound mixer:* Fausto Ancillai. *Shooting period:* April - July 1967. *Studios:* Dino De Laurentiis Cinematografica (Rome). *Locations:* Veneto, Bassa Lombardia, Cascina Moncucca and environs, Sant'Angelo Lodigiano, Bologna; It'ben Addu, Ouarzazate, Zagora (Morocco). *Running time:* 104'. *Released:* XXVIII Mostra di Venezia, September 3, 1967. *Awards:* CIDALC Award (Comité Internationale pour la Diffusion des Arts et des Lettres par le Cinema), XXVIII Mostra di Venezia; Grolla d'oro, Saint Vincent; Nastro d'Argento 1968 to Alfredo Bini and Luigi Scaccianoce.

APPUNTI PER UN FILM SULL'INDIA
(l.t. Notes for a Film on India)
Italy, 1968

Story and commentary: written and narrated by Pier Paolo Pasolini. *Collaboration:* Gianni Barcelloni. *Camera operators:* Federico Zanni, Roberto Nappa. *Editor:* Jenner Menghi. *Production Company:* RAI Radiotelevisione Italiana. *Producer:* Gianni Barcelloni, BBG cinematografica srl. *Stock:* Kodak, 16mm, b/n. *Shooting period:* December 1967 - January 1968. *Locations:* Maharashtra (Bombay), Uttar Pradesh, Rajahstan, New Delhi. *Running time:* 34'. *Premiere:* broadcast on RAI television, program "Tv7",

July 5, 1968. *Released:* XXIX Mostra di Venezia, "Documentari" section, August 18, 1968.

TEOREMA
(Theorem)
Italy, 1968

Story and screenplay: Pier Paolo Pasolini. *Director of photography:* Giuseppe Ruzzolini. *Camera operator:* Otello Spila. *Camera assistants:* Luigi Conversi, Giuseppe Buonaurio. *Art director:* Luciano Puccini. *Costume designer:* Marcella De Marchis. *Special painting consultant:* Giuseppe Zigaina. *Original music score:* Ennio Morricone. *Music co-ordination:* Pier Paolo Pasolini. *Orchestra conducted by:* Bruno Nicolai. *Musical theme:* Wolfgang Amadeus Mozart's "Requiem", performed by the Academic Russian Chorus, Moscow Philarmonic. *Sound:* Dario Fronzetti. *Editor:* Nino Baragli. *Assistant director:* Sergio Citti. *Stills photographer:* Angelo Novi. *Continuity*: Wanda Tuzi. *Cast:* Silvana Mangano (*Lucia, the mother*), Terence Stamp (*the visitor*), Massimo Girotti (*Paolo, the father*), Anne Wiazemsky (*Odetta, the daughter*), Laura Betti (*Emilia, the maid*), Andrés José Cruz Soublette (*Pietro, the son*), Ninetto Davoli (*Angelino, the postman*), Carlo De Mejo (*a young man*), Luigi Barbini (*the boy at the station*), Susanna Pasolini (*the old peasant woman*), Adele Cambria (*the other maid*), Cesare Garboli (*interviewer in the prologue*), Alfonso Gatto (*the doctor*), Ivan Scratuglia. *Production Company:* Aetos Film (Rome). *Producers:* Franco Rossellini, Manolo Bolognini. *Production manager:* Paolo Frascà. *Production secretary:* Sergio Galiano. *Stock:* Kodak Eastmancolor, 35mm, colour, Arriflex. *Processing laboratory and opticals:* SPES. *Sound recording:* NIS Film. *Sound mixer:* Fausto Ancillai. *Shooting period:* March - May 1968. *Studios:* Elios Film (Rome). *Locations:* Milano, Lainate, Cascina Torre Bianca (Pavia), Roma, valle dell'Etna. *Running time:* 98'. *Premiere:* XXIX Mostra di Venezia, September 4, 1968. *Awards:* Coppa Volpi for the Best Actress to Laura Betti, XXIX Mostra di Venezia; Navicella d'oro; OCIC Award.

LA SEQUENZA DEL FIORE DI CARTA
(l.t. The Paper Flower Sequence)
Italy-France, 1968

Story and screenplay: Pier Paolo Pasolini. *Director of photography:* Giuseppe Ruzzolini. *Original music score:* Giovanni Fusco. *Music co-ordination:* Pier Paolo Pasolini. *Musical theme:* Johan Sebastian Bach's "St. Matthew's Passion". *Editor:* Nino Baragli. *Assistant editor:* Attilio Vinicioni. *Assistant directors:* Maurizio Ponzi, Franco Brocani. *Continuity*: Marina Chierici. *Cast:* Ninetto Davoli (*Riccetto*), Rochelle Barbieri (*girl*), Bernardo Bertolucci, Graziella Chiarcossi, Pier Paolo Pasolini, Aldo Puglisi (*God's voices*). *Production Company:* Castoro Film (Rome) / Anouchka Film (Paris). *Producer:* Carlo Lizzani. *Production manager:* Armando Bartuccioli. *Stock:* Kodak Eastmancolor, 35mm, colour, cinemascope. *Synch sound:* Sound Recording Service. *Sound recording:* Westrex Recording System, NIS Film. *Sound mixer:* Renato Cadueri. *Shooting period:* Summer 1968. *Studios:* Cinecittà-Teatri CSC (Rome). *Locations:* Roma. *Running time:* 10' 28". *Released:* May 30, 1969 (Rome). Third episode of the film *Amore e rabbia* (Love and Rage). The other episodes are *L'indifferenza* by Carlo Lizzani, *Agonia* by Bernardo Bertolucci, *L'amore* by Jean-Luc Godard, *Discutiamo, discutiamo* by Marco Bellocchio.

PORCILE
(Pigsty)
Italy-France, 1969

Story and screenplay: Pier Paolo Pasolini. *Directors of photography:* Armando Nannuzzi (first story), Tonino Delli Colli, Giuseppe Ruzzolini (second story). *Camera operators:* Franco Di Giacomo, Michele Cristiani. *Camera assistants:* Giuseppe Lanci, Federico Del Zoppo, Roberto Forges Davanzati. *Costume designer:* Danilo Donati. *Original music score:* Benedetto Ghiglia. *Musical theme:* "Horst Wessel Lied" (Nazi marching song). *Sound:* Alberto Salvatori. *Editor:* Nino Baragli. *Assistant editor:* Andreina Casini. *Assistants director:* Sergio Citti, Fabio Garriba. *Second*

assistant director: Sergio Elia. Stills photographer: Marilù Parolini. Continuity: Beatrice Banfi. Cast: First story: Pierre Clementi (first cannibal), Franco Citti (second cannibal), Luigi Barbini (the soldier), Ninetto Davoli (a young man), Sergio Elia (a servant); Second story: Jean-Pierre Léaud (Julian), Alberto Lionello (Klotz, the father), Margherita Lozano (Madame Klotz, the mother, dubbed by Laura Betti), Anne Wiazemsky (Ida), Ugo Tognazzi (Herdhitze), Marco Ferreri (Hans Günther, dubbed by Mario Missiroli), Ninetto Davoli (Maracchione, the witness). Production Company: Gian Vittorio Baldi e IDI Cinematografica, I Film dell'Orso (Rome) / CAPAC Filmédis (Paris). Associate producer: Gianni Barcelloni. Production manager: Rodolfo Frattaioli. Production supervisor: Enzo Jaccio. Stock: Kodak Eastmancolor, 35mm, colour. Processing laboratory: Technostampa. Dubbing: CID. Synch and sound recording: NIS Film. Shooting period: First story: November 1968; Second story: February 1969. Locations: First story: Valle dell'Etna, Catania, Roma; Second story: Verona, Stra, Villa Pisani. Running time: 98'. Premiere: Cinema Cristallo, Grado, August 30, 1969; XXX Mostra di Venezia, August 30, 1969.

MEDEA
Italy-France-Germany, 1969

Screenplay: Pier Paolo Pasolini, based on Euripedes' Medea. Director of photography: Ennio Guarnieri. Camera operator: Sergio Salvati. Camera assistants: Giorgio Urbinelli, Pasquale Rachini. Art director: Dante Ferretti. Set decorator: Nicola Tamburro. Costume designer: Piero Tosi. Assistant costume designers: Piero Cicoletti, Gabriella Pescucci. Costumes: Tirelli. Music co-ordination: Pier Paolo Pasolini with Elsa Morante. Sound: Carlo Tarchi. Editor: Nino Baragli. Assistant director: Sergio Citti. Second assistant director: Carlo Carunchio. Stills photographer: Mario Tursi. Continuity: Beatrice Banfi. Cast: Maria Callas (Medea), Laurent Terzieff (the Centaur), Massimo Girotti (Creon), Giuseppe Gentile (Jason), Margareth Clementi (Glauce), Fabio Mauri (Pelia), Graziella Chiarcossi, Sergio Tramonti, Anna Maria Chio,

Gerard Weiss, Paul Jabara, Luigi Barbini, Gianpaolo Duregon, Luigi Masironi, Michelangelo Masironi, Gianni Brandizi, Franco Jacobbi, Anna Maria Chio, Piera Degli Esposti, Mirella Panfili. Production Company: San Marco SpA (Rome) / Le Films Number One (Paris) / Janus Film und Fernsehen (Frankfurt). Producers: Franco Rossellini, Marina Cicogna. Associate producers: Pierre Kalfon, Klaus Helwig. Production manager: Fernando Franchi. Unit manager: Pietro Nardi. Production secretary: Paolo Luciani. Production supervisor: Sergio Galiano. Stock: Kodak Eastmancolor, 35mm, colour. Negatives and positives: Technostampa. Synch and sound recording: NIS Film. Shooting period: May - August 1969. Studios: Cinecittà (Rome). Locations: Uçhisar, Göreme, Çavuşin (Turkey), Aleppo (Syria), Pisa, Marechiaro di Anzio, Grado, Viterbo (Italy). Running time: 110'. Released: December 27, 1969 (Milan).

APPUNTI PER UN'ORESTIADE AFRICANA
(Notes for an African Orestes)
Italy, 1970

Screenplay: Pier Paolo Pasolini. Commentary: written and narrated by Pier Paolo Pasolini. Directors of photography: Pier Paolo Pasolini, Giorgio Pelloni, Mario Bagnato, Emore Galeassi. Original music score: Gato Barbieri, performed by Gato Barbieri (sax), Donald F. Moye (drums), Marcello Melio (bass) and sung by Yvonne Murray and Archie Savage. Sound: Federico Savina. Editor: Cleofe Conversi. Stills photographer: Giorgio Pelloni. Production Company: Gian Vittorio Baldi e IDI Cinematografica, I Film dell'Orso (Rome). Producer: Gian Vittorio Baldi. Stock: Eastmancolor, 16mm, b/n. Negatives and positives: Luciano Vittori. Synch and sound recording: NIS Film. Shooting period: December 1968 and February 1969. Studios: Folkstudio (Rome). Locations: Uganda, Tanzania, Lake Tanganika, Università La Sapienza, Roma. Running time: 73'. Premiere: Cannes MIDEM, April 16, 1970.

IL DECAMERON
(The Decameron)
Italy-France-Germany, 1971

Screenplay: Pier Paolo Pasolini, based on Giovanni Boccaccio's *Decameron*. *Director of photography:* Tonino Delli Colli. *Camera operator:* Giovanni Ciarlo. *First camera assistant:* Carlo Tafani. *Second camera assistants*: Alessio Gelsini, Giuseppe Fornari. *Art director:* Dante Ferretti. *Assistant art director:* Carlo Agate. *Set decorator:* Andrea Fantacci. *Costume designer:* Danilo Donati. *Assistant costume designer:* Piero Cicoletti. *Costumes*: Piero Farani. *Music co-ordination:* Pier Paolo Pasolini with Ennio Morricone. *Sound:* Pietro Spadoni. *Editors:* Nino Baragli, Tatiana Casini Morigi. *Assistant editor:* Anita Cacciolati. *Assistant directors:* Sergio Citti, Umberto Angelucci. *Second assistant director:* Paolo Andrea Mettel. *Stills photographer:* Mario Tursi. *Post production:* Enzo Ocone. *Continuity*: Beatrice Banfi. *Cast:* Franco Citti (*Ciappelletto*), Ninetto Davoli (*Andreuccio from Perugia*), Angela Luce (*Peronella*), Pier Paolo Pasolini (*Giotto's disciple*), Giuseppe Zigaina (*a friar*), Vincenzo Amato (*Masetto from Lamporecchio*), Guido Alberti (*a rich merchant*), Gianni Rizzo (*father superior*), Elisabetta Genovese (*Caterina*), Silvana Mangano (*the Madonna*), Giorgio Iovine, Salvatore Bilardo, Vincenzo Ferrigno, Luigi Seraponte, Antonio Diddio, Mirella Catanesi, Vincenzo De Luca, Erminio Nazzaro, Giovanni Filadoro, Lino Crispo, Alfredo Sivoli, E. Jannotta Carrino, Vittorio Vittori, Monique Van Voren, Enzo Spitaleri, Luciano Telli, Anne Marguerite Latroye, Gerard Exel, Wolfgang Hillinger, Franco Marlotta, Giacomo Rizzo, Vittorio Fanfoni, Uhle Detlef Gerd, Adriano Donnorso, E. Maria De Juliis, Patrizia De Clara, Guido Mannari, Michele Di Matteo, Giovanni Esposito, Giovanni Scagliola, Giovanni Davoli, Giuliana Fratello, Lucio Amatelli, Gabriella Frankel, Vincenzo Cristo. *Production Company:* PEA (Rome) / Les Productions Artistes Associés (Paris) / Artemis Film (Berlin). *Producers:* Alberto Grimaldi, Franco Rossellini. *Production manager:* Mario Di Biase. *Unit manager:* Sergio Galiano. *Production secretary:* Vittorio Bucci. *Line producer:* Alberto De Stefanis.

Stock: Kodak Eastmancolor, 35mm, colour. *Synch and sound recording:* Cinefonico Palatino. *Sound mixer:* Mario Morigi. *Shooting period:* September - October 1970. *Studios:* Safa Palatino. *Locations:* Napoli, Amalfi, Vesuvio, Ravello, Sorrento, Caserta, Roma and Viterbo environs, Nepi, Bolzano, Bressanone, Sana'a (North Yemen), Valle della Loira (France). *Running time:* 110'. *Premiere:* XXI Berlin Festival, June 29, 1971. *Awards:* XXI Berlin Festival, Silver Bear.

LE MURA DI SANA'A
(l.t. The Walls of Sana'a)
Italy, 1971-1974

Commentary: written and narrated by Pier Paolo Pasolini. *Director of photography:* Tonino Delli Colli. *Editor:* Tatiana Casini Morigi. *Production Company:* Rosima Amstalt (Rome). *Producer:* Franco Rossellini. *Stock:* Kodak Eastmancolor, 35mm, colour. *Synch and sound recording:* Cinefonico Palatino. *Shooting period:* October 18, 1970 and Autumn 1973. *Locations:* Sana'a (North Yemen), Adramaut (South Yemen), Orte (Italy). *Running time:* 13'. *Premiere:* June 20, 1974 (Milan).

I RACCONTI DI CANTERBURY
(The Canterbury Tales)
Italy-France, 1972

Screenplay: Pier Paolo Pasolini, based on Geoffrey Chaucer's *The Canterbury Tales*.
Director of photography: Tonino Delli Colli. *Camera operator:* Carlo Tafani. *Camera assistant:* Maurizio Lucchini. *Art director:* Dante Ferretti. *Assistant art director:* Carlo Agate. *Set decorator:* Kenneth Muggleston. *Costume designer:* Danilo Donati. *Music:* selected by Pier Paolo Pasolini with the assistance of Ennio Morricone. *Sound:* Primiano Muratore. *Editor:* Nino Baragli. *Assistant editors:* Anita Cacciolati, Ugo De Rossi. *Assistant directors:* Sergio Citti, Umberto Angelucci. *Second assistant director:* Peter Shepherd. *Stills photographer:* Mimmo Cattarinich. *Continuity*: Beatrice Banfi. *Cast:* Hugh Griffith (*Sir January*),

Laura Betti (*the woman of Bath*), Ninetto Davoli (*Perkin the fool*), Franco Citti (*the devil*), Alan Webb (*the old man*), Josephine Chaplin (*May*), Pier Paolo Pasolini (*Geoffrey Chaucer*), John Francis Lane (*the monk*), J.P. Van Dyne (*cook*), Vernon Dobtcheff, Adrian Strett, Derek Deadmin, Nicholas Smith, George Datch, Dan Thomas, Michael Balfour, Jenny Runacre, Peter Cain, Daniele Buckler, Settimio Castagna, Athol Coats, Judy Stewart-Murray, Tom Baker, Oscar Fochetti, Willoughby Goddard, Peter Stephen, Giuseppe Arrigo, Elisabetta Genovese, Gordon King, Patrick Duffett, Eamann Howell, Albert King, Eileen King, Heather Johnson, Robin Asquith, Martin Whelar, John McLaren, Edward Monteith Kervin, Franca Sciutto, Vittorio Fanfoni. *Production Company:* PEA Produzioni Europee Associate (Rome). *Producer:* Alberto Grimaldi. *Production manager:* Alessandro von Normann. *Unit manager:* Ennio Onorati. *Production secretary:* Franca Tasso. *Stock:* Kodak Eastmancolor, 35mm, colour. *Negatives and positives:* Technicolor. *Synch and sound recording:* Cinefonico Palatino. *Sound mixer:* Gianni D'Amico. *Shooting period:* September - November 1971. *Studios:* Safa Palatino (Rome). *Locations:* Canterbury, Battle, Warwick, Maidstone, Cambridge, Bath, Hastings, Lavenham, Rolvenden (United Kingdom), Etna (Sicilia). *Running time:* 110'. *Premiere:* XXII Berlin Festival, July 2, 1972. *Awards:* XXII Berlin Festival, Golden Bear.

IL FIORE DELLE MILLE E UNA NOTTE
(Arabian Nights)
Italy-France, 1974
Screenplay: Pier Paolo Pasolini, based on *Thousand and One Nights*. *Screenplay collaboration:* Dacia Maraini. *Director of photography:* Giuseppe Ruzzolini. *Camera operator:* Alessandro Ruzzolini. *Camera assistant:* Marcello Mastrogirolamo. *Art director:* Dante Ferretti. *Costume designer:* Danilo Donati. *Costume House:* Farani. *Music:* Ennio Morricone. *Sound:* Luciano Welisch. *Editors:* Nino Baragli, Tatiana Casini Morigi. *Assistant directors:* Umberto Angelucci, Peter Shepherd.

Stills photographer: Angelo Pennoni. *Continuity:* Beatrice Banfi. *Cast:* Franco Merli (*Nur ed Din*), Ines Pellegrini (*Zumurrud*), Ninetto Davoli (*Aziz*), Tessa Bouché (*Aziza*), Franco Citti (*the Genie*), Margareth Clementi, Luigina Rocchi, Elisabetta Vito Genovese, Abadit Ghidei (*Princess Dunja*), Giana Idris, Alberto Argentino, Francesco Paolo Governale, Salvatore Sapienza, Fessazion Gherentiel, Gioacchino Castellina, Salvatore Verdetti, Luigi Antonio Guerra, Francelise Noel, Christian Alegny, Jocelyn Munchenbach, Jeanne Gauffin Mathieu, Franca Sciutto. *Production Company:* PEA (Rome) / Les Productions Artistes Associés (Paris). *Producer:* Alberto Grimaldi. *Production manager:* Mario Di Biase. *Unit managers:* Giuseppe Banchelli, Alessandro Mattei. *Production secretary:* Carla Crovato. *Stock:* Kodak Eastmancolor, 35mm, colour. *Special optical effects:* Rank Film Labs (England). *Synch and sound recording:* NIS Film (Rome). *Sound mixer:* Fausto Ancillai. *Shooting period:* March - May 1973. *Studios:* Stabilimenti Labaro Film (Rome). *Locations:* North Yemen, South Yemen, Persia, Nepal, Ethiopia, India. *Running time:* 129'. *Premiere:* May 20, 1974 (Cannes).

SALÒ O LE 120 GIORNATE DI SODOMA
(Salò or the 120 Days of Sodom)
Italy-France, 1975
Screenplay: Pier Paolo Pasolini, based on D.A.F. De Sade's *120 Days of Sodom*. *Screenplay collaboration:* Sergio Citti and Pupi Avati. *Director of photography:* Tonino Delli Colli. *Camera operators:* Carlo Tafani, Emilio Bestetti. *First camera assistant:* Sandro Battaglia. *Second camera assistant:* Giancarlo Granatelli. *Art director:* Dante Ferretti. *Set decorator:* Osvaldo Desideri. *Costume designer:* Danilo Donati. *Assistant costume designer:* Vanni Castellani. *Music co-ordination:* Pier Paolo Pasolini. *Music advisor:* Ennio Morricone. *Piano played by:* Arnaldo Graziosi. *Sound:* Domenico Pasquadibisceglie, Giorgio Loviscek. *Editors:* Nino Baragli, Tatiana Casini Morigi. *First assistant editor:* Ugo De Rossi. *Second assistant editor:* Alfredo Menchini. *Assistant director:* Umberto Angelucci.

Second assistant director: Fiorella Infascelli. *Stills photographer:* Deborah Beer. *Continuity:* Beatrice Banfi. *Cast:* Paolo Bonacelli (*Duke*), Uberto Paolo Quintavalle (*His Excellency, dubbed by Giancarlo Vigorelli*), Giorgio Cataldi (*the Bishop, dubbed by Giorgio Caproni*), Aldo Valletti (*President, dubbed by Marco Bellocchio*), Caterina Boratto (*Mrs. Castelli*), Hélène Surgère (*Mrs. Vaccari, dubbed by Laura Betti*), Elsa de' Giorgi (*Mrs. Maggi*), Sonia Saviange (*the virtuosa*), Sergio Fascetti, Antonio Orlando, Claudio Cicchetti, Franco Merli, Bruno Musso, Umberto Chessari, Lamberto Book, Gaspare di Jenno (*male victims*), Giuliana Melis, Faridah Malik, Graziella Aniceto, Renata Moar, Dorit Henke, Antinisca Nemour, Benedetta Gaetani, Olga Andreis (*female victims*), Tatiana Mogilanskij, Susanna Radaelli, Giuliana Orlandi, Liana Acquaviva (*daughters*), Rinaldo Missaglia, Giuseppe Patruno, Guido Galletti, Efisio Erzi, Claudio Troccoli, Fabrizio Menichini, Maurizio Valaguzza, Ezio Manni (*soldiers*), Anna Maria Dossena, Anna Recchimuzzi, Paola Pieracci, Carla Terlizzi, Ines Pellegrini (*ruffians and servants*). *Production Company:* PEA (Rome) / Les Productions Artistes Associés (Paris). *Producer:* Alberto Grimaldi. *Production manager:* Antonio Girasante. *Unit managers:* Alessandro Mattei, Renzo David, Angelo Zemella. *Production secretary:* Vittorio Cudia. *Stock:* Kodak Eastmancolor, 35mm, colour. *Negatives and positives:* Technicolor. *Synch and sound recording:* International Recording (Rome). *Sound mixer:* Fausto Ancillai. *Shooting period:* March - May 1975. *Studios:* Cinecittà (Rome). *Locations:* Salò, Mantova, Gardelletta (Emilia), Bologna. *Running time:* 116'. *Premiere:* Festival of Paris, November 22, 1975.

Collaborations

La donna del fiume (*The River Girl*) by Mario Soldati. Italy, 1954.
Screenplay: Antonio Altoviti, Giorgio Bassani, Basilio Franchina, Pier Paolo Pasolini, Mario Soldati, Florestano Vancini.

Il prigioniero della montagna (l.t. The Prisoner of the Mountain) by Luis Trenker. Italy, 1955.
Screenplay: Giorgio Bassani, Pier Paolo Pasolini, Luis Trenker.

Manon: finestra 2 (l.t. Manon: Window 2) by Ermanno Olmi. Short. Italy, 1956.
Text: Pier Paolo Pasolini.

Grigio (l.t. Grey) by Ermanno Olmi, Short. Italy, 1957.
Text: Pier Paolo Pasolini.

Le notti di Cabiria (*Nights of Cabiria*) by Federico Fellini. Italy-France, 1957.
Collaboration on the dialogues: Pier Paolo Pasolini.

Marisa la civetta (l.t. Marisa the Flirt) by Mauro Bolognini. Italy, 1957.
Screenplay: Tatiana Denby, Pier Paolo Pasolini, Mauro Bolognini.

Ignoti alla città (l.t. Strangers to the City) by Cecilia Mangini. Short. Italy, 1958.
Text: Pier Paolo Pasolini.

Giovani mariti (l.t. Young Husbands) by Mauro Bolognini. Italy, 1958.
Screenplay: Enzo Curieli, Luciano Martino, Pier Paolo Pasolini, Mauro Bolognini.

Il mago (l.t. The Magician) by Mario Gallo. Short, Italy 1958.
Text: Pier Paolo Pasolini.

A Farewell to Arms by Charles Vidor. USA, 1958.
Coll. dialogues: Pier Paolo Pasolini, Leopoldo Trieste, Cesare Zavattini.

Morte di un amico (l.t. Death of a Friend) by Franco Rossi. Italy, 1959.
Story: Giuseppe Berto, Oreste Biancoli, Pier Paolo Pasolini, Franco Riganti.

La notte brava (l.t. The Big Night) by Mauro Bolognini. Italy, 1959.
Story and screenplay: Pier Paolo Pasolini.

Caschi d'oro (l.t. Golden Helmets) by Mario Gallo. Short. Italy, 1960.
Text: Pier Paolo Pasolini.

La dolce vita (Id.) by Federico Fellini. Italy-France, 1960.
Screenplay: Federico Fellini, Ennio Flaiano, Tullio Pinelli, Brunello Rondi, Pier Paolo Pasolini (not credited).

Stendali (l.t. Id.) by Cecilia Mangini, Short. Italy, 1960.
Text: Pier Paolo Pasolini.

Il bell'Antonio (Id.) by Mauro Bolognini. Italy-France, 1960.
Screenplay: Pier Paolo Pasolini, Gino Visentini.

La canta delle marane (l.t. The Song of the Mashes) by Cecilia Mangini. Short. Italy, 1960.
Story: inspired from Pier Paolo Pasolini's *Ragazzi di vita* (*The Ragazzi*).
Text: Pier Paolo Pasolini.

La giornata balorda (*From a Roman Balcony*) by Mauro Bolognini. Italy, 1960.
Screenplay: Alberto Moravia, Pier Paolo Pasolini, Marco Visconti.

Il carro armato dell'8 settembre (l.t. The Tank of the 8th September) by Gianni Puccini. Italy, 1960.
Screenplay: Bruno Baratti, Elio Bartolini, Goffredo Parise, Pier Paolo Pasolini, Giulio Questi.

Il Gobbo (l.t. The Hunchback) by Carlo Lizzani. Italy-France, 1960.
Dialogues advice: Pier Paolo Pasolini.
Cast: Gérard Blain, Anna Maria Ferrero, Bernard Blier,

Pier Paolo Pasolini (*Leandro, er Monco*).

La lunga notte del '43 (*One Night in '43*) by Florestano Vancini. Italy, 1960.
Screenplay: Ennio De Concini, Pier Paolo Pasolini, Florestano Vancini.

La ragazza con la valigia (*Girl with a Suitcase*) by Valerio Zurlini. Italy, 1961.
Screenplay collaboration: Pier Paolo Pasolini.

La ragazza in vetrina (l.t. Girl in the Window) by Luciano Emmer. Italy-France, 1961.
Screenplay: Vinicio Marinucci, Luciano Martino, Pier Paolo Pasolini, Luciano Emmer, José Giovanni (not credited).

Milano nera (l.t. Dark Milan) by Gian Rocco e Pino Serpi. Italy, 1961.
Screenplay: Pier Paolo Pasolini, Gian Rocco e Pino Serpi.

La commare secca (*The Death*) by Bernardo Bertolucci. Italy, 1962.
Story: Pier Paolo Pasolini.
Screenplay: Sergio Citti, Pier Paolo Pasolini, Bernardo Bertolucci.

Il ragazzo motore (l.t. The Motor Boy) by Paola Faloja. Short. Italy, 1967.
Text and commentary narrated by: Pier Paolo Pasolini.

Requiescant (l.t. Id.) by Carlo Lizzani. Italy, 1967.
Cast: Mark Damon, Ninetto Davoli, Pier Paolo Pasolini (*Don Juan*).

Ostia (l.t. Id.) by Sergio Citti. Italy, 1970.
Story and screenplay: Pier Paolo Pasolini, Sergio Citti.
Direction supervisor: Pier Paolo Pasolini.

12 dicembre (l.t. December 12) by Giovanni Bonfanti. Italy, 1972.
Idea: Pier Paolo Pasolini.
Sequences filmed by Pier Paolo Pasolini: Carrara, Sarzana, Reggio Calabria.

Storie scellerate (l.t. Bawdy Tales) by Sergio Citti. Italy, 1973.

Story and screenplay: Pier Paolo Pasolini, Sergio Citti.

Trash by Paul Morrissey. USA, 1973.
Translations and dialogue adaptations: Dacia Maraini, Pier Paolo Pasolini.

Sweet Movie by Dusan Makavejev. France, 1974.
Translations and dialogue adaptations: Dacia Maraini, Pier Paolo Pasolini.

Edited by Roberto Chiesi and Francesca Fanci

BIBLIOGRAPHY

Poems

Poesie a Casarsa, Libreria Antiquaria Mario Landi, Bologna 1942.

Poesie, Stamperia Primon, San Vito al Tagliamento 1945.

Diarii, Pubblicazioni dell'Academiuta, Casarsa 1945.

I pianti, Pubblicazioni dell'Academiuta, Casarsa 1946.

Dov'è la mia patria, 13 drawings by Giuseppe Zigaina, Edizioni dell'Academiuta, Casarsa 1949.

Tal còur di un frut, Edizioni di Lingua Friulana, Tricesimo 1953.

Dal diario (1945-47), Sciascia, Caltanissetta 1954.

La meglio gioventù. Poesie friulane, Sansoni ("Biblioteca di Paragone"), Florence 1954.

Il canto popolare, Edizioni della Meridiana, Milan 1954.

Le ceneri di Gramsci, Garzanti, Milan 1957.

L'usignolo della Chiesa Cattolica, Longanesi, Milan 1958.

Roma 1950. Diario, All'insegna del pesce d'oro - Scheiwiller, Milan 1960.

Sonetto primaverile (1953), All'insegna del pesce d'oro - Scheiwiller, Milan 1960.

La religione del mio tempo, Garzanti, Milan 1961.

Poesia in forma di rosa (1961-1964), Garzanti, Milan 1964.

Poesie dimenticate, edited by Luigi Ciceri, Società filologica Friulana, Udine 1965.

Poesie. Le ceneri di Gramsci, La religione del mio tempo, Poesia in forma di rosa Garzanti, Milan, 1970

Trasumanar e organizzar, Garzanti, Milan 1971.

La nuova gioventù. Poesie friulane 1941-1974, Einaudi, Turin 1975.

Le poesie: Le ceneri di Gramsci, La religione del mio tempo, Poesia in forma di rosa, Trasumanar e organizzar, Garzanti, Milan 1975.

Poesie e pagine ritrovate, eds. Andrea Zanzotto and Nico Naldini, Ed. Lato Side, Rome 1980.

Bestemmia. Tutte le poesie, eds. Graziella Chiarcossi and Walter Siti, Garzanti, Milan 1993.

Poesie scelte, eds. Nico Naldini and Francesco Zambon, TEA, Milan 1997.

Tutte le poesie, ed. Walter Siti, Mondadori, Milan 2003.

Poeta delle Ceneri, ed. Piero Gelli, Archinto, Milan 2010.

Translations

Tutte le poesie, II vol., ed. Walter Siti, Mondadori, Milan 2003.

From Latin

From *Eneide*, in Umberto Todini, "Virgilio e Plauto, Pasolini e Zanzotto. Inediti e manoscritti d'autore tra antico e moderno, " in *Lezioni su Pasolini*, eds. Tullio De Mauro and Francesco Ferri, Sestante, Ascoli Piceno 1997.

From French

Roger Allard, "Storia di Yvonne," in *Poesia straniera del Novecento*, ed. Attilio Bertolucci, Garzanti, Milan 1958.

Jean Pellerin, "La romanza del ritorno," in *Poesia straniera del Novecento*, ed. Attilio Bertolucci, Garzanti, Milan 1958.

André Frénaud, "Esortazione ai poveri," *L'Europa letteraria*, December 1960.

From Friulan

Niccolò Tommaseo, "A la so pissula patria," *Il Stroligut*, n. 1, August 1945.

Giuseppe Ungaretti, "Luna," *Il Stroligut*, n. 2, April 1946.

From Greek to Friulan

Tre frammenti di Saffo, in Massimo Fusillo, *La Grecia secondo Pasolini. Mito e cinema*, La Nuova Italia, Florence 1996.

Narrative

Ragazzi di vita, Garzanti, Milan 1955.

Una vita violenta, Garzanti, Milan 1959.

L'odore dell'India, Longanesi, Milan 1962.

Il sogno di una cosa, Garzanti, Milan 1962.

Alì dagli occhi azzurri, Garzanti, Milan 1965.

Teorema, Garzanti, Milan 1968.

La Divina Mimesis, Einaudi, Turin 1975.

Amado mio preceduto da Atti impuri, foreword by Attilio Bertolucci, ed. Concetta D'Angeli, Garzanti, Milan 1982.

Petrolio, eds. Maria Careri and Graziella Chiarcossi, Einaudi, Turin 1992.

Un paese di temporali e di primule, ed. Nico Naldini, Guanda, Parma 1993.

Romàns, followed by *Un articolo per il "Progresso" e Operetta marina*, ed. Nico Naldini, Guanda, Parma 1994.

Storie della città di Dio. Racconti e cronache romane (1950-1966), ed. Walter Siti, Einaudi, Turin 1995.

Romanzi e racconti, eds. Walter Siti and Silvia De Laude, Mondadori, Milan 1998.

Screenplays and film texts

"La notte brava," *Filmcritica*, November-December 1959.

Accattone, foreword by Carlo Levi, FM, Rome 1961.

Mamma Roma, Rizzoli, Milan 1962.

Il Vangelo secondo Matteo, Garzanti, Milan 1964.

"La commare secca," *Filmcritica*, October 1965.

Uccellacci e uccellini, Garzanti, Milan 1966.

Edipo re, Garzanti, Milan 1967.

"Che cosa sono le nuvole?" *Cinema e Film*, 1969.

"Porcile" (first episode's storyline, original title *Orgia*), *ABC*, January 10, 1969.

"Appunti per un poema sul Terzo Mondo (storyline)," in *Pier Paolo Pasolini. Corpi e luoghi*, ed. Michele Mancini and Giuseppe Perrella, Theorema, Rome 1981.

Ostia, screenplay by Sergio Citti e Pier Paolo Pasolini, Garzanti, Milan 1970.

Medea, Garzanti, Milan 1970.

Il padre selvaggio, Einaudi, Turin 1975.

Trilogia della vita (Il Decameron, I racconti di Canterbury, Il fiore delle Mille e una notte), ed. Giorgio Gattei, Cappelli, Bologna 1975.

San Paolo, Einaudi, Turin 1977.

"Ignoti alla città (commentary)," in Pier Paolo Pasolini, *Il cinema in forma di poesia*, ed. Luciano De Giusti, Cinemazero, Pordenone 1979.

"La canta delle marane" (commentary), *ibid.*

"Comizi d'amore," *ibid.*

"Storia indiana," *ibid.*

Appunti per un'Orestiade africana, ed. Antonio Costa, Quaderni del Centro Culturale di Copparo, Copparo (Ferrara) 1983.

"Le mura di Sana'a (commentary)," *Epoca*, March 27, 1988.

"Porno-Teo-Kolossal," *Cinecritica*, April-June 1989.

"Sant'Infame," *ibid.*

Il Vangelo secondo Matteo. Edipo Re. Medea, Garzanti, Milan 1991.

Accattone. Mamma Roma. Ostia, Garzanti, Milan 1993

"La Terra vista dalla Luna (storyboard)," *MicroMega*, October-November 1995.

"La nebbiosa," *Filmcritica*, 459/460, November-December 1995.

Trilogia della vita. Le sceneggiature originali di Il Decameron, I racconti di Canterbury, Il fiore delle Mille e una notte, Garzanti, Milan 1995.

Per il cinema, eds. Walter Siti and Franco Zabagli, Mondadori, Milan 2001.

La Rabbia, ed. Roberto Chiesi, Edizioni Cineteca di Bologna, Bologna 2008.

La terra vista dalla luna, Edizioni Polistampa, Firenze 2010.

Theater

"Italie Magique," in *Potentissima signora, canzoni e dialoghi scritti per Laura Betti*, Longanesi, Milan 1965.

"Pilade," *Nuovi Argomenti*, July-December 1967.

"Affabulazione," *Nuovi Argomenti*, July-September 1969.

Calderón, Garzanti, Milan 1973.

I Turcs tal Friùl (*I Turchi in Friuli*), ed. Luigi Ciceri, Forum Julii, Udine 1976.

Affabulazione-Pilade, foreword by Attilio Bertolucci, Garzanti, Milan 1977.

Porcile, Orgia, Bestia da stile, note by Aurelio Roncaglia, Garzanti, Milan 1979.

Teatro (Calderón, Affabulazione, Pilade, Porcile, Orgia, Bestia da stile), foreword by Guido Davico Bonino, Garzanti, Milan 1988.

Affabulazione, note by Guido Davico Bonino, Einaudi, Turin 1992.

"La sua gloria," *Rendiconti*, no. 40, March 1996.

Teatro, eds. Walter Siti and Silvia De Laude, Mondadori, Milan 2001.

Teatro 1 (Calderón, Affabulazione, Pilade), foreword by Oliviero Ponte di Pino, Garzanti, Milan 2010.

Teatro 2 (Porcile, Orgia, Bestia da stile), foreword by Oliviero Ponte di Pino, Garzanti, Milan 2010.

Drama translations

Eschilo, *Orestiade*, Istituto Nazionale del Dramma Antico per le rappresentazioni classiche nel teatro greco di Siracusa, Urbino 1960 (Einaudi, Turin 1985).

Plauto, *Il vantone*, Garzanti, Milan 1963.

Essays

Poesia dialettale del Novecento, eds. Mario Dell'Arco and Pier Paolo Pasolini, Guanda, Parma 1952 (Einaudi, Turin 1995).

Canzoniere italiano. Antologia della poesia popolare, ed. Pier Paolo Pasolini, Guanda, Parma 1955 (Garzanti, Milan 2006).

Passione e ideologia (1948-1958), Garzanti, Milan 1960.

Empirismo eretico, Garzanti, Milan 1972.

Scritti corsari, Garzanti, Milan 1975.

Lettere luterane, Einaudi, Turin 1976 (Garzanti, Milan 2009).

Pier Paolo Pasolini e "Il setaccio" (1942-1943), ed. Mario Ricci, Cappelli, Bologna 1977 (essays: "*Umori di Bartolini*"; "Cultura italiana e cultura europea a Weimar"; "I giovani, l'attesa"; "Noterelle per una polemica"; "Mostre e città"; "Per una morale pura in Ungaretti"; "Ragionamento sul dolore civile"; "Fuoco lento. Collezioni letterarie"; "Filologia e morale"; "Personalità di Gentilini"; "*Dino* e *Biografia ad Ebe*"; "Ultimo discorso sugli intellettuali"; "Commento a un'antologia di lirici nuovi"; "Giustificazione per De Angelis"; "Commento allo scritto del Bresson"; "Una mostra a Udine").

Descrizioni di descrizioni, ed. Graziella Chiarcossi, Einaudi, Turin 1979 (Garzanti, Milan 1998).

Stroligut di cà da l'aga (1944) - Il Stroligut (1945-1946) – Quaderno romanzo (1947), ed. Circolo filologico linguistico padovano, Padua 1983.

Il Portico della Morte, ed. Cesare Segre, Associazione Fondo Pier Paolo Pasolini, Garzanti, Milan 1988.

Antologia della lirica pascoliana. Introduzione e commenti, ed. Marco Antonio Bazzocchi, Einaudi, Turin 1993.

I film degli altri, ed. Tullio Kezich, Guanda, Parma 1996.

Saggi sulla letteratura e sull'arte, eds. Walter Siti and Silvia De Laude, Mondadori, Milan 1999.

Saggi sulla politica e la società, eds. Walter Siti and Silvia De Laude, Mondadori, Milan 1999.

Dialogue with the readers

Le belle bandiere. Dialoghi 1960-65, ed. Gian Carlo Ferretti, Editori Riuniti, Rome 1977.

Il caos, ed. Gian Carlo Ferretti, Editori Riuniti, Rome 1979.

I dialoghi, ed. Giovanni Falaschi, foreword by Gian Carlo Ferretti, Editori Riuniti, Rome 1992.

Epistolary

Lettere 1940-1954, ed. Nico Naldini, Einaudi, Turin 1986.

Lettere 1955-1975, ed. Nico Naldini, Einaudi, Turin 1988

Pier Paolo Pasolini. Vita attraverso le lettere, ed. Nico Naldini, Einaudi, Turin 1994.

Various

Pasolini on Pasolini, ed. Oswald Stack [Jon Halliday], Thames and Hudson, London-New York 1969.

I disegni 1941/75, ed. Giuseppe Zigaina, foreword by Giulio Carlo Argan, All'insegna del pesce d'oro, Scheiwiller, Milan 1978.

Pier Paolo Pasolini. Corpi e luoghi, eds. Michele Mancini and Giuseppe Perella, foreword by Paolo Volponi, Theorema, Rome 1981.

Il sogno del centauro, ed. Jean Duflot, Editori Riuniti, Rome 1983.

Disegni e pitture di Pier Paolo Pasolini, eds. Achille Bonito Oliva and Giuseppe Zigaina, Banca Popolare di Pordenone – Balance Rief SA, Basel 1984.

Interviste corsare sulla politica e sulla vita 1955-1975, ed. Michele Gulinucci, Liberal, Rome 1995.

Pasolini rilegge Pasolini. Intervista con Giuseppe Cardillo, ed. Luigi Fontanella, Archinto, Milan 2005.

English translations of Pier Paolo Pasolini's works

The Ragazzi, trans. Emile Capouya, Grove Press, New York 1968.

A Violent Life, trans. William Weaver, Jonathan Cape, London 1968.

Pasolini on Pasolini, ed. Oswald Stack [Jon Halliday], Thames and Hudson, London-New York 1969.

Oedipus Rex, trans. John Mathews, Lorrimer Publishing, London 1971.

The Divine Mimesis, trans. Thomas E. Peterson, Double Dance, Berkeley 1980.

Poems, trans. Norman MacAfee and Luciano Martinengo, Random House, New York 1982.

The Ashes of Gramsci, trans. David Wallace, Spectacular Diseases, Peterborough (England) 1982.

Lutheran Letters, trans. Stuart Hood, Carcanet-Raven Art Press, Manchester-Dublin 1983.

The Scent of India, trans. David Clive Price, Olive Press, London 1984.

The First Paradise, Odetta, trans. and ed. Antonio Mazza, Thee Hellbox Press, Kingston (Ontario) 1985.

Roman Poems, trans. Lawrence Ferlinghetti and Franca Valente, City Lights Books, San Francisco 1986.

Roman Nights and Other Stories, trans. John Shepley, Marlboro Press, Marlboro 1986.

Heretical Empiricism, ed. Louise K. Barnett, trans. Ben Lawton, Louise K. Barnett, Indiana University Press, Bloomington-Indianapolis 1988.

Ciant da li ciampanis, trans. Not Vital, Robert Henry Billigmeier, Luisa Famos, Andri Peer, Caldewey, New York 1988.

A Dream of Something, trans. Stuart Hood, Quartet Books, London 1988.

Pier Paolo Pasolini: A Cinema of Poetry. A cultural initiative for the recovery, restoration, conservation and multimedia dissemination of the complete cinema works of Pier Paolo Pasolini, ed. Laura Betti, Associazione "Fondo Pier Paolo Pasolini," Rome 1989.

A Violent Life: a novel, trans. William Weaver, Pantheon Books, New York 1992.

Poetry, trans. and ed. Antonio Mazza, Exile Editions, Toronto 1992.

The Letters of Pier Paolo Pasolini 1940-1954, vol. 1, ed. Nico Naldini, trans. Stuart Hood, Quartet Books, London 1992.

Theorem, trans. Stuart Hood, Quartet Books, London 1992.

A Desperate Vitality, trans. Pasquale Verdicchio, Parentheses Writing Series, La Jolla 1996.

Poems, trans. and ed. Norman MacAfee and Luciano Martinengo, Noonday Press, New York 1996.

Petrolio, trans. Ann Goldstein, Secker & Warburg, London 1997.

The Savage Father, trans. Pasquale Verdicchio, Guernica, Toronto Buffalo 1999.

The Book of Crosses, eds. Jack Hirschman, Philip Lamantia, Deliriodendron Press, San Francisco 2001.

The Ragazzi, trans. Emile Capouya, Carcanet, Manchester 2001.

Stories from the City of God: Sketches and Chronicles of Rome 1950-1966, trans. Marina Harss, Handsel, New York 2003.

The New Youth, trans. Lucia Gazzino, introduction Jack Hirschman, Marimbo, Berkeley 2005.

Heretical Empiricism, ed. Louise K. Barnett, trans. Ben Lawton, Louise K. Barnett, New Academia Publishing, Washington DC 2005.

"Manifesto for a New Theatre," trans. Thomas Simpson, *PAJ: A Journal of Performance and Art*, 29, 1, Johns Hopkins University, Baltimore 2007.

"Affabulazione", trans. Thomas Simpson, *PAJ: A Journal of Performance and Art*, 29, 1, Johns Hopkins University, Baltimore 2007.

A Violent Life, trans. William Weaver, Carcanet, Manchester 2007.

Pier Paolo Pasolini - Poet of Ashes, eds. Roberto Chiesi, Andrea Mancini, trans. Michael F. Moore, Ann Goldstein, Stephen Sartarelli, Angela Carabelli, City Lights-Titivillus, San Francisco-Corazzano 2007.

Fabrication (Affabulazione), trans. Jamie McKendrick, London, Oberon Books, London 2010.

In Danger: a Pasolini Anthology, ed. Jack Hirschman, City Lights, San Francisco 2010.

Poems, trans. and ed. Stephen Sartarelli, University of Chicago Press, Chicago 2013.

Edited by Roberto Chiesi, Francesca Fanci and Lapo Gresleri

We wanted this book not only to tell the story of Pier Paolo Pasolini's cinema in his own words, but also to be a visual account of his work. This was made possible thanks to the work of the extraordinary photographers who were present on his film sets.

Alfonso Avincola: *La terra vista dalla luna* (1966)

Gianni Barcelloni: *Appunti per un film sull'India* (1968) - *Appunti per un'Orestiade africana* (1970)

Deborah Beer: *Salò o le 120 giornate di Sodoma* (1975)

Bruno Bruni: *Edipo Re* (1967)

Domenico Cattarinich: *Medea* (1969) - *I racconti di Canterbury* (1972)

Divo Cavicchioli: *Mamma Roma* (1962) - *Uccellacci e uccellini* (1966)

Mario Dondero: *La ricotta* (1963) - *La Rabbia* (1963) - *Comizi d'amore* (1964)

Angelo Novi: *Mamma Roma* (1962) - *La ricotta* (1963) - *Comizi d'amore* (1964) - *Sopraluoghi in Palestina* (1964) - *Il Vangelo secondo Matteo* (1964) - *Uccellacci e uccellini* (1966) – *La terra vista dalla lun*a (1966) - *Che cosa sono le nuvole?* (1967) - *Teorema* (1968)

Marilù Parolini: *Porcile* (1969)

Giorgio Pelloni: *Appunti per un'Orestiade africana* (1970)

Angelo Pennoni: *Accattone* (1961) - *Il fiore delle Mille e una notte* (1974)

Carlo Riccardi: *Il padre selvaggio* (1963)

Paul Ronald: *La ricotta* (1963)

Mario Tursi: *Medea* (1969) - *Il Decameron* (1971) - *Le mura di Sanà'a* (1970-1974)

Roberto Villa: *Il fiore delle Mille e una notte* (1974)

This book was printed in November, 2012
by Tipografia Moderna, Bologna (Italy)